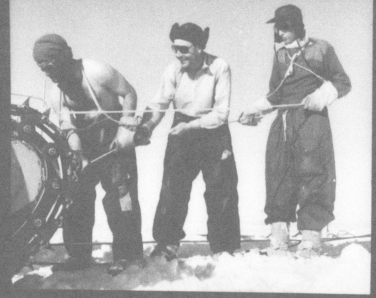

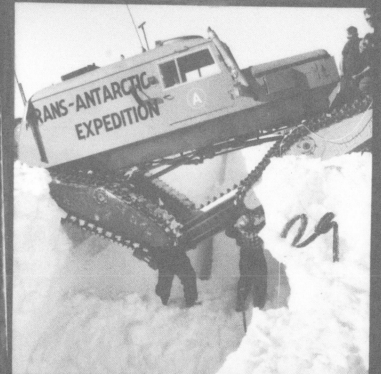

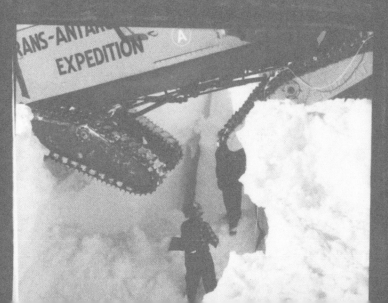

THE CROSSING OF
ANTARCTICA

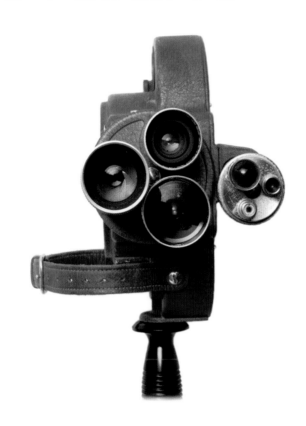

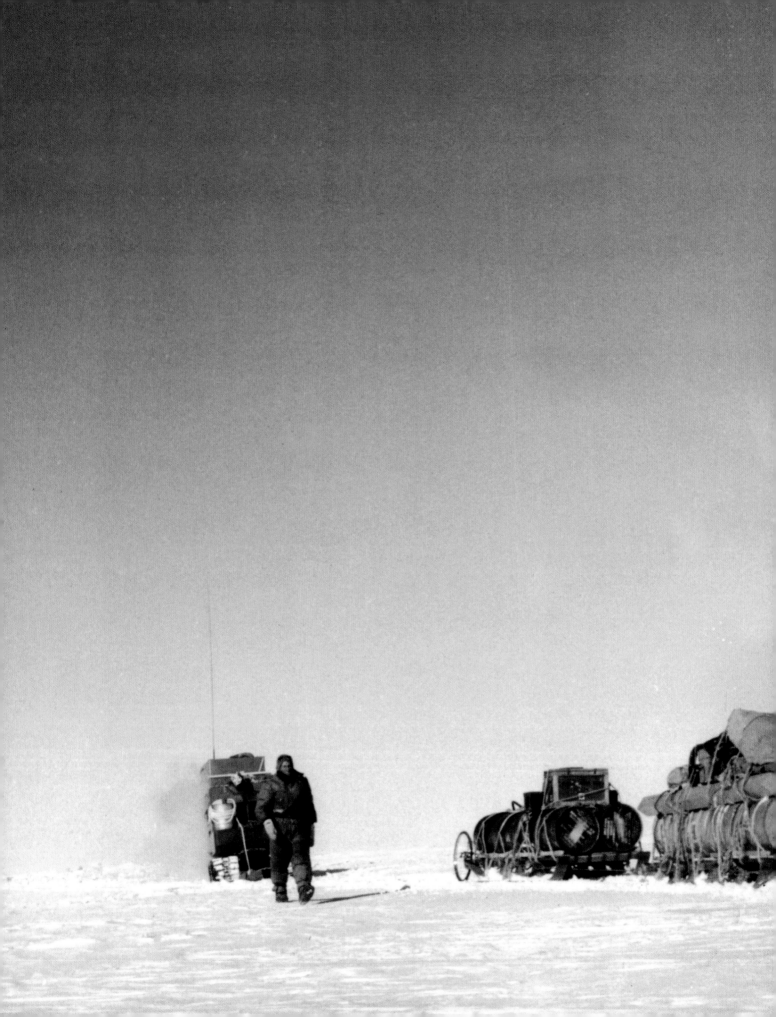

THE CROSSING OF
ANTARCTICA

ORIGINAL PHOTOGRAPHS FROM
THE EPIC JOURNEY THAT FULFILLED
SHACKLETON'S DREAM

GEORGE LOWE

AND HUW LEWIS-JONES

154 illustrations, 60 in color

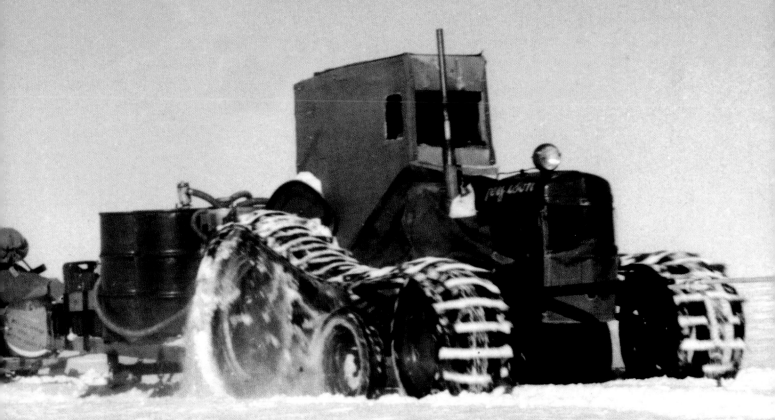

Thames & Hudson

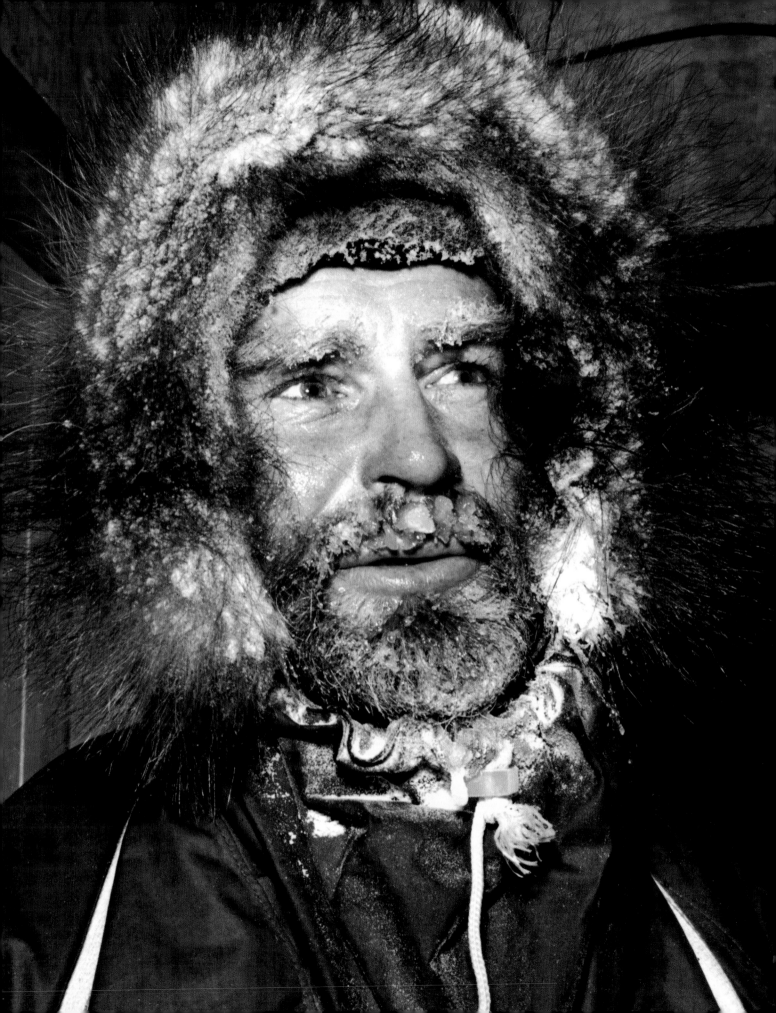

WITH PERSONAL REFLECTIONS FROM

FELICITY ASTON

KEN BLAIKLOCK

JON BOWERMASTER

SEBASTIAN COPELAND

PAUL DALRYMPLE

KLAUS DODDS

SIR RANULPH FIENNES

ARVED FUCHS

PETER FUCHS

SIR WALLY HERBERT

BØRGE OUSLAND

JONATHAN SHACKLETON

GEOFF SOMERS

EIRIK SØNNELAND

For the men of the Trans-Antarctic Expedition of 1955–58, whose efforts pushed back the boundaries of the known world. These were real explorers and all who are drawn to this challenging continent follow in their footsteps.

The Crossing of Antarctica © 2014 Thames & Hudson Ltd, London

Designed by Liz House
Directed by Huw Lewis-Jones

First published in 2014 in hardcover in the United States of America by Thames & Hudson Inc., 500 Fifth Avenue, New York, New York 10110

thamesandhudsonusa.com

Library of Congress Catalog Card Number 2014930126

ISBN 978-0-500-25202-4

Printed and bound in China by C & C Offset Printing Co. Ltd

PAGE **1** George had to juggle several cameras; this is his Bell & Howell 70DL ciné camera. During the crossing it often froze, though after he'd warmed it over the Primus stove it was ready for action once more.

PAGE **2/3** Ed Hillary's train of converted Ferguson farm tractors embarks on the intrepid southern journey. Despite their rough-and-ready appearance, the tractors were tough and were the first vehicles ever to drive to the South Pole.

PAGE **4** Dr Vivian Fuchs – known to all as Bunny – was a polar explorer of huge experience. George Lowe took this photograph on 3 August 1957 as the expedition overwintered on the shores of the Weddell Sea.

RIGHT Sno-Cat *Able* is stranded across the mouth of a deep ice chasm, December 1957. In order to take this shot George climbed down to a small ledge halfway down the crevasse. After reinforced aluminium bridging spans were wedged under the Sno-Cat's tracks it was eventually hauled free.

PAGE **8/9** A mile from Halley Bay was an Emperor penguin rookery containing many thousands of birds, one of the largest in Antarctica.

PAGE **10** 'The ramparts of Mount Erebus' by Herbert Ponting, 1911, a stunning image from the Royal Collection. An ice cliff of the Barne Glacier is in the foreground, with the volcano Mount Erebus behind. In 1958, it wasn't until this famous volcano came into view that George knew they'd finally made the coast and were reaching the end of their journey.

PAGE **12** Dog teams rest during explorations in the Queen Alexandra Range to the west of the Beardmore Glacier. On Christmas Day 1957 the Southern Party surveyors Bob Miller and George Marsh came upon two entirely new mountain chains, and went on to map some 38,850 sq. km (15,000 sq. miles) of previously unknown land.

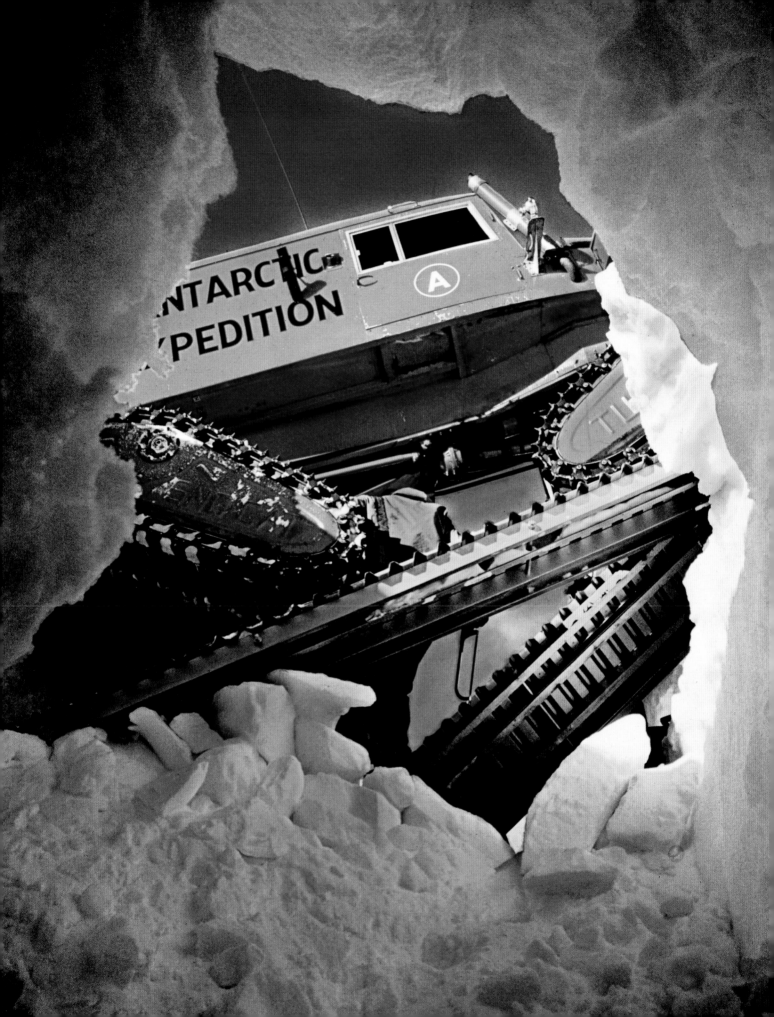

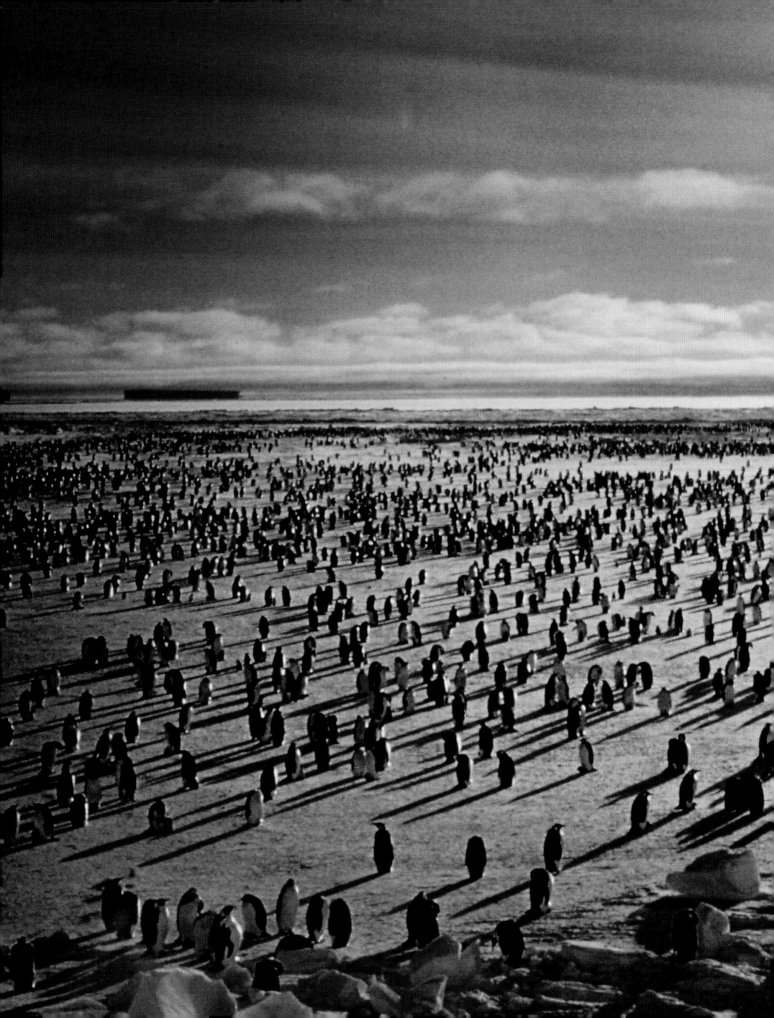

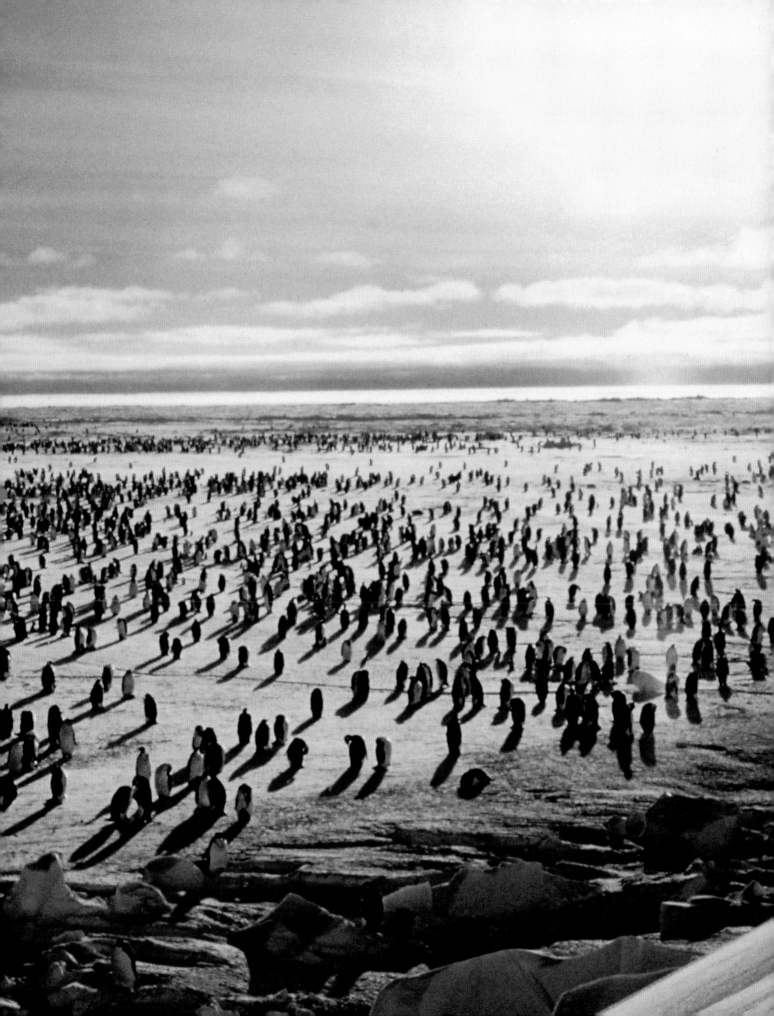

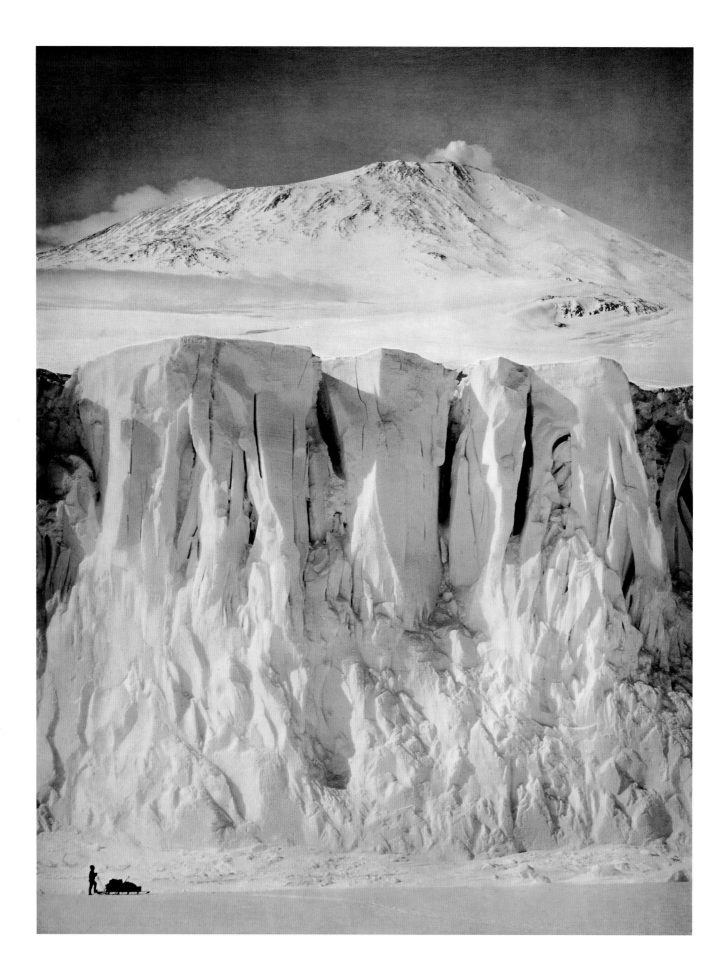

CONTENTS

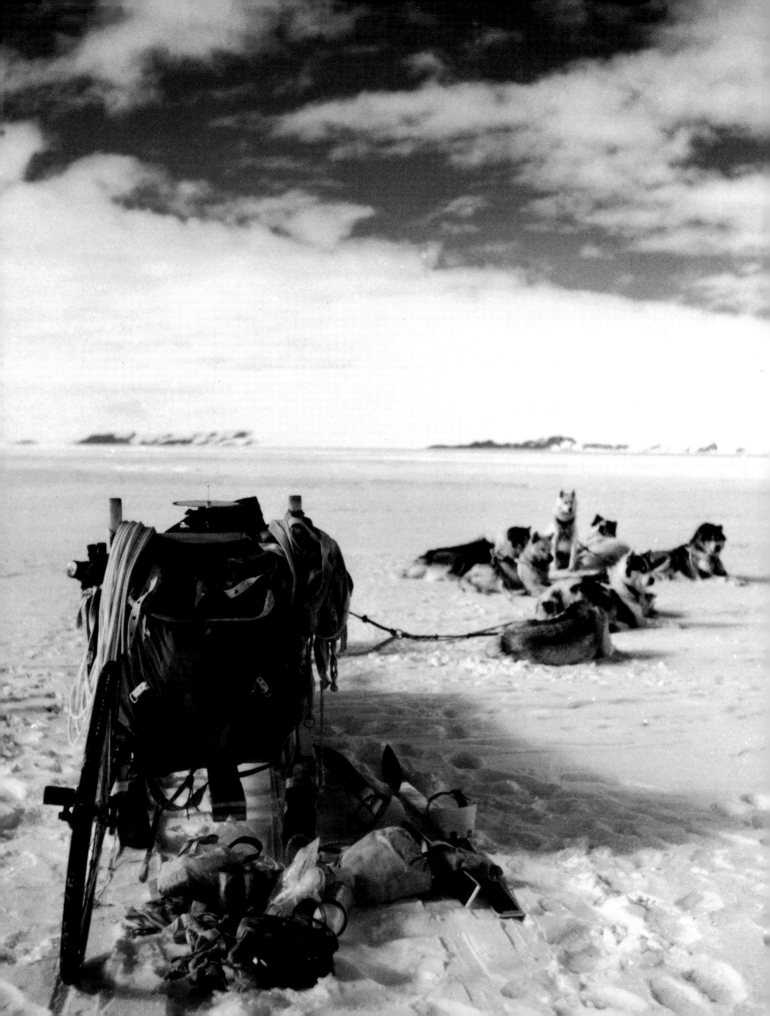

After the conquest of the South Pole, there remained but one great main object of Antarctic journeyings – the crossing of the South Polar continent from sea to sea. Every step would be an advance in geographical science; every step a journey into the unknown. It is the last great expedition that can be made.

Sir Ernest Shackleton, 1914

And yet even today we hear people ask in surprise: what is the use of these voyages of exploration? What good do they do us? Little brains, I always answer to myself, have only room for thoughts of bread and butter.

Roald Amundsen, 1912

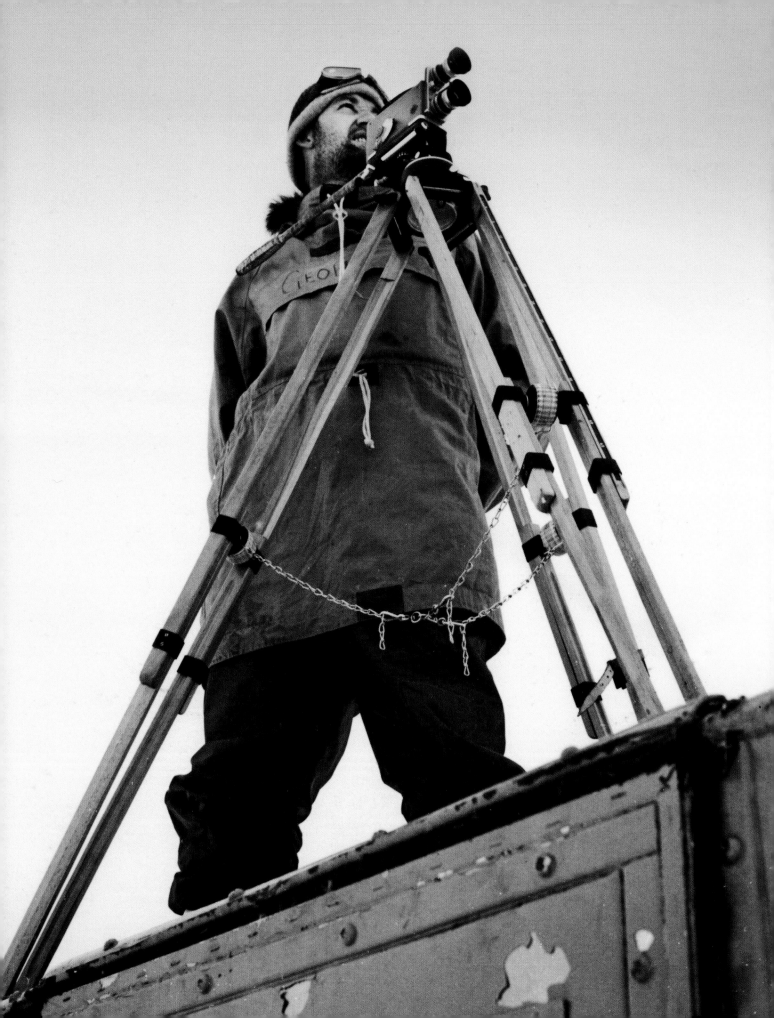

A FORGOTTEN HERO

HUW LEWIS-JONES

The first crossing of Antarctica in the austral summer of 1957–58 by the Commonwealth Trans-Antarctic Expedition (TAE) was one of the twentieth century's triumphs of exploration. It was a powerful expression of technological ambition as much as a testament of sheer, bloody-minded human willpower. It was also a journey long thought impossible, but after almost five years of preparation and effort the dream was at last fulfilled.

New Zealander George Lowe was a key member of the team. He proved to be both a master of ice and a very talented photographer, just as he had done a few years earlier on that other great expedition of the era: the first ascent of Everest. A trove of unpublished photographs and other rare materials from George's collection are now brought together here for the first time, along with his own account of the expedition in the central section of this book. These materials are joined by items from the family collection of the TAE's leader, Sir Vivian Fuchs, to create an unrivalled testimony of their remarkable achievement.

George Lowe was a man that I had long admired. He was the last of the Everest climbers of 1953 still alive as we entered the 60th anniversary year of that ascent and we had just finished a book together describing his experiences. Sadly, George would not see its publication. He passed away in March 2013. It's a cruel fact that in death people often receive the acclaim and attention that they deserved in life, and this is very much the case with George. Despite his considerable success he was a modest man who never courted the limelight, but his passing drew people to his life's story. He has been hailed in New Zealand as their 'forgotten hero' and recognition of his efforts has now spread around the world.

When George met Ed Hillary while working in New Zealand's Southern Alps just after the Second World War and they struck up a friendship, little did they know it would be the beginning of an adventure to the highest altitudes and latitudes on the planet. George's skills on steep ice – as much as his positivity and sense of humour – were of huge benefit to the team on Everest. He placed a final camp for Ed and Tenzing Norgay just 350 m (1,150 ft) below the summit. And it was to his old friend that Ed first told the news of his success, with the now immortal words: 'Well, George, we knocked the bastard off!'

Everest was an experience that would shape much of George's life, but it was not the end of his travels; rather it was something that enabled him to live fully, combining his passion for photography, the outdoors and teaching too. Was George upset in later years that he had not made it all the way to the summit of Everest? Of course not – as he said, he 'had helped his team-mates

LEFT George Lowe shot much of the ciné film standing on the roof of his Weasel tractor vehicle. In this photograph he is using a magazine-loaded Bell & Howell 603T ciné camera, which he had also carried high on Everest in 1953. Most of his expedition footage, destined for his film *Antarctic Crossing*, was shot on a larger Bell & Howell 70DL.

get there', and he did go on to make the first crossing of Antarctica. Not a bad way to follow on from Everest, after all. However, the majority of people I spoke to had never even heard of this expedition, let alone realized that George had played such a big part in it.

George was invited to join the TAE as its official photographer. In fact, he produced an unprecedented pictorial record – on 16mm ciné film, for general release in cinemas; in medium-format black and white, for newspapers and advertising; and 35mm colour transparencies, for lectures and journals – juggling a number of cameras all at once. Around his neck on leather straps hung a Rolleiflex loaded with Verichrome Pan and a Leica IIIf loaded with Kodachrome. In his hands, or hanging from a wrist strap, he usually carried a Bell & Howell 70DL and, whenever practicable, a tripod. He also played an important role in the scientific work of the expedition, assisting with the daily experiments and seismic soundings that greatly furthered our knowledge and understanding of the continent, parts of which are, even now, still largely unexplored. All this as well as cooking, repairing, surveying, developing images, building huts, laying depots or dodging major crevasses in whiteouts that not only halted their progress but also imperilled their lives. In the most extreme conditions he managed to create pictures at minus 50°C (-58°F).

We completed George's Everest memoirs that Christmas before he died. It was a happy project, and one that led naturally to thinking about his time in Antarctica. Although parts were finished and others drafted, we looked forward to spending more time bringing it together. This was not to be. With the encouragement of his family I have continued this work in his honour, and in his own words. We all hope that it stands as a fitting tribute to George and to his companions on their pioneering polar journey.

<div align="center">෮</div>

'Polar exploration', wrote Apsley Cherry-Garrard, 'is at once the cleanest and most isolated way of having a bad time which has been devised.' Considering what happened to his friend Captain Scott in 1912, it is understandable that he felt this way. And yet, Antarctica is enchanting, a land of beauty and unanticipated delight. For many centuries the idea of this place confounded the cartographers, who filled their charts with fabulous landmasses and the words *Terra Australis Nondum Cognita*, 'Southern Land Not Yet Known', inked across the empty, white spaces. In a way the mapmakers were right. Ice is everywhere, and everything. Antarctica contains 90 per cent

RIGHT Glass-mounted slides from the Antarctic expedition gathered on the lightbox. After nearly five years of planning, and many gruelling months of effort, twelve men finally crossed the last unknown continent on Earth.

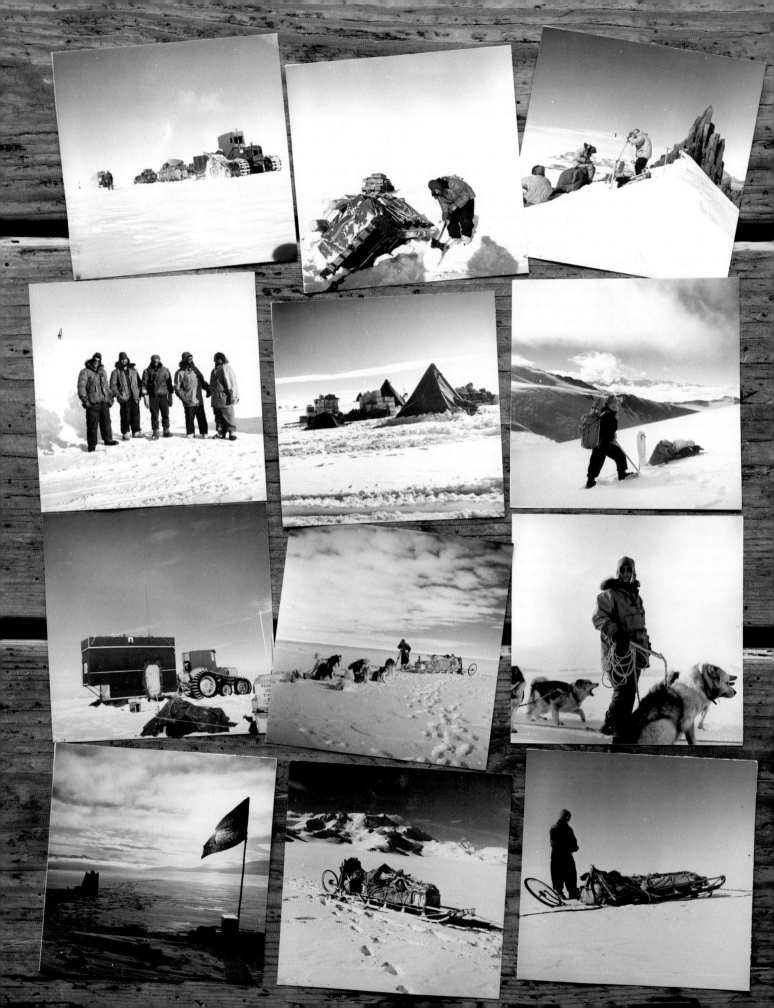

of the planet's glacial ice, and during the austral winter the seas around its shores congeal into a frozen pack, which doubles the continent's size and locks everything in its embrace. It's no surprise that it took time for Antarctica to surrender its secrets. It was Captain James Cook who finally enlightened the world, sailing through speculation in 1773 to describe a terrifying region where ice-choked seas were rich in seals and whales. His reports would entice generations of men to risk their lives in trying their fortunes here. With them would come those who were willing to brave terrible odds in the name of national glory and geographical knowledge. These were the explorers whose ambitions drove them towards the South Pole, which soon became a much sought-after prize.

My own grandfather came here in the 1950s as a young naval officer on HMS *Protector*, flying helicopters and landing on remote islands, and much later his stories opened my eyes to this world. He actually met George and Ed Hillary among the ice, helping guide their ship *Theron* to open water. They ate and drank together one night, singing songs around a piano, and he returned them to their ship with a crate of beer to wish them on their way. I've now been lucky to have voyaged to Antarctica both as a historian and guide, so can understand a little of the spell that this place has cast on those who went before us. And here a stellar team of polar travellers describe their own Antarctic experiences – they share with us why they went on their journeys, as much as how they did so.

Antarctica is many millennia old. The timescale of human activity here is just a heartbeat in comparison; it is little more than a century since the first footprints were made in the snow of the polar plateau. The year 2014 is the hundredth anniversary of another great polar adventure, the beginning of Ernest Shackleton's Imperial Trans-Antarctic Expedition, and we can perhaps best consider his legacy by looking at those who followed him. Shackleton's voyage was in many respects a failure. His ship, *Endurance*, was gripped by the heavy pack ice in the Weddell Sea and his party never set foot on the Antarctic continent. *Endurance* was crushed by the ice and sank; Shackleton's great vision of adventure rapidly turned into a struggle for survival as he sailed with a handful of men in the tiny *James Caird* from Elephant Island to South Georgia to seek rescue for the rest of his stranded crew. Shackleton's lifelong dream – to cross the continent – was at last realized by George Lowe and his companions in 1958. They achieved what was long thought impossible and so earned their place in history. It is a good time to enjoy their story again.

LEFT Original prints from the New Zealand party explorations, covering their extensive sledge surveys and Ed Hillary's dash to the South Pole.

FOLLOWING Inside George's battered expedition case are the Leica IIIf that he loaded with Kodachrome transparency film to create images for his lectures. For the Leica the shutter was hardly ever varied from 1/100s with an aperture of f/8. In temperatures below minus 29°C (-20°F) he wore three pairs of gloves – white silk, soft leather, as worn by chauffeurs, and finally heavy working mitts that were slung from a neck harness.

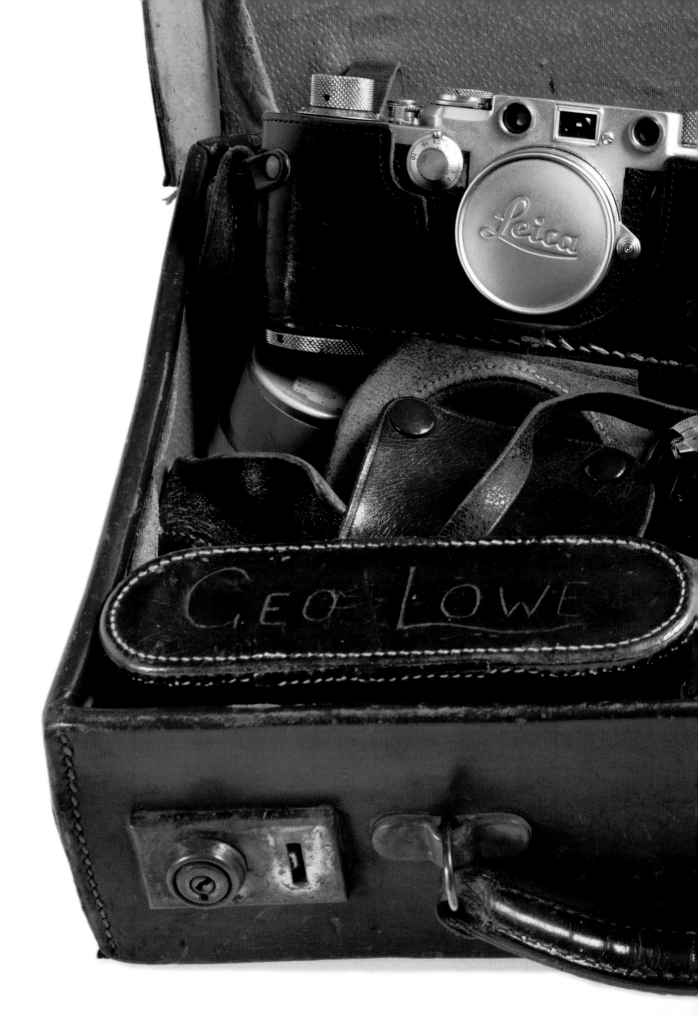

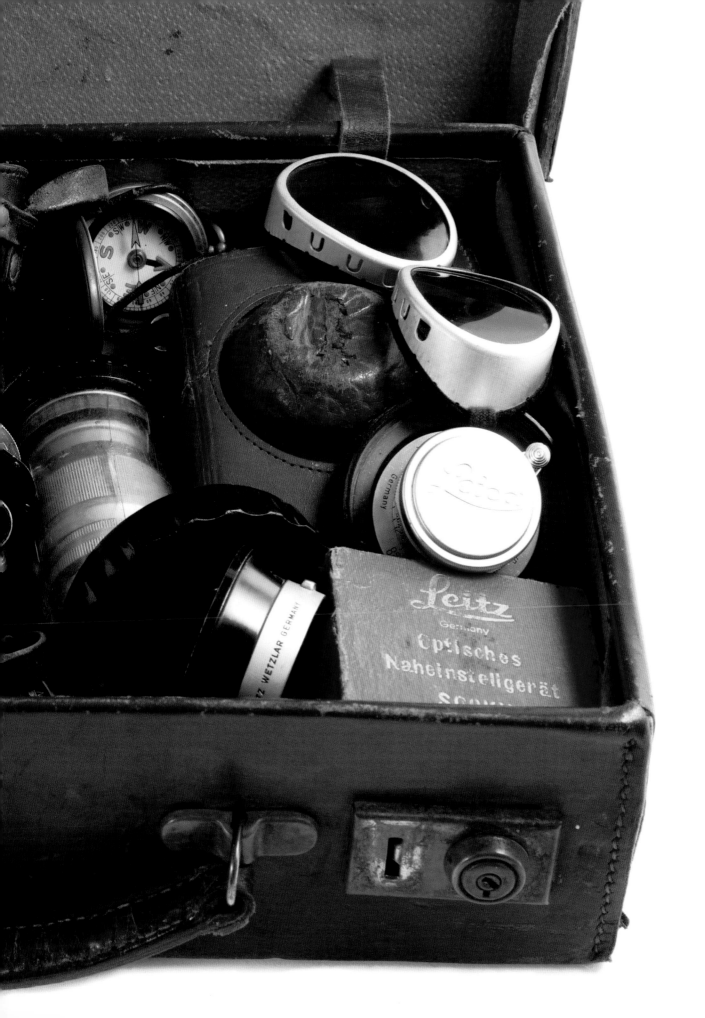

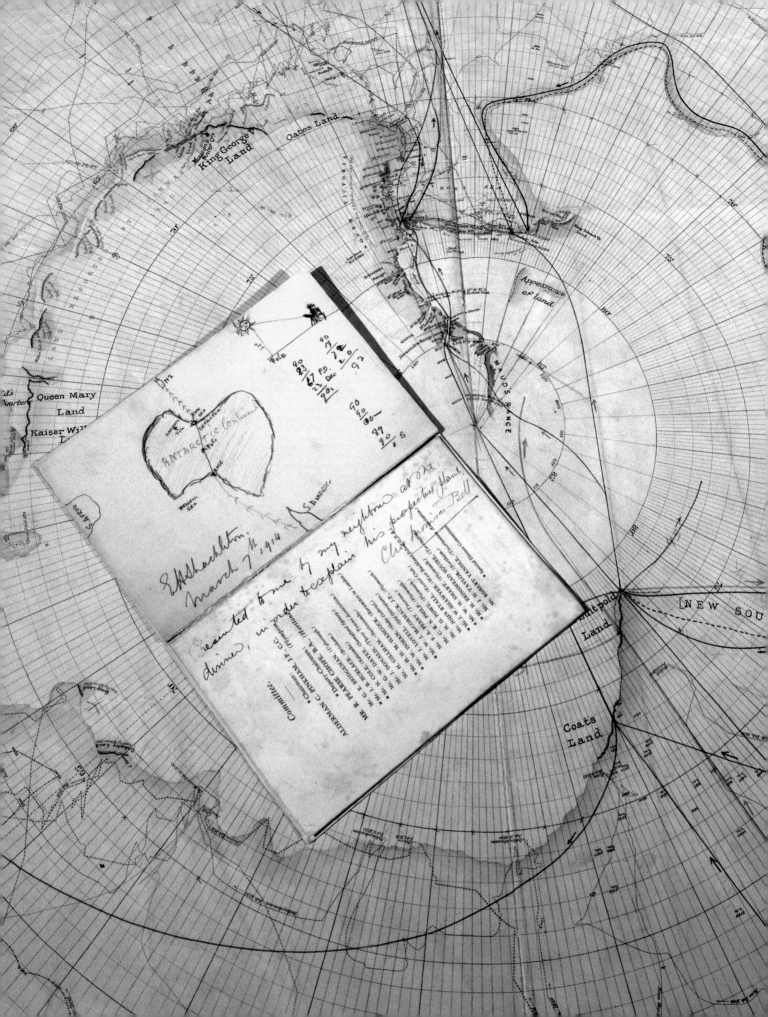

A DREAM FULFILLED

PETER FUCHS AND JONATHAN SHACKLETON

'So what is it like to be the son of Sir Vivian Fuchs?' That's a question I've been asked throughout my life. The simple truth of having an explorer for a father is that by the time I was ten years old he had been at home for a total of just two years. Not long after the Second World War he was appointed as Field Commander for the bases of the Falkland Islands Dependencies Survey (FIDS), the forerunner of the British Antarctic Survey. So I describe my relationship with my father as distant, but happy. It made for an interesting life though, that's for certain.

My first 'polar' memory is an unusual one. My father and his ten companions were marooned at their base on Stonington Island as their relief ship could not force its way through the ice to bring them to safety, and they would have to remain for an extra year. In 1949, my mother, sister and I broadcast messages to my father via radio. They became known as the 'Lost Eleven' and newspapers were full of vivid accounts of peril and winter danger. Yet, down in Antarctica, it was business as usual for them. They were able to do even more science and surveying work and it was also during this period that the plan of crossing Antarctica began to form in their minds, sketched out, as my father used to joke, on the 'back of a fag packet'. My father and his sledging companion, Ray Adie, had been confined to their tent as a blizzard vent its fury outside and they spent many days discussing the plan, improving upon that bold idea that had once been Shackleton's dream.

To cross the continent from coast to coast: could such a thing be done? On returning to England in 1950, plans for the Commonwealth Trans-Antarctic Expedition – later known simply as the TAE – gradually took shape, yet they only became fully public in 1954. As with the Heroic Age expeditions, there were huge efforts to raise money. My father and the others also faced a real struggle against so many doubters who thought the whole thing impossible. Despite this, they had little trouble in getting volunteers to join them, such is the appeal of the South for those who feel its call. It was in this aspect that George Lowe was so helpful, arranging a meeting for my father with his dear friend Sir Ed Hillary, with the hope of interesting him in the part that New Zealand could contribute to the endeavour. In fact, it was the TAE that led New Zealand to play such an active role in Antarctic matters, which it continues to great effect to this day.

One of the ongoing English peculiarities, it seems, is that success is not remembered as much as disaster. TAE was an immense achievement, completing the first traverse of Antarctica without loss of life or ship, or serious mishap; the same cannot be said for Shackleton. There were a few close calls on TAE: the advance party's ship *Theron*, a Canadian sealer, was nearly trapped in the Weddell Sea like Shackleton's doomed *Endurance*. After hurried unloading as the weather

LEFT A 1914 chart of Antarctica with Shackleton's proposed route penned energetically across the empty spaces of unexplored land. Saved for posterity, a menu card bears a simple sketch by Shackleton, who was explaining to his neighbour at dinner his ambitious plan to cross the continent.

worsened, *Theron* left eight men to overwinter and build the main base hut. They suffered the most appalling conditions through the months of darkness, and slept in tents as the temperature plummeted to minus 40°C (-40°F). When the expedition began there were two overland journeys to an inland base, South Ice – a reconnaissance and the actual crossing – and both were fraught with danger. The Sno-Cats towing loaded sledges were always at risk of plunging into the depths of hidden crevasses. Spare a thought for the men driving over this unknown ground. Some did it twice. That is silent bravery indeed.

Throughout the duration of the expedition bulletins appeared in newspapers around the world. The most talked-about news, of course, was a sensation manufactured by the press itself: a 'Race to the Pole' as Ed Hillary made his dash there ahead of the main crossing party. Media frenzies rarely let the facts get in the way of a good story. The manner in which Amundsen's and Scott's journeys to the South Pole in 1911 are remembered as a race now, though they were not such in reality, bears a striking resemblance to this. I know my father and the management team back in England were more than a little frustrated, but there was no bad blood between him and Ed Hillary: neither on the ice, nor in the years that followed. They were different men that's for sure, but both achieved incredible things.

TAE was very much an expedition of its time, carried out with expertise by a dedicated team. They took on the challenges, and boredom, of motorized travel interspersed with moments of danger, mechanical failure and frustration. My father had calculated that the crossing would cover 2,200 miles in 100 days, and it was completed on 2 March 1958 after 2,158 statute miles in 99 days. But it was by no means an easy task.

At last, Shackleton's dream had been fulfilled. It was a complete success that deserves to be celebrated, but competence doesn't always grab the headlines or stay long in the public imagination. When finally the journey was over, they were welcomed to safety by a scrum of journalists and a cacophony of music from an orchestra hastily assembled from the nearby American base. The volunteers there were told: 'It doesn't matter if you can play well – you just gotta be able to play loud.'

Peter Fuchs

☙

I first met Ed Hillary at the BBC in Bristol when we were both being interviewed. As a fellow beekeeper, I gave him a jar of my Irish honey after we came off air. He was pleased with this and we chatted a while. He'd had little time for his bees for some years, he told me, as his fame after Everest had overwhelmed any hope for a quiet life or a return to the family business. Mind you, he and George Lowe had been in the process of organizing another Himalayan expedition when it was first suggested they join with Vivian Fuchs in his plan to cross from one side of the Antarctic to the other, so bees were always going to come second to the demands of his adventurous life.

He'd read about the exploits of Captain Scott and my cousin Ernest Shackleton and said he felt huge respect and admiration for what they'd done, but he admitted that before the expedition he knew very little about Antarctica itself. However, he had learnt quickly back then; you have to. He joked that with experience he'd made a better sledging hoosh, a sort of soup or stew, than Shackleton by adding pieces of chopped up bacon, even a little honey too. I was to meet Hillary again in Tralee, County Kerry, where, aged eighty, he opened an exhibition on Tom Crean, another famous polar Irishman, who had been on Scott's last expedition. As the local schoolchildren clambered around Hillary with scraps of paper to sign, his patience and kindness were inspiring. They will never forget their moment with this living hero.

Like Shackleton, Hillary preferred to do his own thing. Sure of his own beliefs, committees were to be circumvented and establishment authority was usually just given lip-service. Calculated risk-takers and adventurous spirits, they both seized the opportunity to make their mark, achieve fame, and, certainly in Shackleton's case, earn a few bob, but they also both benefited from the experience of others. Shackleton, for example, owed much to his mentors, especially for the opportunity to travel with Scott on the *Discovery* expedition, leaving England for the South in 1901. This was the catalyst for his three further expeditions.

In 1914 Shackleton described the dream of making an Antarctic crossing as 'the greatest polar journey ever attempted'. In fact, he barely even began his attempt. His ship, *Endurance*, was crushed and lost in the ice, but he managed to bring his men to safety. It's a well-known survival story now, a timeless tale of the human spirit, I suppose. The explorer Roald Amundsen once stated 'Do not let it be said that Shackleton has failed. No man fails who sets an example of high courage, of unbroken resolution, of unshrinking endurance.' Luck played its part in their deliverance too, but one has to feel the luck was deserved.

Shackleton may also be remembered for his compassionate leadership and his ability to understand the minds of the men with him. He was largely good-natured and liked to get on with people: his leadership was not autocratic and he often led by example. He was approachable, resourceful and always working to keep his men's spirits up. On his *Nimrod* expedition on 2 January 1909, just before he turned back short of the South Pole, he wrote in his diary: 'I cannot think of failure yet I must look at the matter sensibly and consider the lives of those who are with me.' His ambition was always overlaid by humanity.

Interestingly, Vivian Fuchs himself said in 1974: 'It may therefore be permissible to comment that the loss of the *Endurance* may have saved a worse disaster. Yet the crossing was possible, and in those days risks were taken which today would be quite unacceptable.' Nonetheless, for Shackleton to have had even a glimmer of hope in making a successful crossing, he would have needed constant good weather and near perfect ice conditions. Anyone who has travelled in Antarctica will know how unlikely this is. But, for a man like Shackleton, a glimmer of hope was certainly enough to have encouraged him to have a go and try.

'Difficulties are just things to be overcome', Shackleton often said in typical understatement. The same spirit was expressed by Fuchs, Lowe and Hillary too. They were adventurous men who were brave enough to have a go at something when others said it simply *can't be done*. Shackleton also spoke for all those who have travelled, worked and explored in Antarctica when he wrote: 'the stark polar lands grip the hearts of the men who have lived on them in a manner that can hardly be understood by the people who have never got outside the pale of civilization'. The TAE overcame terrible conditions, and huge odds, to be successful in 1958. Some might wonder why anyone would want to put themselves through such an ordeal? Yet, the challenges to be found there continue to be strangely seductive for many people.

In 1914, shortly before leaving for Antarctica, Shackleton wrote an article on adventure for a magazine for young boys. He described the qualities he thought best-suited for a polar explorer, and indeed for anyone to go through this world successfully. 'I put these qualities in the order that I think are most essential: 1. Optimism. 2. Patience. 3. Idealism. 4. Courage.' Fuchs, Hillary, George Lowe and their companions had these qualities in abundance. They trusted in each other and were inspired by the efforts of those who had gone before them. They succeeded. They should be remembered, like Shackleton, not because they were some sort of mythical supermen, but rather because they were human. They set themselves a goal and had the will to see it through to the end.

Jonathan Shackleton

RIGHT A giant crevassed berg photographed by Frank Hurley in 1915, close to where *Endurance* was trapped. Frank Worsley, the skipper, wrote: 'Huge masses of pressure ice are piled to a height of about 60 ft, showing the stupendous forces that are being brought to bear by the drifting pack.' A wooden ship caught in ice like this had little chance of survival.

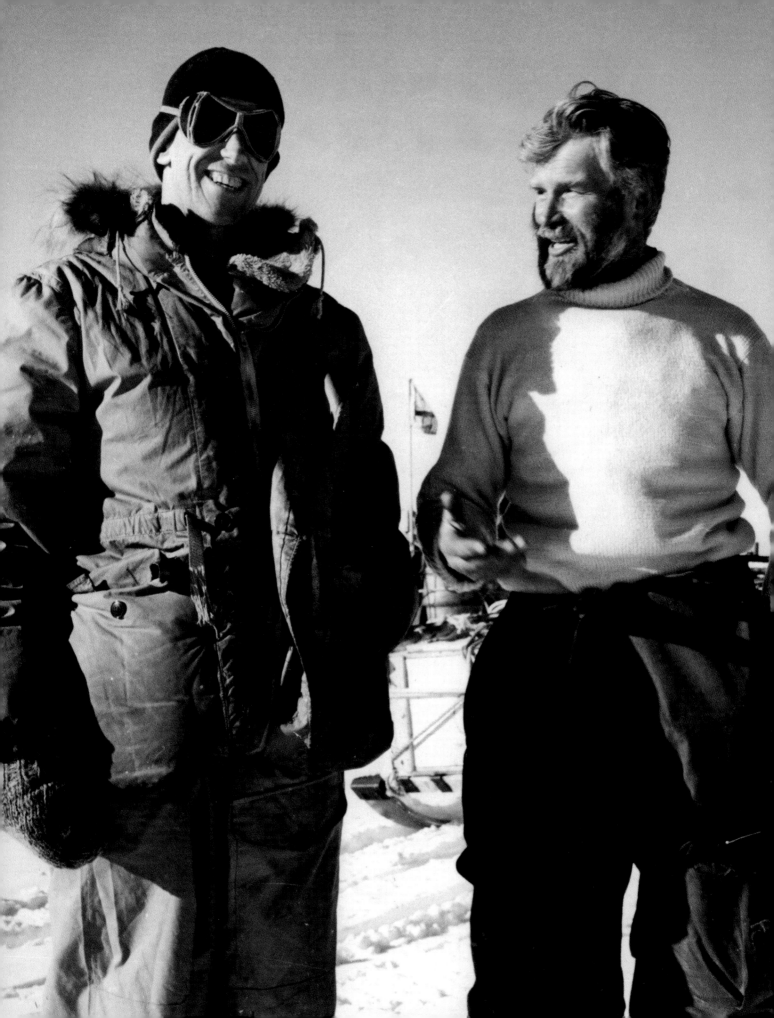

BRAVE SPIRITS

SIR RANULPH FIENNES

I'm not sure I always wanted to be an explorer. When I was a boy it was enough just to get through the horrors of school. I longed for the summer holidays though, to roam the woods and fish for wild brown trout during the long days or go roof-climbing at night, enjoying life by the moment. I rarely read books or watched television, but I do remember what really helped me endure the gloom of school: learning to box and some great history lessons, especially the study of British sailors and exploration. No surprise there, I suppose.

It was 1957 and at that time Vivian Fuchs and the Everest hero Sir Ed Hillary were in the process of completing the first crossing of Antarctica. My history master traced the course of their Trans-Antarctic Expedition on an ancient chart of the frozen continent. 'History in the making', he proudly called it. I also prided myself somewhat on my knowledge of famous naval heroes and explorers, but one attempt to show off rebounded when I shot my hand up to the master's question, 'What did Stanley say at his famous jungle meeting?' My instant reply, 'Kiss me, Livingstone', was greeted with the derision it deserved.

The Trans-Antarctic Expedition, or TAE as it was known, what an exciting thing! It was to be the realization of the dream that Sir Ernest Shackleton had failed to carry out some forty years before. His story was familiar to all of us schoolboys. His ship sank in the Weddell Sea before he had even touched land. Fuchs's dashing new plan was taking advantage of the latest equipment for the crossing itself – snow vehicles supported by aircraft – yet there was a lot that was the same as in the old days. Like Scott and Shackleton, the TAE overwintered in huts they built themselves and used dog sledge teams for reconnaissance and survey work. Fuchs had an impressive scientific plan too, a seismic survey to test the depth of the ice covering the continent, as well as glaciology, meteorology and so on – though none of this was that interesting to me back then.

❧

It was 1973 and I had the bare bones of a grand plan scribbled on paper. 'The first circumpolar journey round Earth', I'd declare, to be met with stony silence. It seemed to me to be one of the few genuinely great adventures left – to circumnavigate the world the hard way, along a line of longitude, crossing both the North and South Poles. 'Mad but marvellous', was how my expedition patron HRH Prince Charles famously described it. I suppose in a way he was right. Of course no one had tried it before, why on earth would they?

LEFT Ed Hillary and Bunny Fuchs stand together at the South Pole on 20 January 1958. Though the world's press whipped up a frenzy about a supposed 'race', the two leaders were proud of each other's achievements.

From the Ross Sea side, three great travellers, Amundsen, Scott and now Hillary had reached the South Pole overland. Fuchs had pioneered the way from the opposite side, the Weddell Sea – the unknown shore.

In actual fact the Transglobe Expedition, as we called it, was my wife's idea, a chance dream. Ginny was adamant – why waste our time in planning interesting trips which somebody, anybody, had done before? She was right, though the odds were not stacked in our favour. We would need an icebreaker, a resupply ski-plane, snowmobiles, canoes and rubber boats, and some £30-million worth of sponsorship to stand even the remotest chance of success. At that time we had about £200 in the bank, owned a very second-hand butcher's delivery van, a Jack Russell terrier and a heavily mortgaged house near Hammersmith. The economics clearly didn't add up, not to forget the actual difficulties we would face daily on the ice itself. But, remarkably, we willed it into reality through perseverance, a little luck and a good deal of hard work. We wanted it more than anything else. It became our life's effort.

Transglobe would take almost ten years from conception to completion. Our dedication to the venture survived even our total lack of know-how in all polar matters, insufficient funds, stonewalling refusals from various government bodies and the advice of experts that our plans were 'impossibly ambitious'. There were a few, though, who stood by us from the beginning, sharing a belief I've always had: it only seems impossible until it is done. Seasoned explorer Sir Wally Herbert was one of the kindred spirits. He'd made the first crossing of the Arctic Ocean and had done so by being both tremendously skilful and courageous enough to want to go beyond what was thought possible at the time. I admired him then hugely and I still do now. Veteran Sir Vivian Fuchs, leader of the TAE of 1955–58, was also willing to offer his support. A meticulous planner, it was true he didn't share our enthusiasm for wildly pushing the boundaries of risk, but his knowledge and sound guidance were invaluable to us.

I longed for a journey of true exploration in a land where no man had ever been. Sir John Hunt's expedition, with Hillary and Tenzing in the vanguard, had ascended Everest, Francis Chichester had sailed solo around the world, Herbert had crossed the Arctic and endured a winter floating on the ice, Fuchs had forged across Antarctica and into the history books. They had all been the first to do so. Many hundreds of others would later follow in their footsteps, but merely as also-rans. To be second was of no value to us, or to our sponsors. Priority was the key.

Such a policy would mean, of course, our risk of failure would always be high. Trying difficult things undoubtedly means setbacks; to believe otherwise would be unrealistic and conceited. Men who try to do something and fail are infinitely better than those who try to do nothing and succeed. This is said often, but I believe it to be true. We left Greenwich, London, in 1979 with

absolutely no certainty of a successful outcome, other than the strong feeling in our hearts that we would give it our best. In August 1982, almost three years to the day since we had set out, we chugged back up the Thames having gone all the way round the world. The river glittered under a stiff breeze and the warmth of a lovely summer's day. Colourful bunting and 10,000 cheering people lined the banks. We had realized our long-held dream, and after such immense effort it was good to be home.

<div align="center">❧</div>

On Transglobe, instead of overwintering on the edge of the Weddell Sea as the Fuchs TAE team had done, we chose a site in Queen Maud Land and based ourselves inland at a decent height above sea level. It was at the limit of the range of our Twin Otter aircraft. South of our hut at Ryvingen we became true explorers in one of Earth's last untrodden regions. Emerging from the winter darkness, having survived in cramped, damp, dirty and cold conditions, the horizon was now open to us. For almost a thousand miles we would pass through terrain neither seen nor touched by mankind.

I remember a cynical journalist in London once telling his listeners on the radio: 'Of course, it's not the same exploring now as it was all those years ago with Captain Scott. Now you have all the trappings of modern technology.' I could think of no technology that could prevent us falling into crevasses, stop us slowly starving, or help us not to feel almost constantly cold. Antarctica is a place – as it was for Fuchs in 1958, and as it was 100 years ago – that pays little respect to whatever tools you might choose to use.

Yet the same kind of journalists also criticized Scott in turns for blundering to the Pole, man-hauling when he might have used dogs, and wasting too much time and effort on surveying or science. Believe me, having dragged a heavy sledge-load through the great crevasse fields of the Beardmore Glacier, explored uncharted ice fields and walked a thousand miles on poisoned feet, I have nothing but respect for Scott's efforts, and those of his men. I get frustrated when people pass quick judgment on the past, without considering what it must have been like to be the first to try something. I've endured and suffered, and my appreciation and respect for the explorers of old is a natural response to that experience. I've always thought that to write about Hell, it helps if you have been there.

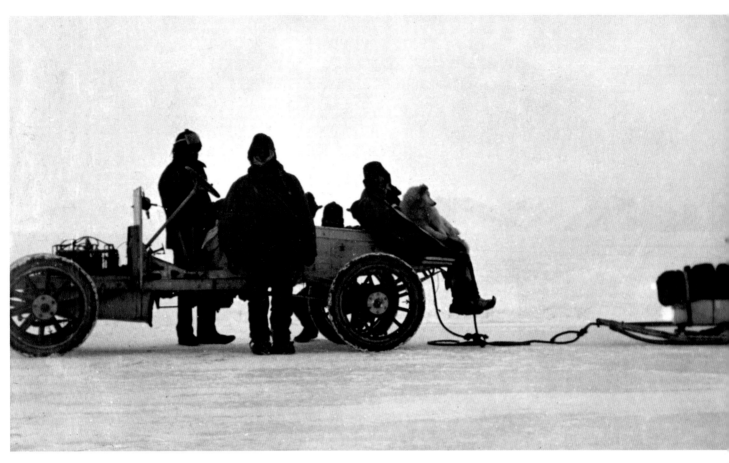

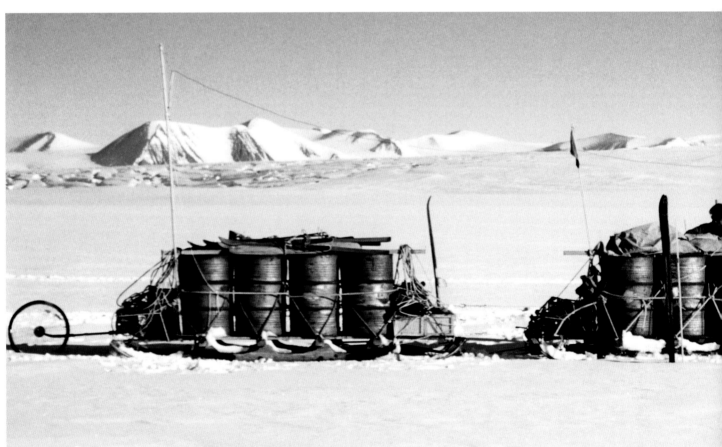

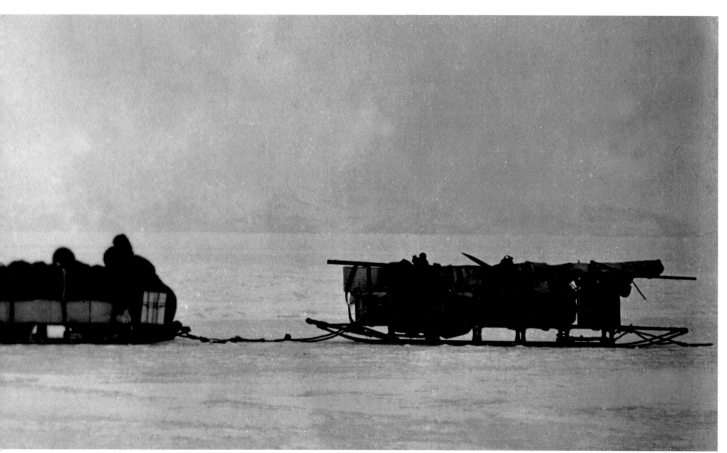

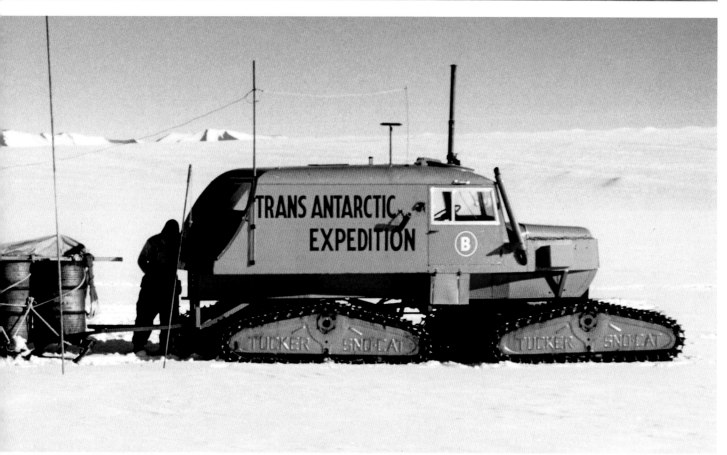

Mind you, I've not always been successful. In 1986 I attempted the North Pole with Mike Stroud, when one of my toes, frostbitten after an unscheduled swim, became gangrenous. The following year we tried again, but ice conditions were so bad we failed to improve on the world distance record that we ourselves had set. We attempted it in 1990 from the Russian side, ending up running out of food and drifting with the ice until finally rescued by a Soviet gunship helicopter. In 1996 I had to be airlifted from Antarctica, unable to continue on another crossing expedition because of a kidney stone blockage. My solo and unsupported attempt to reach the North Pole in 2000 ended in severe frostbite to five fingers and very near death. Both times I was desperate to continue. The biggest danger of all, though, is blindly determining to keep going at all costs instead of recognizing the need to turn back – to fail but to live to fight another day is best.

My recent attempt to make the first Antarctic crossing in winter – 'the coldest journey', as it has become known – came to an end as I again suffered frostbite to my hand, this time attempting to fix a ski-binding when the temperature was minus 30°C (-22°F). Small mistakes are costly in this unforgiving land. The doctors are still unsure if I will need another operation on my fingers. Back in 2000, I cut my dead finger-ends off with a fret-saw in order to help the stumps heal properly. It's not something I want to do again.

There's no point in feeling glum about these setbacks because in order to win at some of the big ones, you will always lose at others along the way. I won't cry over spilt milk, or split fingers. The key is to learn from the failures and then to keep going the next time. But there's no denying it: however beautiful Antarctica may be, it is still a place that is *damnably* cold. I've often said that there is no such thing as bad weather, just inappropriate clothing, and this usually rings true – but Antarctica is a land apart when it comes to rotten weather. The cold doesn't just freeze skin and bone, it breaks metal and, worst of all, it saps your soul.

When I'm asked for my own life motives I openly admit that expedition leadership is quite simply my chosen way of making a living: under 'occupation' in my passport the entry always stated 'travel writer'. I am not introspective and find it awkward having to dig within myself to produce replies to journalistic questions about motivation. I like the response of Jean-Louis Etienne when asked why he went on polar expeditions. He replied: 'Because I like it. You never ask a basketball player why he plays: it is because he enjoys it. It is like asking someone why he likes chocolate.'

<center>❧</center>

PREVIOUS Innovative technology was a part of all early expeditions to Antarctica. Shackleton toyed with a motorcar on his *Nimrod* expedition, as pictured here (above) pulling sledges at Cape Royds in 1908. It performed tolerably well on firm ice, but on soft snow it was virtually useless. By 1956, Bunny's team had these powerful Sno-Cat tractors, but still they found the conditions tough going and needed to haul immense amounts of fuel.

In November 1992, when Mike Stroud and I set out on our bid to make the first unassisted crossing of the continent, we didn't actually reach the Antarctic coastline until the twentieth morning of our march. We had to fight our way across the sea ice to get to the shore just to begin. At first, any uphill gradient was imperceptible, but by that afternoon each and every heave on the traces required concentrated mental and physical effort. And then we reached the start of the first sastrugi field, a great rash of iron-hard furrows lying directly across our route. I know no other way to advance when the ice gets nasty than to attack it head-on with every ounce of gristle at your disposal.

My practice was to hype up my mind during the first hour of every day, when the pain from my feet was at its worst, by simply remembering that I was not alone in facing the dreaded hours ahead. I pictured my grandfather, who had trapped in northern Canada and fought for his country all over the world. I thought of my father and uncle, who were killed in the two world wars. I pictured my wife, my mother and my sisters and I knew that all of them were right behind me, helping to suppress the ever-lurking urge to put a stop to the pain and the cold by giving up.

On our sixty-eighth day the wind dropped and the mists cleared. Towards evening there was a thing ahead. Could it be the Pole? We had a two-part wager between us. Whoever spotted the first sign of the Pole would get a free hamburger snack, and, for sighting the Pole itself, a 'slap-up lunch'. The item turned out to be a half-buried meteorological balloon. After seven hours' hauling on 16 January 1993, on the eighty-first anniversary of Scott's sad arrival at the same point, we topped a slow rise. I thought I saw movement. Removing my goggles and squinting to focus, I could just make out a series of dark, blurred objects. I shouted to Mike. It was a rare moment of sheer elation. It was the South Pole. The journey was far from over but we had dragged to the Pole just enough stores to allow us to cross the continent and survive. If our luck held.

All the isolation of the past months fell away. The polar site had vastly altered, even in the twelve short years since my last visit. Strangely shaped installations on jacked-up steel legs reared monstrously in every direction from the main black-roofed dome in which overwintering scientists lived and worked. A small huddle of nine figures had come out to greet us, but we put aside the thoughts of food available in the dome canteen as we forced ourselves to continue north. In all, we paused at the Pole for only eighty minutes.

Only then, beyond the Pole, did we discover the true meaning of cold. Our conditions in terms of body deterioration, slow starvation, inadequate clothing, wind-chill temperature, altitude and

even the day of the year, exactly matched those of Scott and his four companions as they struggled from here in 1912. We also learned that the incredible Norwegian skier Erling Kagge had reached the Pole before us and had been airlifted out the previous week. The Norwegian press, unsurprisingly, talked at length of his winning a 'race', but our sledges were twice as heavy and our journey twice as long, so our morale was not too badly dented by the news.

On our ninety-second travel day, clear of crevasses at last, we hauled for ten-and-a-half hours over the floating Ross Ice Shelf. On 12 February 1993, the last US aeroplane left Antarctica that year. In five days our ship would steam out of the Ross Sea. We were still 289 nautical miles from Ross Island. The time for procrastination was over. I radioed the Twin Otter, which picked us up from the ice. Mike wrote in his diary that evening: 'While Ran made the radio call for our pick up, I went and stood outside. Our tent was pitched in the middle of a huge white plain and the sun was shining. To the south, a thin line ran back from where I stood to disappear beyond the horizon, towards mountains and wind-sluiced valleys. There it ran back up the glacier and then due south to the Pole. It continued on, straight for the rest of the plateau, and dropped tortuously through valleys and sastrugi to the ice on the far side and so to the Atlantic coast. It was the longest unbroken track that any man had ever made.'

We will never know how much further we could have continued over the ice shelf because there are too many ifs and buts. As it was, we had made the longest self-supported polar sledge journey and crossed the Antarctic landmass. We had overcome immense hardships and our friendship was still intact. But we had not reached the coast and safety. If, like Scott, there had been no option but to battle on, it is my opinion that we would have died short of Ross Island. We were lucky that it wasn't 1912.

'Look for a brave spirit', *Fortem posce animum*, is a motto that I've always liked. I look to the TAE of 1955–58 – in the success of which George Lowe, as on Everest, played such an important part – and I see so much to admire. These men were the brave spirits, like Scott and Shackleton before them, willing to take a chance on their dreams. Theirs was the opportunity to participate in some of history's great polar endeavours, and they were happy to risk everything in the process. Not everyone will understand what compels someone to behave like this, but in this marvellous book you can discover a little more of the *why* we go. Why we continue to be drawn into these challenging, and often terrible, white spaces at the very end of our Earth; and why it is that some of us keep coming back for more.

RIGHT Despite rapid advances in technology, dog teams remained an important part of the Trans-Antarctic Expedition. This shot was taken by members of the New Zealand party during their early reconnaissance forays on the Skelton Glacier. They were the first men to set foot there, and securing a route up on to the plateau was crucial to the future success of the main crossing. A cavalcade of machines would roar down here in 1958.

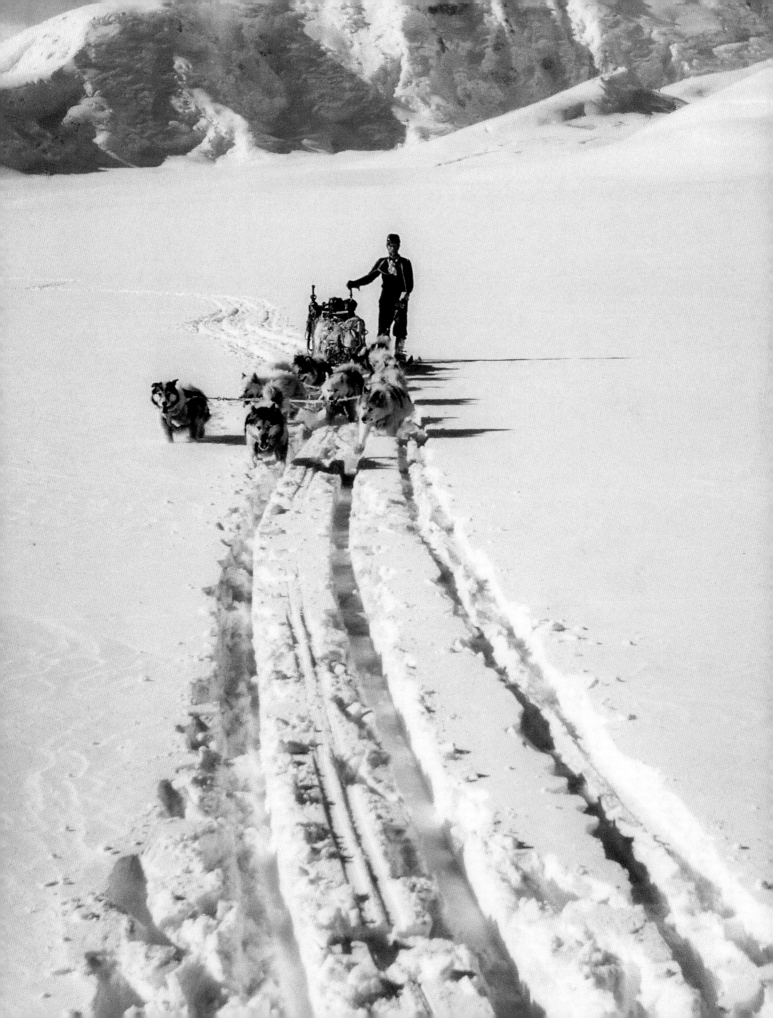

1 | THE MAP ON THE WALL

My ideas of the Antarctic were hazy in the extreme … I imagined a sombre land of bitter cold and heroic suffering, of serious men dedicated to impossible ideals, and of lonely crosses out in the snowy wastes – not really my cup of tea at all. But it sounded an interesting venture, and I decided it would do no harm to learn more about it.

Sir Ed Hillary, 1961

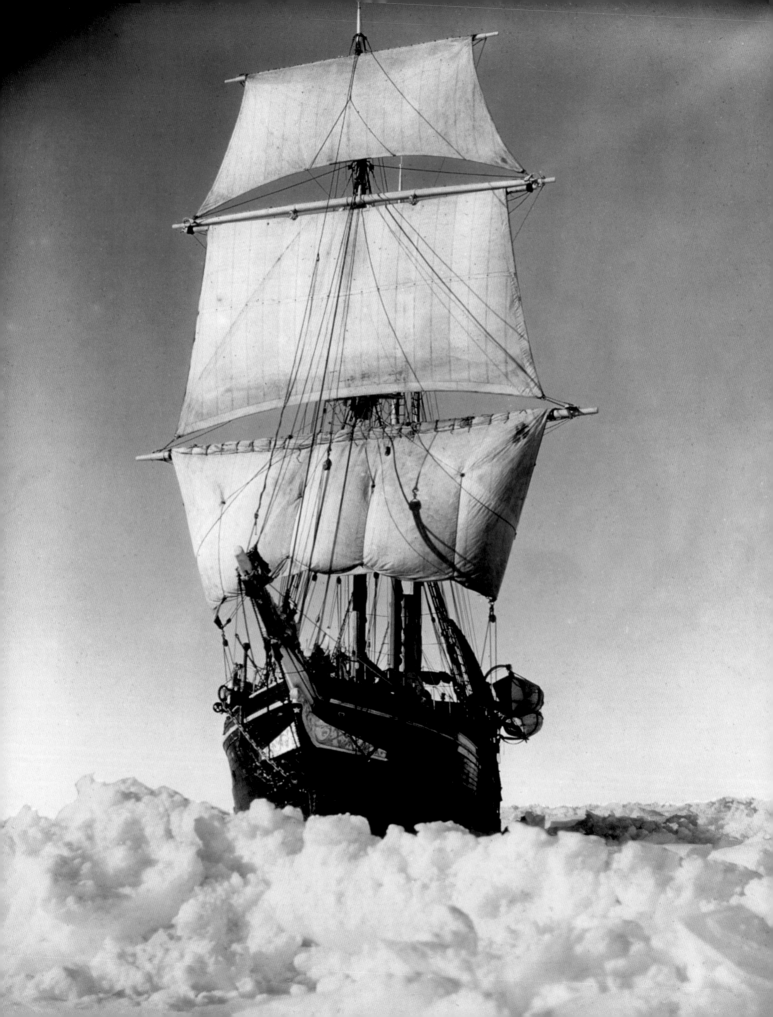

Some forty years after the death of Captain Scott and his companions, a small, proud group of men were gathering for their annual meeting in London, which took place on a Friday in January, around the anniversary of Scott's arrival at the South Pole in 1912. This was the celebration dinner of the exclusive Antarctic Club, and in 1954 I found myself among the 150 guests and members.

The occasion happened to coincide with my thirtieth birthday, and surrounded by such distinguished company at first I couldn't help but feel overwhelmed by it all. I was reflecting that although forty years does not represent much in the history of exploration I had nevertheless grown up to think of Captain Scott in the same timeless vacuum as Marco Polo, Columbus or Livingstone. The Antarctic continent meant little to my mind, but like many others I saw Antarctica, with its tales of adventure and the ghostly figures of Scott, Wilson, Evans, Oates and Bowers stumbling through whirling snowstorms, as history.

So it now came as a sharp surprise to be suddenly face to face with men who had actually been south with Scott. While the port was passed I watched the glistening faces, old and young, to the accompaniment of tinkling glasses and the occasional jangle of rows of medals. Then the heavy decanter reached me, and as I lifted it my distinguished neighbour said: 'Have you ever tried to share a tent with a raving lunatic? I remember one dreadful night back in…'

He got no further. A pink-coated toastmaster, ready for his brief hour of dictatorship, brought all anecdotes to a full stop. 'Gentlemen!' he boomed. 'The President desires to take wine with the members of the 1901–03 *Discovery* Expedition.' Whereupon the noise of a chair scraping in a far corner made the whole assembly turn. The President, beaming from the top table, stood with glass poised, pointing it towards the distant corner. The chair scraped again, and knives and forks clattered as a very old man struggled with difficulty to his feet. His back was bent, and his medals rattled and his glass shook as he raised it. A burst of applause broke out. The old surviving member drank, then settled back heavily into his chair. The rest of us sipped in tribute. 'Who is he?' I whispered to my neighbour. 'That's Admiral Skelton,' he hissed. 'He was with Scott's first.'

The toastmaster intoned once more. 'Gentlemen, the President desires to take wine with the members of the 1908–09 Shackleton *Nimrod* Expedition.' Leaping up, the President toasted three more ageing members who rose very slowly. Their bemedalled figures were no less vigorously applauded. And yet another… 'Gentlemen, the President desires to take wine with the members of…' I was fascinated as the ceremony continued through every Antarctic expedition of the fifty-four years of the century. It was a living parade of history, and I had thought all these people were dead. Then suddenly… 'Gentlemen, the President desires to take wine with the member of the successful Everest Expedition of 1953.'

Good Lord, that's me, I suddenly realized, and blushing at the surprise I got to my feet. As I stood with my glass held shoulder high, the President, now glowing and rubicund, rose for the toast, drank gallantly and crashed into his seat to another roar of applause. Wishing for the comforting presence of my Everest colleagues, I finished my port in silence, knowing that my old friend Ed Hillary, now the harassed Sir Edmund, was giving a lecture somewhere else in England; for one reason or another I was the sole 'surviving' Everest climber for the Antarctic Club guest list.

A few weeks before the dinner I had met Dr Vivian Fuchs for the first time, introduced by his guide and mentor, Sir James

LEFT One of Frank Hurley's rare Paget Plate colour photographs from 1915, made during Shackleton's Imperial Trans-Antarctic Expedition. Though the expedition ship, *Endurance*, was later trapped and crushed inexorably by the ice, Hurley was able to salvage many of his images by diving into the freezing water inside the sinking ship.

PREVIOUS Icebergs in the Weddell Sea, 27 January 1956, on our first journey south. It was a good day: our ship, *Theron*, was soon sailing at full speed ahead along the coast of Antarctica. At last we were through the pack ice!

Wordie at the Royal Geographical Society. Wordie had been the geologist on Shackleton's famous *Endurance* voyage in 1914–16 and had gone on to make many other expeditions to Greenland. He was Master of St John's College in Cambridge, where a young Fuchs had come under his guidance, and he maintained a keen interest in all things polar. I didn't quite appreciate it then, but Wordie was another man who had done such amazing things – part of that Heroic Age of explorers, yet walking among us. It was overwhelming to be so close to history.

And it was Vivian Fuchs, or 'Bunny' as he was known, who was going to lead a new generation of pioneers. Our paths crossed once or twice again during 1954, and even the magic words Trans-Antarctic Expedition were mentioned. But still the notion of myself in the role of Antarctic explorer was remote, to say the least. Above all else I was a climber, a mountaineer. Some men enjoy going 'up'; others choose the hard frozen Antarctic flatness and the conquering of its horizontal hazards. I belonged to the school that generally prefers going 'up'.

It was not till November of the same year that Bunny Fuchs presented me with a confidential foolscap document, which I placed carefully in my briefcase. 'That's the detailed plan,' said Bunny. 'Take it away and see what you can make of it. If you will also write to Ed Hillary and sound him out, I'd be glad. I want to know if I can get a New Zealand support party interested.' He twisted his pipe, relit it with his petrol lighter, then added: 'And if this comes off – would *you* want to go with Ed?' There was a pause while I pondered hard and quickly, thinking that if I went on the expedition I would prefer to be with the main party that would cross the entire Antarctic continent. 'I should like to make the complete crossing,' I said at last, 'if you will have me.' 'Well, I do want a New Zealander,' said Bunny.

'That's me – but what else would I be?' I asked. 'I want not only a mountaineer, but one who can also look after the photography,' said Bunny. 'Photographer and New Zealand liaison officer,' I reflected, 'that'll do for me.' 'Interpreter, too', said Bunny laconically. 'Of what?' I asked. 'New Zealand messages', he said with a wry smile.

We shook hands, I hopped on a bus, went to my bedsit in Earl's Court, pinned a large map of Antarctica to the dingy Victorian wallpaper and began studying the folder that was labelled 'Plans for a Trans-Antarctic Journey, by VE Fuchs, MA, PhD'. I had never been certain of my desire or willingness to commit to an expedition that would spread over the lengthy span of three years. Projects for climbing even the highest mountains were usually reckoned in months, not years, and in my world a Pole venture was an altogether new idea that took some getting used to.

Perhaps I would never have reached a firm decision without the spur of a certain shadowy mental picture that kept blurring the great Antarctic map on the wall, a kind of projection that fixed on to the map not only the figures of Scott, Shackleton and Amundsen, but also those of the elderly gentlemen who rose to their feet that night of the Antarctic dinner. The old survivors, indeed, rather than the historic hero leaders, made the icebound continent come truly alive, or at any rate fired the new enthusiasm for the polar regions that was gradually growing inside me.

❧

I suppose my first polar recollection would be when I was ten years old, one hot New Zealand summer's day in 1934. We went as a family to see a film called *Ninety Degrees South*. It was shot,

directed and most of it actually processed in the Antarctic by its remarkable creator, Herbert Ponting, and it told the story of Scott's dramatic 1912 expedition. Ponting, who justifiably called himself a camera artist, travelled with the Scott party on their great adventure, but didn't join them on the doomed march to the South Pole and so lived to tell the tale.

It would be convenient but untrue to draw the conclusion that as a schoolboy, having sat enthralled through the film (which I did), I was henceforth captivated by the dream of an Antarctic crossing (which I was not). I was not even a climber until well past my twenty-first birthday, at which point I was still terrified by heights, and the idea of nobly meeting a frozen end, as in Ponting's film, didn't appeal to me in the slightest. But I did find a copy of Ponting's book *The Great White South* and spent time with the images between its covers. I was a very keen amateur photographer even then, and as I grew older I learned to develop my own film. The Australian Frank Hurley was another celebrated photographer at that time; he went to Antarctica an incredible six times. I would have loved to have met them both. Hurley had first been south with Douglas Mawson in 1911 and was with Shackleton when their ship *Endurance* was crushed by the ice and sank to the bottom of the Weddell Sea in 1915. Hurley had scrambled into the sinking ship to salvage his glass-plate negatives and undeveloped cinéfilm stock.

Hurley and Ponting really were the first 'extreme photographers', and it was soon clear that photography and film had a huge role to play in future expeditions, helping with funding and creating a lasting image of achievements. Both men also embraced new technologies: Hurley created a handful of early colour images using the then-innovative Paget process, and later their silent films were given the 'talkie' makeover with music and full sound narration. These were the kind of shows that enthralled so many people in the 1930s when I was growing up.

I could not have imagined, sitting in my shorts in that hot theatre, that twenty years later I would be in London, dressed in a dinner jacket showing my own expedition film. We had just climbed Mount Everest, the highest mountain on Earth, and I had played my part in that incredible first ascent, cutting steps on steep ice and taking photographs almost all the way to the top. I'd never shot a movie in my life, but as our cameraman could not cope at altitude I took over his job and my footage formed a large part of our film, *The Conquest of Everest*. News of the success was in all the newspapers on 2 June 1953, the very day that the young Queen Elizabeth was crowned. By the time we landed in London later that month, we were avalanched with attention. I was thrilled to be one of the lucky young men at the centre of it.

Looking back, I'm still amazed how life really is an ebb and flow of chance encounters. I met Ed Hillary in the back of a bus bumping its way along a glacier in the Southern Alps and before long we were climbing on the same rope. Even then I remember his wild enthusiasm for life, a restless energy. He hated going slowly and, worse still, when bad weather kept us confined to a mountain hut or tent, not being able to climb. 'The battle against boredom' was an oft-repeated phrase, followed by laughter. It was something we'd come to know intimately on polar expeditions, that's for sure. Ed was a great companion. We joked together, took risks and shared the same dreams for the future.

After Everest we were overwhelmed by public interest – a sort of Everest frenzy that was sometimes more exhausting than the climb itself, and we all did the rounds of dinners and lecture tours. In the summer of 1954 Ed and I travelled to the

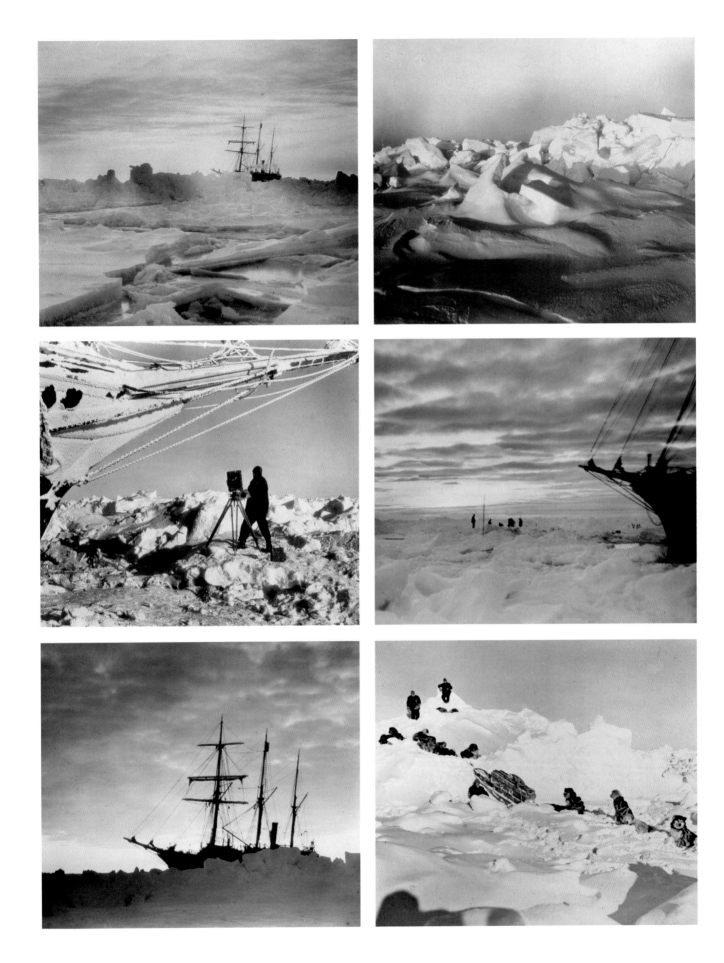

Himalaya, to be finally free of the crowds as a reward. But by that autumn I was back in London for more, which is when Bunny Fuchs presented me with his first detailed blueprint for the Antarctic crossing. He had already spent a whole year lobbying, and it was beginning to pay dividends. In January 1955 the big chance came with the opening of the Commonwealth Prime Ministers' conference in London. Churchill was bowing out, Eden bowing in. Bunny received a phone call asking him to attend in person to outline the Antarctic plan for the benefit of the assembled Premiers. He did so, gained their support and the money slowly began to come in. Churchill started the ball rolling with a British offer of £100,000. New Zealand was not at first responsive, though a contribution of £50,000 was eventually agreed.

In the same year, after another far-flung lecture circuit with Ed, he and I arrived in Paris to attend the Antarctic Treaty conference and learn about the forthcoming International Geophysical Year (IGY). An ambitious global plan for collaborative research, it would begin on 1 July 1957 and last until the end of 1958. There'd be over 60 countries joining in, with hordes of clever people studying the aurora, radar and rockets, cosmic rays, seismology, oceanography and the like. It would also herald the setting up of research bases around the coasts of Antarctica, as well as an impressive American plan to build a base at the South Pole itself. Solar power, spandex and space travel are just a few of the wide-ranging things that emerged in the years following this remarkable intellectual co-operation.

Our own organization in London was now also beginning to hum. We had our executive offices a few hundred yards from the Houses of Parliament, and it was here that I first met my colleagues. There, we were just young men with tidy haircuts and uncomfortable suits, but once free of London, on ship or out on the ice, each would come into his own. David Stratton was deputy leader; David Pratt was engineer and Hal Lister glaciologist; RAF Squadron Leader John Lewis was in charge of flying. I think we were the first explorers in the history of British polar expeditions to be paid a salary. It was not a bulky pay packet for Antarctic pioneers: £500 a year for bachelors, £700 for married men. Still, it was something, and most of us would probably have gone for less, or even nothing. I was prepared to join the expedition as a mountaineer and general handyman, but I soon realized that everyone had some specialist skill, and I was glad to have photography as mine.

Organizing food supplies, fuel, vehicles and chartering the ship, the Canadian sealer *Theron* that would take us on the first long voyage to the Antarctic to land the advance party, these and a thousand other jobs kept everybody busy till November. Then, one year to the day since I had met Bunny Fuchs and heard his plan, *Theron* sailed. It was biting cold as I drove down to the Millwall Docks and carried my kitbags past the policeman, through a maze of crates to where the ship was tied up – at the end of a long boulevard of beer bottles.

c⁄ɔ

Forty years before us, just as the First World War broke out, a Trans-Antarctic Expedition under Ernest Shackleton sailed from England with the same purpose: to cross the continent from the Weddell to the Ross Sea, using dog teams. Their effort failed and their ship, *Endurance* – a wooden vessel of 350 tons – was gripped by the pack ice and drifted for seven months before finally sinking. Shackleton and his men took three lifeboats filled

LEFT Frank Hurley travelled to Antarctica six times over a varied career, most famously on Shackleton's *Endurance* voyage. These are a few more of his rare colour images, taken when the expedition was locked in the ice of the Weddell Sea in 1915. By the 1950s it was still a huge challenge to operate cameras in this environment.

with stores on to the ice, man-hauled them to open water and eventually built themselves a tiny refuge on the truly inhospitable Elephant Island. Shackleton then took five men with him and sailed 800 nautical miles in the little *James Caird*, navigating the huge seas of the Southern Ocean to reach South Georgia and the whaling stations there. It's a dramatic story that never palls in the re-reading.

The mad notion to cross Antarctica had been proposed publicly in 1910 by the Scottish naturalist William Bruce, and in February 1912 the German Wilhelm Filchner almost landed on the continent, but the collapse of his hut on an unstable iceberg put an end to his attempt. Even after Amundsen and Scott had reached the Pole from the Ross Sea, much was still *terra incognita* – no one knew what lay beyond the Weddell Sea coast, or indeed, what shape the coastline took. Filchner was hoping to determine whether Antarctica was even a continent at all.

After Shackleton had failed, few men were brave enough to suggest another attempt at a crossing. By the early 1930s, though, some in Britain's polar community – including James Wordie – were pushing for the idea. In 1932 the young explorer Gino Watkins began gathering support for an attempt, though the Depression made raising the necessary funds almost impossible. That summer he settled on a trip to the Arctic, the scene of his successful air route surveys, but this time he would not return. He drowned while hunting seals from his kayak, alone amongst the ice in Tugtilik Fjord; he was only 25.

During the war years, Britain's involvement in the South was limited to the establishment of three manned bases: one in the sunken volcanic crater that forms Deception Island, and others at Port Lockroy and Hope Bay on the Antarctic Peninsula. In 1944 a clandestine Royal Navy-led operation known as Tabarin entered the icy waters, hoisting the Union Jack in an effort to forestall pro-German Argentine and Chilean activities there. After the end of the war the bases were handed over to the civilian members of the newly established Falkland Islands Dependencies Survey (FIDS), with whom Bunny cut his teeth as a young geologist after his travels in East Africa. He first sailed south at the end of December 1947 on a small wooden vessel, the *John Biscoe*, impressing his shipmates with the elephant gun he brought with him.

✺

Our own voyage south in 1955 on *Theron* slipped by in uneventful hours – we read and talked and slept, lazy days down the sea-lanes, though at first I and several others suffered dreadfully from seasickness. Everything was small on *Theron*, and there was hardly room to move. I caught my head on every doorway and was forced to turn sideways to climb the steep stairs, the poop deck was cluttered with winches, lifeboats and water pipes, and the well-deck was invisible, buried deep in our Antarctic cargo. This included two aircraft, an Otter and an Auster, one in a box and the other with the wings stowed but otherwise ready for flight, thousands of gallons of petrol and paraffin and cases of oil and grease. There was also a Sno-Cat, a tracked vehicle designed especially for travel over snow, two Ferguson tractors and two Weasels, smaller tracked vehicles. On top of all, in wooden crates, were the dogs: twenty huskies bought from the Inuit in Greenland and four pups supplied by Whipsnade Zoo.

On the wall of my cramped cabin I pinned a map of the Antarctic continent, which helped to while away the hours when I lay miserably seasick in my bunk. I was attracted by the

RIGHT Antarctica is vast – about the same area as Europe and the United States combined. First sighted in 1820, it has been an object of fascination and conjecture ever since. This map shows the route we eventually pioneered across the continent. The shaded areas indicate explored territory by 1960; even now, large parts are still blank.

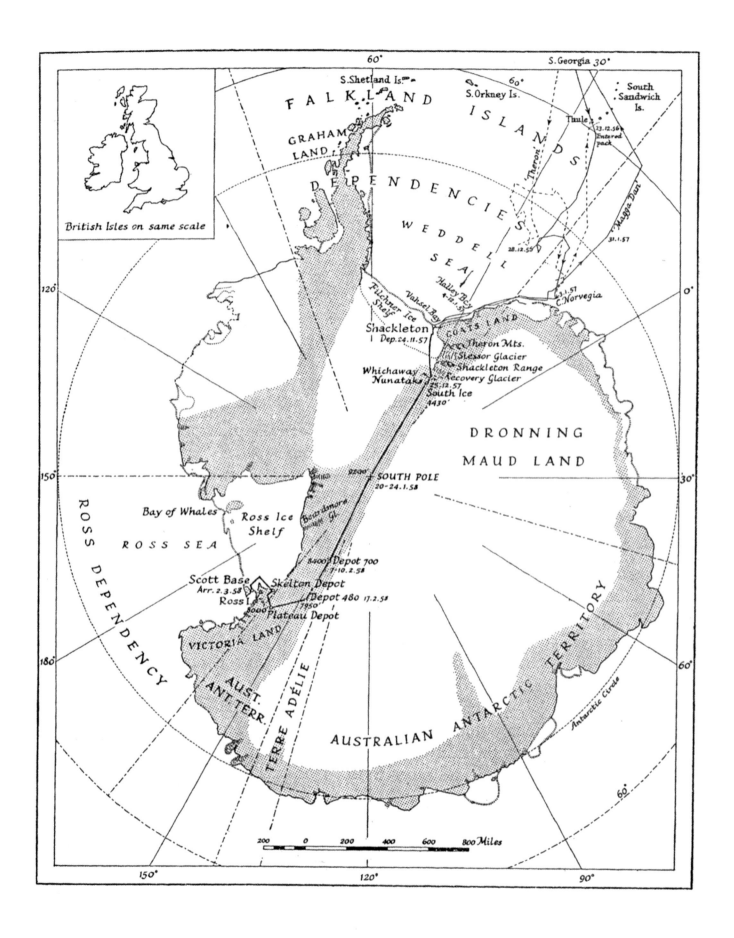

simplicity of the blank white wastes and especially the bold red line drawn slap through the South Pole bull's-eye in the centre, like a geographer's dartboard. Our 2,000-mile journey across the continent via the Pole was planned to last a hundred days. To accomplish this, the expedition would extend over a total of three years. First we would take *Theron* to the Weddell Sea, establish a base and land the advance party of eight men, who would remain there to build the expedition hut. The following year we'd return in another ship, *Magga Dan*, and overwinter before setting out on the crossing itself. At the end of that second year, on the far side of Antarctica, a New Zealand support party led by Hillary would search out a route towards the Pole for us to follow to complete the crossing after we'd reached the Pole.

But first we had to cover the 10,000 miles of water between England and the Antarctic. After calling at the Cape Verde Islands we sailed down the Atlantic and came slowly into Montevideo in Uruguay in brilliant sunshine. Here Sir Ed Hillary and his deputy, Bob Miller, joined the ship, having flown by the tortuous air route from New Zealand. It was good to see Ed again and I was glad when our bantering companionship returned immediately. Marriage had made him if not fat then at least well padded, in contrast with the lean angular man of five Himalayan journeys. There was another minor change: instead of waxing enthusiastically over a beautiful blade of ice surrounded by unknown valleys, he now produced snapshots of his wife, Louise, and their baby son, Peter. This much was certain, though, the heavier Hillary had not grown softer.

Soon *Theron* steamed down the Rio de la Plata and in five days we moved out of the tropical oceans into the frigid waters around the southern continent. South Georgia, our last port of call before entering the Weddell Sea, came into view in the evening light after an azure day. A solitary mountainous island with an ice-plastered backbone uplifted high, South Georgia lies on the fringe of the Antarctic at the same degree of latitude south as England is in the northern hemisphere. There the resemblance ends. Glaciers sweep down from the peaks and poke their tongues into the sea; there are no trees, only a tough golden snow grass and emerald green mosses that sprout in the cold bogs.

Next day at dawn, after a little more than four and a half weeks at sea, we approached a narrow fjord, and our captain, Harold Marø, berthed *Theron* neatly at King Edward Point. The few houses of the island sprawled on a spit of land; there was a post office, a generating shed, a meteorological office and, standing apart and beyond, a stark white cross looking out to the snowy peaks. The cross is a memorial to Shackleton, who died there of heart failure during the voyage of the *Quest* in 1922. His grave at Grytviken, among a little collection of those of whaling men, was marked by two wreaths of flowers made of tarnished copper and a roughly carved granite block bearing the words: 'Ernest Shackleton, Explorer'.

We put the dogs ashore and let them run and roll in the snow. The Auster was also brought out and dressed in her wings so that the pilots, so long earthbound, could taxi into the bay on floats and join the sea birds in flight. We reflected on the days ahead: tomorrow we would sail into the Weddell Sea, across the magic circle – 66° south – and deep into the realm of ice.

☙

To begin with after we set sail we were rolling and pitching in a blue-black sea, many of us sick and subdued. Bunny, who was never seasick, watched and waited or sat poring over his charts

of all the previous voyages into the Weddell Sea. I pottered about doing a bit of filming and processing stuff that I had shot in South Georgia. I had made myself a corner in the wash-room where I could do a little printing. At 63° South, shapeless chunks of ice were strewn in the sea. The rolling eased; the sea was flat and sullen and the sky grey, without contrast or colour. Harold climbed to the crow's-nest and slid into the chest-high barrel. The engine-room telegraph and steering control were switched to his lofty control point. By the evening of 22 December – midsummer in these regions – without our noticing the moment of transition, the battle proper had commenced.

At first the pack ice was thin and open. With an occasional clang and judder, *Theron* forced forwards. We all stood on the bridge-wings or hung over the bow to watch the thin pack ice split. I had little notion of what pack ice would be like, just a vague picture of a frozen, lumpy sea. I also had no idea that it would take us over a month to fight our way through. We were frequently trapped between the floes, but Harold Marø's eyes would be cast ahead and around, not always searching for the immediate twists and turns but for certain dark shadowy marks on the underside of clouds, which reflect light or dark according to whether there is water or ice below. With this 'water sky', as it is called, no great compass accuracy is possible and our direction was only approximate as we went through the maze, trying to work our way southeast.

Just before each impact the engine was stopped, and for a moment all was quiet and all vibration ceased as the ship glided in towards the silent ice. As the bow crunched into the soft edge the noise was no louder than a sigh. But then, *thump!* and another thump, and another. The entire ship was convulsed, shuddering and riding up as it smashed the ice into huge floating islands.

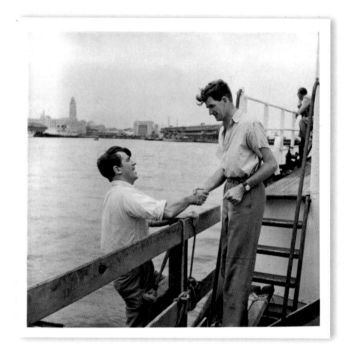

The cracked lumps – the size of a car – grumbled along the side of the ship as the motor throbbed once more, urging us into the next winding waterway.

For two days we made good progress. But on Christmas Eve there was a change in the sea ice, it became thicker and heavier and soon a high wind began pressing it together. Harold came down from long hours in the crow's-nest, and sighed: 'It's no good, I can't see. Let's all have a drink.' While chief officer Karl stayed on watch we began our celebrations by eating dinner on Christmas Eve – as is the Scandinavian custom. Norwegian in timing, it was Canadian in character: chicken soup, turkey and cranberry sauce, with strawberries and ice-cream. The singing of songs was in progress when Bunny slipped out for a walk on

ABOVE Ed Hillary joined *Theron* in Montevideo in December 1955, where I was pleased to welcome him on board the ship.

deck. He returned to say that we had been cut off by a large floe astern, and pressure was forming along the side.

As I went to lunch on Christmas Day we were almost stationary, grinding against a huge unmoving bank of ice. In the crow's-nest I could see Harold searching for an alternative, and suddenly we made it. The ice broke with a crash and he jammed the prow like a wedge into the break and kept it there, pressing open the ice for a new lead. At three o'clock Bunny called up to Harold: 'Will you stop the ship and let all listen to the Queen's broadcast?' He waved assent. The telegraph rang – the engines stilled and stopped. The anthem boomed out and the Queen's voice came through. She alluded to life being like a voyage of discovery and mentioned the explorers of new lands. We all took this to mean us personally. A dozen of us were crushed into the radio room; everyone seemed to be projecting himself away to his home – I know I was.

On Boxing Day the ice became thicker than ever and four tabular bergs could be seen ahead, the first big icebergs we had encountered. In the afternoon we battered through towards a pool in the ice. It seemed large enough to fly from, and Bunny decided to send the Auster on an ice reconnaissance. As the low fog clouds lifted, a lifeboat went over one side and the plane over the other. With the lifeboat we cleared chunks of drifting ice so that John Lewis could thunder off in the dramatic knight-errant take-off that he loved to make. He flew on a wide arc around the ship and was back with news of good leads and better water to the southeast. We set off. The ice had turned pink, with long blue shadows; the water had an oily texture, opal green in colour.

But we drifted a long way north with the wind and current until we were nearly back across the Antarctic Circle. It was maddening. We knew exactly how Shackleton must have felt when *Endurance* was locked in a similar fate. Often I'd climb the mast to sit and watch from my favourite position, the crosstree just below the crow's-nest. I'd take three cameras, one loaded with colour and one with black and white slung around my neck, and the movie camera hanging from my wrist on a strap. Weighing nine pounds, the movie camera was a handful on these occasions, for the ship lurched and quivered every time we charged the ice, and I always seemed to be climbing the wire ladder at a crucial moment.

As far as the horizon, all we could see was floating, drifting, moving pack ice. I could not help being fascinated by Harold's fantastic game of skill. It was incredible to watch how he judged the power and weight of the ship as he smashed into the floes. He was worried all the time about *Theron*'s safety, and we knew well enough that he was half destroying his vessel to get us through. Ed Hillary and David Stratton were going over the side with axes and crowbars to cut away the ice. Nearly everybody joined eagerly in the attack. We once worked all night for sixteen hours, hacking and dynamiting at the ice jaws, but gave up as the wind and tide pressed the two floes more firmly together.

The ice piled up and the pressure increased, until we had ice standing above the height of the well-deck. The heavy side plates of *Theron* began to buckle. Fortunately the ship did not burst. All paint had long been stripped from the hull; we were now leaving a brown scar of rust on the ice as we passed, a trail that matched our snail's pace. On 19 January dynamite was used to demolish an ice island, but the charge was unwittingly placed in soft ice that was rotted by seeping water. This sent the blast upwards instead of against the floe. Ice flew into the air and rained down like flak. I ducked under a ventilator. Fortunately no one was hit, but several holes were torn in the wings of the Auster.

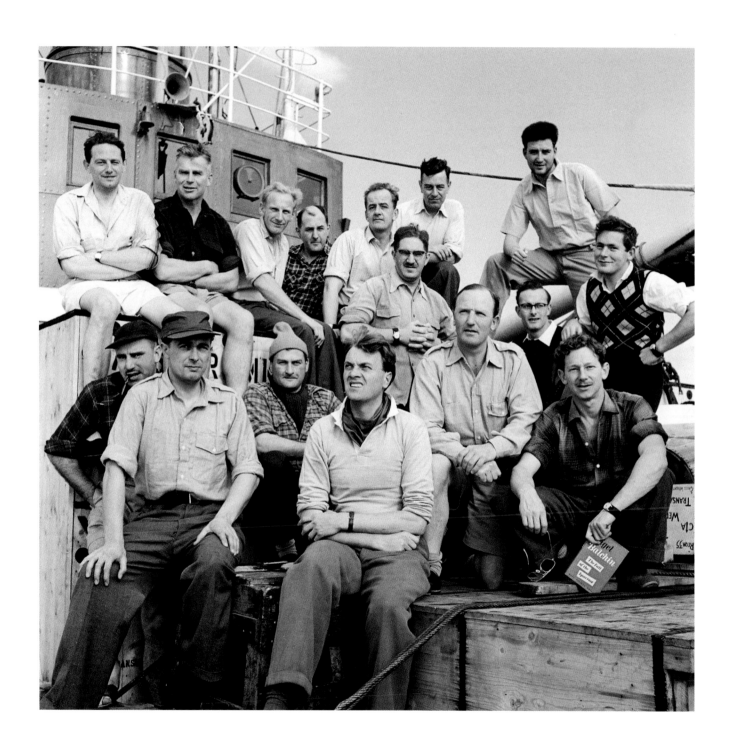

ABOVE We sailed from London in November 1955 aboard the
Theron. From left to right, back row: David Stratton, Bunny
Fuchs, Ken Blaiklock, Ralph Lenton, Taffy Williams, Hannes
la Grange, Tony Stewart, Derek Williams, Rainer Goldsmith.
Front row: Gordon Haslop, Peter Weston, John Lewis, David
Pratt, John Claydon, Peter Jeffries and Roy Homard.

As the days drifted by our excursions on to the ice grew more regular, and more distant, as we absorbed the fact that *Theron* was virtually a part of the landscape. At first we just walked over the ice to take photographs, to chase penguins or watch seals, which swam and made curious metallic clinking sounds as they searched for breathing holes. More frightening were the whales, as their blue-black nostrils appeared in the smallest of pools, and air and condensation steamed out with the suddenness of a train; but within a few seconds they were gone. When the high, hard dorsal fin of the killer whale cut through the surface of the pools I felt like a visitor inside the lions' cage at a circus.

Chasing the lively Adélie penguins was irresistible. It was almost impossible to catch one, and judging by the playful manner in which they ducked, dived and evaded, never actually running away from us, it was easy to believe that they positively enjoyed the game. When, eventually, my film sequences were shown, I was disappointed that every penguin shot had been deleted. Arguing, with reason, that the prime object of the film was to depict the crossing of Antarctica, the backroom powers insisted: '*Every* Antarctic picture is full of penguins – this one will do without them.' It was a pity, especially as our chasing games gave us real joy when the ice was causing such frustration.

By about midday on 22 January finally the floe that held us split and the pressure eased. *Theron* backed out and we made slow progress to the north. Late in the afternoon we sailed into open water and rose gently to the swell. We were all relieved to be free. By now the frigate HMS *Protector* was sailing into the Weddell Sea with the aim of telling us where the ice edge lay. *Protector* had two helicopters, which were of great use in finding leads through the ice. It was a memorable rendezvous. We parted after dining on board one evening, thanking them

for their help; as a gift, several crates of beer were placed in the longboat that rowed us back to our ship.

At long last, on 26 January, we sighted Antarctica. From the clear water of Halley Bay, Bunny and John Lewis flew the Auster to see if the way inland was a practical proposition for vehicles. During that night Bunny and the captain were among the few who stayed awake. An immense field of pressured pack ice lay in our path. At 5 a.m. Ed Hillary woke me to say that a possible landing site could be seen. John and Bunny flew in the Auster again. The day was perfect, and with the crispness of the weather came crispness of decision and a vigorous desire to get ashore. David Pratt's mind was already leaping ahead, working on the problems of how the tractors would tackle the slope behind the terrace we could see. Deck crates were being opened and shiny tractors were emerging from their cocoons. Steel wire ropes were cut from the petrol drums on deck. Sledge-hammers demolished the flimsy wooden deck railings that had been hurriedly built in London. Dogs howled and leapt about in the general excitement.

Quite suddenly this landing site was abandoned. From the air Bunny had chosen to land on the ice shelf proper and build the base some 30 miles from the crevassed hills and broken ice of Vahsel Bay. At a point where sea ice formed a convenient landing, *Theron* lay alongside and we jumped ashore. With axes we dug into the ice and buried some heavy timbers; to these we anchored *Theron* with steel wire ropes.

We began unloading on 30 January; it happened to be a Monday morning, though days of the week had little meaning here. The skies were clear, the temperature just above zero, with a biting wind. The dogs were the first overboard. They rolled in the snow and jumped for joy, quite mad with delight. Next went

the Sno-Cat. We then worked hard to get the two Ferguson tractors and two Weasels out on to the ice. At midnight we dragged ourselves to bed. The hut site for Shackleton – as we decided to call our base – was chosen on a level ice shelf 2 miles from the sea-front. By the evening of the second day the Ferguson tractors were taking stores from the ship to a dump at the foot of the

200-ft climb up the sloping ice shelf to the base site, while the Weasels relayed the loads to the top.

On the third morning one of the Weasels developed track trouble and this caused some difficulty in synchronizing unloading and transporting. By midday a great number of boxes and stacks of hut timber were piled on the sea ice beside the ship.

ABOVE *Theron* literally sailed off the edge of our charts as we tried to penetrate the pack ice which drifts on the Weddell Sea. For long nights we were over the side digging at the ice with poles and axes, pushing and levering the huge frozen chunks away. When the pressure eased we managed with dynamite and pick-axes to break the ship free, only to be gripped again and again. We all grew weary of endless days of struggle with few miles gained.

But the tractors roared on in the grey mist. Quite suddenly the sea began to rise, and soon it was bursting in waves over the ice front, swamping the ice in slushy water. *Theron* rose and fell. The unloading went on grimly. I was driving a tractor-load from the ship across the sea ice to the dump when the storm got going in earnest. On the return journey to the ship it became more and more difficult to see the way ahead. The wind, sleet and snow lashed my eyes. By four o'clock a full gale was blowing.

☙

The storm was a bitter blow. Wading up to our knees in the slush of ice and water, we tried desperately to rescue stores and equipment that were soon floating everywhere. What proved to be the last load was hitched to my tractor and I hurried away again inland. In the flying snow I nearly collided with Ed Hillary who, head down, was making his way back to the ship. At the depot I met David Pratt coming down the hill with a Weasel. I passed on Bunny's order for everyone to get back to the ship as fast as possible and turned my tractor round. Visibility was now only a few yards, snow and sleet plastered my goggles, eyes and face, and I was able to keep direction only by steering with one arm shielding my face from the torment of the wind.

Beard and eyes were soon packed with ice particles. It was impossible to judge how near to the ice edge of the sea I was driving and I began to get nervous, so I stopped the engine and went forward on foot, feeling my way; then I stumbled back to the tractor to climb aboard and once more grope ahead for a few yards. Forward on foot again, investigating, then running back to the tractor like a motorist caught in a blind fog – but still no sign of the ship or sea. I abandoned the tractor and struck out on foot to where I knew the ship would be. At the ice edge I found the rest of the party still wading among the stores floating in the icy slush and water. But *Theron* had gone.

As the storm increased its ferocity the ship had been ripped away from the edge – the cables to the ice anchors had snapped. Harold Marø started his engines and disappeared into the blizzard, shouting through a megaphone to Bunny and three or four others who were left on shore that he would try to get back to them. So I joined Bunny and Ed Hillary, Gordon Haslop, Roy Homard and Ken Blaiklock, and for a while we used a small rowing boat to salvage the equipment, but we were all feeling utterly frozen, our feet and clothes wringing wet.

Like a ghost ship through the storm, *Theron* eventually reappeared. Through the megaphone Harold roared that he was about to try coming alongside. 'But I can't tie up, you'll have to jump aboard while we're on the move!' he shouted. Hazardous as it sounded, we were all grimly aware that there was no choice. As the ship churned slowly abreast of our group, the entire crew were leaning over the side throwing ropes, ladders, anything they could find, to help us clamber aboard. Harold's judgment in the raging storm was superb. He brought *Theron*'s bow in towards the ice just close enough for each of us to make our neck-or-nothing leap to safety. Once safely aboard we peeled off our drenched clothes and had the enormous luxury of putting on dry outfits. Straightaway the warmth of the ship transformed our view of the incidents on the ice from one of grimness to gaiety, and we felt a surge of relief that no one had been seriously injured.

But the light-heartedness was quickly dispelled by the news that there were still five men marooned inland at our base site. Stratton, Lenton, Pratt, Bob Miller and Peter Jeffries had tried to make their way back to the ship but were foiled by the storm;

they spent the entire night huddled in their Weasel, cold as only the Antarctic knew how to make it, ruefully considering their future if the ship was unable to return. When *Theron* eventually came up to the ice we found the five men making a gallant effort to salvage the still floating equipment. We re-anchored and unloading continued non-stop for the next six days. But we were into February, the season was getting on, the sun setting a good deal earlier each day, and soon the whole sea would freeze over.

We now had to face the distressing prospect of the most vital issue of all: leaving behind the advance party of eight men who were to become voluntarily imprisoned on the Antarctic continent for the next year. We dumped their stores at the sea ice depot and the question was, could we with a clear conscience leave these men and sail away? Bunny told them to get their personal gear ready because we might have to depart at short notice. All the time Harold Marø was anxiously observing the state of the ice, spending much time in the crow's-nest peering out with his binoculars. About noon on the crucial day, stopping for a brief farewell lunch, Bunny gathered the eight men of the advance party together to deliver his last little speech before we sailed. 'I know it's a risk,' he told them, 'and I am throwing the weight on your shoulders. If you stay here and build the base, the original scheme can go forward. But if we pull out now, if we all go home, it may jeopardize the whole expedition. We shall have no base, no advance party, nothing – and the scheme will be thrown out by at least a year. It's now up to you to make a go of it.'

Bunny had made his difficult decision with speed and without sentiment. The truly heavy burden was placed, nevertheless, on Blaiklock and his men – and they took it squarely. I believe theirs was one of the greatest, if not the greatest, of all the contributions that led to our ultimate success. Ken Blaiklock

was soon to be revealed as a man of strong calibre. Above all, he had the two prime qualities for an Antarctic leader, as did Fuchs himself: the ability to wait and endure, plus the mentality for 'keeping on steadfastly'.

Our departure was a split-second thing, with huge fields of new pack ice bearing down. The sea was starting to freeze like wet cement, coagulating in a thick mess around the ship. But *Theron* succeeded in getting away. The smashed bow had to be welded at South Georgia before we could continue, and we had broken more than half the steel ribs, dented the plates along the side and twisted the hull, yet we had accomplished what we set out to do: to land our advance party at Shackleton. We sailed back into London with just a scrap of white paint showing above *Theron*'s waterline. The rest was a rusting, tired hulk.

☙

On 15 November 1956, exactly a year after *Theron*'s departure from London, our new ship, *Magga Dan*, sailed. She was a Danish vessel, specially built to withstand the pressure of ice. It was her maiden voyage and at 1,800 tons she was twice the weight of *Theron*; she was also fatter, stronger, more powerful and a lot more comfortable. She was loaded once more with Sno-Cats, Weasels, a Muskeg tractor and the Otter and the Auster. After Madeira, Montevideo and then across the stormy Atlantic, we arrived at South Georgia on 17 December. But it was not until *Magga* sailed further south that I had the surge of feeling that the expedition had truly begun again. For the second time we were entering the unpredictable Weddell Sea, but on this occasion our intention was then to drive across the entire continent and sail back from the other side.

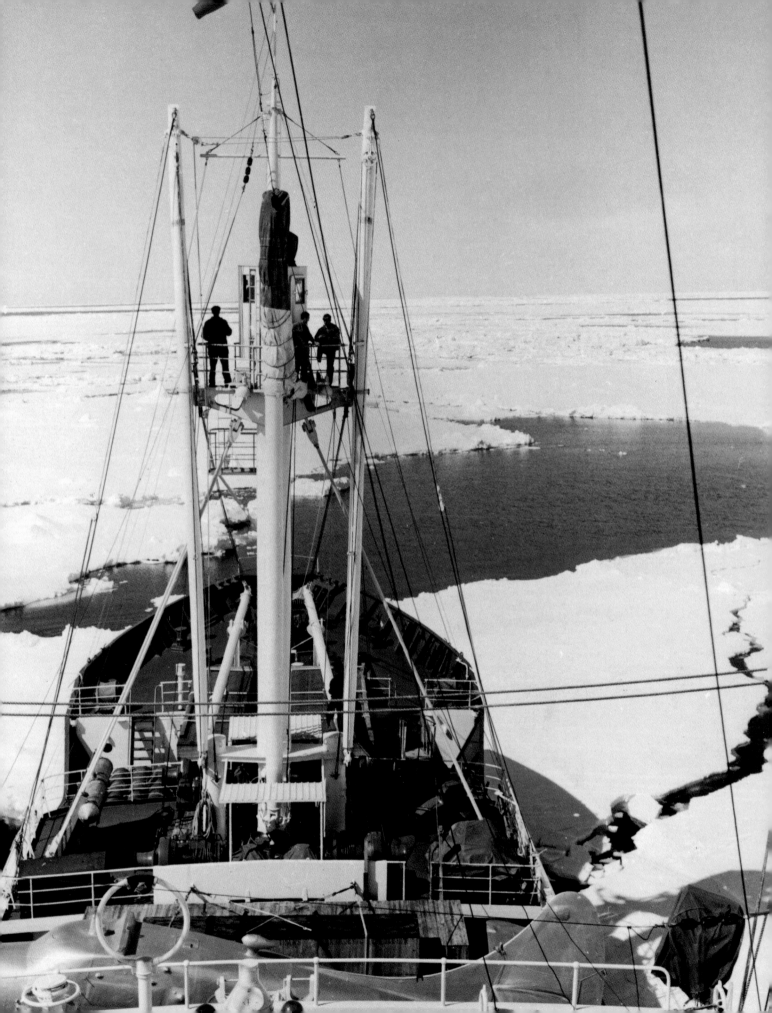

Two days before Christmas we entered the fringe of the dreaded pack ice. *Magga*'s route was to be along the same track as *Theron*'s exit, and a ripple of excitement ran through us – even Bunny was frisking about in a jubilant mood. Ice fever. He was continually scanning the southern horizon with binoculars; the captain, Hans Christian Petersen, sat in the crow's-nest, a glassed-in control box at the top of the mast, steering the ship with skilful ease.

During the afternoon Ralph Lenton called the ship from Shackleton Base – the first radio-telephone contact with the men who had overwintered came through loud and clear. We talked for more than an hour, asking about their living conditions and the state of the sea ice. The temperature in the hut, in which they had no heating stove, had gone above freezing-point for the first time. It was clear that the advance party had suffered far more then we suspected.

Everybody crowded on deck to watch the *Magga*'s christening in the ice. An area of pack could not easily be skirted, so Captain Petersen drove straight for it. *Magga* slowed cautiously, glided up and slid her nose into the ice, cutting through silently like a big cheese knife. Then came a bump and a shudder as we hit and smashed a big floe some 10 ft thick. Red paint stains appeared on the bursting ice and two seals rudely wakened from their sleep on the floe slid quickly into the water. Under Petersen's hand the *Magga* was superb. The variable-pitch propeller gave more control, and instead of backing and charging in frenzied bursts she barged forwards at a steady, unhurried pace. For two days we pushed through the ice fields, the ship cutting her way with tremendous power. On 24 December we celebrated a Danish Christmas and ate till we were fit to burst. We began with rice pudding and then came goose, stuffed with prunes, washed down with madeira that had been given to David Stratton – rare old vintages, two bottles of 1874 and two of 1910. We all had a taste but kept a bottle of each intact to help us through the coming winter.

On 27 December we crossed the Antarctic Circle. Progress was still good although the ice was now thicker and heavy, nearly ten-tenths cover, which meant there was no water in sight. The ship smashed everything at a steady walking pace. The captain and first mate took it in turns to keep *Magga* thrusting forwards twenty-four hours a day. I saw the New Year in from the crow's-nest with the first mate. The captain handed over with the warning: 'Be careful now – go easy and *don't get stuck.*' On 2 January 1957 we reached a small pool of clear water. Around the edge the sea was frozen into flowery patterns, standing up like clusters of white moss. We lowered a plane into the water and John Lewis flew from the pool with the mate as observer. They found open water under clear sunny skies and directed our ship towards it – finally, these were our last hours in the sea ice. We sailed into open water as Antarctica came in view, the coastal sea a shining blue like the Mediterranean, with distant mountains cloaked in snow. Beyond them lay *terra incognita*, a vast unknown land, the blank on our maps. Our polar expedition was now truly beginning.

LEFT In December 1956 *Magga Dan* moves carefully but forcefully through the pack ice. High above the steel deck I clung to a stanchion with my legs, waiting to film any spectacular phase of the ice-breaking.

CHAPTER 1

PORTFOLIO

THE MAP ON THE WALL

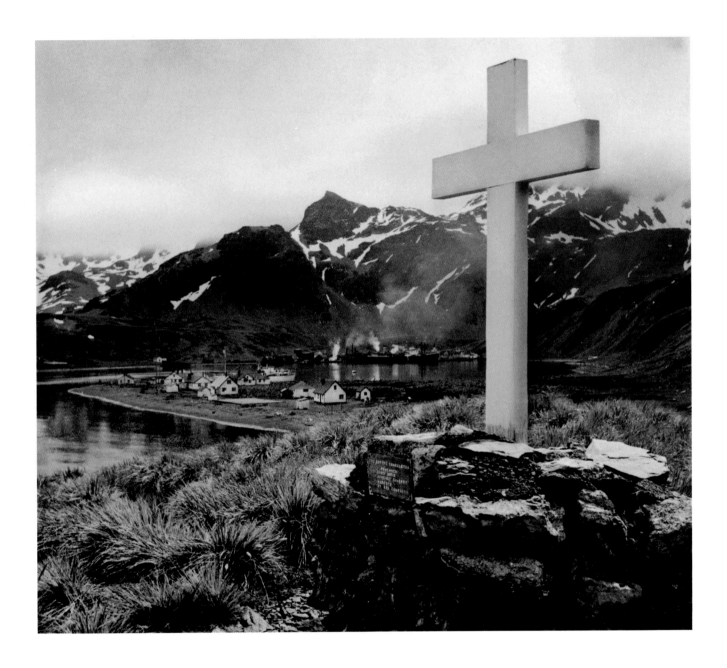

ABOVE Everywhere on South Georgia the mountains dominate, often with their peaks in the clouds. At the head of fjords stand the whaling factories, devouring and rumbling and smoking like resident dragons. Beauty and destruction are here side by side. At Grytviken a memorial cross honours Sir Ernest Shackleton, who is buried in the small cemetery there.

RIGHT Sir Ed Hillary is surrounded by crowds of children on the steps of Wellington Town Hall, 1 September 1956. Many schools were given the morning off to come and cheer him as he left for our expedition – no wonder they all look happy.

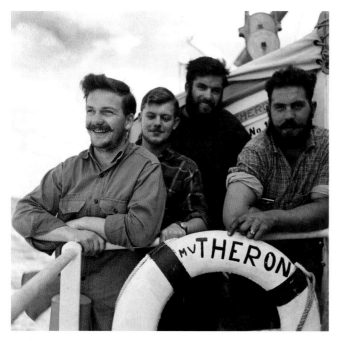

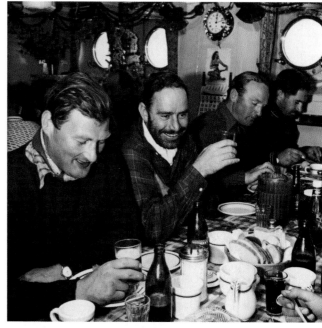

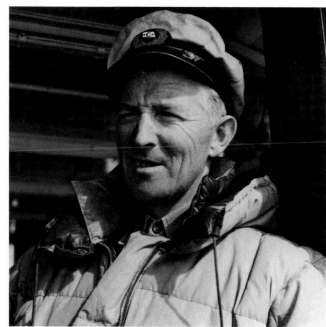

LEFT AND TOP LEFT Jonas Olsen was *Theron*'s second officer; all the crew were Scandinavian mariners and many had decades of experience of Arctic conditions. They would prove crucial to our efforts in the Weddell Sea.

TOP RIGHT Enjoying lunch on Christmas Day, 1955: John Lewis, Gordon Haslop and John Claydon.

BOTTOM LEFT Ed Hillary, Ken Blaiklock, Bob Miller and Peter Weston playing bridge aboard *Theron* while we were beset in the ice. This became a favoured way of passing the time as we waited in listless inactivity to break free.

ABOVE Captain Harold Marø was a strong, determined sailor – he had the clear blue eyes with a faraway look, the abrupt statement that served as conversation and the wry sense of humour of the story-book seaman.

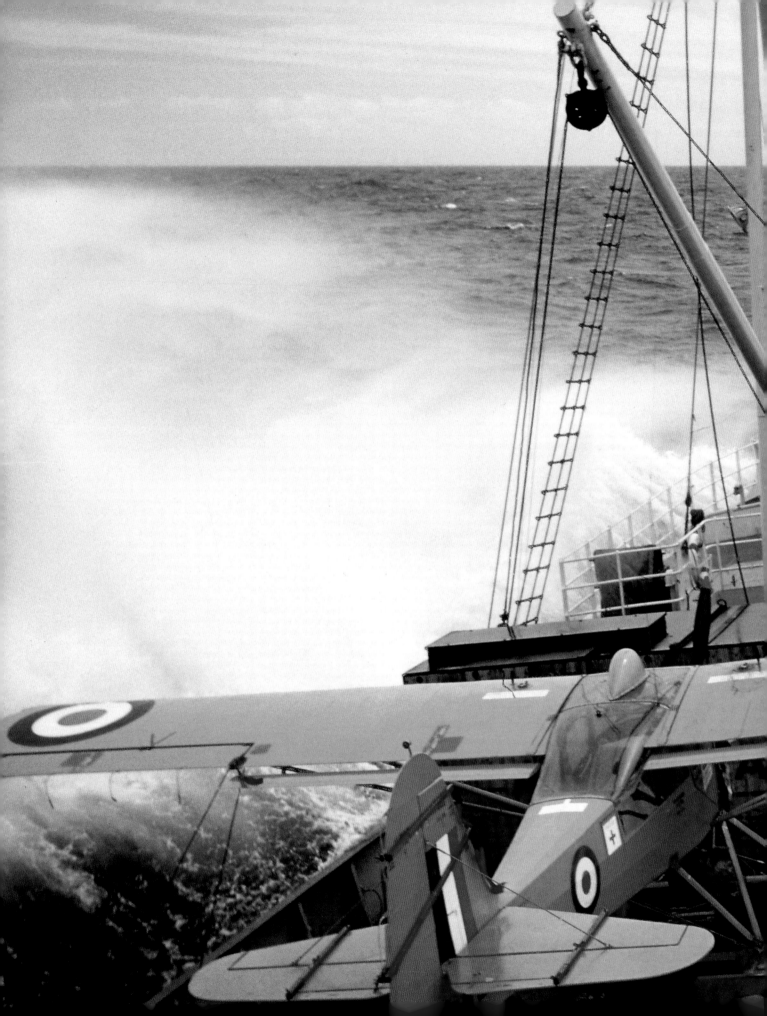

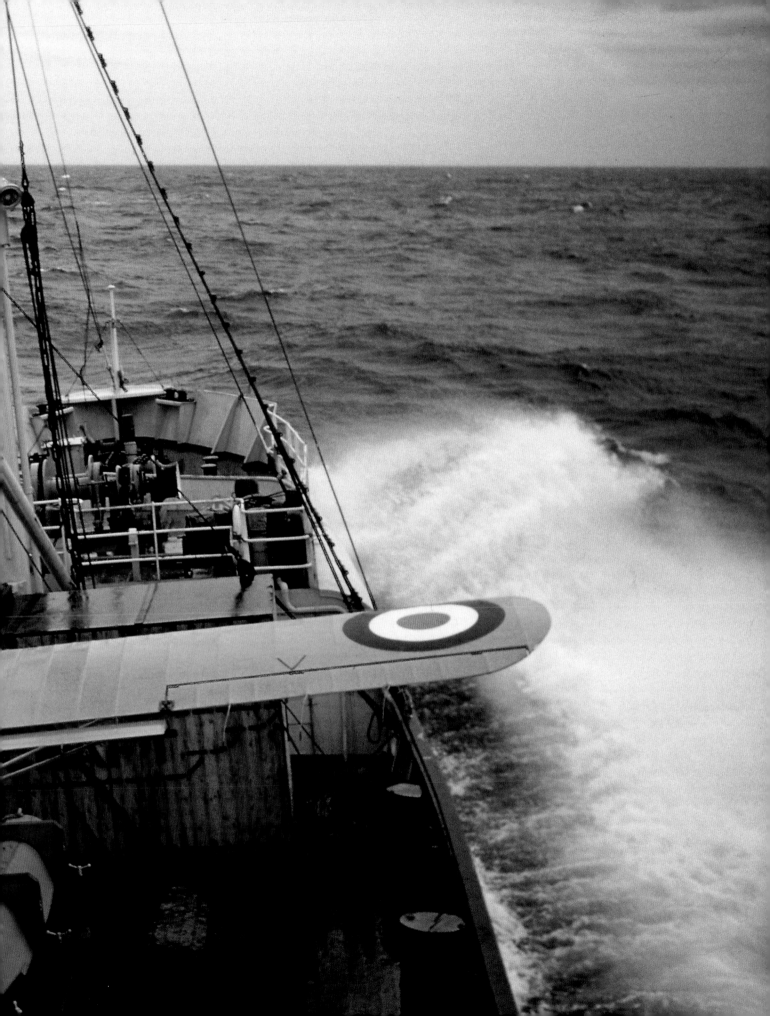

PREVIOUS A few days before Christmas – on Midsummer's Day – we rolled and pitched in a blue-black sea; waves spilled over the bow. The Auster was now ready for immediate reconnaissance use if needed.

ABOVE At South Georgia we put the dogs ashore. Bouncer was the eldest of the eight huskies that would end up hauling sledges to the South Pole; he had a habit of slipping his harness to help himself to our pemmican.

RIGHT When we reached South Georgia the Auster aircraft was lowered into the water and made ready for flight.

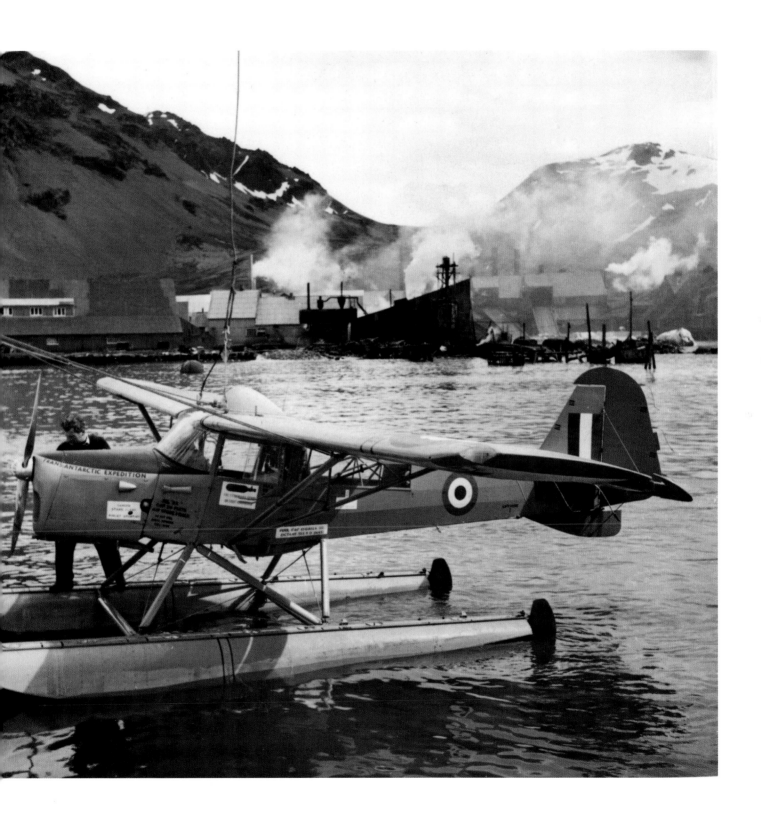

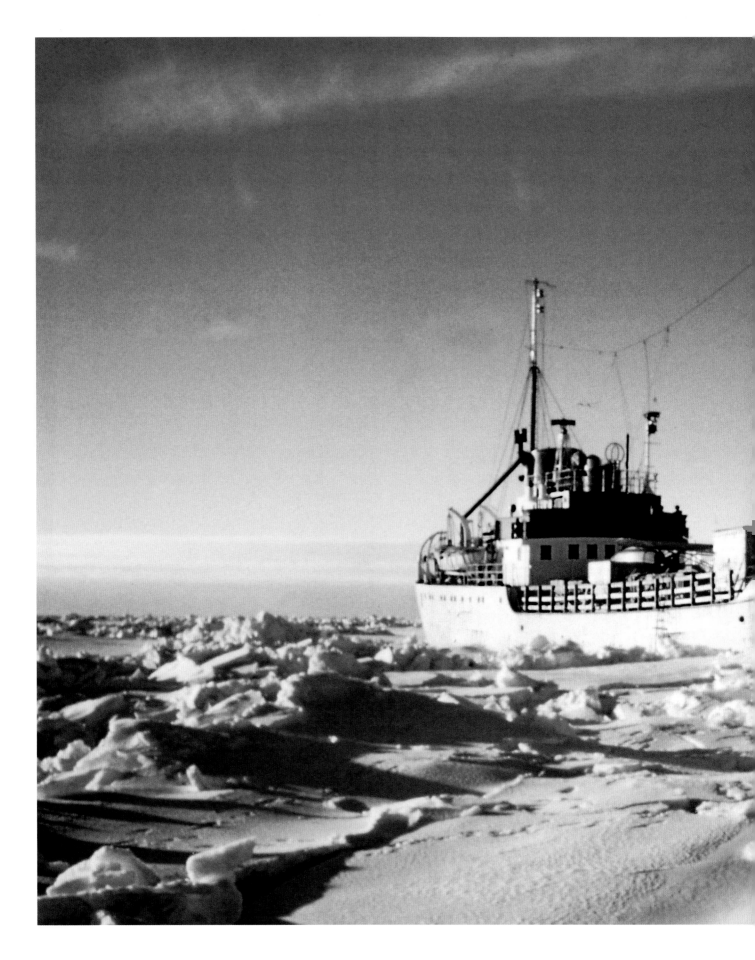

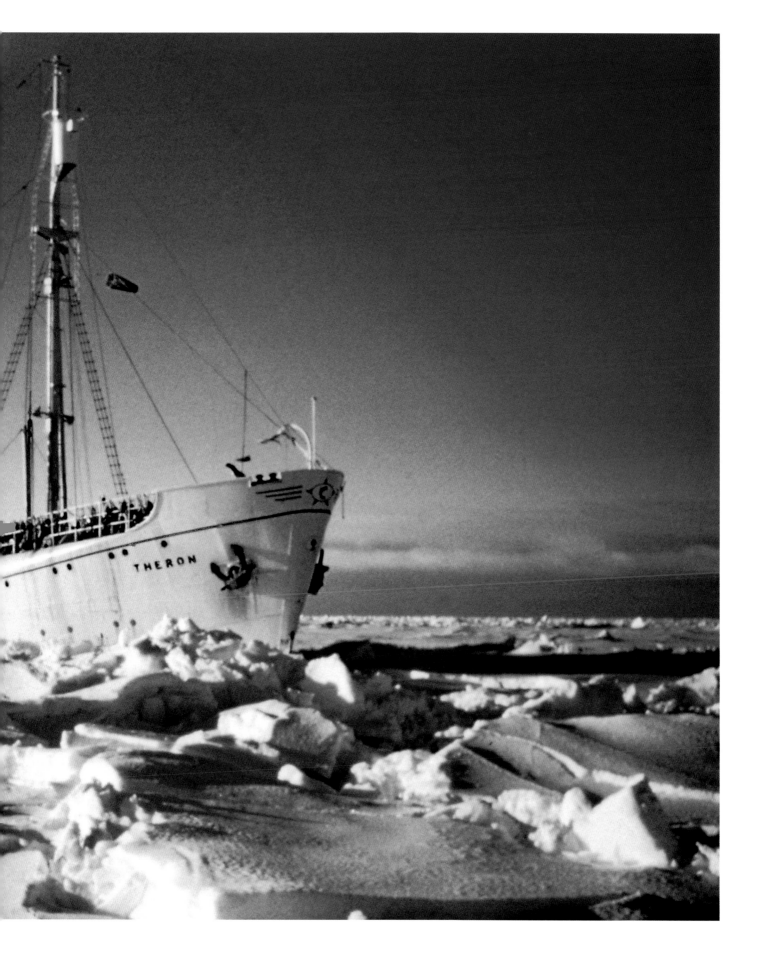

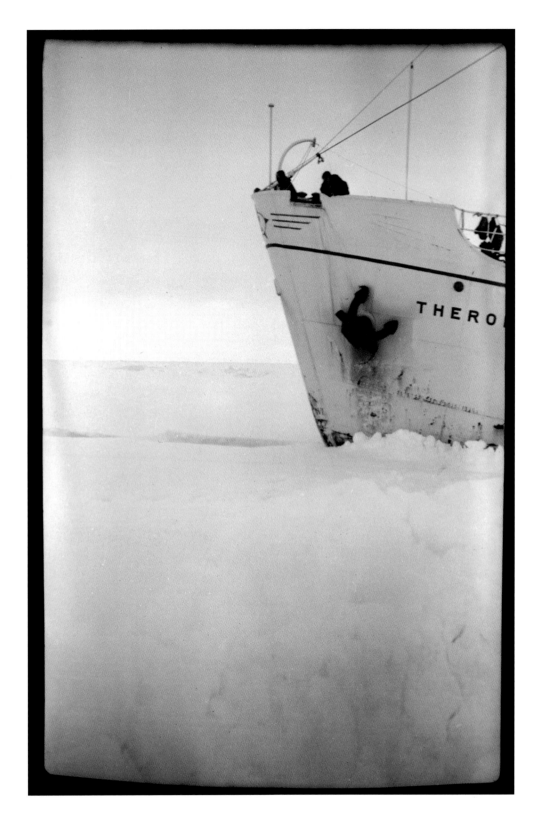

PREVIOUS On New Year's Day 1956 *Theron* was beset at 69° South – strong winds forced the ice into huge ridges, jamming the ship. This photograph was taken at 9.30 p.m. We spent almost five days here without moving.

ABOVE AND RIGHT On many occasions we thought the expedition would founder before we had even reached the Antarctic coast. Day after day, time after time, for hours on end, everyone was over the side of the ship with axes, shovels, poles and boat-hooks to clear the ice. Unlike Shackleton, we were eventually able to smash our way through.

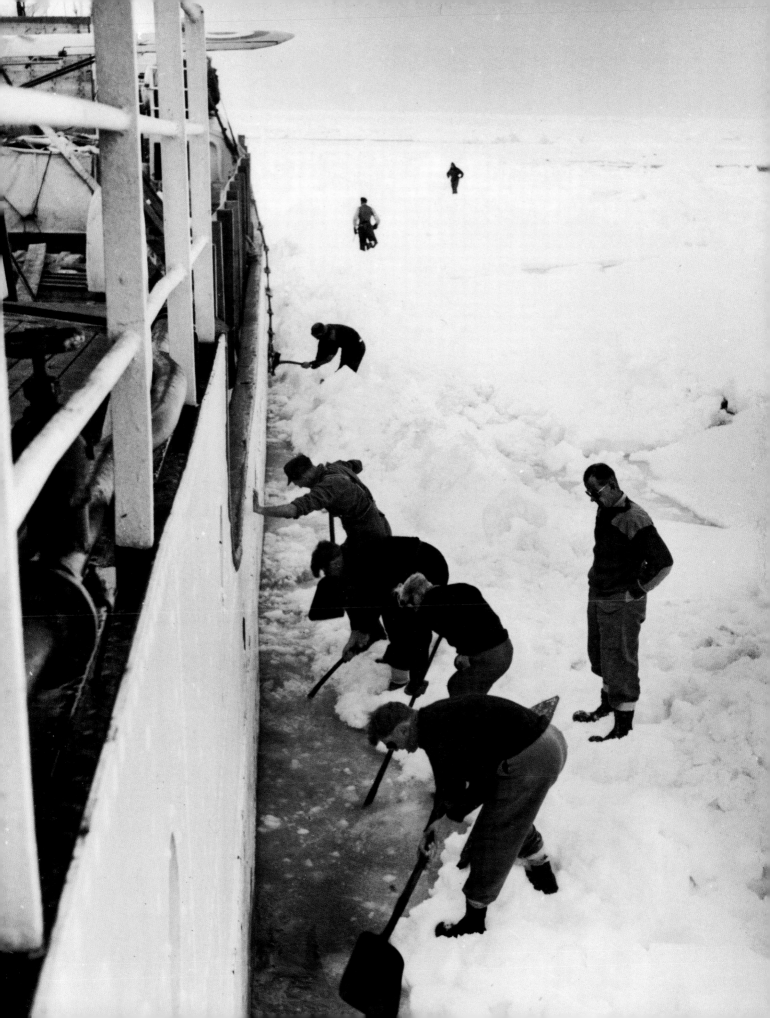

LEFT Icebergs calve from the crevassed edge of a prodigious ice-stream about 50 miles south of Halley Bay; these giants are slowly moving north. It was within a few miles of here that Shackleton's ship *Endurance* became beset and began the long drift until crushed by the sea ice.

FOLLOWING Bunny leads the party cutting ice from pressure ridges to replenish our fresh water supplies in *Theron*, 15 January 1956. A month was spent fighting and drifting with the ice, until we broke out to make landfall on the continent at 78° South – as far south as it is possible to sail by sea. Nine hundred miles further south still lay the Pole.

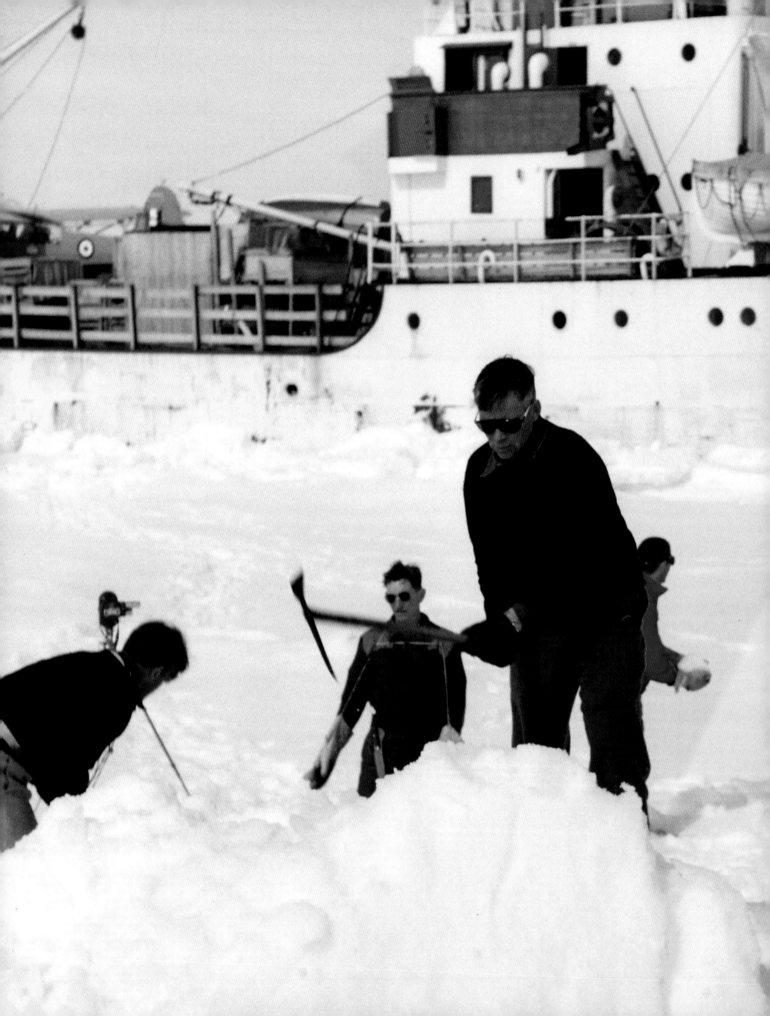

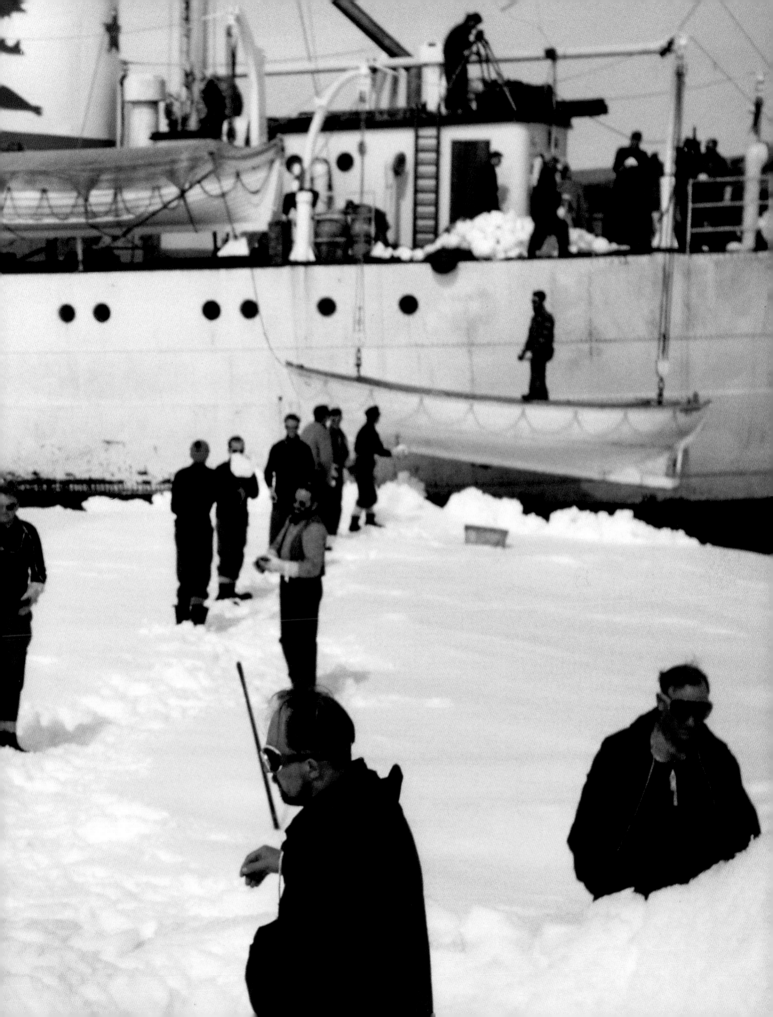

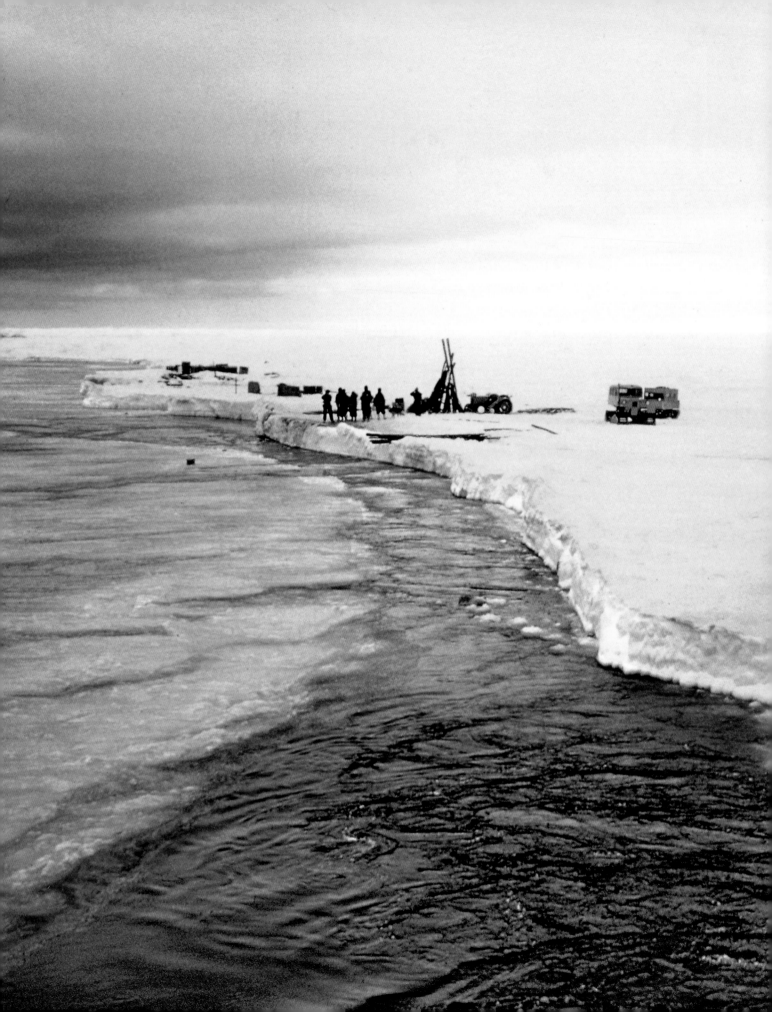

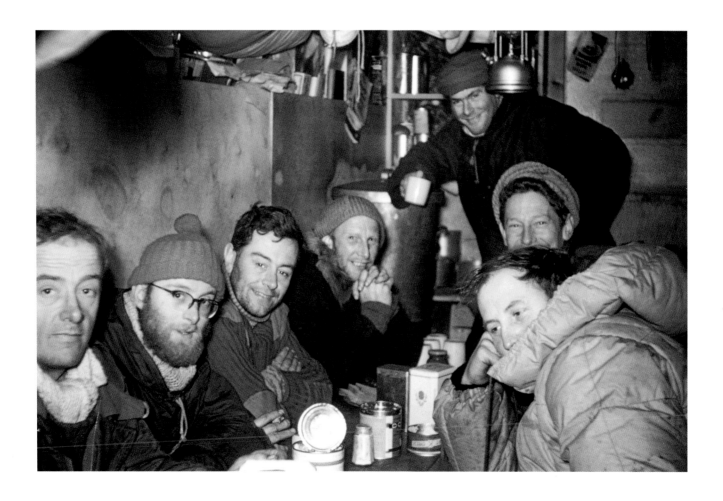

LEFT On first landing in Antarctica we established a foothold and unloaded supplies, but within a week the sea began to freeze and *Theron* sailed homewards on 7 February 1956. For the advance party left behind it was to be a very tough winter.

ABOVE The men of the advance party in the empty Sno-Cat crate in which they ate their meals. From left to right: Taffy Williams, the radio operator; Peter Jeffries; Tony Stewart; Ken Blaiklock, leader and surveyor; Rainer Goldsmith, the doctor; Roy Homard, the engineer; and carpenter Ralph Lenton, Ken's deputy. Hannes la Grange, the meteorologist, took the photograph. We finally saw them again almost a year later, when we returned in *Magga Dan*.

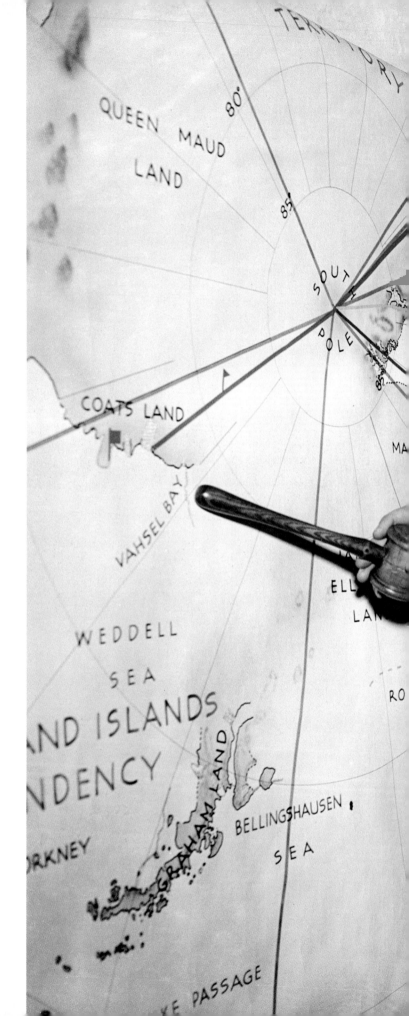

RIGHT We arrived back in London in March 1956. Bunny and Ed Hillary gave a press conference at Butler's Wharf near Tower Bridge, outlining our plans for the next season. Bunny and our party would return to the Weddell Sea on a new ship, while Ed would lead his men to establish a base at Ross Island on the far side of the continent and lay depots on our planned route. We would meet up with Ed the following summer as we crossed Antarctica straight through the South Pole.

FOLLOWING Huge crowds came to wave goodbye as our new ship, *Magga Dan*, made her way down the Thames. It was 15 November 1956 and we were glad to be finally off again, this time for the actual crossing of Antarctica.

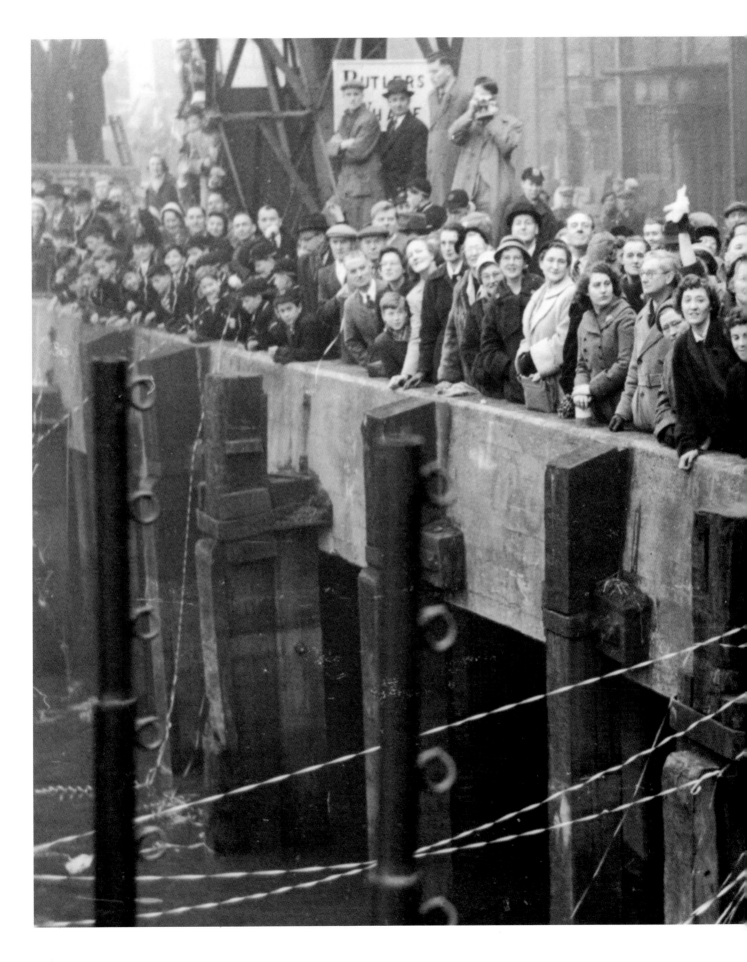

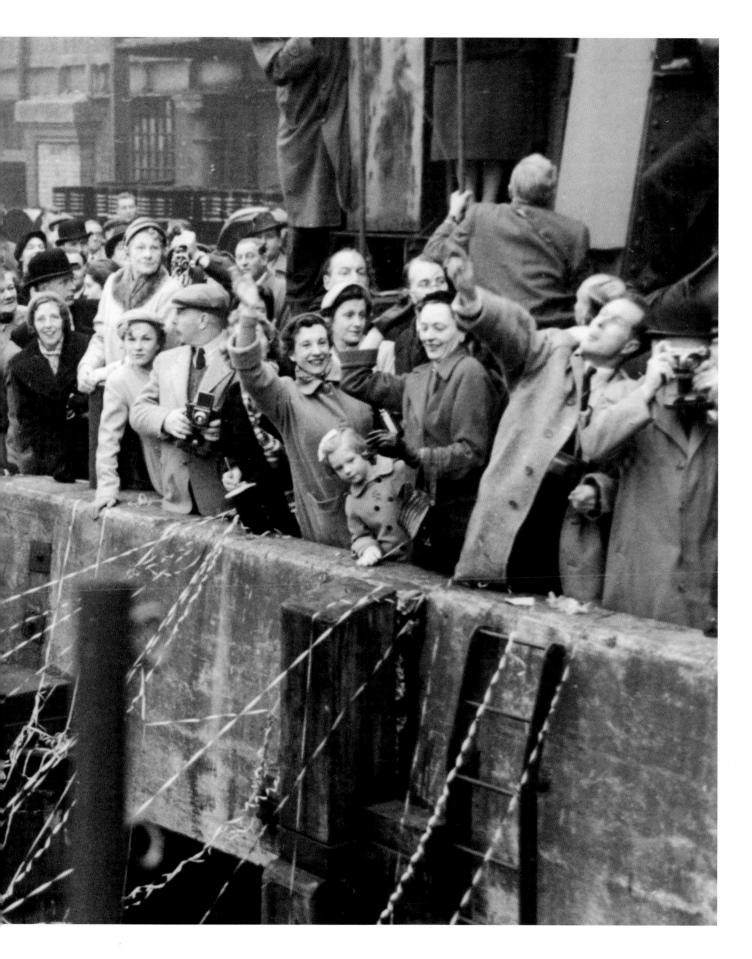

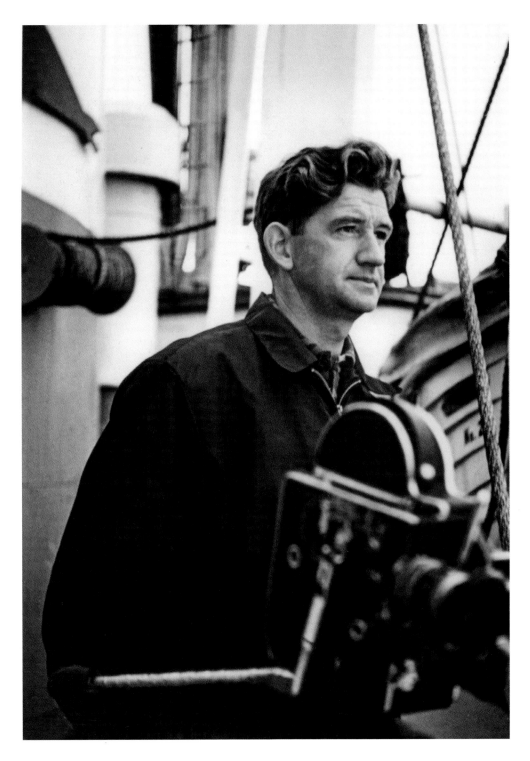

ABOVE AND RIGHT Christmas Day
1956, and I'm feeling a little
apprehensive. David Stratton will lower
me over *Magga Dan*'s bow in a rope
sling to film while we smash through
the ice. For over an hour I swung
within 5 ft of the bursting ice, vaguely
conscious of being with, but not quite
part of, the ship. It was bitterly cold but
I felt the discomfort was worthwhile
for the movie footage I got – a nice
Christmas present in the end.

FOLLOWING *Magga Dan*'s engines
smashed a path, carving her own dock
for quick unloading of stores; I took this
shot during a reconnaissance flight.
Vehicle trails lead across the sea ice
to the left and up on to the ice shelf
where our base hut, Shackleton, can
just be seen as a few black specks on
the surface, about a mile away inland.
Down at sea level again, as *Magga
Dan* is unloaded her bow towers high
over the ice.

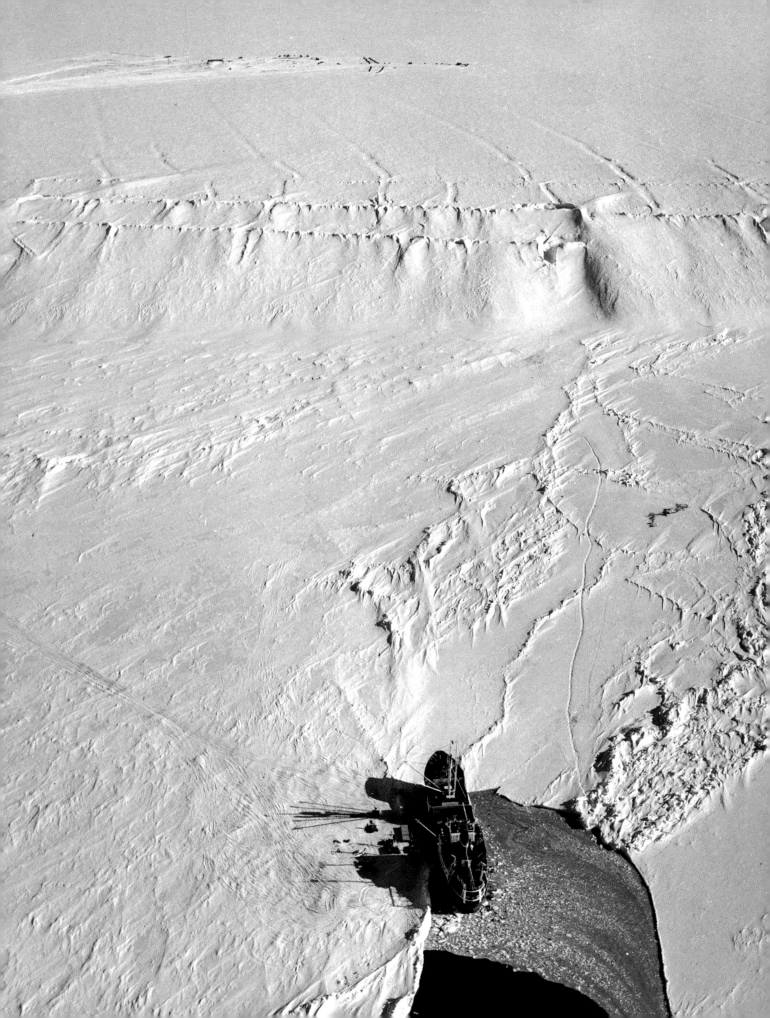

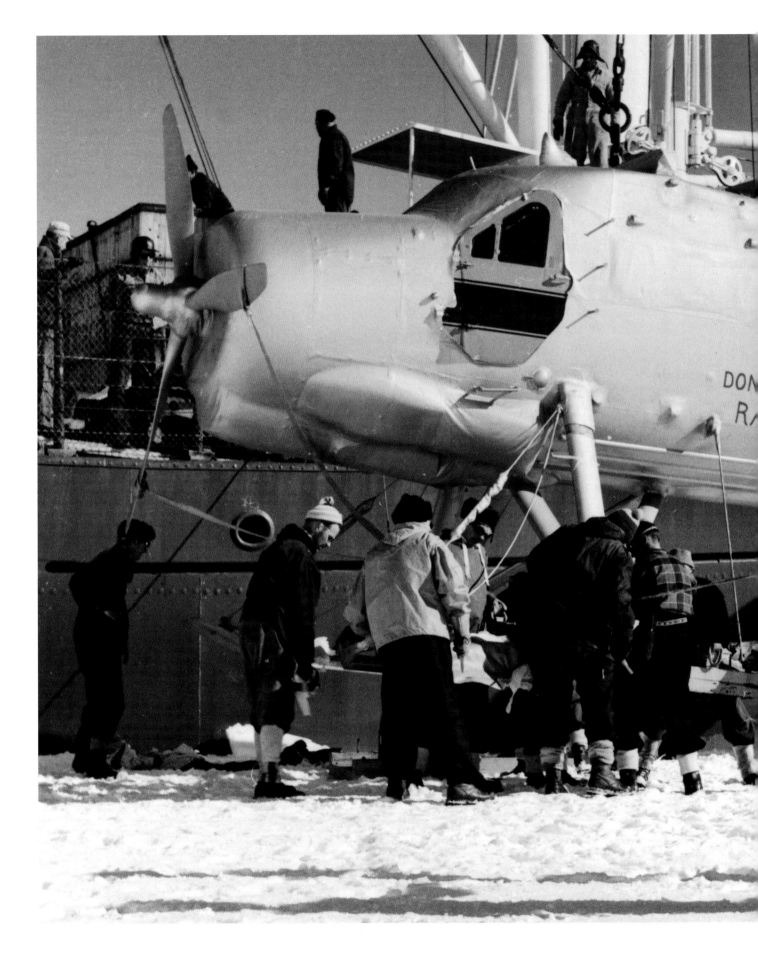

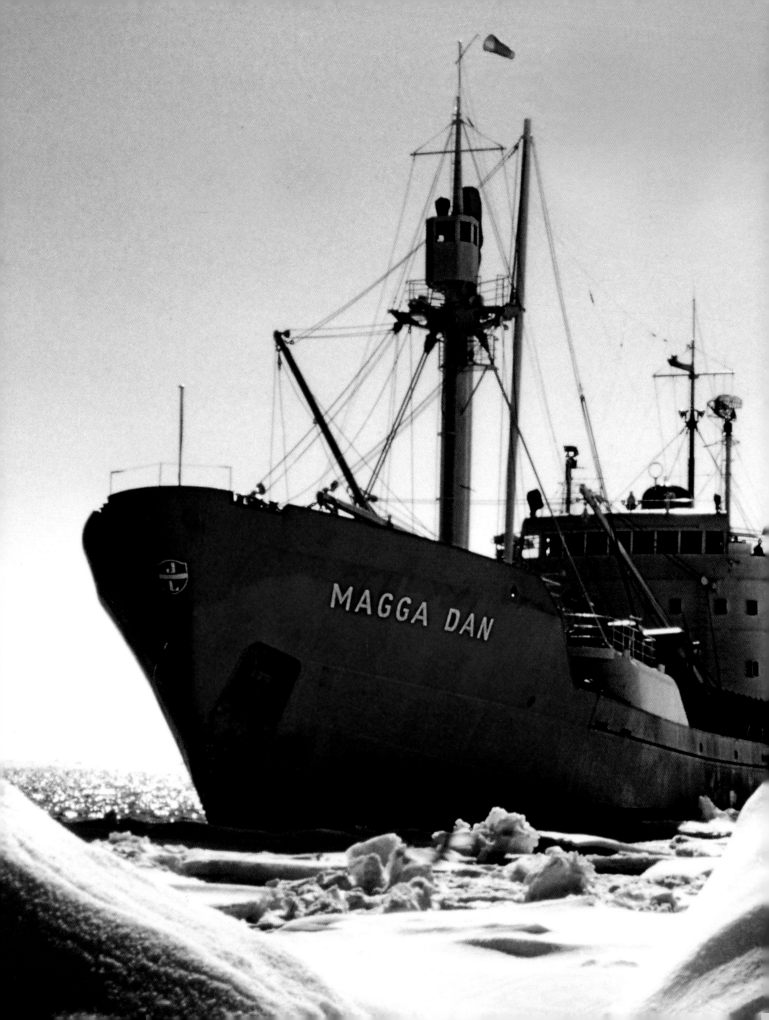

PREVIOUS The Otter aircraft being off-loaded at Halley Bay in December 1956. We hauled it away by man-power alone. It then took even more of us to lift the wings and fit them securely. Aircraft were essential for reconnaissance on this expedition; it would be difficult to imagine success without them.

LEFT *Magga Dan* left us at the end of January 1957. After a frantic day of writing last letters for home, we headed down to the ice edge to wave her off. We felt no regrets as we had not been marooned; instead our real adventure was just beginning. Our thoughts turned to the huge challenges that would lay ahead to secure our way out – 2,000 miles across a continent.

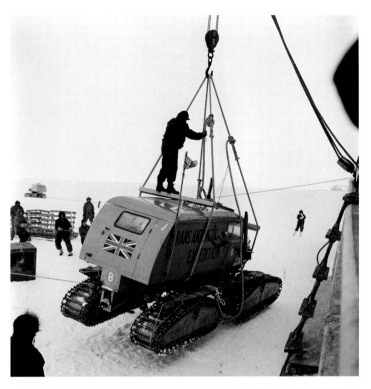

LEFT Over the side go our Sno-Cats, specially designed for snow travel, together with fuel and stores for our base – everything needed to keep men alive in a hostile environment for another two years.

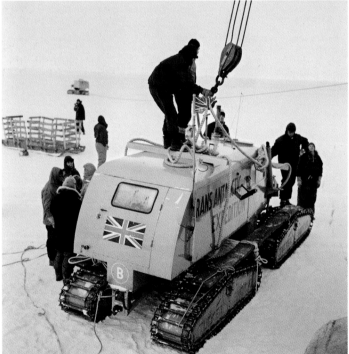

RIGHT We also established a small base depot 300 miles inland and named it South Ice. Hal Lister, Ken Blaiklock and Jon Stephenson assemble its aluminium roof framework at midnight on 13 February 1957. The three men then spent over six months living in this tiny hut, measuring just 16 x 16 ft. Completely buried under the drift, they'd emerge from it to make meteorological and glaciological observations.

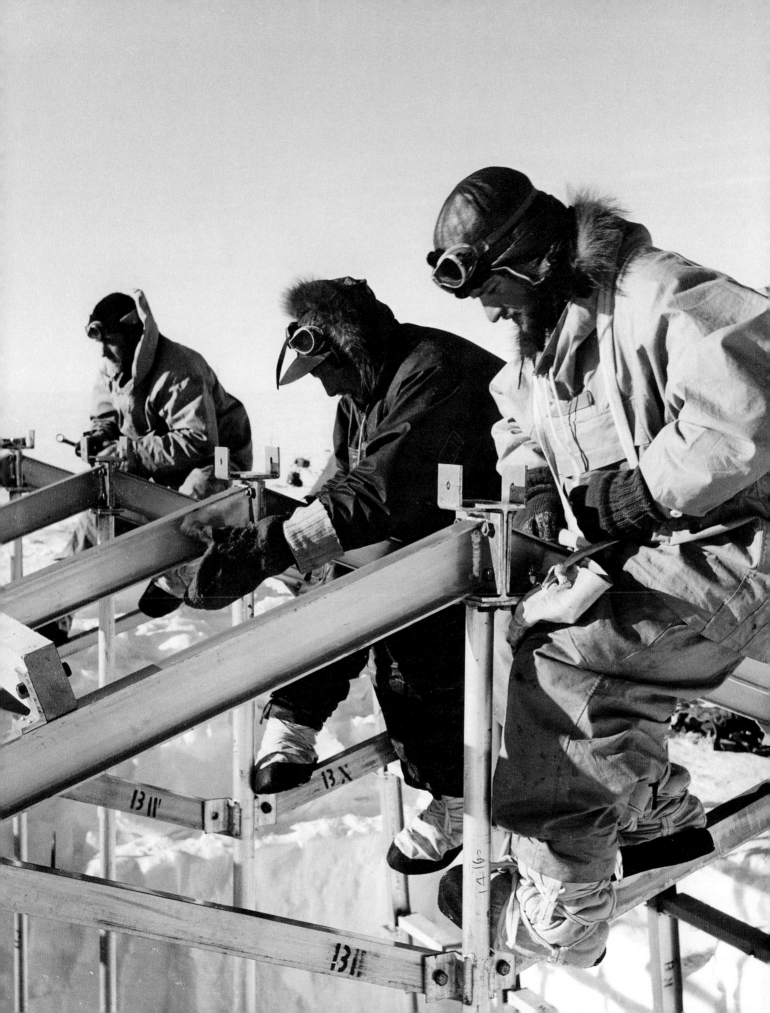

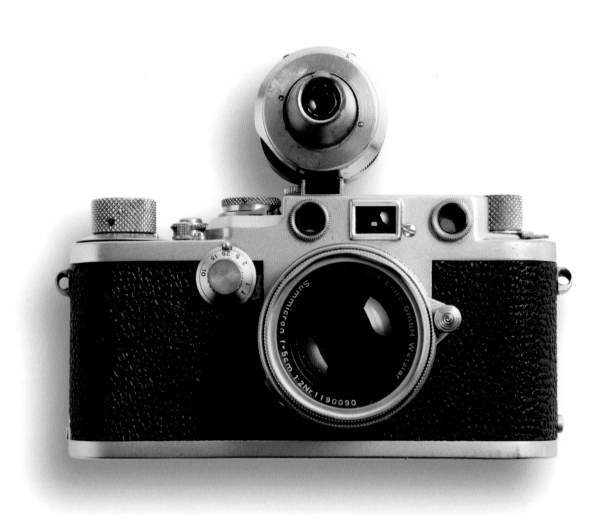

2 | ACROSS THE ICE

Nothing in the world is worth having or worth doing unless it means effort, pain, difficulty.... I have never in my life envied a human being who led an easy life; I have envied a great many people who led difficult lives and led them well.

Theodore Roosevelt, 1910

ABOVE All that was visible of Shackleton
Base, 28 February 1957; soon there
would be four months of unbroken winter
darkness. This was to be our home for the
next nine months; inside, life would go on
as normally as we could make it.

While we were approaching Antarctica from the Atlantic for the second time, Ed Hillary and the New Zealand support party were arriving from the Pacific. Their job was to establish the route that we would take after we had reached the South Pole from our direction. The two sides of the expedition struck Antarctica on the same day, 4 January 1957, and as soon as he arrived Ed sent a radio message to say he had landed. Bunny's apt reply was: 'SNAP'.

After a week of unloading scientists at Halley Bay we were still 250 miles from our men at Shackleton Base, and though *Magga* would be sailing there in the next twenty-four hours Bunny did not want to wait any longer before reuniting us with the advance party. To save time, and especially to hurry a few luxury supplies including fresh meat, fruit and bread, he decided to fly there in the Otter. John Lewis was the pilot, and I went with them to film the scenery as well as the first reunion.

We headed south along the coast, keeping underneath the cloud, but as we went further the cloud got lower and a good deal of the time we were at 300 ft, or even down as low as 100 ft. We were at the level of the tops of the icebergs, winding in and out. But then we ran into limitless blue sky, almost indigo, like the high-altitude sky over Everest and a wonderful contrast to the white ice. We made altitude, radio conditions improved, and at last we could contact Shackleton. Taffy Williams, the radio operator there, came through loud and clear; there was a lot of banter when John Lewis told him we were carrying cans of beer.

After two hours' flying John Lewis spotted the base, just specks on the ice shelf. From the air the place seemed tiny – the stores were mostly either underground or hidden by snow, and it looked an incredible place for eight men to have spent the winter. They had managed to erect the expedition hut, but it too was buried, with only the roof visible. We landed on the airstrip they had prepared and I leapt out with my three cameras to film the meeting. For Ken Blaiklock and the others this was just a normal day; for us the temperature and cold south wind were shrivelling. We dived for the hut thinking it would provide warmth and protection, but it was in fact colder inside than out. The hut had no heating – we were soon to discover why.

We carried in our gifts from the outer world with some ceremony – a bag of coal, fresh bread from the ship, fresh meat, apples, oranges, bananas. Then came a surprise. Ken led us into their kitchen, which was small and fairly warm, where a feast of welcome was laid out. They had baked enormous cakes, homemade biscuits, sugared buns of all sorts, and a cottage loaf, far better than those we brought. All were baked in an oil-drum stove that Roy Homard had made. Next we handed over the large bag of mail from home – the first letters they had received for a year. Silence fell as each man took himself into a quiet corner with his pile of correspondence. Almost the first letter Roy opened contained an invitation to join another expedition when this one ended. 'Not bloody likely,' he said, then added, 'but I suppose when I've been home a few months I'll be a fool again and probably say Yes.' They all went on reading, and I watched them as they sat or sprawled, surrounded by the torn envelopes and sheaves of news, gossip and affection from wherever home was. Their clothing, greasy from constant wear and work, was patched everywhere. Their faces were scaly and lined; their hands, etched deep with grime, were calloused. Nobody had bathed or even washed much during the year.

Later in the evening and well into the night as we lay in our sleeping-bags I listened while Ralph, Roy, Hannes and Ken told the stories, or some of them, that summed up the hard year

PREVIOUS The Leica IIIf that I used right across Antarctica. I often slept with it to keep it from freezing until I was able to rig up a hot-box connected to a Sno-Cat's battery. During the journey I stored film in large aluminium containers, developing it in batches at the South Pole and Scott Base. The finished negatives were sealed in tins and flown to London at the end of the expedition.

through which they had fought to keep their slippery foothold on the continent. In March 1956, only a few weeks after we had left on *Theron*, ten days of wind and storm swamped the hut frame they were building up to the eaves with hundreds of tons of snow. Worse still, the sea ice broke up, taking much of their stores out to sea. Devastatingly, they lost their coal and petrol, a tractor and much other equipment. They were left with no heating for the winter.

At first, the eight men were understandably quite numbed by this blow. Dumbfounded, they went to the hut site to sit. Ken said he brewed a cup of tea and they talked about it. The party's confidence was already beginning to be shaken. Could they survive? Could they eke out the stores they had and get through a winter of unknown severity in tents with no heating? They felt marooned on the continent. After the first shock, Ken went round carefully assessing the stores they had earlier brought away from the sea edge to the hut site. He had chosen wisely and transported a small selection of all that was vital. If they rationed paraffin carefully – for cooking only – they could survive, he said. The stock of seal-meat for the dogs had gone and this would mean strict rationing until more seals could be caught when the sun returned. But they themselves had ample food. The hut lay in pieces around them and erecting it was their first task. It took seven months to complete it.

The hut was their Achilles' heel. Designed by a bridge builder, it could withstand a load of more than 300 tons on roof or walls; every bolt-hole was already drilled and in theory the prefabricated sections could be easily assembled. The trouble was that not everything in Antarctica was quite as it had been on a plumb floor in London, and as soon as they got down to the task of erection, nothing – or almost nothing – would fit with

the easy, trouble-free rapidity envisaged. Then came the March storm. Before long they were digging the partially built structure free from nearly 200 tons of snow. When that was practically cleared the wind blew up more fiercely and flung the snow back at them, to be dug away once more. They had to dig, too, for every piece of hut material they needed, for it was being constantly buried in deep drifts.

They had passed the winter in tents, a grim, very uncomfortable experience. The sun set completely in April, and for the next four months they lived in more or less continuous darkness. Even in the dark, however, they continued building the hut, using small Tilley lanterns for light. They continually had to dig their tents out from the drifts, and shifted them six times in the four winter months to keep them on the surface. Little of their time could be devoted to actual building, since most days were spent digging, shifting snow, moving out of the weather. Each day the party met and ate their meals inside a Sno-Cat crate just 20 ft long, 10 ft wide and 8 ft high. Listening to their stories it was clear that they had undergone a profound experience.

Magga Dan reached Shackleton the day after our arrival by air, unloaded all the vehicles and stores for our expedition and sailed away at the end of January. As she moved off, at the precise hour and minute the captain had said he would leave, we were not saddened; of course we felt kinship with *Magga* and her crew, but our thoughts were now rapidly turning to the exciting problems of exploring the interior. A cold wind blew in our faces as we drove back to the hut site from the sea. Ken and David Stratton had brought down a dog team and they set off at a wild pace. We chased them hard with a Sno-Cat and the Muskeg tractor, but the huskies were much faster over the rough ice. With the ship gone, we celebrated our real establishment in

Antarctica with mugs of tea. For the first time the expedition seemed to have come together and there was a feeling of unity.

The base stretched all round the hut. A quarter of a mile away long lines of fuel drums lay end to end, a perfect marker from the air. Beyond the fuel dump stood the Otter and Auster, ready and eager for flying our first reconnaissance forays. 'Well, all we have to do now,' somebody was heard to murmur, 'is cross the bloody continent.' True enough, I thought, as I looked at the map on the wall – an entire ice-covered continent as big as the whole of the United States and Europe together. *All we had to do was cross …*

<center>☙</center>

For want of a better name we called it 'winter', though the seasons in Antarctica have little in common with those elsewhere. Cold and light is the Antarctic summer, colder and dark the winter. Inside the hut at Shackleton, our home for the winter, the heavy, undressed crossbeams gave the impression that we lived under the roof of an ancient chapel; measuring 73 x 27 ft, it was solidly built. At one end were four rooms: radio room, meteorological office, darkroom and kitchen. The radio room was the warmest in the hut; it backed on to the kitchen and contained a small stove, though its most efficient heating seemed to be the actual transmitter, a not very powerful set of only 350 watts but able to carry our voices 10,000 miles to England.

The transmitter was arranged to connect to any telephone in the British Isles, and we could all make calls at a special rate of 10 shillings and sixpence a minute. I never ceased to marvel when I heard the phone bell buzzing in a friend's house in England, and heard the operator say to the recipient, 'I have a call for you

from the Antarctic'. There was usually a pause of incredulity and people even put the receiver down, refusing to believe it was true. Reception was not always good, but this personal link became the talking point of our week; it was a source of excitement but also embarrassment, for most of us suffered at one time or another from the inability to express ourselves across the great distance with anything more inspired than 'Hello, dear, how are you, dear? I'm fine, how is everybody at home, dear?'

Our hut was divided down the centre with heavy pillars: one half was occupied by the main living-room and in the other half were sixteen bunks separated into groups of four by low partitions – there were no private rooms and no doors on the bunk cubicles. We each used the bunk space of two people when some of the occupants left to winter at South Ice, our advance base we established inland in February. Bunny and I occupied one set of four; this allowed Bunny an office or desk on which to write, and enabled me to spread out my equipment. In addition to this extra bunk space I had my darkroom, which was small but extremely well equipped. There were tables, sinks, shelves, an enlarger and drying cabinet, and once established I added a record player and a small selection of classical recordings. In this way it became a haven to be enjoyed at any time, for Bunny's antipathy to music meant that the record player in the main room of the hut could be used only on Saturday night and Sunday. Bunny regarded it all as a distracting din and the convention was soon established that musical silence was, if not golden, the easiest way of avoiding unnecessary strain.

In the large main room we lived a club-like existence. At one end were some tables and chairs, and at the other was a high bench used as a shelf for drinks. We had a dartboard, two maps, a sewing machine and collapsible canvas chairs. Around

the walls in three separate units was our superb library of over a thousand books, including an almost complete collection of works on the Antarctic.

Electric power was rationed. We had a small generator and the radio transmitter took nearly half the output. Whenever I wanted lighting for filming indoors I had to arrange to do it when the radio was not in use. The transmitter was less efficient than it might have been – it was quite a problem to 'earth' the electrics when living on a floating ice shelf – and it was possible to light a neon bulb merely by placing it on any metal object in the room. The warmth of the radio room had a further unexpected advantage. It was used by Ralph Lenton to grow mustard and cress and he tended this little allotment with great enthusiasm; we ate mustard and cress sandwiches every ten days.

Hannes la Grange lived like a brown bear in his meteorological office. Wind gauges whirled and clicked and there was a constant hum of electrical devices. Charts lay in neat piles and the record books were in English and Afrikaans. Hannes was devoted to meteorology and the policies of the South African government. It was not easy, as an Afrikaner, to take his place in our community, but Hannes was an undoubted success.

By the middle of May the sun was rising slowly just above the northern horizon, where it remained for only an hour or two and then disappeared. Mirages made icebergs float upside down in the sky and the blue sea turned grey as the 'young' ice formed more firmly each day. Soon there was no morning sun to greet us at all. The long lull before we would set out for the continental crossing in November had begun. I found eternal night on the whole far less monotonous than eternal day. Continuous daylight, with all its blazing whiteness, had many disadvantages, not least the difficulty of ensuring a good 'night's'

sleep of seven or eight hours. But in the dark we could work and live with a greater sense of community and relaxation. We could light up the darkness and switch off when sleep was needed. The moon's ghostly light was never a glare; the stars moved and wheeled all day; the aurora waved like a curtain, pulsating with changing colours – reds, greens and whites predominating. The diversions, whether mundane and routine, or dramatic and unexpected, were always important in our winter lives.

Bath night at Shackleton was an operation of some magnitude. It happened for each man only once every thirteen days and was a pleasurable luxury. For some reason known only to the Crown Agents, the bath they supplied us with had no plug hole, so we had to cut one ourselves. It was a major effort to drill through the heavy steel bath so that the water could drain away; when it did, a great pit was melted in the ice below. My own method for getting maximum benefit out of the fortnightly event was not universally practised. During the day I collected sufficient water (we melted ice) and after heating up the bathroom with a Primus stove and boiling the water, I managed to achieve a near-Turkish bath atmosphere. Steaming profusely, I scrubbed myself clean. Then, with my whole body hot and while still dripping wet, I walked naked straight out of the hut door into the ice tunnel from the hut entrance, where the cold was usually minus 30 or 40°F. The sudden onset of the freezing night air, tolerated for only a minute or so, tingled and toned up the skin. From the sub-zero temperature I then returned to the bathroom and again soaked myself. It was always advisable to guard against practical jokers during this sortie into the cold, for the favourite sport of at least two of the party was to slam the hut door on any unfortunate naked man luckless enough to be caught out, as it were, with his pants down.

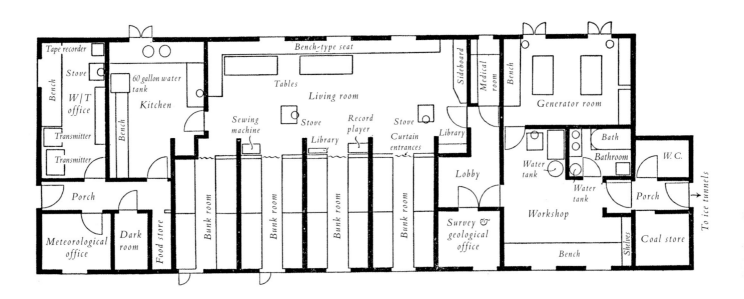

Inside the floor plan:

Tape recorder

Bench

Stove

W/T office

Transmitter

Transmitter

Porch

Meteorological office

Dark room

Food store

60 gallon water tank

Kitchen

Bench

Bench-type seat

Tables

Sewing machine

Living room

Stove

Library

Record player

Bunk room

Bunk room

Bunk room

Bunk room

Stove

Curtain entrances

Library

Sideboard

Medical room

Bench

Generator room

Lobby

Survey & geological office

Water tank

Water tank

Workshop

Bench

Bath

Bathroom

W. C.

Porch

Shelves

Coal store

To ice tunnels

Sixteen men and no trained chef, yet the standard of cooking was remarkably high, and especially so given the limited range of our rations. For many of us the duties of chef were a recurrent trial bringing real anxiety. Gordon Haslop was the undisputed master in the kitchen. He was irate if anyone dared to serve food straight out of the pots and pans, for he always dished up meals in casseroles and laid the tables neatly. John Lewis and the adaptable Ralph Lenton were also superb cooks, and for our midwinter parties Ralph created the spread of cheese straws, iced cakes and cherry-topped morsels with all the finishing touches that made the vital difference between his results and the commonplace ones achieved by others. Ralph good-naturedly guarded a jarful of glacé cherries under his bed.

Although I belonged to the mediocre class of chefs, I became – like many others – reasonably adept at all kinds of dishes I would never have believed myself capable of producing. At teatime, for example, the man who took his turn in the kitchen soon found he could not get away with a few biscuits; we had to learn to make Swiss rolls, bath buns, sponge cakes and a host of frills beyond the plain cook's usual fare. It was extraordinary, too, to catch oneself feeling momentary disappointment when, having slaved all day over the proverbial hot stove, the others showed something less than the hoped-for measure of appreciation. Like some tearful young wife with a boorish husband, many of us confessed to a faint touch of outrage if the party came in to dinner, sat down to the meal and in silence consumed the proudly presented result while reading a book.

Reading at every meal, however, was soon an accepted custom. I think it was Bunny himself who started it, and eventually it was agreed to maintain a 'quiet' table for those who preferred it, and a 'noisy' table for those who wanted to chatter. There was some method in Bunny's encouragement of the

ABOVE The layout of our hut at Shackleton Base. It served us perfectly – we had all the facilities needed for the scientific work of the expedition, while bunks ran down one side with the snug living room on the other.

reading habit, for there was no doubt that he disapproved of any discussion touching on the expedition's plans or progress. One day a group of three or four were listening with interest while Geoff Pratt held forth on the subject of the gloves we wore. 'These things are no bloody good', said Geoff. 'I wouldn't mind betting I could design a far more efficient glove for conditions like ours.' Bunny glanced up sharply from his book, took off his glasses and laid them on the open pages. 'When you know a good deal more about Antarctic conditions,' he said quietly, 'you'll also know more about gloves. These have been designed after years of experience – and I think you'll find they'll do the job.' Bunny replaced his glasses, picked up the book and went on reading. After his intervention the glove topic, like many another, was dropped.

In fact the skin on our hands and fingers was gradually adapting to the cold, becoming thicker, tougher and very much drier, and we found it possible to handle metal parts and similar cold objects at temperatures well below 30 degrees of frost. Yet badly split fingers, with deep cracks at the ends, were a discomfort, and fingernails were also affected – in the cold they ceased to grow, broke off short and remained brittle. Sore hands were possibly the cause of one camera accident, which required a highly skilled repair operation by our doctor, Allan Rogers. Returning from one of my frequent filming expeditions around the site, I dropped my Rolleiflex camera on the hut floor, seriously jamming the shutter release knob and damaging the interior. Luckily, Allan was a master technician who could carry out the minutest repairs to the most delicate parts. He stripped the entire shutter mechanism and restored it perfectly. As a doctor he was kept decidedly short of employment. We had little sickness, no serious illnesses or fractures and no troubles

requiring operations, fortunately. As a dentist, however, he was exceptionally busy. The Antarctic cold had a disastrous effect on our teeth, causing fillings to drop out by the score.

Midwinter for us arrived in the third quarter of June. As if to remind us that darkness would now progressively lessen, the sky showed a delicate red sun-glow to the north. There was a quickening of energy in almost everybody, an instinctive surge of enthusiasm for what would be called spring – and the approach of the day when all our energy would be needed to prepare for the long crossing that was, after all, the *raison d'être* of our work and waiting through the four months of winter at Shackleton. Meantime, all signs of vigorous activity were being harnessed for a less solemn purpose: the Shackleton hut party to celebrate Midwinter's Day, undoubtedly the biggest bender the Antarctic had ever known. It began before noon with a cocktail party at which our new vehicle workshop, known as the Chapel, was ceremoniously declared open, while Gordon Haslop staged a fireworks display. At three o'clock we sat down to a vast mid-winter meal of roast turkey, potatoes – frozen under the ice ever since *Magga Dan* departed – plum pudding, sherry, champagne, coffee, cigars and liqueurs.

Afterwards the whole party slumped quietly into sleep, unable to touch the extensive buffet prepared by Ralph and John. But by evening the party spirit had returned with gale force and continued throughout the next day and night. In the midst of it all we did not forget to send messages of goodwill to all the other expeditions, at the Pole and elsewhere in Antarctica, and especially to the men of our own group who were doubt-less indulging themselves in like manner on Hillary's side of the continent. Ralph's skiffle band, with double-bass manufactured from a tea chest, a broom handle and twine, filled the night with

RIGHT During the winter I printed many photographs in my small darkroom and every week I would add new images to a 'rogues' gallery' on the hut wall. I made this montage of pilot Gordon Haslop getting to grips with a model from a magazine. When we left Shackleton I took them all down and carried the photos right across the continent.

ABOVE Midwinter's Day celebrations at Shackleton, 21 June 1957. We had a happy time that winter – made easier by a huge amount of Jamaican rum which had been intended for the New Zealand party at Scott Base. Our weeks in darkness were also marked by turning the hut into a pub on a Saturday evening, playing bar skittles, shove-ha'penny and darts. On Sunday mornings we scrubbed the floors and cleaned out every room.

a kind of music that was not half as bad as it might have been. The drink flowed freely, as there would be no more liquor once we set out on the crossing. Later, Ralph performed a dance of the seven veils, garbed in red drill marker flags taken from the petrol dump. Everyone watched him and cheered. Only Geoff Pratt was unmoved – seated with his back to the orgy, his eyes and brain concentrated on some fascinating dissertation in the *Encyclopaedia Britannica*. The dance reeled to a crazy conclusion. Misty-eyed as we were, most of us were aware that with midwinter gone, our days of gracious living were strictly numbered.

<center>℘</center>

For exactly one hour on a Tuesday morning towards the end of August the sun made its first diffident appearance since May. It was only a fraction of the orb that showed above the horizon, but it was the sun, a bright golden blaze and the finest sight we had seen in four months. That day the temperature was -28°F, and there was a 30-knot wind hurling drift and spumes of snow. Despite the lengthening days, the glimpse of spring sunshine was something of a false promise. September roared in like a lion. For the first two days of the month we had a temperature of -60°F and gale winds of up to 54 knots (63 miles per hour). And with our little foothold at Shackleton under threat from high drift as never before, all effective work came to a halt.

Bunny's original plan, reckoning on weather conditions a good deal better than we eventually experienced, was to send into action the first of five field parties beginning 1 September 1957. On that day, six men and four vehicles were to leave to investigate the structure of the great chasm south of Shackleton Base. The plan was then for us to proceed as follows. On 10 September, by air, we would relieve South Ice, our advance base set up inland earlier in the year, where Ken Blaiklock, Hal Lister and Jon Stephenson had wintered. A few days later two men and one dog team would be flown to the Theron Mountains for survey and geological work. On 27 September four men, with two dog teams, were to fly to the western end of the Shackleton Range, where they would be set down on the ice shelf close to the mountains. Their first task would be to find and mark a route for us from the heavily crevassed Filchner Ice Shelf up the steep and broken 'ice wall'; this done, they would make a survey of the mountains. On 30 September four men and four vehicles would leave by land on the all-important reconnaissance journey to South Ice – thus far, the route to South Ice was known only from the air and no land crossing had yet been accomplished. By 22 October it was intended to have everyone back at Shackleton preparing for the start of the trans-continental journey itself on 14 November. But these plans, we soon came to realize, would have to be greatly modified. The Antarctic rarely permits a precise schedule.

As things turned out, the chasm journey was initially abandoned; blizzards wrecked the flying programmes; the relief of the South Ice men was delayed for several weeks; and it was not until 8 October, more than a week behind schedule, that the four vehicles for the South Ice reconnaissance that Bunny regarded as essential could set out. Bunny and his three companions arrived there on 13 November – only one day ahead of our original scheduled departure date for the main crossing – after a hazardous trip of thirty-seven days during which they suffered the total loss of one vehicle and the temporary abandonment of another. While they were gone, we at Shackleton grew daily more despondent as the loss of time nagged at us constantly. On

the far side of the continent, Ed Hillary and the New Zealand support party were already setting out – after a vigorous spell of pre-journey exercises, dog training and modifications to their vehicles – while we sat cooling our heels at Shackleton.

Bunny's rate of progress during his South Ice reconnaissance had turned out to be no more than 10 miles a day, precisely half the average regarded as a minimum for our main journey. Although it was soon crystal clear that we had no hope of setting out from Shackleton by 14 November, we were frequently embarrassed into evasive responses when plagued by the press, the BBC and even our own London headquarters, demanding to know our departure date. 'Proceeding according to plan', the stock reply over our radio, had a depressing ring to us if not the outside world.

The South Ice reconnaissance team were flown back from their destination by John Lewis at 10 p.m. on 15 November. The next day Bunny called one of his rare round-table conferences, gave us a detailed picture of the problems along the difficult route to South Ice, discussed the recasting of our plans, and announced with an unmistakable insistence that we would now leave Shackleton, regardless of our state of preparedness, on 24 November. For this definite decision we were all thankful.

We had done everything possible to ensure the readiness of equipment and supplies. The checking of rations alone provided Ralph, Ken, John Lewis and me with several days' work. The food boxes had come out from England two years earlier in *Theron*, and we could not take the risk of assuming that all was in good order, so we went carefully through the food crates, examining each carton, tapping every tin.

In the final eight days' rush, sleep was limited to the bare essential necessary for working efficiency. We had to assemble all we would need: the food, ours and the dogs'; the sledges and clothing; the seismic apparatus and the explosives; the radio and camera equipment; tools, ropes, skis, tents, cooking utensils and Primus stoves; first-aid supplies. It seemed we would never have time to finish. Yet above all these reared the twin anxieties – *fuel and vehicles, fuel and vehicles*, thundering repeatedly through our minds like train wheels. How many miles to the gallon? We did not know. On Bunny's South Ice recce it was a little more than a mile for a Sno-Cat and two for a Weasel, in both cases less than we bargained for. And what would we need in the way of spares? On the recce they found that fan belts and radiators wore out at a rapid speed. And would we have enough anti-freeze? That too was being gulped at an alarming rate. Every day of travel across the continent would mean burning a weight of fuel almost as great as the load of our entire supply of food.

It was on the shoulders of David Pratt and Roy Homard that the worries of fuel and vehicles would fall. By the morning of 24 November, David was tossing spares into sacks and boxes, racing against the clock and refusing even to stop for food. It was a Sunday. Zero hour was fixed for 2.30 p.m. Tension was affecting everybody; we had worked well into the night and no one had got to bed much before 5 a.m. Shortly before lunch Bunny climbed into his Sno-Cat, *Rock 'n Roll*, which he would share with David Stratton, drove out on the ice about two hundred yards, and planted the vehicle with its nose pointing south. I then started out in my Weasel, *Wrack & Ruin*, and pulled in behind the leader. Inside the vehicle I had fixed a variety of racks and slings to hold my cameras. For a while I would have no sledge to tow; mine was lying 8 miles ahead, left there by the earlier reconnaissance party, fully loaded with two and a half tons of fuel.

John Lewis and the RAF boys were seeing us off. Noticing how badly things were going they bestirred themselves to prepare the last meal we would consume at Shackleton Base. All except David had a stand-up farewell luncheon; still rushing to meet zero hour, he went without. It was already past 2.30. Bunny looked at his watch and spoke impatiently. 'For heaven's sake let's be gone by three o'clock'. But the hour arrived and still we were not ready to move. Someone had forgotten to check the steel wire tow ropes which were the safety lines for our sledges, and the last-minute discovery meant that all these had to be bolted together. Bunny was furious, for this caused hours of delay. He and I completed the bolting. We were almost beginning to wonder if we could get away before the next morning when Bunny in no uncertain terms put an end to any further shilly-shallying. 'Listen, everybody,' he said, 'I'm getting out of Shackleton tonight – even if it means camping only half a bloody mile away.' The challenge was fair enough. At 6.45 p.m. we moved off.

We had three main Sno-Cats: Bunny and David Stratton occupied *Rock 'n Roll* at the front of the column; David Pratt and Ken Blaiklock were in *Able*; Roy Homard and Ralph Lenton drove *County of Kent*. Geoff Pratt drove another Sno-Cat, full of his seismic equipment, and it was christened *Haywire*. The Weasel *Wrack & Ruin* contained me and my cameras, and Allan Rogers, the doctor, drove another, *Rumble*. One red-painted Muskeg tractor was first manned by Jon Stephenson, who with Ken Blaiklock would soon take over the dogs already awaiting us at the South Ice depot and become the first men to drive dog teams to the South Pole since Amundsen in 1911.

A strange metamorphosis took place as soon as we were on the move. Tensions fell away, faces relaxed and smiled. I raced *Wrack & Ruin* at a good 12 miles an hour up and down the line, filming and firing each 'still' camera in turn. The convoy was going smoothly along the first few miles of the 900 that separated us from the Pole. Irritations and delays forgotten, our comradeship was visibly strengthened. As the motors roared and the Cats, Weasels and Muskeg rolled forward in line, I stood on the roof of my vehicle in an effort to record the great exodus from Shackleton; but the weather had clamped down, there was no blue sky and no sea to be seen in the background – just the vehicles trailing past with their drivers making rude signs at the camera. Photographically it was all rather flat, but more than ever now I was glad to be a member of this expedition. Jumping to the ground, I placed the tripod and cameras inside the cab, swung myself through the door into the bucket seat and hurried after the cavalcade. This is tremendous fun, I thought, as I sped to the front of the column and fired all the cameras again, and then, satisfied for the moment, just bowled along southwards with the party.

The first day was wholly enjoyable. Once, I overtook the leading Cat – Bunny sat seriously at the wheel in steel-rimmed snow glasses and black leather helmet. His eyes looked steadily ahead, judging the surface, and turned occasionally to the compass mounted just above his gaze. As I overtook him he glanced across to me, grinned and paternally waved me out of his way. Beside him, David Stratton poked a black horn out of the window and blew a loud blast. Immediately it set off a succession of bells and hooters and raucous whoops from the following company. Every man was glad to be on the way.

103

We made only 17 miles before camping shortly before midnight, but the break was complete. Shackleton lay behind us and the frenzy of the departure faded. My Weasel was now hauling the almost crippling load of petrol drums picked up along the route. *Wrack & Ruin* was the oldest vehicle in the convoy. There had been no time for an engine overhaul, but she ran sweetly, started without trouble and had brand new tracks and sprockets, even if her appearance was dilapidated – and it was certainly that. The scaly paint on the cab was blotched; pieces of canvas and sacking were glued over the many holes to keep out the snow; the doors hung awry, secured with pieces of wire and tending to fly open when in motion; the glass in the windscreen was cracked and held together with sticking plaster; the windscreen wiper gave up in a heavy drift and I drove with my head out the door. I cursed her and many a time wished fervently that she would break down so that I could drive a comfortable Sno-Cat.

On the second day out the cloud was thicker and lower, the wind more searching. Driving was easy as long as there was somebody making tracks out in front. At first I wondered why Bunny and David in the front Cat moved so slowly. But leading was very different from following. In the grey whiteness nothing stood out clearly, the hillocks and hollows were indistinguishable from the smooth, and the direction could be maintained only by steering on the compass, a task demanding concentration.

Several weary miles flipped by, and my attempts at photography were unrewarding in the shadowless grey. Far away, beyond practical thought, lay the Pole. Between it and us was a blank of days and miles, with no shape, reality or measurement in my mind. Of the first 300 miles I had long ago caught a bird's-eye view, having flown over it. From Shackleton stretched an undulating, thick ice shelf, covering 100 miles of sea. After the first 40 miles the rhythmic pattern of gentle hollows and crests is interrupted by a huge chasm several hundred yards wide, a couple of hundred feet deep and many miles long. This is a hinge or fracture point where tidal action is slowly breaking up the ice shelf, which will eventually float off into the Weddell Sea as a vast iceberg. Beyond the chasm lay a carpet of smooth snow leading to the point where the solid Antarctic continent begins to lift itself out of the sea, rising abruptly and bursting through the thick ice cover in the form of a black mountain range, the Shackletons, which stood squarely across our path.

We drove on, but suddenly the lead vehicle stopped without a signal. In a moment I knew something odd was happening. As I climbed out of my cab, David Pratt was already running ahead towards *Rock 'n Roll* and I ran after him. 'Here's trouble – big trouble', he groaned as soon as we reached the spot.

Rock 'n Roll had burst the lid of a deep crevasse, 15 ft wide. The front of the Cat was leaning forwards and downwards; it would have plunged right in if the pontoons had not buried themselves in the far wall and the roped sledges behind held back the rear. Below the dangling Cat gaped a black hole, with loose snow trickling away to fall soundlessly into the cavernous depths. Bunny, magnificently calm, leant out of the cab, peered into the death-trap and said: 'I don't think this is a particularly good side to get out.' He and David then climbed out and sprang across a gap to safety. At first sight the recovery looked impossible. David Pratt minutely examined and tested the ground disbelievingly. Before long a tide of ideas began to flow and a workable plan emerged. I ran to my Weasel, unstrapped the skis and tripod, snatched three cameras and skied back to film and photograph the scene.

During the weeks to come we were to experience a score of such crevasse incidents. Anything from five to twenty hours of preparation were needed before we could begin shifting the trapped vehicle; but then it was hauled to safety in as many seconds. All the vehicles were used and the drivers fixed their eyes on a controller who conducted them with the utmost precision in a movement of pull and counter-pull. First, steel wire ropes were tied to the front and rear end of the stranded Sno-Cat, then three vehicles had somehow to get around and across the crevasse to pull the victim forwards. If we merely pulled on one side, however, the back of the vehicle would fall into some yet more perilous position – so to avoid this a counter rope was anchored at the rear, generally with two Weasels to hold it, putting as much tension as possible on the trapped machine. Sometimes we pulled them out from the front, sometimes backwards, according to how they lay in the crevasse.

What the others were saying in their tents after this sobering second day – only 25 miles covered and the near loss of a Sno-Cat – I did not know, but alone in mine I swallowed my pemmican (that archaic Polar standby made of dried meat and fat), wrote up my film log and lay back to ruminate once again on the journey ahead. If we ran into too many crevasses like this one we would not get far. Might dogs after all be the best form of transport for such a journey?

Hal Lister, who was then flown in from South Ice to join our party, was to be my tent companion for the rest of the journey. Before leaving Shackleton, Bunny had posted on the notice board a list of our tenting pairs, with a footnote stressing that these were final and there would be no swapping *en route*. At first I thought this was a mistake, but looking back I realized Bunny was right. Over the long journey across what was mostly a monotonous, unchanging ice desert, with occasional moments of fear and excitement, there had to be an attitude of discipline and determination to quash the inevitable personal differences. The philosophy could be summed up as: 'You volunteered, so get on with it.'

We rolled forwards towards the 50-mile depot – established the previous year by Ken Blaiklock – and Bunny's Sno-Cat stopped again. This time the engine was overheating. David Pratt fretted and searched until he found where the battery box was leaking precious cooling fluid. Our total delay this time was nearly five hours, and it was but the first of many similar hold-ups. When we did move we were breaking through crevasses after driving only a few hundred yards. Here, at one end of the great east–west chasm, lay a crevasse belt 5 to 7 miles wide. On foot, which meant on skis, we would first have to probe ahead to ensure the vehicles could cross safely. This was a long and exhausting business – working for twelve to fourteen hours each day we managed to cover only around a couple of miles. Working in pairs we forced metal rods down into the snow. Many crevasses were covered by a lid of winter snow 3–5 ft thick, which would withstand the passage of a man on foot, or even a dog team and sledge, but not the pounding of six heavy vehicles – with no warning the invisible snow lids broke.

Whenever a crevasse was found by probing, an inspection hole was first made in the lid. Sometimes we dropped down into it on the end of a rope, but mostly we peered in from the surface to gauge the width of the supporting walls. If the gap was more than 3 ft wide we looked along underground to see where the crevasse narrowed and probed again, marking the narrowest gaps with flags. In the most difficult areas, with interlocked crevasses, delicate routes necessitated driving the vehicles through

ABOVE I had experienced crevasses in the mountains many
times before, but in Antarctica they were wider, deeper and
much harder to detect. We groped ahead of the vehicles on skis,
probing the ice with long poles. We then marked a route with
flags for the vehicles to follow. It was slow, backbreaking effort,
but the success and safety of the expedition depended on it.

the marker flags and judging the pathway to the nearest inch in order to ensure a safe crossing. The first crevasse area took us four days to cross. It was perhaps the most uncomplicated belt that we would have to deal with, but it still shook our optimism considerably – 9 miles in four days was not going to get us to South Ice very fast, let alone the Pole. We now understood why Bunny had been so convinced that his 37-day reconnaissance to South Ice was the crux of the expedition.

But Bunny was unshaken even when we heard by radio that Hillary had reached Depot 480, his second depot on the polar plateau, 480 miles from his start point at Scott Base; we had done just 40 miles! And then, suddenly, dejection changed to high spirits when fortune began favouring us again in the early days of December. In a couple of sparkling, windless days we were free of the unsafe area near the chasm and set off in a line like ships at sea, tossing, rolling and throwing sprays of snow from the vehicle tracks like a bow wave. Each engine ate petrol at the rate of one mile for one gallon; every hour our monsters used enough fuel to take my small saloon car 1,600 miles.

During this stretch we were to pick up fuel from a depot left during the painstaking reconnaissance journey to South Ice. Leading as usual, Bunny and David were undeniably proud of their navigation, and as we neared their estimated position for the dump we all searched the white wastes about us. No dump could be seen. Bunny checked his calculations and said: 'I can't understand it – we're right on the spot now.' We drove on another mile and stopped. David Pratt then caught sight of the depot – several miles to our right. We streamed away, each thinking up droll remarks about Bunny's navigation. But Bunny stumped us all with his old unshakeable confidence, saying without a flicker of a smile: 'I can't understand it – the depot must have shifted.'

By 4 December we were nearing the end of the great ice shelf and came in sight of the Shackleton Range and the junction between the sea ice and land ice. This was the aptly named 'ice wall'. Before we could reach it, however, we had to cross another badly crevassed area. The ground looked deceptively solid. Crevasses in the Antarctic I found very different from those in the mountains of New Zealand or the Himalaya. Here there was no change on the surface, no buckling or pressure twisting the ice.

While I rattled along in the tracks of the others I was disturbed to see small crevasses opening. I increased speed and hurried over them. Behind *Wrack & Ruin* the heavy sledge slipped across without sinking. The leading Cat, with Bunny and David Stratton, rumbled on towards the flag that marked the first dangerous crevasses, their sledges opening wider and wider holes.

Before long the inevitable happened. *Rock 'n Roll* broke through and sank into an enormous cavern. Miraculously she was jammed across the top of the hole, but the engineers were pessimistic when they saw that the steering rockers under the chassis were snapped and heavy bars bent. The usual recovery procedure went into action, and in bleak, windy weather *Rock 'n Roll* was once again hauled to the surface; repairs lasted two days. Then came a week or more of probing on foot, with painful progress – a whole week and 11 miles. The days were now hot and windless, quite unlike anything I had expected. We worked and sweated in shirt-sleeves, some even stripped to the waist; the endless prodding made arms and backs ache.

When crevasses had to be crossed the order of running was changed; Sno-Cats were the more valuable vehicles, so our two Weasels would lead the slow convoy. But in all the miles of crevasses we crossed (and sometimes fell into) Bunny still drove the leading vehicle. His was undoubtedly the most dangerous

and nerve-racking position, never shared, and it was a remarkable performance requiring an iron will. A steady, well-paced, fearless progress was Bunny's technique, and he was superb, with not a hint of shying or faltering. First in line was the most dangerous place, last in line the next; and second to the leader (where I usually drove) was probably the safest.

It generally took a whole morning to probe and flag a crevasse mile; it was always with relief that we stopped the backbreaking task, to stand exchanging views on the most dangerous areas while eating a spartan lunch of two dry biscuits held apart with a half-inch of butter and a layer of Marmite, washed down with two cups of cocoa from a Thermos flask. Motors were meanwhile started and warmed up to working temperature; crash helmets were donned, the drivers stepped in, fastening their safety harnesses; Bunny gave a signal and simultaneously we moved forwards, changing gear and watching the heavy rope that linked us.

After seven tormented days we shook ourselves free of the long crevasse run and climbed up and up, to run along the glacier a mile or so from the black peaks of the Shackletons. Crossing the Recovery Glacier (so named simply because of the difficult vehicle recoveries involved) occupied a full week. We drove at right angles to the glacier's flow and the first stage was astonishingly easy. It had taken four and a half days during Bunny's October reconnaissance, and he was jubilant, as we all were, when the fine warm weather helped us to flag a route through in a single day. So delighted was Bunny that he declared a half-day holiday, which we used to change the engine oil and grease, tighten tracks and draw breath for the next encounter with broken ground. We enjoyed the break and Ralph painted a sign advertising his café in the stern of *County of Kent*, where tea or hot soup was brewed.

While crossing the glacier we were halted by lack of visibility, and I was foolhardy enough to suggest to David Pratt a camera angle from the ground. He agreed to drive the Sno-Cat over me while I lay between his oncoming tracks. So, with the camera tucked into my face, I went down on my back in the snow. I had crawled under a Sno-Cat often enough to grease the tracks – but at speed the 12 inches of clearance seemed terrifyingly little. David made his run and as the tracks flashed past I pressed the button and got my shot: once was enough.

The glorious Indian summer that had warmed us in the first half of December had ended abruptly when low clouds hurried in from the north, heavy with moisture from the sea. This brought 'whiteout', the atmospheric Antarctic version of a pea-soup fog, and we drove 18 miles one day bumping and pounding an iron-hard surface, straining our eyes to see. By the end of the following day's run, at times creeping forwards roped together, the black rock faces of the Whichaway Nunataks were only 4 miles away. Next day the battle with crevasses was on again. We were crossing the last of the Recovery Glacier, where the flow swirled past the nunataks, exposed ridges of rocks rising above the ice and snow. Of all the miles of crevasses this stretch was the most difficult and the most dramatic.

And so it went on. Twice in one day Ken had narrow escapes in crevasses. We longed to cross to the safe, solid ice slope we could see beyond, so near and yet so far. Bunny drove the leading Weasel and there was stress in his face as we prepared to drive over the last two sections. He lit his pipe, grinned and slipped into his harness. 'Okay, let's go,' he said, 'I'm sure it will be all right.' We moved forwards, with blue cracks and sagging snow on all sides, over crevasse after crevasse, eyes on the rope and flags. There was not a moment to think of anything but driving.

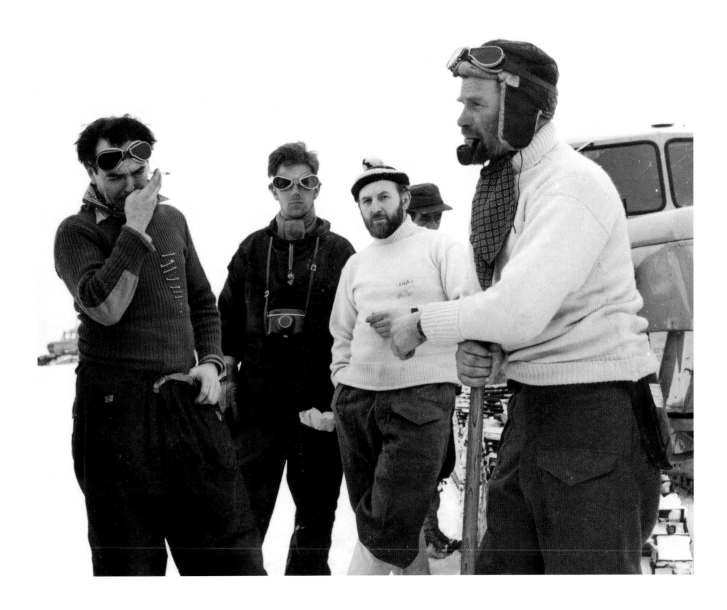

We came out of a gully, turned and jumped three hard-lipped crevasses and drove up a slope between the nunataks. And finally, after such agonizing effort, we were through without a casualty.

We did not then know it, but this was the last of the crevasses for many weeks; there was to be no further trouble until long after the Pole, when we descended the other side of the continent. South Ice lay 40 miles ahead and we drove there in a couple of days. In just under a month – 29 days, in fact – we had covered nearly 350 miles. The Pole was still 555 miles distant, and the far side of the continent sprawled for another 1,250 miles beyond that. 'Oh, well driven that man', said Jon in his most cultured Australian, amid much back-slapping and expressions of relief. 'Marvellous,' said Hal, laughing, 'less than two thousand miles to go ...'

ABOVE Bunny Fuchs calls a break during one of our crevasse-probing sessions. Our exhausted doctor, Allan Rogers, lights up a cigarette. On his jumper he wears an array of safety pins ready for instant clothing repairs when required.

PORTFOLIO

ACROSS THE ICE

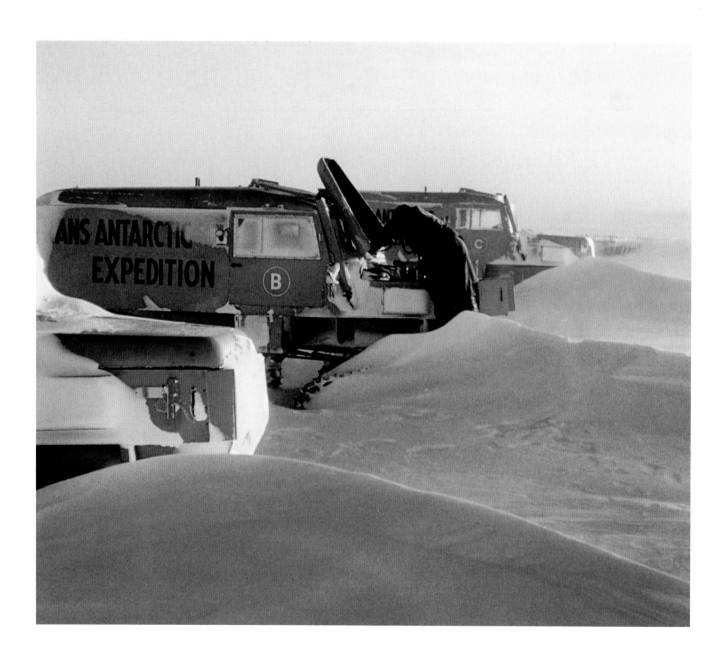

ABOVE It was always an effort to get the Sno-Cats started again after a storm. The blizzards caused huge drifting snows that seemed to bury everything in sight.

RIGHT Sunset at South Ice. Hal Lister stands on the roof of the hut, which was deliberately buried deep within the snow to try to gain some protection from the bitter winds. The photograph is by Jon Stephenson, who with Hal and Ken spent six months there as the rest of our party wintered at Shackleton. The wind generator mast is visible, as are the vent shafts from the hut and underground tunnels in which they kept fuel, food and other scientific gear.

ABOVE When building your house in Antarctica you make use of the drifting snow, which soon piles up over the roof, helping to keep the heat in. This is 21 March 1957 at Shackleton, minus 38°F, with a fierce wind hurling snow about.

That evening we celebrated, because Taffy Williams, our RAF wireless operator and morse-key expert, had just received a cable from England informing him that his proposal of marriage had been accepted.

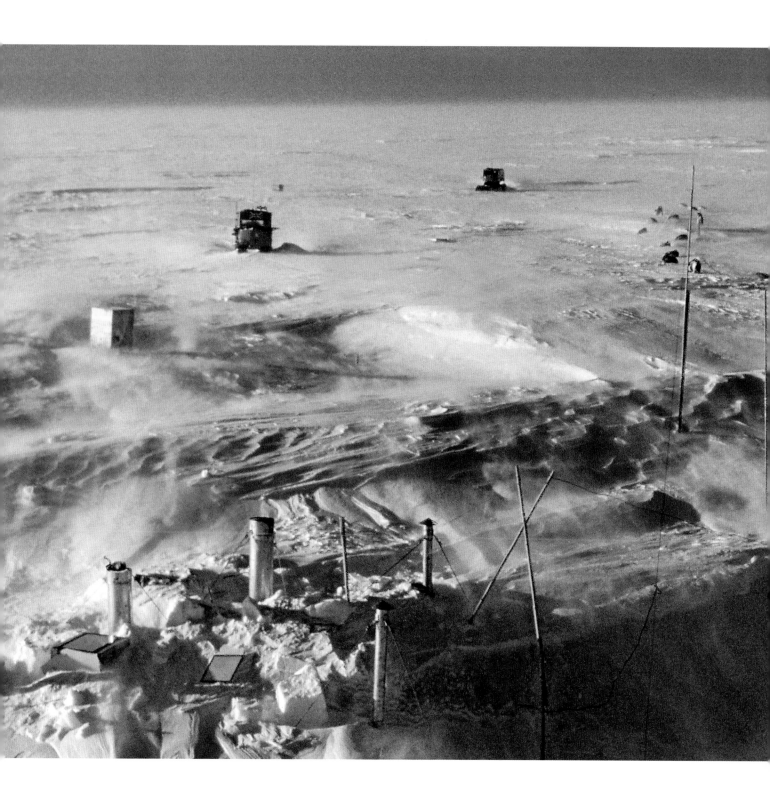

ABOVE Members of the expedition during winter at base camp. Clockwise from top left: our pilot Gordon Haslop excelled at cooking, and insisted on napkins and serving with style. Hannes la Grange in bed relaxing with reading matter. Allan Rogers fixes my Rolleiflex – the window of the built-in exposure meter was broken and he moulded a new one from Perspex and did intricate repair work with his surgical tools. I was able to continue to take pictures in temperatures of minus 60°F. During work in the dog tunnels David Stratton enjoys a well-earned cigarette. This shot was taken by the flare from his match, the only light available out there in the long winter night.

RIGHT Our tough aircraft mechanic Peter Weston was capable of gentle precision, demonstrated here as he darns his woollen socks. We all soon became fairly good with needle and thread.

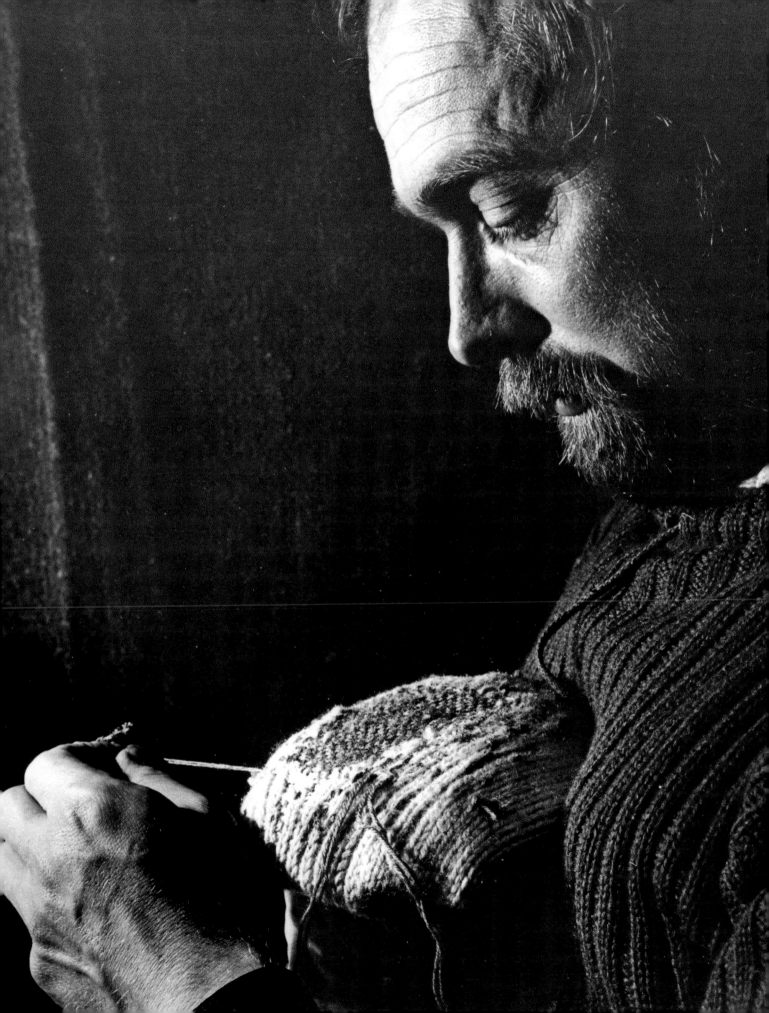

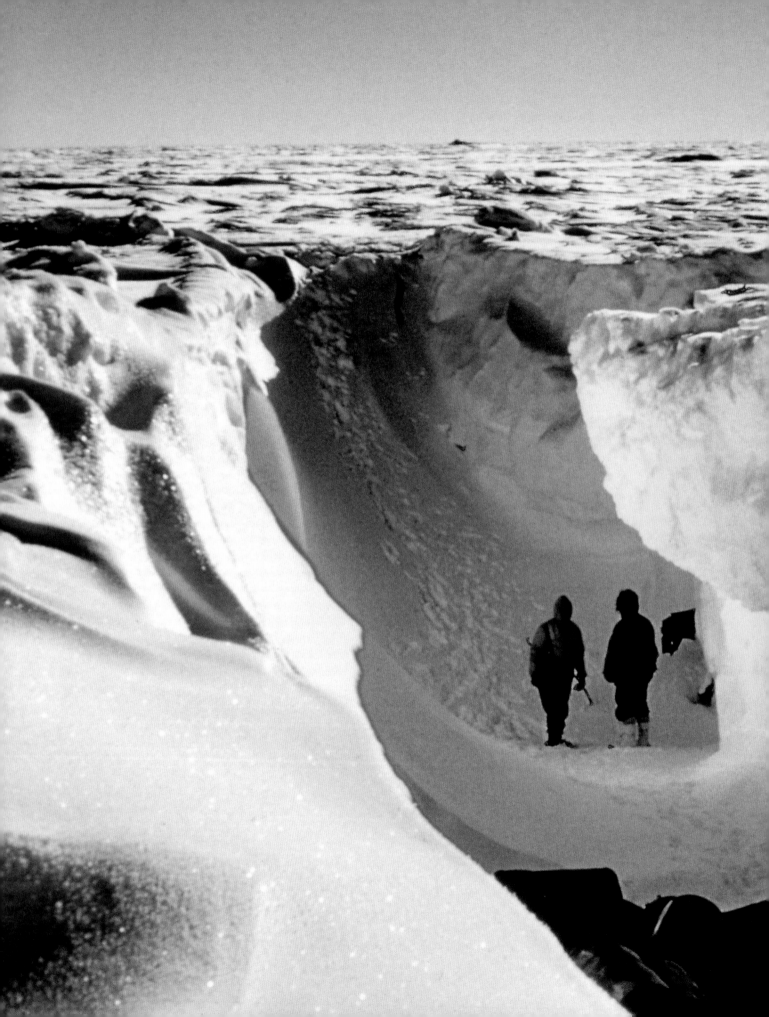

LEFT Fierce winter winds scoured the ice into a large gully behind the hut at Shackleton. Our meteorologist Hannes la Grange always got excited when he recorded high winds. One winter night, with speeds nearing 60 knots, he encouraged me to experiment by moving about outside, tied on with a safety line. I was continually blown over and had to crawl back to the hut. He was greatly pleased by my efforts; totally pointless, he said, but fun to watch.

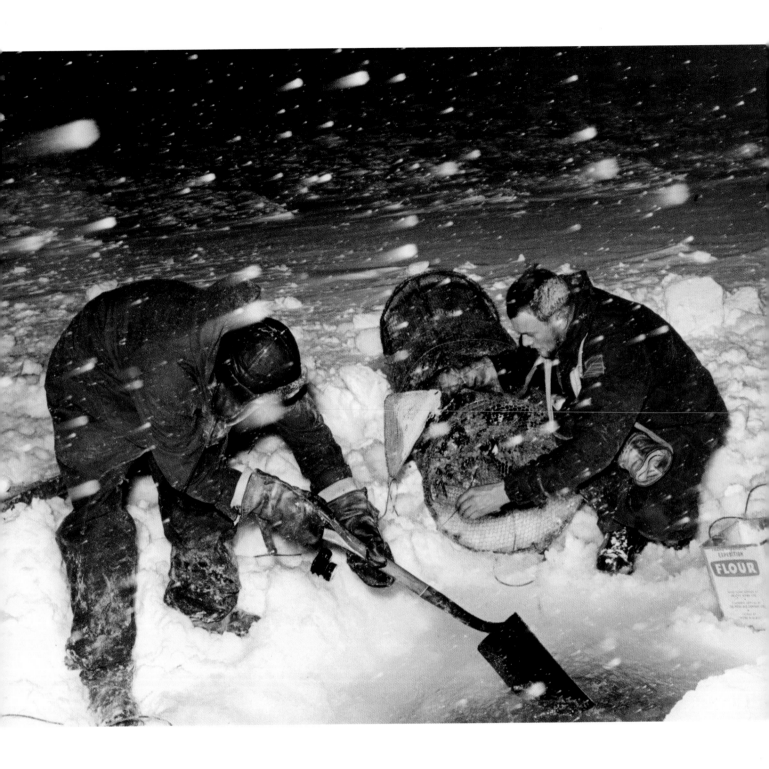

ABOVE Roy Homard and David Pratt fishing through a hole
in the ice. The fish trap was for biological research, but this
time we used it to catch something for deputy leader David
Stratton's birthday. I guess people might think us slightly mad
to go shrimping in a snowstorm in the dead of night in the
Antarctic winter.

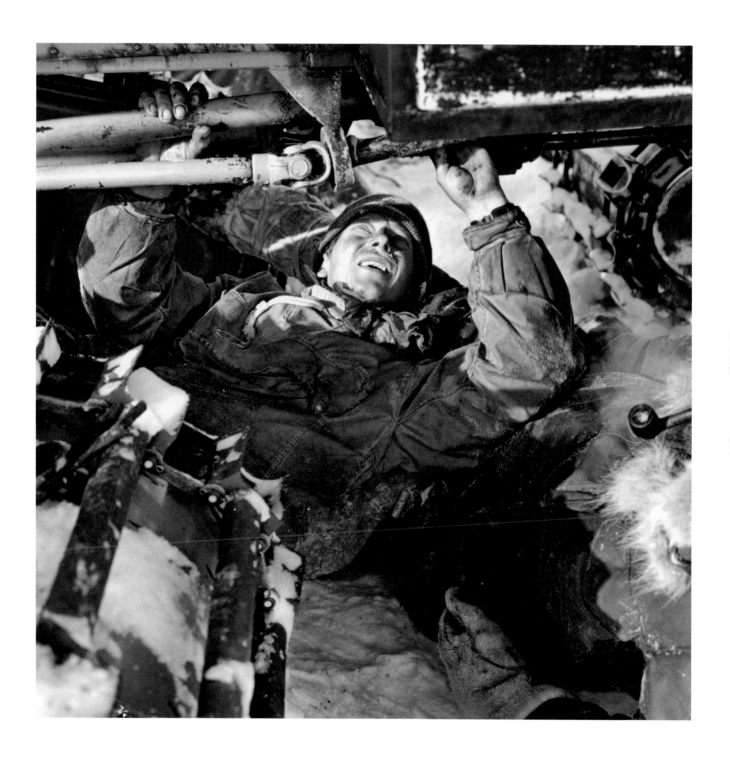

ABOVE Lying on his back at work in our repair shop, Roy
Homard fixes the drive shaft of a Sno-Cat. He really was a
marvel when it came to keeping machines working in the
coldest of temperatures. Without his skills we would never
have started our journey, let alone completed it.

ABOVE Giving me an exhausted smile, Bunny pauses for a moment while cutting meat for the dogs during the winter darkness. It was a really tough routine as everything was frozen solid and rock hard. Once large chunks had been sawn off, we'd use an axe to divide them into smaller pieces, like splitting logs for the fire. The dogs appreciated our efforts. During the long winter they were kennelled in tunnels we had carved for them underneath the ice.

LEFT The dance of the seven veils as performed by Ralph Lenton at our midwinter celebrations at Shackleton Base. Geoff Pratt is not greatly impressed.

BELOW LEFT Taffy Williams takes a quick break for a cup of tea during his turn as expedition chef. He was making bread for us that morning; ten loaves were baked every second day.

RIGHT Ralph Lenton cuts my hair but not my moustache; it was the first time I had waxed it. Behind us David Pratt lurks pensively, waiting his turn. On the wall behind him you can just make out my 'rogues' gallery' of portraits that I took and developed that winter.

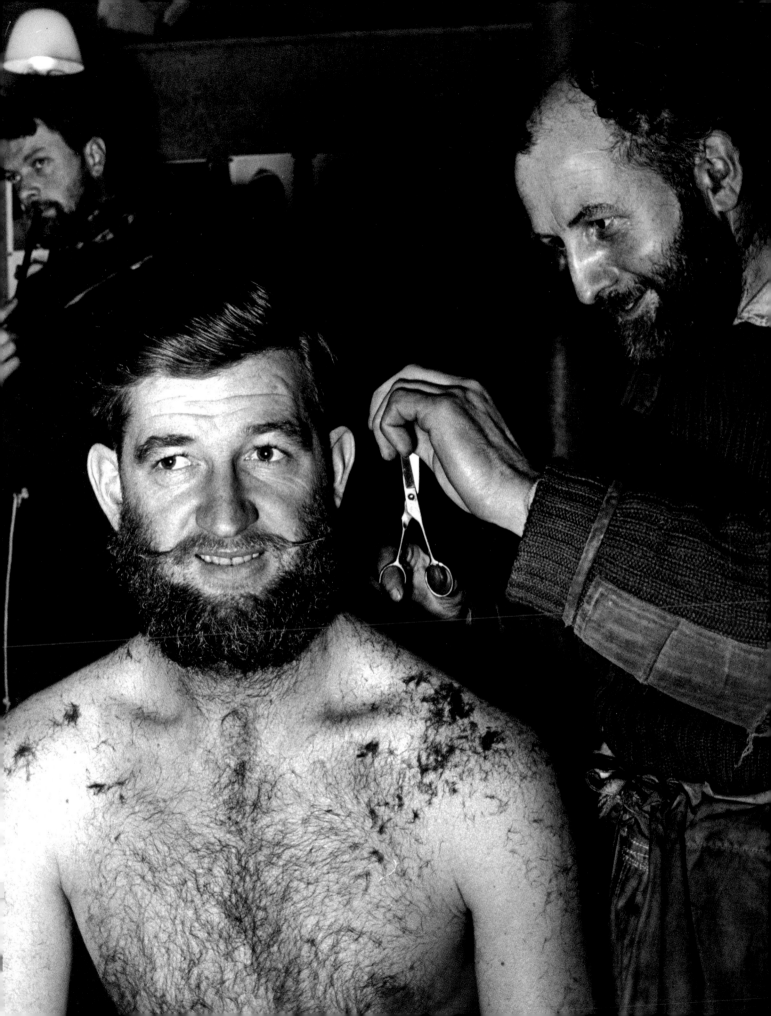

RIGHT I took this self-portrait in my darkroom using the Leica on a timer with an indoor lighting rig. I even combed my hair and trimmed my beard for the occasion. The darkroom was supplied by Kodak, who created it in their basement in London to the floor space allocated for it in the base hut, 6 x 4 ft. Into this mock-up was fitted a zinc-lined sink unit with all the paraphernalia of bottles, dishes, thermometers and clocks. I worked in it there for a day and we made adjustments. The darkroom was then quickly dismantled and packed to be sent out on our ship.

PAGE 126 Allan Rogers, our doctor, had a busy science programme and we were his 'guinea-pigs'. Taffy pulls a loaded sledge during physiology tests in May 1957. Outside in total darkness it was minus 55°F. Amazingly, the fourteen flash bulbs and my Rolleiflex worked well at this temperature.

PAGE 127 Geoff Pratt wears the 'Integrating-Pneumotachograph' equipment. The experiment was devised to help determine the 'horse-power' energy rating of a human being by collecting the subject's expired air. It was tedious and uncomfortable, but Geoff gallantly participated for a week.

PAGE 128/129 The long Antarctic night was ending and darkness was giving way to the twilight weeks. Having dug out the aircraft it was time to get everything set for the long journey.

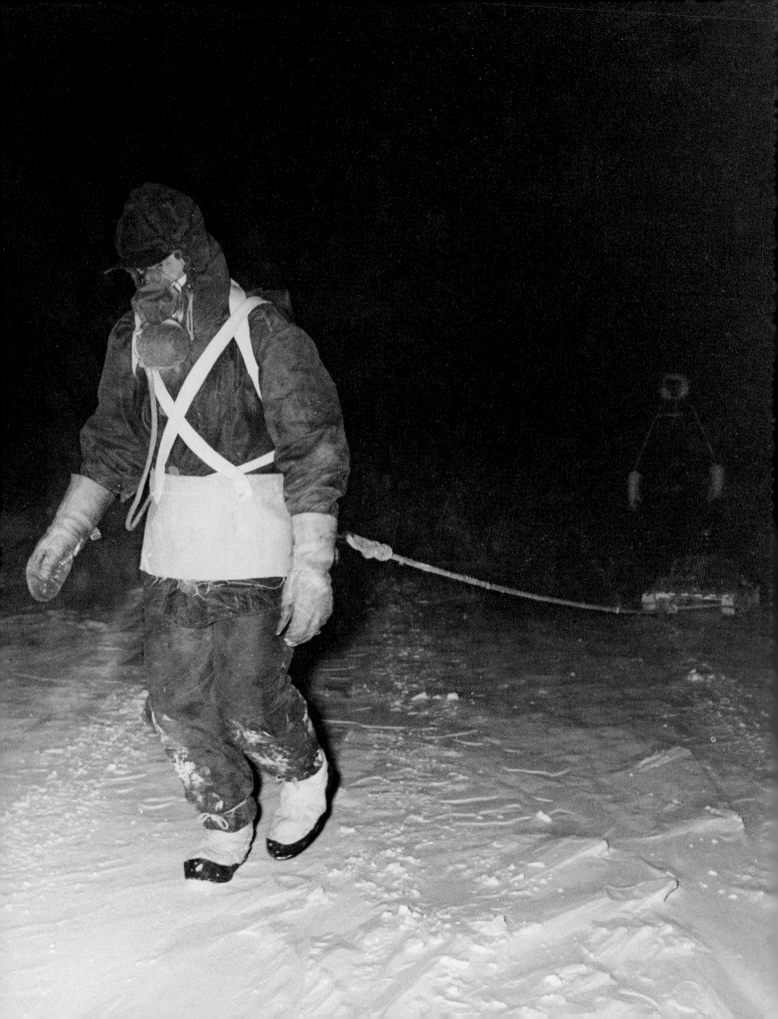

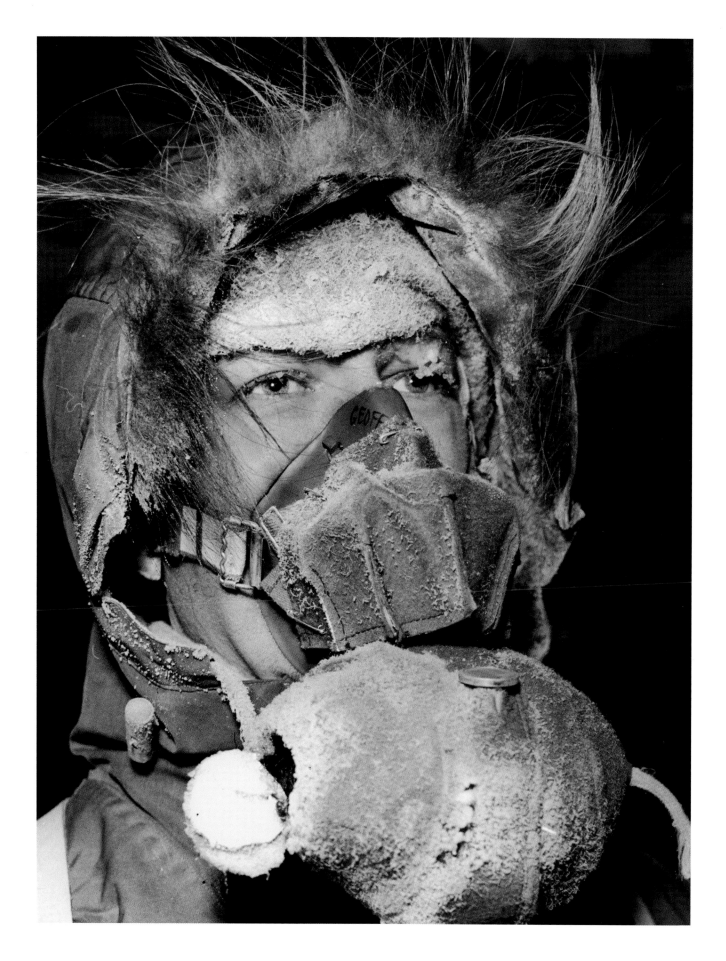

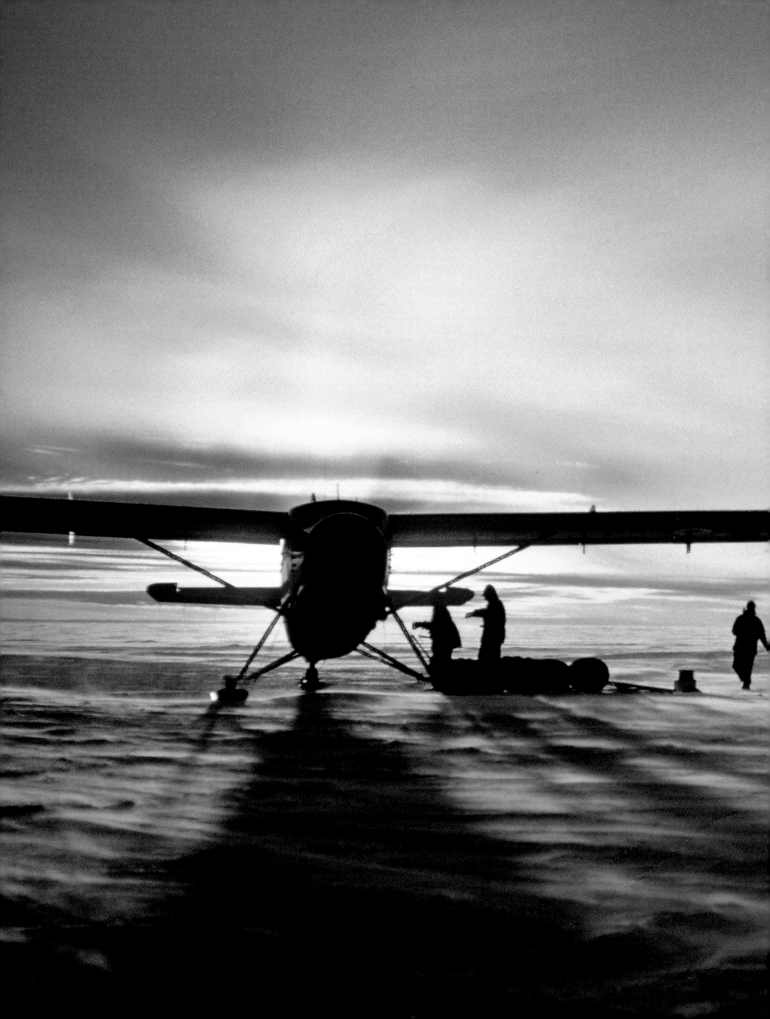

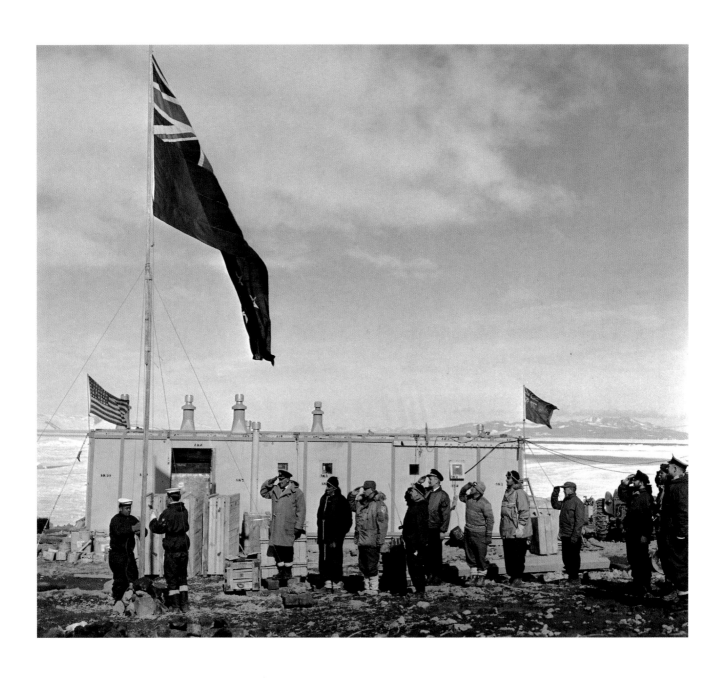

ABOVE AND RIGHT On the far side of the continent, Ed Hillary's team were bedding in for the winter. They set up nine connected huts on Ross Island and called it Scott Base. The mess hut was the first to be finished, and this was their flag-raising ceremony in January 1957. The structure was assembled in one working day; a vast improvement when compared to our complicated huts at Shackleton and South Ice. Inside, they feast on Midwinter's Day, 1957.

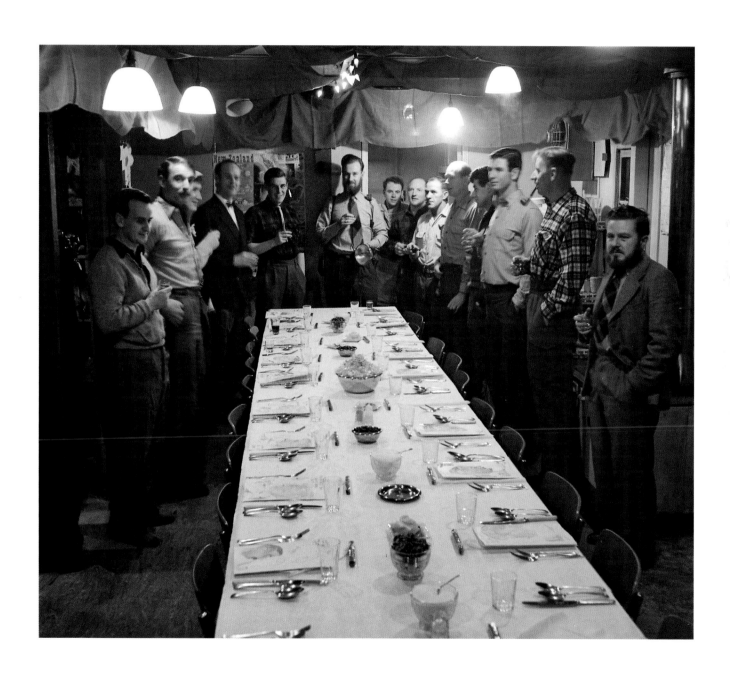

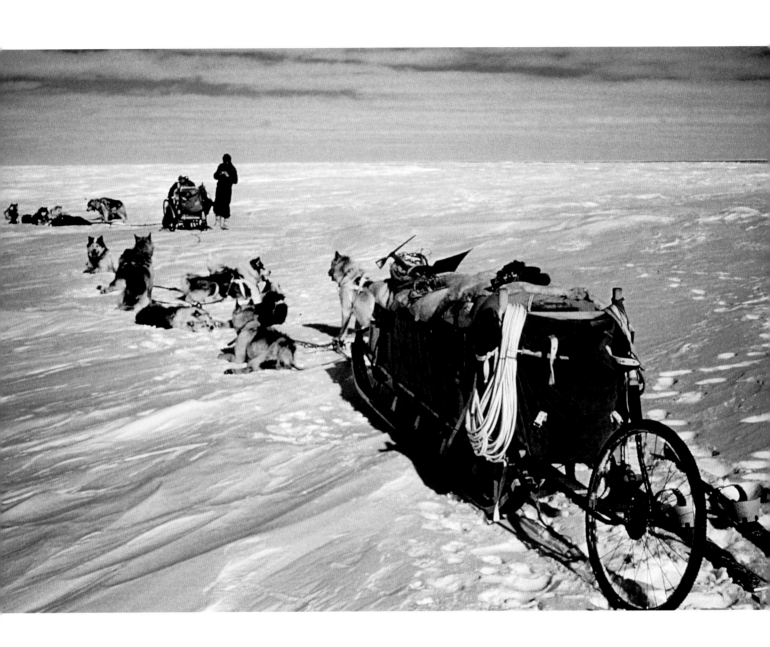

ABOVE AND RIGHT Mostly bred and selected in Greenland, our huskies were the best means of hauling sledges when scouting a route through unknown and difficult terrain, and often went ahead. Our third summer on the continent was devoted to land explorations. Meanwhile, Ed Hillary led his party up through the mountains of Victoria Land for a big push across the polar plateau, also making sledge journeys using dog teams.

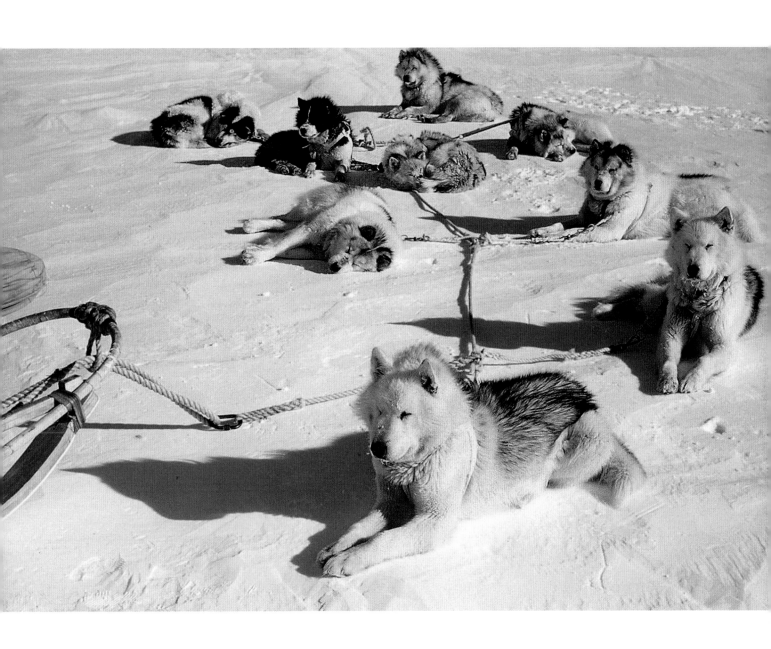

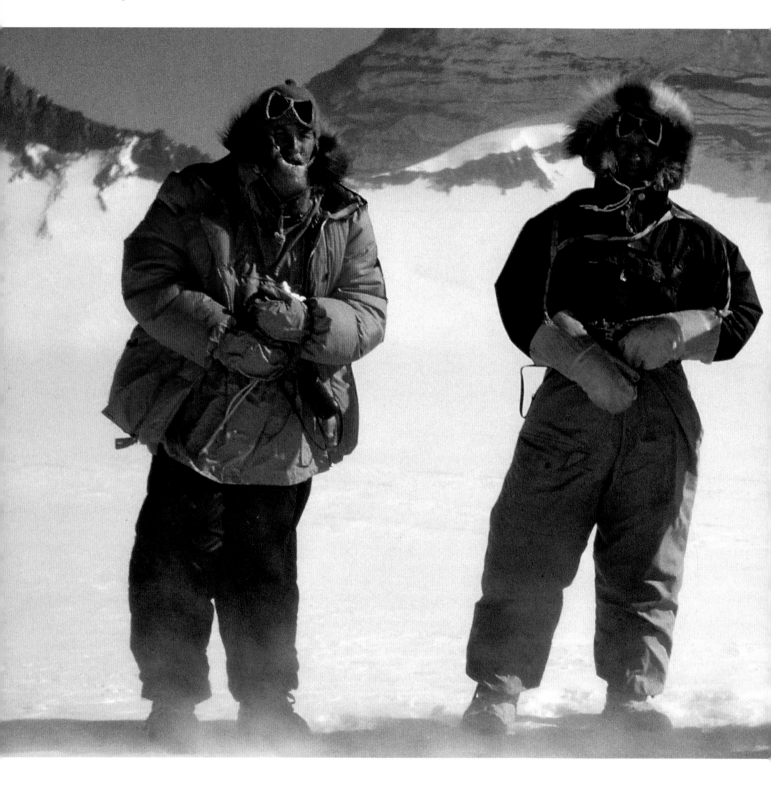

ABOVE During survey work in Victoria Land, the New Zealand Northern Party of Richard Brooke, Guyon Warren, Murray Douglas and Bernie Gunn climbed some 40 peaks varying in height between 3,000 and 10,000 ft. The ascent of the 12,860-ft Mount Huggins by Brooke and Gunn on 26 January 1958 was certainly the most important climbing achievement in Antarctica then completed. They ascended at first via the west flank, after a 1,000-mile sledge journey with dogs. Ed's unquenchable spirit for adventure, shared by his teammates, seemed to overcome every problem they faced.

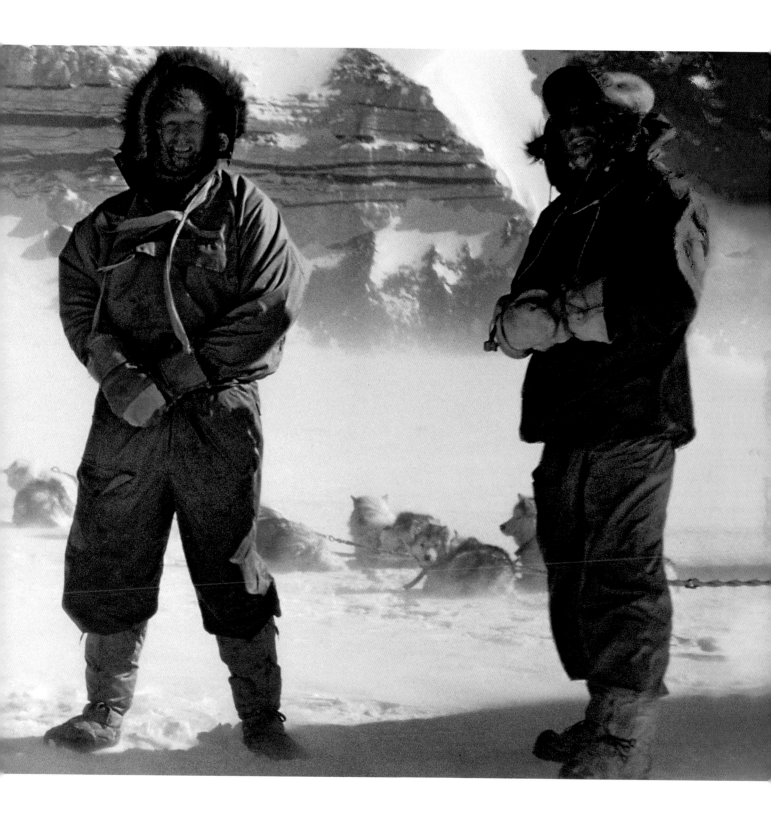

FOLLOWING Among many sledge journeys made by Ed Hillary's team, two stand out. One was the trek by George Marsh and Bob Miller beyond Depot 700 when Hillary left for the South Pole, and the other was by Richard Brooke's Northern Party. This shot was taken on Christmas Day 1957, during the latter's incredible surveying explorations of the mountains at the edge of the polar plateau. Their urge for discovery left footprints over a vast area of this great Southern Continent.

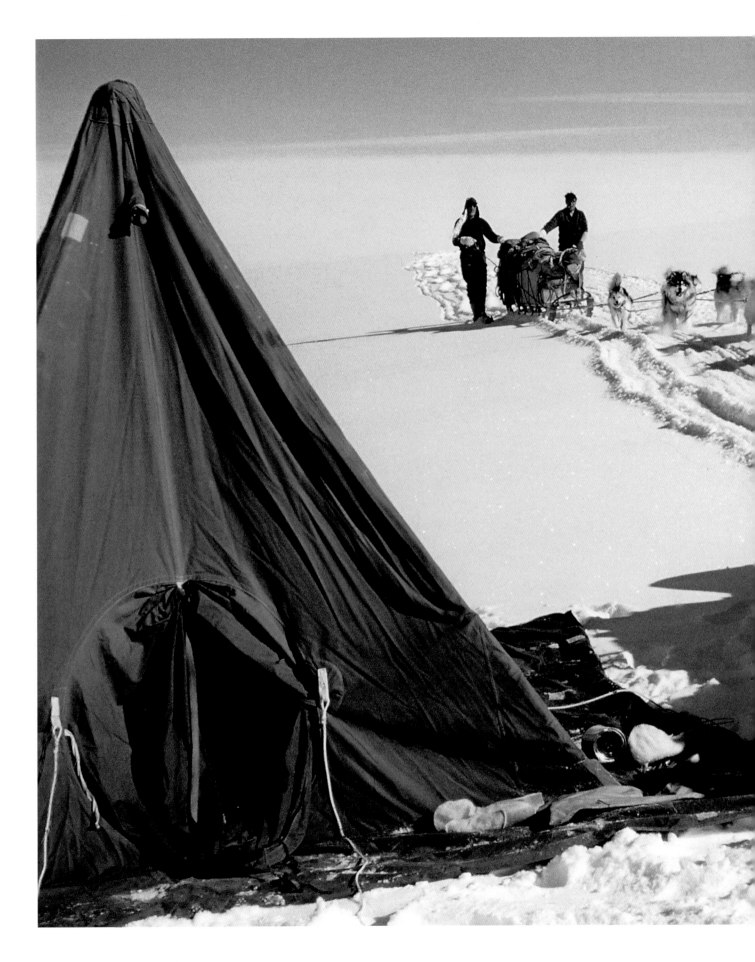

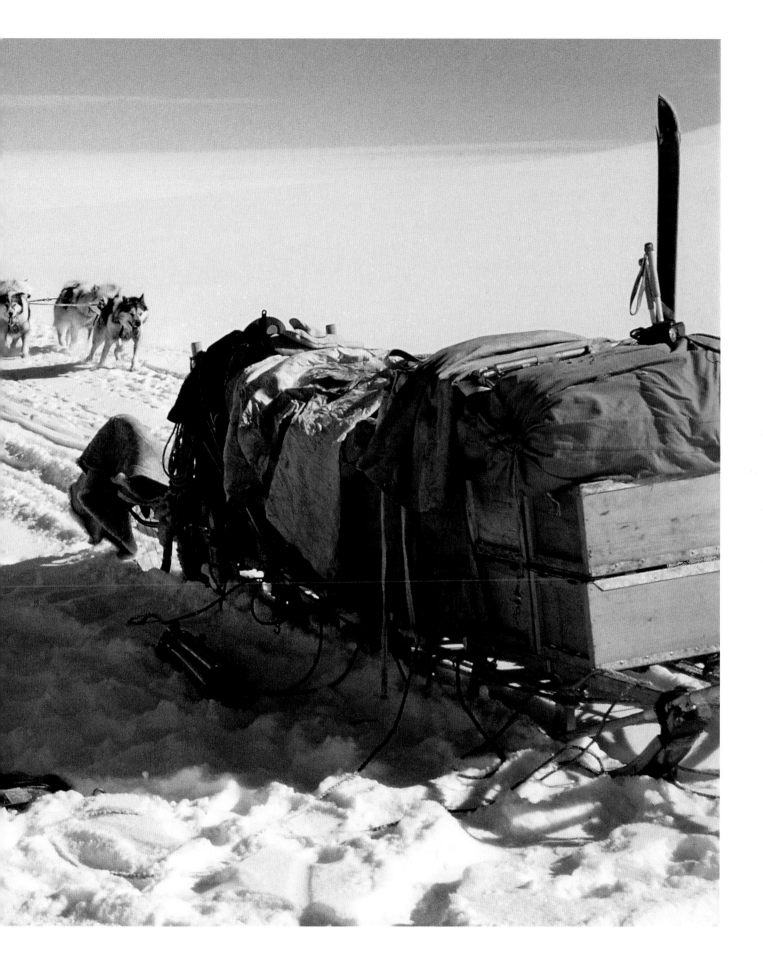

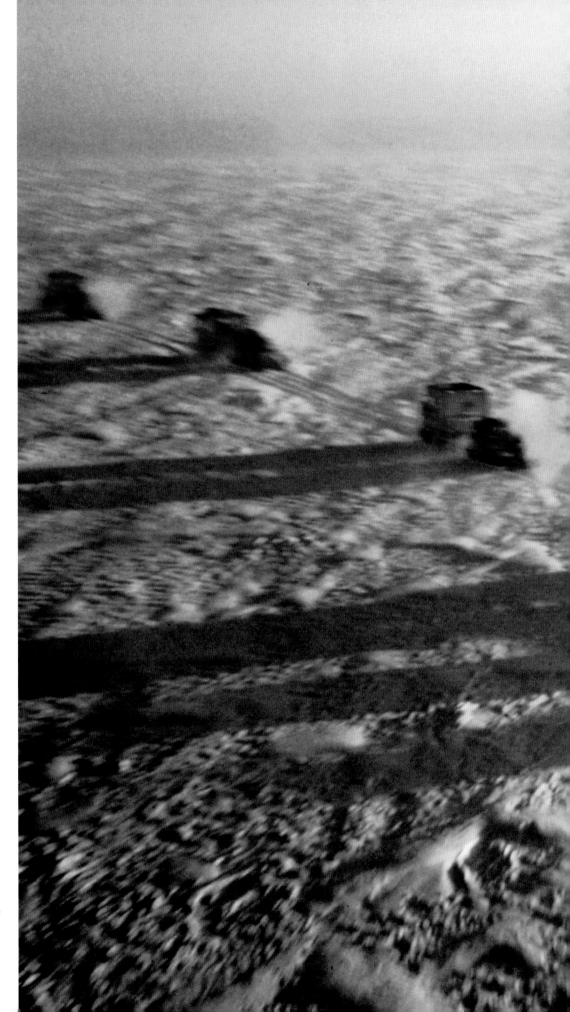

RIGHT We left Shackleton Base on
24 November 1957. I never ceased
to be impressed by the sight of the
Sno-Cats ploughing forwards in line,
with flags and pennants flying, and
always the flurry of snow spraying from
their tracks. In this shot taken from our
aircraft, dwarfed by the frozen vastness,
vaporized exhaust fumes create great
clouds in the sub-zero air.

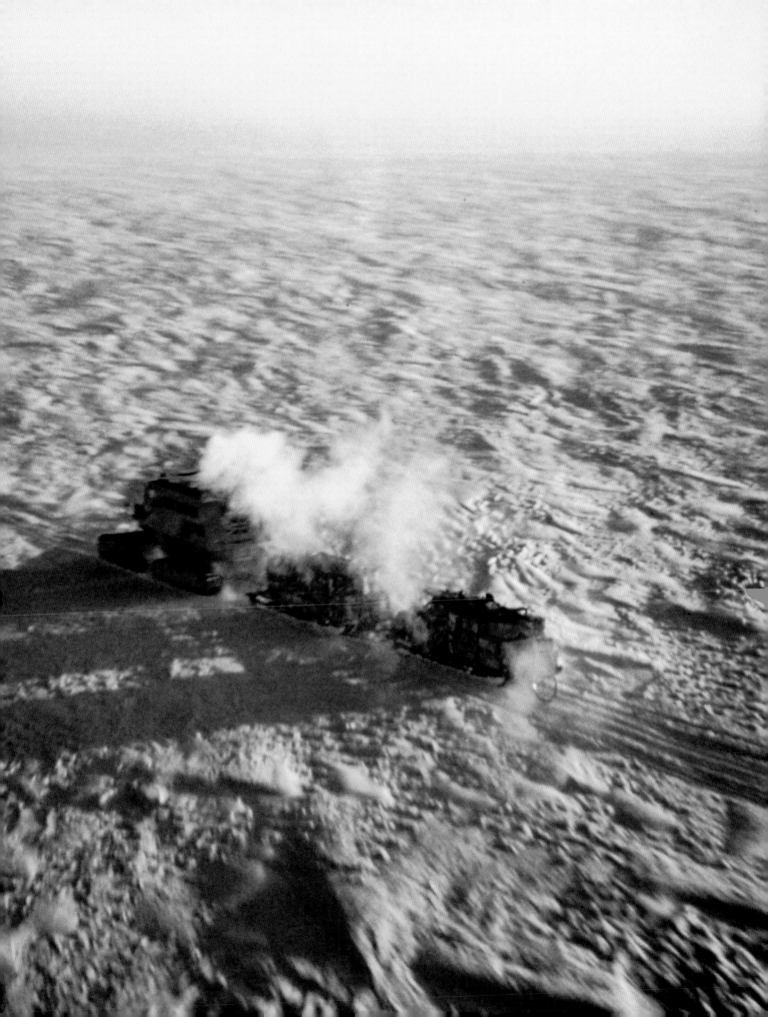

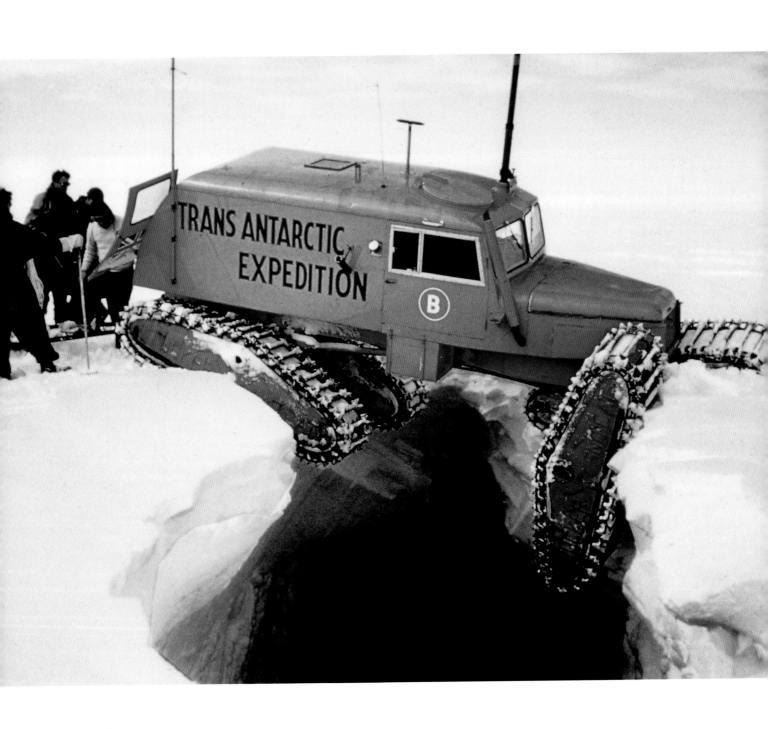

ABOVE We'd scarcely set off before we ran into trouble. This was the first deep crevasse, just 25 miles from Shackleton. Leading from the front, Bunny's Sno-Cat *Rock 'n Roll* became jammed nose first in the far wall. In such cases recovery was a long and skilled manoeuvre and often seemed impossible, but our engineers always managed to figure a way to haul our vehicles to safety.

RIGHT We were frequently held up while one of the Sno-Cats needed rescue, repair or refuelling. Jon Stephenson often sat on an engine bonnet, keeping warm, engrossed in the *Confessions* of Jean-Jacques Rousseau. I managed to get through *War and Peace* during the crossing.

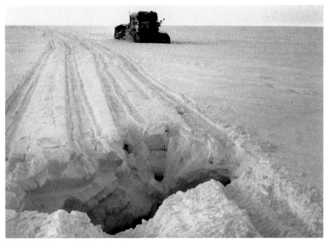

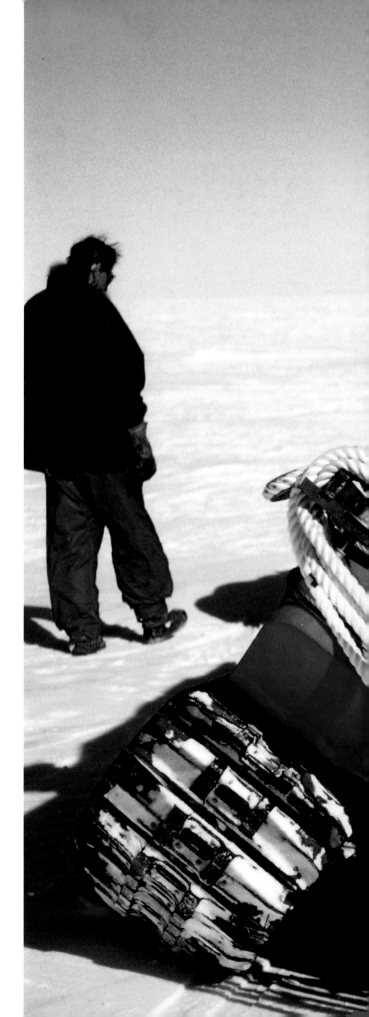

ABOVE AND RIGHT A Sno-Cat and the Weasel *Rumble* trapped in invisible crevasses. After much delicate digging, we managed to save the vehicles. Crossing heavily crevassed terrain was like driving a tank across a minefield, except that one was waiting for something to go down instead of up!

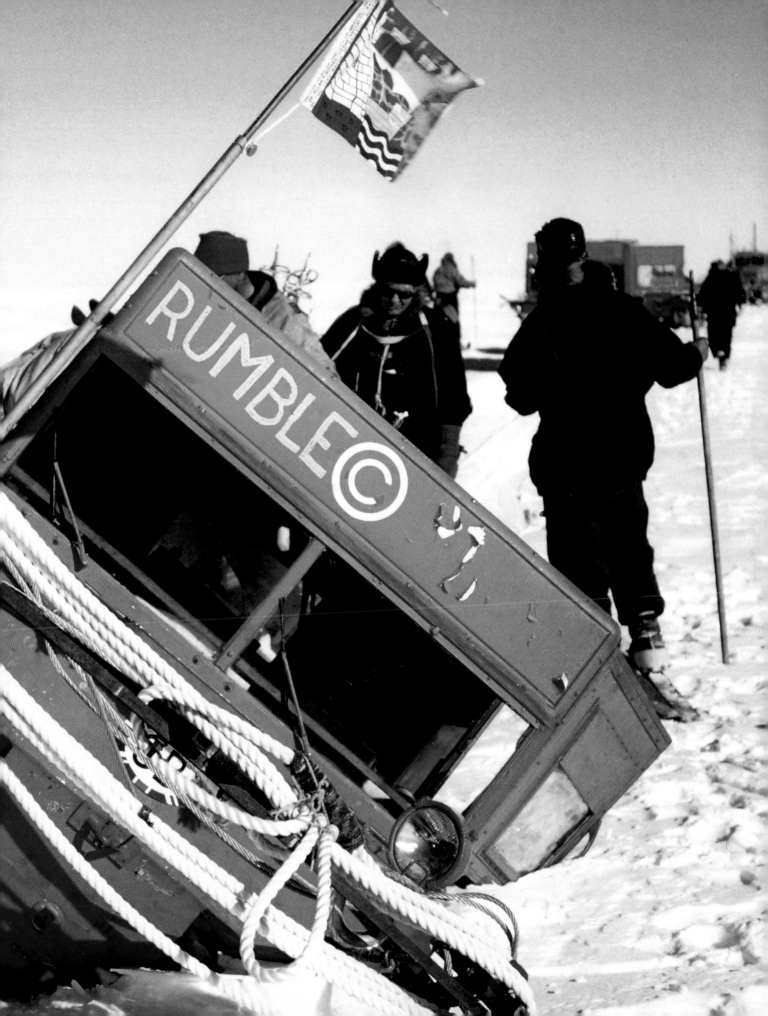

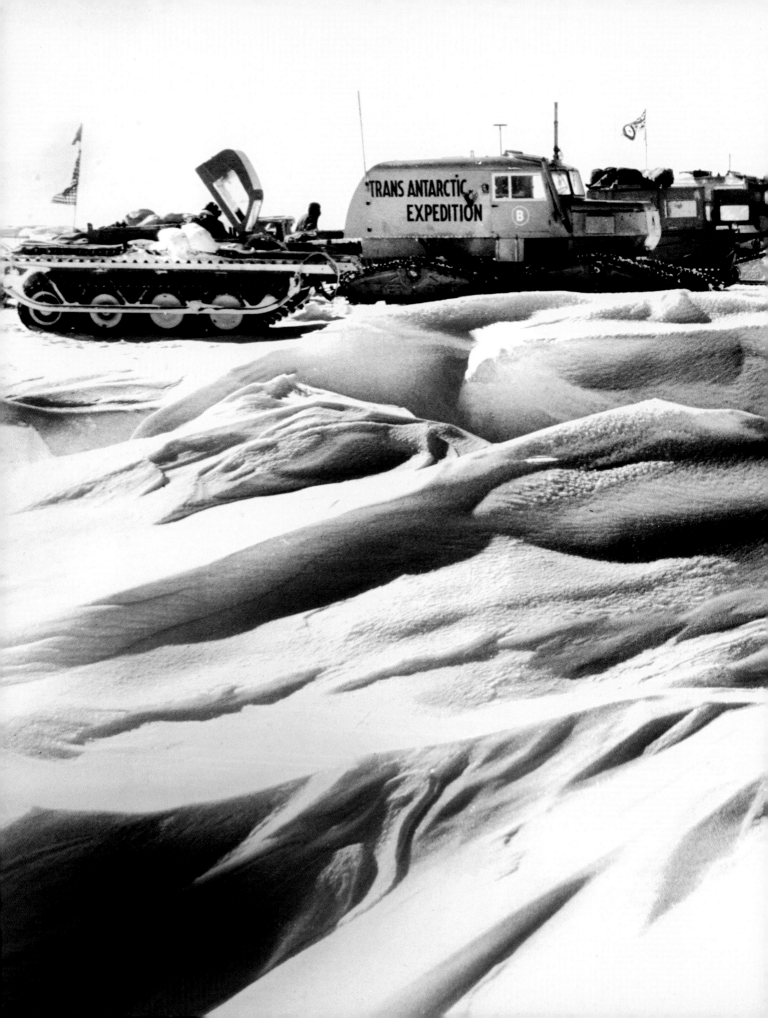

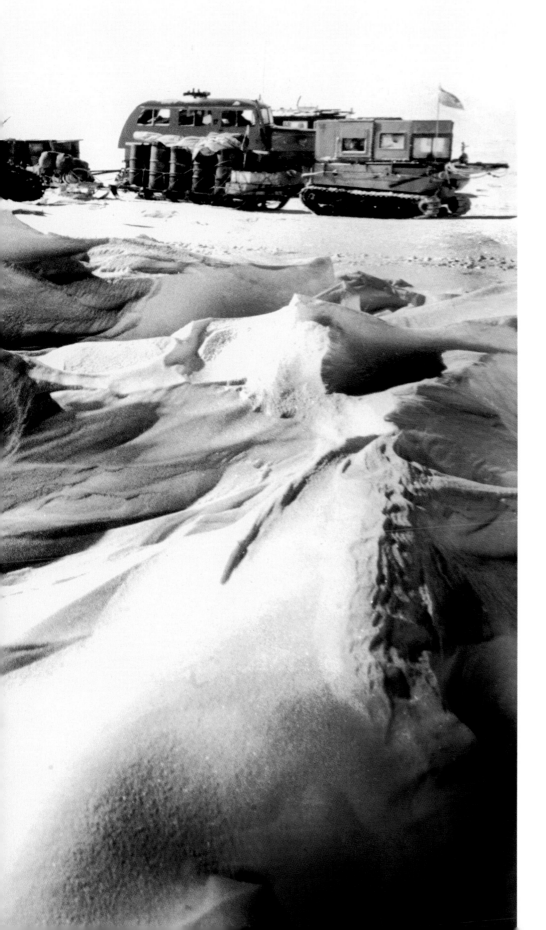

LEFT By New Year's Day 1958 we had finally reached the polar plateau, but we were still some 500 miles from the South Pole. The wind carved the ice into rutted fields of sastrugi, like the waves of a choppy sea suddenly frozen into immobility.

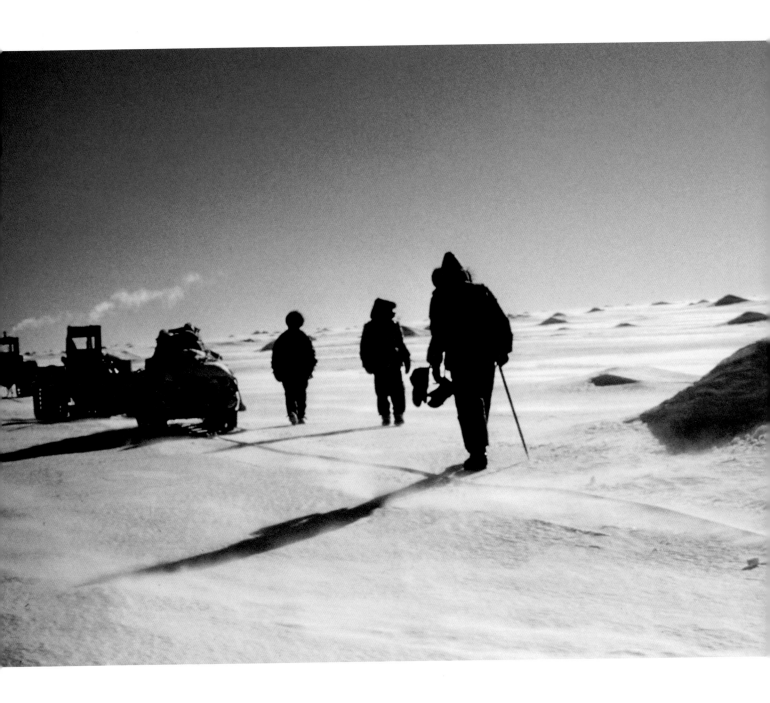

ABOVE AND RIGHT Ed Hillary and his companions Murray Ellis and Peter Mulgrew left Scott Base on 14 October 1957. The brilliant mechanic Jim Bates, the fourth member of this 'Old Firm', flew out to join them at the Skelton Glacier. Cameraman Derek Wright would also join later. Together they blazed a 1,250-mile trail for our main crossing party.

They took three Ferguson tractors, a Weasel, a homemade caravan and seven sledges loaded with fuel, food, tents and survival gear, and became very skilled at keeping them all going in tough conditions. In the photograph opposite, taken in November 1957, they are charging across the polar plateau, some 400 miles from Scott Base.

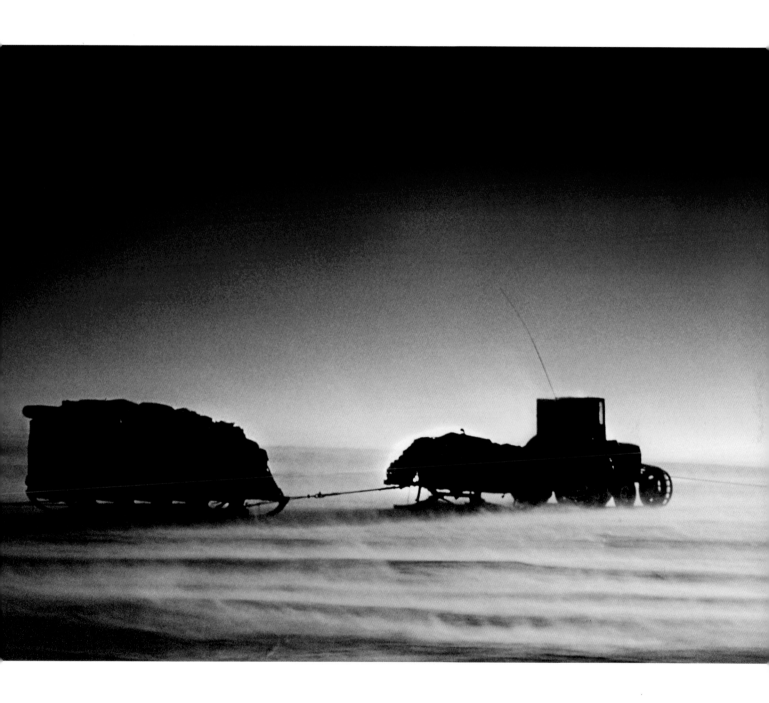

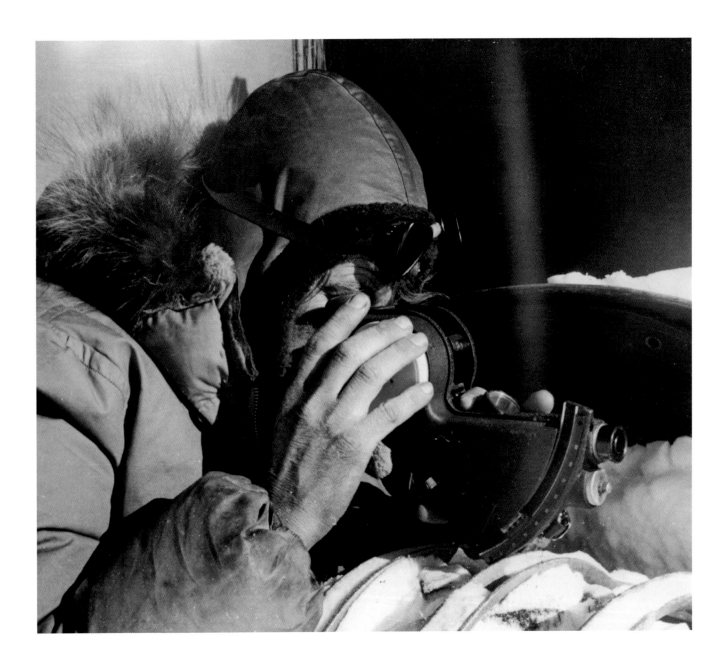

ABOVE AND RIGHT The British-made Ferguson farm tractors had modified canvas windbreaks around the cabs and continuous tracks over the wheels. An astro-compass was mounted on a bracket above the cab. Over 700 miles from Scott Base, Ed Hillary stops to gain another accurate fix on his position. Above he is shooting the sun's altitude with his sextant. With fuel running low, he knew he couldn't afford to miss the South Pole by too much and they eventually reached it on 4 January 1958. Hillary described his journey as a 'jaunt', but his team slogged through endless crevasse fields to provide a safe route for us from the South Pole to the other side of Antarctica.

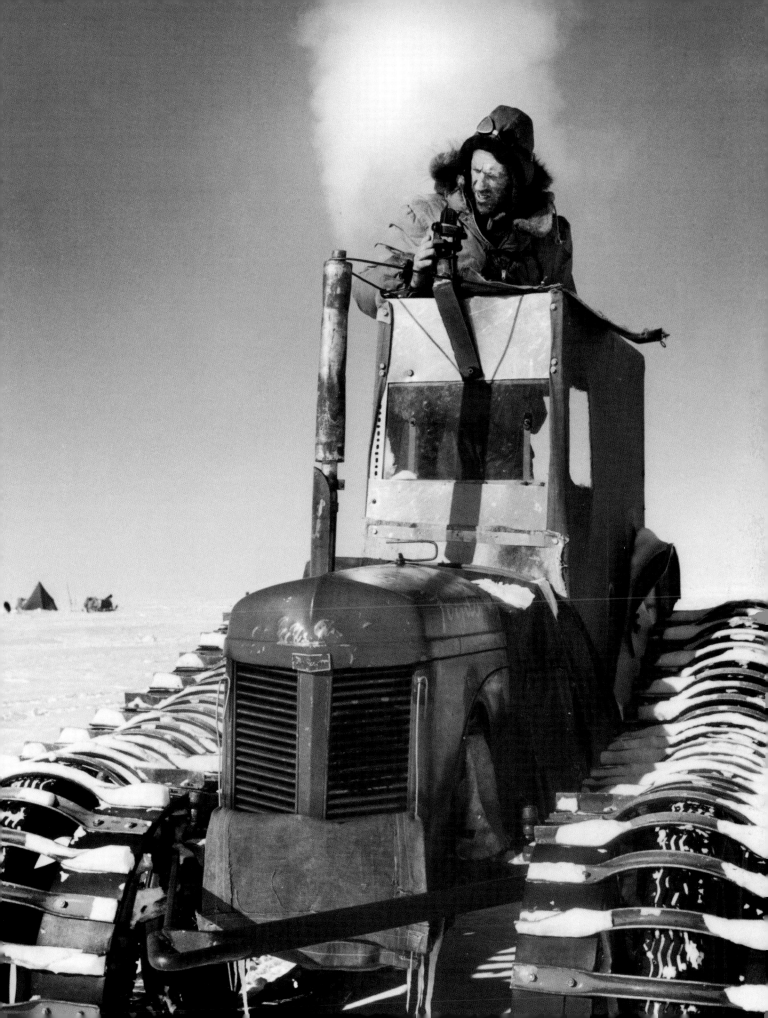

3 | BEYOND THE HORIZON

Snow-piled mountains, saw-toothed glaciers, deadly crevasses and killing cold … rugged men building huts in the snow, living in them through the dark of winter, coming out with the first light of spring and setting off across the jagged, frozen landscape with dog sleds, airplanes and tractor trains … a real adventure.

The New York Times, 1959

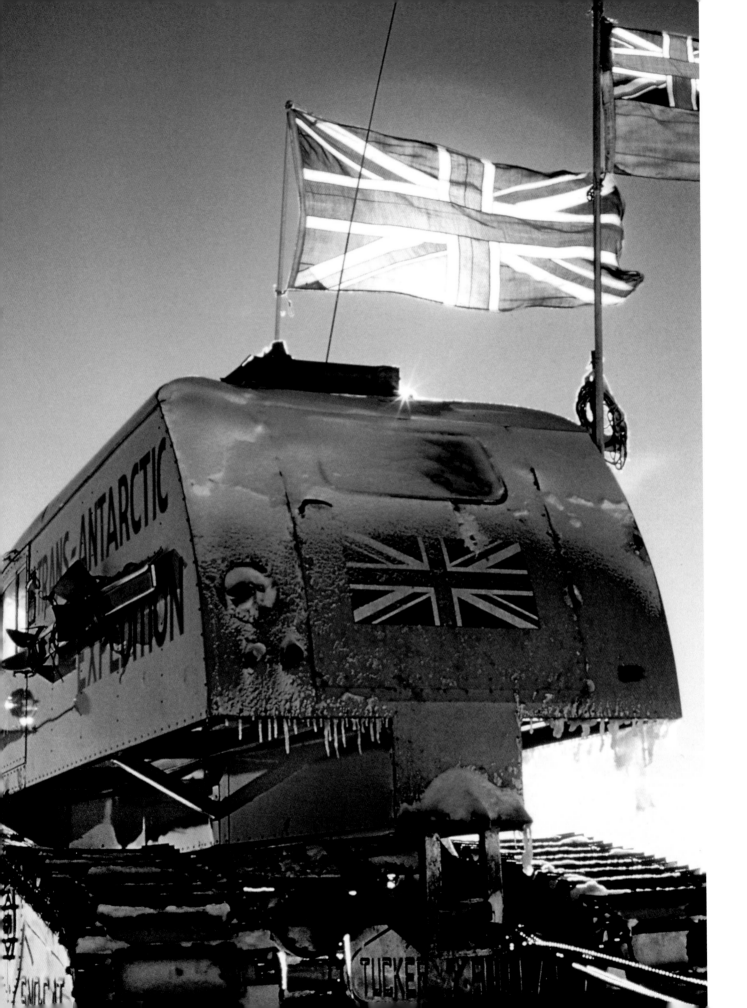

Our third Christmas dinner in the Antarctic was eaten under bizarre conditions at South Ice depot a few hours before we set off for the last stretch to the Pole. The hut, erected the year before, was now completely buried under snow almost to the top of its chimneys. Sixteen feet below the surface, there was not much room for ten thickly clothed men in a little hut designed for just three. We were staying at South Ice for three days, to dig out the petrol buried there and to overhaul the vehicles. And we would be leaving with the biggest load of the journey, for we would not be able to refuel until we reached the depot 550 miles past the Pole on the route to Scott Base. This was Depot 700 (the distance in miles from Scott), which had already been established according to plan by Hillary and his party.

Crammed into the South Ice hut, we were all set for departure, a relaxed and happy band of bearded brothers, with grease blotching our windproof clothing and newly sewn patches over rents and holes. Greasy leather gloves hung from everybody's neck harness; faces glowed in the warmth of the hut; our bellies were full after three days of feasting on tinned vegetables, and fresh lamb and steak which had been frozen for the year awaiting just this moment. Bunny raised his voice and I knew this was the departure call. 'I want to get away from here in half an hour. Is everybody ready?'

I opened the heavy door, stepped into the long corridor of ice leading out to the pool of light that shone down the entrance shaft. From an alcove cut in the ice I grabbed my precious box marked 'Film' and climbed the steep ladder. Reaching the surface I looked out on the vast plain of dazzling ice and the great dome of sky. Everyone else was still below and our orange and red vehicles stood in line dressed like flagships on review day, with every possible piece of bunting and scrap of crêpe paper fluttering from radio masts. I set up my camera within a few feet of the fading wind-sock; this, the instrument tower and four chimney pots were all that marked the surface. South Ice was now 'To Let' – before long it would be totally buried. Perhaps it will be found again a hundred years hence, or a thousand, a quaint historical oddity, a trace of evidence that we were once there.

Our exodus had a brave, romantic touch about it: the sky was blue and the horizon, though featureless, was not without promise. For a few hundred yards we ran west and then, turning along a line of stakes that had been precisely aligned, the compass was checked and we headed south along the 29th Meridian. Five miles later we came on a small tower of snow blocks bearing a cardboard notice. 'Only 550 miles to go. Next stop the Pole', it said. Ken Blaiklock and Jon Stephenson driving the two dog teams had left two days ahead of us to mark the route with snow cairns, do some survey work and flag dangerous crevasse areas.

From South Ice we began a new routine. Science now came to the fore and each of the party began to pursue their particular passion and specialist skill. Geoff Pratt's work was given the most time and importance; using seismic methods he was measuring the thickness of the ice layer over the continent. His Sno-Cat *Haywire* pulled a mixed cargo, including explosives, and in the Cat were expensive electronics to measure the time taken for shock waves from an explosion to travel down through the ice and bounce back from the rock below. Hannes la Grange, travelling and tenting with Geoff, had his meteorological gadgets mounted in an old food box fixed on the outside of the vehicle.

Now at 5,000 ft we rose steadily in gentle waves to a shimmering horizon day after day. It was a strange place on which we made not the slightest impression, and I could never come

LEFT The first months of our journey were full of fear, frustration, boredom and excitement. But then we crossed the last, almost buried, mountain range near its highest point and reached the polar plateau, flags flying.

PREVIOUS When Bunny and I gave a lecture in Norway we met Olav Bjaaland who was with Amundsen when they became the first men to reach the South Pole in 1911; he took the famous photographs there.

to any understanding with the cold impersonality of the polar plateau – there was nowhere more unyielding and monotonous than this white continent.

Not long after leaving South Ice we overtook Ken and Jon with their two lightly laden dog teams. The dogs were running well, tails held high, covering a regular 20 miles each day regardless of the surface roughness. For Ken, who had spent five years in the Antarctic, driving a dog team to the Pole was a dream being fulfilled. Amundsen was his hero and now he was the first to repeat this dog marathon. Taking another light load of food for the dogs and themselves, the two teams disappeared whooping and howling over the horizon.

A new though not unexpected handicap was slowing the progress of our more ponderous train of vehicles – sastrugi. Sastrugi form when the wind packs snow into hard ridges which are carved by wind-blown icy particles into shapes not unlike a choppy sea – a sea, if one can imagine it, frozen into immobility. The devilish sastrugi proved to be higher, wider, harder and far more destructive to tracks and sledges than we had allowed for; so here we were, a few days after setting out, heating, straightening and welding broken bars on sledges. A few days later and for no apparent reason, sudden violent attacks of vomiting and diarrhoea began, first in one tent and then another. The cause baffled our doctor, Allan Rogers, who first suspected the Thermos flask of incubating bugs. Great care was then taken, but still various people were affected for a day or more.

About 200 miles from the Pole our altitude was somewhere near 8,000 ft and we were driving well, strung out through endless fields of sastrugi. The two dog teams ran easily over the ploughed ice, one in front of me and one behind, while nearly a mile ahead the leading Cat was forging implacably onwards. I

then saw Ken's team running slowly, with their driver riding on the sledge: that was wrong – the driver should ski to one side, calling encouragement to the dogs. The sledge stopped and the dogs began to mill about, tumbling over one another, fighting. Of Ken there was no sign, so I hurried forwards. Reaching the sledge I jumped out, leaving my engine running. Ken lay helpless in a paroxysm of vomiting. Grasping Ken's ski I leapt in shouting, kicking and swinging to get the yelping dogs away. Ken recovered slightly, got up and swayed, his face ashen, walked to the Weasel and crawled in to lie shivering across the engine cover.

Five minutes later I got him settled inside a sleeping-bag among the spanners, grease guns and gaskets of Roy Homard's Sno-Cat. Ralph took over my Weasel, and I found myself in command of the panting dog team. The dogs were now greatly excited and a change of driver seemed to bring out new energies. I released the brake, shouted the command to go – and they went. I had just enough presence of mind to hold on to the sledge as it careered forwards, bucking and tossing over the hummocks. Soon I was gasping for breath. There is no command for 'Go slower' in husky language, only 'Go' and 'Stop'. The command for 'Stop' is a long drawn-out 'aah' – and I found it could not be shouted when moving and panting at an unaccustomed altitude. I feared for the sledge as it smacked up and over ridges, becoming airborne. The dogs had their tails high and I cursed them.

After a few hundred yards the sledge jumped a bank, twisted in the air, landed on its side and slowed to a stop. I lay down on it to regain my breath, then strode to the head of the line of dogs and addressed them. They sat blinking as I pleaded for less frivolity. I heaved the sledge upright and the mad rush began all over again; eventually they tired, and as the miles increased we settled into a long steady lope which I could manage. Next day

I drove again, and we covered 30 miles. My muscles ached, and my throat was dry and sore from gasping in the cold air; my lips were cracked by the wind; my clothes were soaked in sweat. When we camped that night Hal cooked the pemmican and cocoa and I quickly fell asleep. On the third day I rode much of the time on skis, as the sastrugi were less troublesome. Even though a cold wind made me turn my head away from the blast, I enjoyed the run, my last spell of dog driving. Ken recovered and took his dog team on to the Pole.

At latitude 89°S the dense ridges of sastrugi gave way to a gentler surface of softer, smoother snow. Our southerly course was still uphill; every day we gained more altitude. At 9,000 ft the horse-power produced by our motors was less than half their sea-level performance. The load I was pulling in my Weasel had been reduced considerably, but even so I maintained only three and a half miles an hour in second gear with my foot hard down. For days now I had been running the motor at maximum and I poured oil into the engine more often than petrol. Exhaust fumes caused me a good deal of worry and headache. Then I contrived a better if queer-looking method of progression. I arranged the Weasel cab so that I could stand upright with my feet on the seat and my head out of the trapdoor in the roof. With two pieces of light rope I controlled the steering tillers and also tied the throttle wide open. In this way I drove non-stop for hours on end and in this position I could also film.

And I could read; this was my absorbing pleasure as I rolled onwards in the tracks of the vehicle ahead. As the miles slipped by I read *War and Peace*. My copy was a remarkable one and I handled it with sentimental care. Turning the thin paper pages I would come unexpectedly on a pressed primula or a brown tea-stain, for this copy had spent five years in the knapsacks of travellers in strange lands. I first saw the book on Everest, wrapped in a plastic bag with an unused shaving kit, where Michael Westmacott loaned it to John Hunt to read. Next year I saw it again with Charles Evans, who carried and read it when we explored the flower-strewn valleys east of Everest. Charles packed it with his paint-box when he led the expedition that climbed Kangchenjunga. There he passed it on to George Band who read it under the precipices of the Yalung face. George handed it to me for my trans-Antarctic journey. Today it still has the flowers and tea-stains – joined now by a lingering aroma of pemmican.

Often as not I ate my frugal lunch while we were on the move; it consisted of four oat biscuits covered with butter more than half an inch thick. To this could be added sardines, thawed out on the engine cover for an hour before eating. Sardines were a rare delicacy, and I had secreted a few tins in my toolkit at South Ice. Everybody had some kind of titbit. Bunny's passion was jam, and he seemed to have a great store which he and David enjoyed to the Pole. Geoff Pratt had the best part of thirty pounds of honey stuffed in tins identical with ones containing explosives. Hal and I had access to this hoard, which was marked 'seismic spares', and I livened up morning porridge with a spoonful of honey.

On 3 and 4 January messages were exchanged between Bunny and Ed that were to have worldwide reverberations. On 6 January Bunny called a meeting to put us in the picture. He read out the two messages, Hillary's and his own. Ed had declared that by leaving the Pole in late January we would be heading into increasing bad weather, and that his mechanics, regarding such a late journey as an unjustifiable risk, were not prepared to wait and travel with our party. He further pointed out that we still had a major journey even to reach the Pole, and suggested

leaving our vehicles there when we arrived and flying on to Scott Base: 'return to civilization for the winter and then fly back to the Pole station next November and complete your journey'. He added: 'If you decide to continue on from the Pole I'll join you at Depot 700. Sorry to strike such a sombre note, but it would be unfortunate if the sterling work you've put into making your route through to South Ice and the Pole should all be wasted by the party foundering somewhere on the 1,250 miles to Scott Base. I will go ahead with the stocking of Depot 700, and I will leave at the Pole station full details plus maps of the route from Scott to the Pole.'

Bunny replied, stating that he appreciated Ed's concern, 'but there can be no question of abandoning journey at this stage'. He went on to say that our vehicles could operate at minus 60°F, that he did not expect such temperatures by March, and that we would wend our way, 'using the traverse you leave at the Pole'.

After reading out the messages Bunny told us that there was no question of not continuing the journey. 'I know we're late,' he said, 'but after all, Scott didn't reach the Pole till 18 January, and we have got vehicles. We're going to arrive about the same time, and then we shall have the benefit of Ed's proved route out.' There was no discussion of either the messages or the decision – and we drove on. Nobody in the party had the slightest wish to postpone our crossing of the continent; on that score we were in full accord with our leader.

On 7 January we learned almost by accident over the radio from the BBC in London the news of startling developments in our affairs. Ed had apparently sent a confidential message to the Committee of Management in London and by an unfortunate blunder in Wellington, a copy of this was given to the press of the world who were now moulding it into a headline storm of controversy, although its scale we did not fully realize, or could scarcely have believed, until we reached the South Pole.

୧୨

By the twenty-fifth day of the journey from South Ice we had completed exactly 500 miles. With only 55 miles to run, the Pole was at last within striking distance. I remembered this day, 18 January, not so much because it was the brink of our arrival at the Pole, but because it was the day I finished *War and Peace*. The surface of our route had smoothed, and after a solitary lunch I settled down to the last pages while *Wrack & Ruin* pitched very gently across the shallow depressions. I left Tolstoy's hero in a state of ineffable peace, and swamped by the impact of the novel I drummed forwards still lost in the world of a century ago.

A few thoughts of Everest flickered through my mind and I knew that this climax would not be the same: for one thing the Pole was not the end of the expedition. In fact we would still not be even halfway across the continent. Yet although the Pole was flat and a man-made point, it still held a powerful attraction. By the time I was full of excitement at approaching the Pole, Bunny had accepted the fact, put it beyond him and was planning his moves ahead. He had such extraordinary composure.

After a long day's run and the usual chores we settled down for sleep. Our position was 89°30'S, about 30 miles from the Pole. On the morrow we expected to reach the American base on the plateau at 90°S. I had almost drifted off to sleep when I heard a distant droning of engines. The noise grew louder and I stuck my head out of the tent to find two American Neptunes flying low over the camp. They circled several times, and Ralph ran to the radio to speak with the pilots, who said they had on board Ed

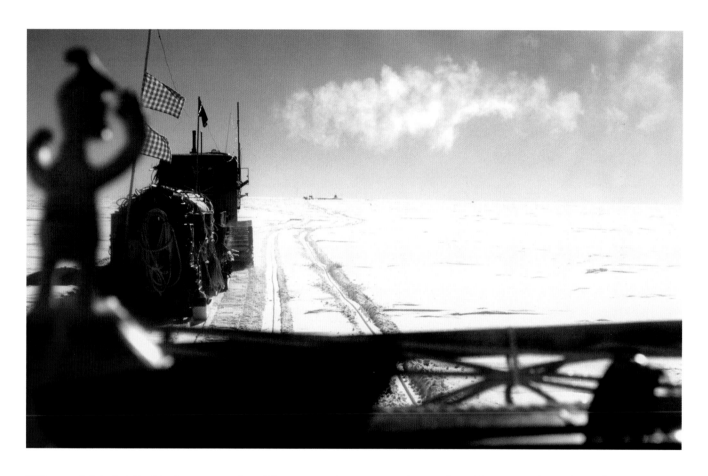

Hillary and Admiral Dufek, the commander of American polar operations. They would be landing at the Pole to await our arrival.

Next day we drove on, with our navigators calculating the precise distance left to run. 'According to me,' said David Stratton, 'we should have about 11 miles to go and we'll probably be a couple of miles off to starboard.' His reckoning was spot on. From a crest we searched the horizon and Bunny and David simultaneously saw the dark smudge. Shading my eyes against the sun I could perceive the outline of a tower and a dome to the left. The South Pole at last.

We turned towards it to seek a line of flags placed to mark the way in. Our pace was funereal – my Weasel could only make a mile and a half an hour and the dogs were very, very tired. The midnight hour passed and the sun blazed down from a cloudless sky. We moved into close order, with every flag flying. Bunny and David led in *Rock 'n Roll*, followed closely by me in *Wrack*

ABOVE The view from inside my Weasel at the glorious moment the South Pole base appeared at last, as little black dots on the horizon. You can also see the blurred outline of my Donald Duck mascot. Photographer Frank Hurley took a cardboard cut-out Mickey Mouse on one of his polar expeditions, so I was in good company.

& Ruin. I was determined to keep up and film as much of the arrival as I could.

Half a mile from the huts and towers a self-conscious group awaited us. As Bunny's Sno-Cat stopped, the figures burst into life and began milling around. I jumped out, festooned with cameras, to record the moment when Bunny met Ed Hillary – the magical point when the two sides of the expedition joined hands across the continent – but all I could see was a heaving mass of people. There was great excitement: the Pole does not receive a lot of visitors and we had not seen a new face for months. I filmed and photographed wherever I could. Then, doffing my hat and extending my hand to Ed, I made the shamefully obvious remark, 'Sir Edmund Hillary, I presume'.

After then parking my overheated Weasel between the Sno-Cats, I stepped out stiffly and swaggered into the station. Friendly American voices said 'Hi there' and 'Howdy' and 'Glad to see you' and went quietly about their business. I walked into the mess hut, where thick warmth wrapped around me like a tight blanket. The unaccustomed sensation made my arms and legs heavy, and I realized just how tired we had become when I saw my companions slumped on stools with drooping heads. Our hosts wore neatly pressed slacks, shoes and open shirts; some had luxuriant well-combed beards. 'Bunny's Boys', they called us, and we were a motley crew, in torn and baggy windproofs, knives hanging from our belts. With scaly, cracked faces we must have looked like a bunch of elderly delinquents as we fingered the radiogram and caressed the steaming coffee pots.

The Americans had prepared an enormous eggs-and-bacon feast. They plied us with food, laughter, speeches and goodwill, but none of us could do justice to the food because our stomachs had shrunk. 'I've got a bag of mail for you', said Ed Hillary

later. He dumped the sack of letters at my feet and stretched out on a bed in the sleeping-hut. I tipped out my pile of correspondence, a whole year's accumulation; it even included my income tax demand!

We began to talk of families, and of mountains; and then apropos of nothing Ed said: 'Well, the press have certainly gone to town on this business.' He meant, of course, the frenzied efforts of the journalists who had been focusing attention on the two principal characters of our expedition, and the 'Race for the Pole', as they inevitably called it. All the flamboyant headline ingredients were present: two parties converging on the polar plateau; two men leading overland journeys to the Pole; two radically different personalities.

It took a long time and much discussion to piece together the picture that I still believe to be the truth. One thing I knew better than most people, from all my experience on our many expeditions: there was absolutely no malice in Ed's character or actions. He did most things simply for the intrinsic joy of them – and reaching the Pole in three commonplace tractors, having finished his specified assignment with time to spare, was his method of brightening the bleak cold weeks of 'hanging about'.

Bunny had originally believed that we would arrive at the South Pole for Christmas. He'd told Hillary we would pass the Pole and reach Depot 700 at about the same time that Ed's party would arrive there to establish the depot. Bunny assumed that because of our superior equipment – particularly the Sno-Cats – we would have an easier and faster journey than Hillary's team marking the route and ferrying in supplies by aircraft.

However, on our side of the continent we spent Christmas not at the Pole but at grim South Ice, several weeks behind schedule; while on Hillary's side they completed Depot 700 a

fortnight earlier than anyone had dreamed possible. Ed told me: 'Quite simply, our feeling was that there was no point in waiting. We'd established the depot, we'd brought in the fuel and the food. What was the use of hanging around?' Moreover, Ed and his party were living in tents. There was no hut at Depot 700, so the prospect of waiting several weeks on the polar plateau held no appeal for anyone. Rather than a long, cold sojourn in the tents, his team favoured flying back to Scott Base. But Hillary, who had decided to bring his tractors on to the plateau, had other ideas. He knew that towards the Pole, ahead of Depot 700, lay crevasses. And after persuading his party to remain, he radioed Bunny offering to clear these crevasse areas so that our path would be marked. Bunny replied: 'Okay – go ahead'.

Shortly afterwards Ed sent another message. This time he told Bunny that unless we wanted yet another depot (nearer the Pole) he proposed paying a visit to the Pole station himself. His cheerful words were: 'I'm going on a jaunt to the Pole'. Bunny replied that to ensure success he would like another depot, 100 miles beyond 700, but unfortunately radio conditions prevented the dispatch of this message for 48 hours, by which time Ed stated that he had already pushed on and had passed the point of no return. This brief radio communication failure later forced Bunny to ask for additional fuel to be flown to Depot 700.

Ed reached the Pole station on 4 January, when we were still nearly 400 miles from it, and acting, as he believed, with a sense of responsibility for the safety of our party (and knowing also, as we did not, what lay ahead of us), he had sent Bunny the notorious message advising him to postpone the full crossing. It was a private communication from one leader to the other. The real blunder had been made in Wellington, where Hillary's message to the Committee of Management in London was handed to the press. It seemed to me, when the shouting eventually died down, that both men had behaved in a logical as well as a characteristic fashion.

The restless Ed Hillary, whose 'jaunt' to the Pole had no selfish, glory-seeking intentions – and who made our journey far easier – did not realize the potential of our Sno-Cats in the last stages of the crossing. In different circumstances his counsel could have been right, but he was proved overcautious. The enigmatic Bunny Fuchs, whose inner motives baffled us, had with dogged persistence got us across the bottom of the world as planned. He could have been foolhardy, but he was proved right.

❧

We left the Pole station and the well-dressed Americans on 24 January. One thing was certain: although there had been no dramatic 'race' between Fuchs and Hillary during the journeys *towards* the Pole, we were without any doubt engaged in a race against both calendar and weather throughout the 1,250 miles of trekking *away* from the Pole. We were aiming to cover the distance in a mere five weeks. To achieve this we were aided by Hillary's clear tracks leading like tram lines to Depot 700, and by the fact that we no longer needed the dog teams; the dogs were flown out from the Pole station by the Americans.

After leaving the Pole we initially climbed to where the crest of the continent is well over 10,000 ft high. For 60 miles we ran at that altitude, and then began the shallow downward glide all the way to Scott Base. The last weeks on the polar plateau were bitterly cold. At minus 40°F I found that even the sheepskin mat and eiderdown coat under my double sleeping-bag were failing to keep out the chill. We usually lit the Primus a long

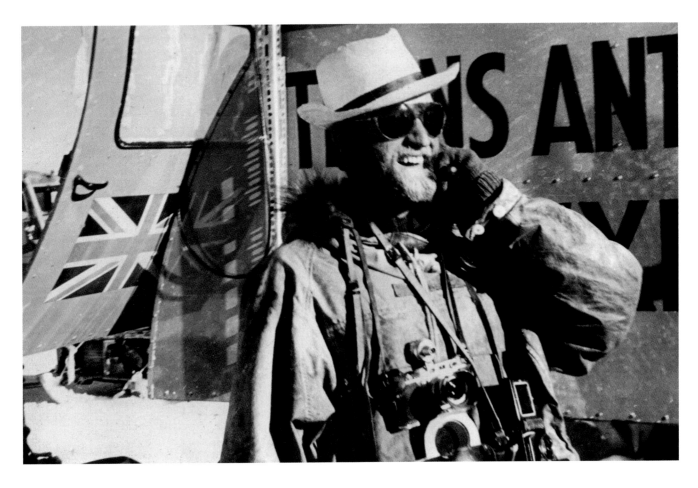

time before breakfast. Hal and I would then lie in torpor until he grew animated enough to start the day with his favourite cry: 'If my mother could see me now – she'd buy me out.'

We were well past the Pole before my amazing *Wrack & Ruin* was finally abandoned in the loneliest part of the continent. The aged, tired Weasel was left to succumb to the fate implicit in her nickname, and I joined one of the majestic Sno-Cats for the

first time. There were now three or four people to each vehicle. In the lead were Bunny, Ed Hillary and David Stratton, and with them rode Hal. Roy Homard's *County of Kent*, which had no partition behind the driver, was more communal. He and Ralph Lenton shared the driving, and in the rear Ken Blaiklock and Jon Stephenson, relieved of the dogs, rode among the piles of spares, tool boxes and radio equipment.

ABOVE My companions often joked that I was the first man ever to cross Antarctica backwards. I did indeed spend a lot of the time looking back, filming with my movie camera ahead of the convoy. The other joke was that I was the 'man in the Panama hat'. It was actually quite useful to stop the glare of the sun, but the journalists at the South Pole thought it hilarious. I'd hoped to keep it on all the way, but an Antarctic gale blew it to icy oblivion.

With Geoff Pratt and Hannes I travelled the last 900 miles in Sno-Cat *Haywire*. We were the only Cat team working as a trio and each half-day we took one of three positions in a strict rotation: driving and maintenance; as co-driver making meteorological and navigational log reports; and lying in our sleeping-bags laid out between ranks of equipment at the rear. *Haywire* was packed very tightly with seismic apparatus, developing tanks, geophones, radio, Thermos flasks, delicate motors, cameras and film.

For some time the remarkable Sno-Cats had been showing signs of wear: we had considerable trouble with steering rods and a variety of mechanical breakdowns. But for me there was a peculiar new thrill in handling the big machine. It was highly disconcerting to take the Sno-Cat's wheel for the first time. It was turned in the same manner, and with about the same effort, as in a car. But for a long moment nothing happened, and I was panicked into turning it even further, thinking the steering had broken away. Slowly, seconds after the first action, the huge Cat began to change course, leaning over, going round fast. I began to correct – but again nothing happened and again I panicked as we continued circling. Suddenly the turn began to unwind and the Cat lumbered forwards in a straight line.

And still we moved on, picking up food and fuel at each of Hillary's depots. We dropped down along a wonderfully scenic route to the head of the Skelton Glacier, descending between 15,000-ft mountains to sea level in another couple of days. Even as we pressed on we received news that the few remaining links with the past were breaking: old Admiral Skelton, who was at the Antarctic Club dinner I had attended four years earlier, and Lord Mountevans, who was David Stratton's godfather, had died. Both were with Scott nearly fifty years earlier. Running

out on to the Ross Ice Shelf, we passed not far from the spot where Scott himself died in that blizzard in 1912.

We travelled fast over the ice shelf to Scott Base, arriving just before 2 p.m. on Sunday, 2 March 1958, after a trans-Antarctic journey lasting ninety-nine days. In fact it was really ninety-eight days, as Bunny said, since we had crossed the date-line on reaching the Pole. Time, finally, for a warm meal and a decent wash. Bunny was in the bath when the good news came in from the Palace that he had been awarded a knighthood, and with that the expedition was over. Several years of effort culminating in three months of battle across the icebound continent, not because we doubted it was there, but rather to discover with some scientific certainty a little more about what exactly was there; and to answer the simple question, *could it be done*? Could man rise to the challenge of *crossing this unknown*?

Well, the answer was a resounding yes, and Bunny Fuchs had made it happen. In Bunny the world had a man who was up to the challenge of this tough place; he was such an impressive character. His confidence was unshakeable and he was competitive to the core. At 50 he was still incredibly strong, single-minded and full of endurance and determination, qualities fundamental for a crossing of the Antarctic continent. Bunny was to become one of the twentieth century's heroes – he was a man who commanded our admiration, obedience and co-operation. He pushed the Antarctic expedition through to its conclusion by the sheer force of his willpower, and proved himself right on many occasions when others took an opposite view, for instance by showing it was possible to land in the Weddell Sea two years running (on this point his critics were utterly confounded).

In the teeth of controversy and a host of Antarctic problems he had crossed the continent as he said he would. He planned

operations almost single-handedly, devised his own methods without asking a soul for advice, and issued his succinct orders whenever his mind was made up. The Bunny Fuchs we all came to respect was like the profile of the continent itself – tough, flat, unchanging, dogged. After three years in his company I could not say I knew him, but I admired the way he dealt with each challenge calmly but forcefully. He was strong, like Ed Hillary, who even from our very earliest days together had always tackled his problems by means of the bold frontal assault, though he would instantly scrap a good idea for a better one. Yet – and here's the shared ground – there was just nothing more appealing for both men than when something was said to be impossible.

&

I have always been drawn to the mountains and I never thought that I would be a flat, polar man, but there is something about the Antarctic that pulls on your heart; however unpleasant the weather, and downright terrible, or tedious, the job, the simple fact that you are there is a treasure in itself. Not many people are lucky enough to reach Antarctica. I've said it many times, and in different contexts, but I do genuinely believe that we were the lucky ones.

Antarctica is seductive too. You quickly forget those moments – and there were many – when you weren't enjoying yourself, and your nostalgic memories of the ice and snow grow sweeter as the years pass. The undeniable size of this wilderness is still awe-inspiring and, even as the modern world nibbles at its edges, the beauty and sheer scale of Antarctica keep calling out. It's a deeply human response to such a magnificently inhuman place. Shackleton felt it too; in trying to account for

it he borrowed the phrase 'the lure of little voices' from Robert Service, one of his favourite poets, when he wrote:

Men go out into the void spaces of the world for various reasons. Some are actuated simply by a love of adventure, some have a keen thirst for scientific knowledge, and others again are drawn away from the trodden paths by 'the lure of little voices', the mysterious fascination of the unknown.

It's important to listen to these voices as often as you can. That said, you don't have to travel all the way to Antarctica to be reminded of the brilliance of our planet. And besides, as our world seems to shrink every day it is good, and right, that some places survive at the edge of the map, not too touched or trodden upon by mankind. Antarctica clearly must be one of these places.

Back in 1958, while the rest of the crossing party sailed on to London, I stopped over in New Zealand and was glad of the chance to be home and spend time with my family. I caught up with the expedition again, landing in London by air on the first commercial flight over the North Pole to Amsterdam from Honolulu. This was a brave new world indeed. I took a train to Southampton and met everyone as the boat arrived. Thousands of people lined the quayside – a sea of waving flags and happy faces. After speeches and handshakes we all took a special train up to London for more of the same.

It was a hugely busy time, stimulating, chaotic. I worked non-stop on the film of our adventure, *Antarctic Crossing*, which seemed to go down well with audiences and was even nominated for an Oscar that year. Bunny worked hard on his book – as was his style, head down, bashing out page after page – and I helped with all the images. Ed also worked on an account of

ABOVE Ed Hillary joined us for the final stages of the crossing, sharing a tent with Bunny. As soon as the Sno-Cats halted for the day, sledges were unlashed and tents erected in quick time. Before long, puffs of steam were drifting out of the ventilators as brews bubbled over the Primuses. Here, Ed and Bunny melt a chunk of ice in their tent to make some tea.

his side of things. I mentioned a phrase, 'no latitude for error', thinking one day that it might make a nice title for my Antarctic memoirs, but Ed promptly took it for his own book. I didn't mind one bit though, that's pure Ed. He was always able to make real the dreams or thoughts of others. And he had a lion's share of great ideas of his own too.

We both continued to lecture and, as after Everest, were invited to all sorts of glittering gatherings. I was lucky enough again to meet many explorers of old. These were the men that I knew little about before I went to Antarctica, but after a long winter in our hut with a great polar library I could not help but read about and be in awe of their achievements. Bunny and I went to Norway and we were pleased to meet the ski champion Olav Bjaaland. He was by then an old man, but he had been with Amundsen when they were the first to reach the South Pole in 1911, and was the only member of the five-man team then still alive. He often skied at the front so that the sledge dogs had something to run after, and it was he who took the famous photographs at the Pole. In 1954 at the Explorers Club in New York I met Matthew Henson, who sledged with Robert Peary towards the North Pole in 1909. A gentle man and modest, he really should have been better known. In later years, while Peary got all the medals, Matthew worked as a lift-boy, running an elevator in one of the new skyscrapers. Exploration heroics don't always lead to fame and fortune.

The times were certainly changing. No matter how advanced our Sno-Cats and other equipment felt to us, even as we departed it seemed our journey was somehow fading into history, destined to be forgotten perhaps. Today it appears to be the ultimate for modern polar travellers to make their journey in the most difficult, old-fashioned, muscular way possible. It's ironic that Scott has frequently been criticized for not using dogs and for stubbornly man-hauling, but this is exactly what the purists demand of the best polar expeditions now.

In 1958 the world was looking to the future – one of rockets, radars and the beginnings of a race into space. The Soviets launched their satellite Sputnik 1 while we were still in our little hut surrounded by snowdrifts. The IGY scientists were discovering cosmic rays and theorizing about the tectonic movements of the Earth. Just three years after our return, on 12 April 1961, Yuri Gagarin was shot into orbit in his Vostok spacecraft, and soon afterwards America pledged to put a man on the moon. Perhaps the TAE really was, as some have written, the last hurrah of a bygone age. But I do think some things can speak across the generations. Courage and innovation are needed no matter what year an expedition sets out.

Curiosity is the heartbeat of exploration – the willingness to have a go and to try and see what is over the next mountain ridge, or beyond the horizon of a plateau iced in millennial snow. But I would also add that optimism and cheerfulness are vital ingredients. There is nothing more cheering when you're freezing in a tent, far from home, than to be able to have a good joke about it. A smile can go a long way.

Did I enjoy Antarctica? Of course, yes, and looking back I see that it really was a privilege to be part of a great undertaking at such an important moment in Antarctica's history. No matter how weary we became of the long days driving, or the delicate but backbreaking labour of prodding for invisible crevasses, the desire to get across had become intimate to us all. It was a shared ambition and we were all to play a part in the successful result. We might not have dreamt about this place before we came, but we would all do so for many years afterwards.

ABOVE One of our Sno-Cats, *Haywire*, was returned by ship to London and then went on a tour of towns all over England, arranged by our major sponsor, British Petroleum. Here Bunny is speaking to a crowd of people in Trafalgar Square on 14 May 1958.

PORTFOLIO

BEYOND THE HORIZON

ABOVE After all the delays, we finally reached the most southerly point on Earth on 20 January 1958. The United States had established a scientific base there and we were treated with wonderful hospitality: the South Pole did not, then at least, get many visitors.

RIGHT With the 'Race for the Pole' controversy bubbling away in the press, the journalists clamoured for the shot of the two men meeting: how would they greet each other? 'Hullo, Bunny', Hillary said. 'Damned glad to see you, Ed', replied Fuchs as they shook hands.

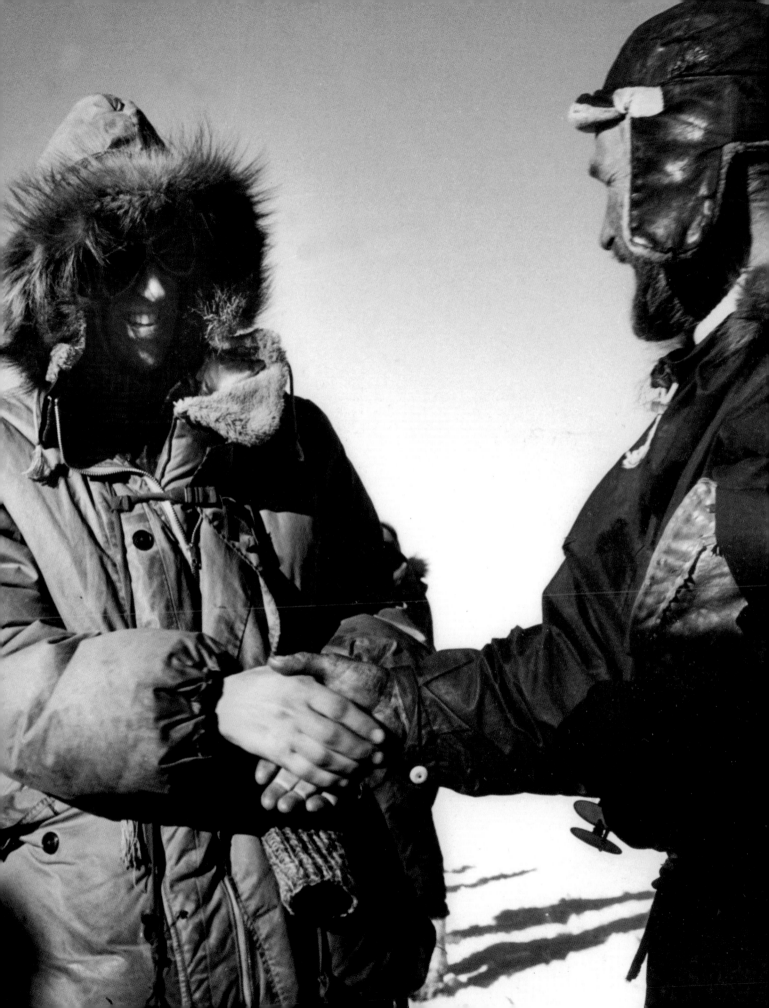

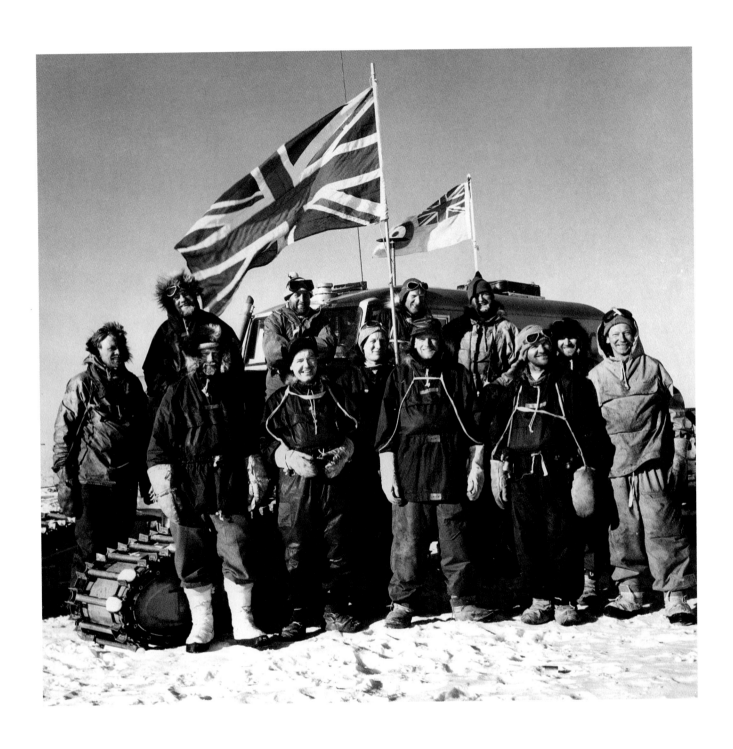

ABOVE Our crossing party – 'Bunny's Boys', as the American's were fond of calling us – at the South Pole on 20 January 1958. There were twelve of us: seven scientists, two engineers, a doctor, a radio operator and me, the photographer-mountaineer. Left to right: (back row) David Pratt, Hal Lister, Ralph Lenton, Ken Blaiklock, me; (front row) Bunny Fuchs, Allan Rogers, Geoff Pratt, David Stratton, Jon Stephenson, Hannes la Grange, Roy Homard.

ABOVE With its New Zealand flag flying, my
trusty Weasel *Wrack & Ruin* is at the bottom of
the world. I drove all the way round the South
Pole, which the Americans had marked with a
huge circle of 180 empty fuel drums and the
flags of the United Nations and of America.

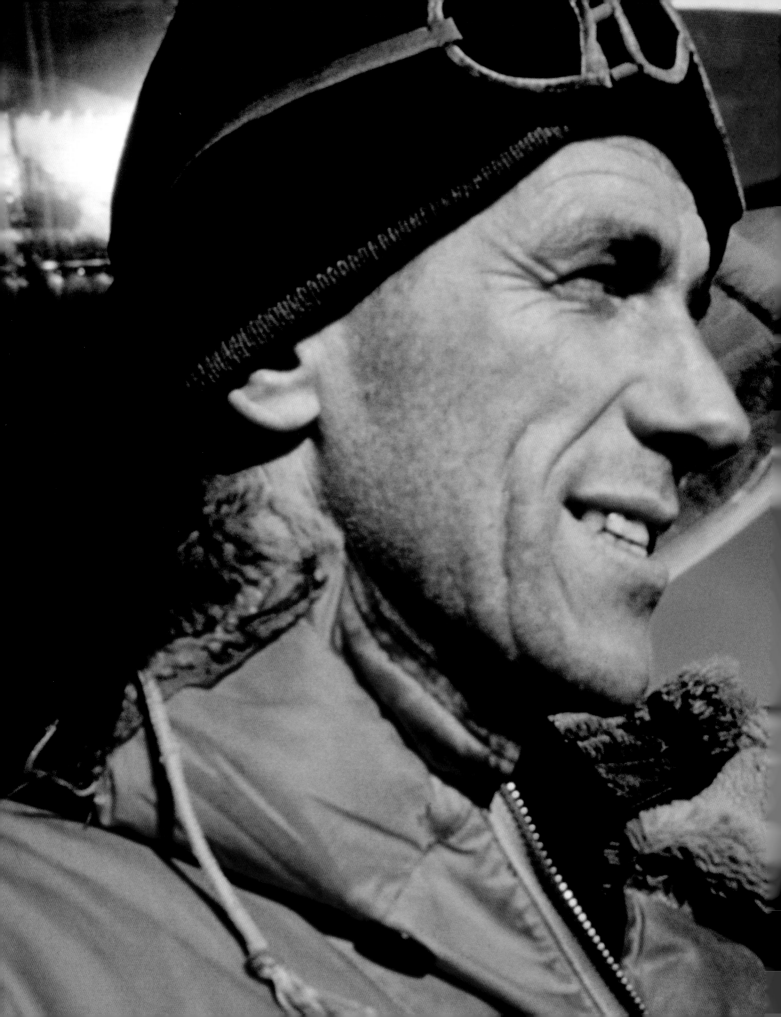

LEFT Ed Hillary and me at the South Pole in 1958, photographed by one of the journalists there. But we were only half way on our great journey – there were still over 1,200 miles to go to complete the crossing before the winter set in. We had the enormous advantage of a route already forged: we could see the tracks made by Ed's tractors etched in low relief by the wind, leading us on like railway lines.

FOLLOWING This double exposure was an accident, but I think it captures the chaos of our arrival at the South Pole well. Our lead Sno-Cat, with Bunny at the wheel, arrived first. A rowdy group of journalists, scientists and servicemen were there to greet us. We later went inside the base, where the Americans treated us to a meal that included a very large cake iced in red, white and blue. They broke out bourbon and beer, but most of us were too exhausted to do the feast justice.

PAGE 174/175 During our descent of the Skelton Glacier in February 1958 we were pinned down by a severe storm of drifting snows. We pitched our tents amid the roaring winds. Having slept on the South Col high on Everest I was used to foul conditions, but nothing quite prepared me for this.

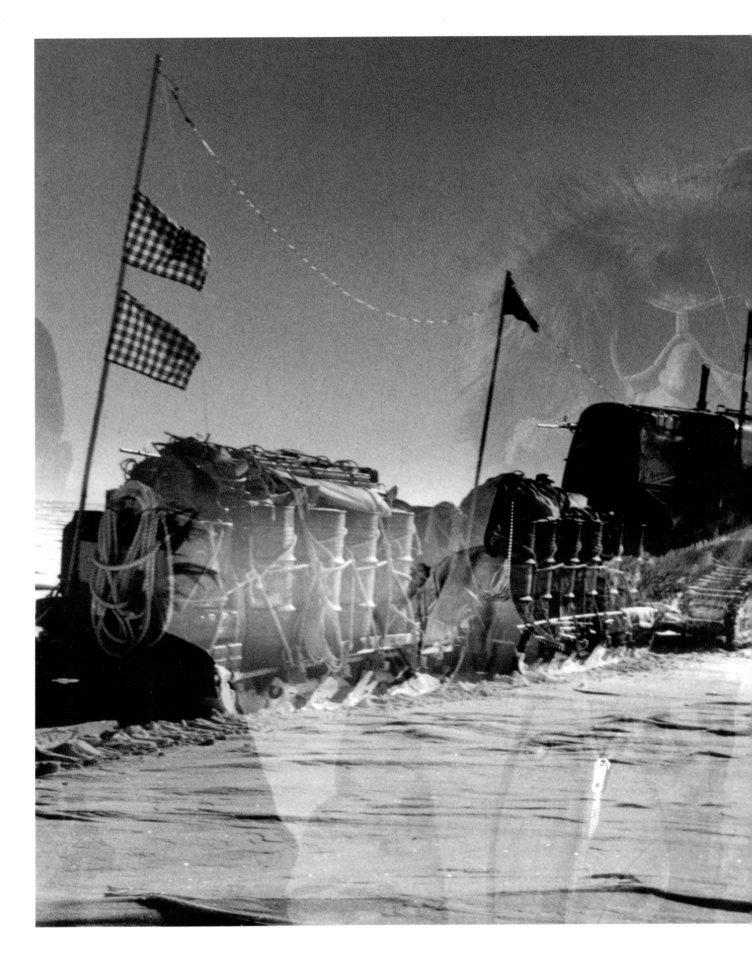

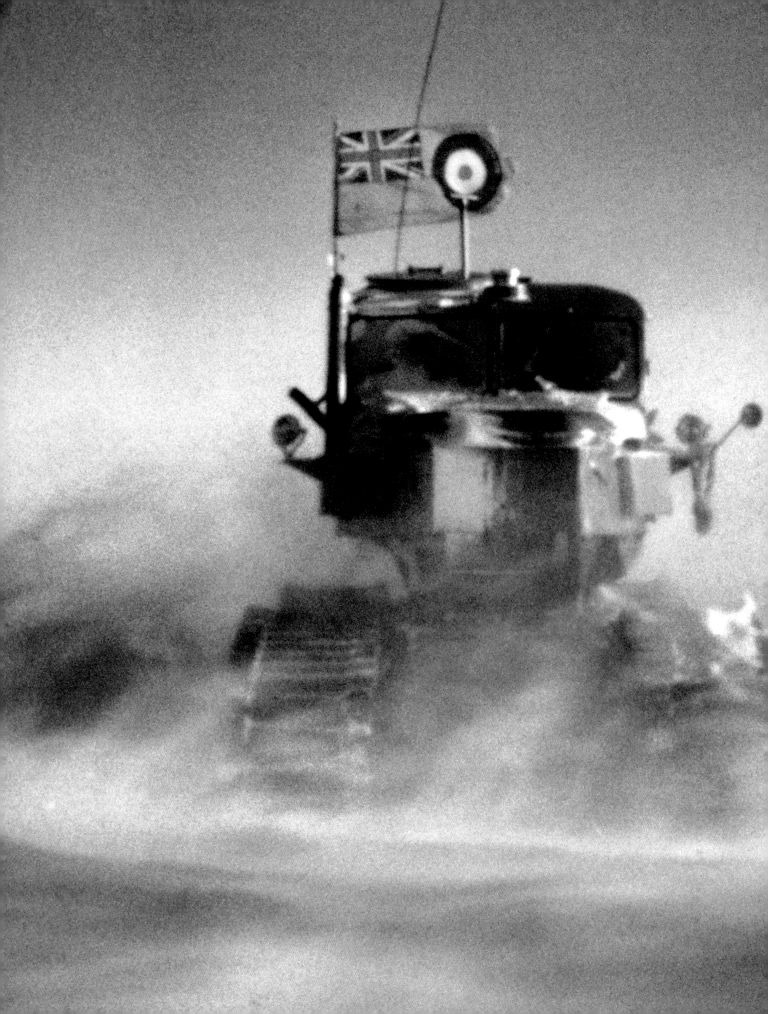

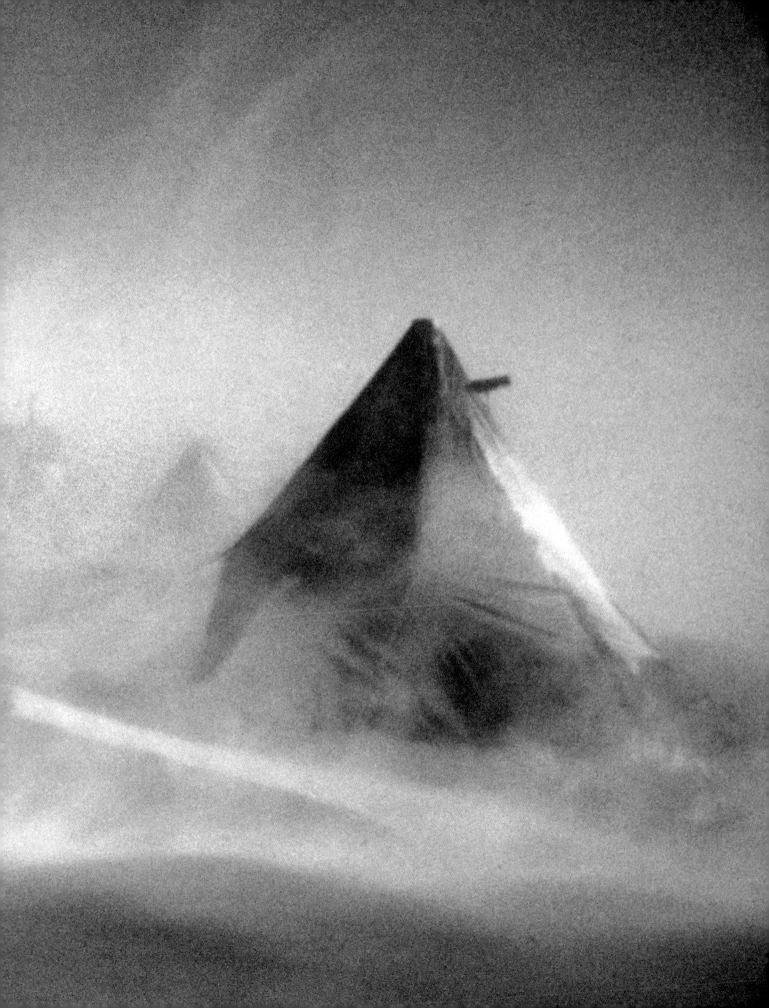

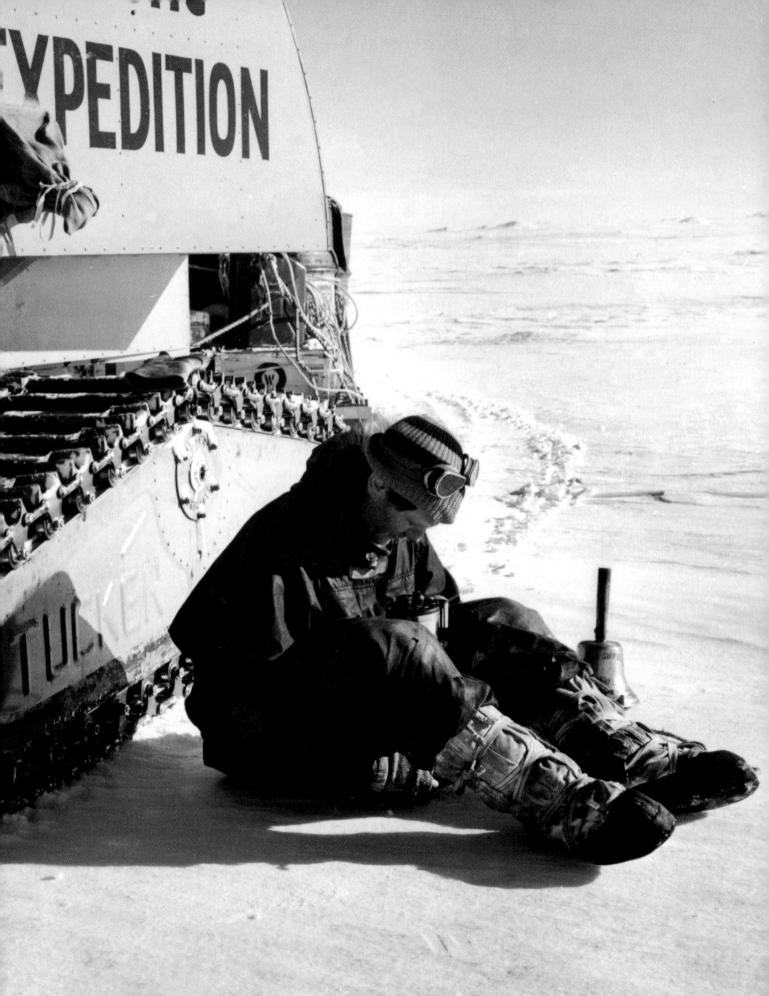

LEFT AND ABOVE Geoff Pratt making a gravity measurement while on the polar plateau. The bell was rung to warn us to switch off engines and stand still. With a roar and a flurry of snow a seismic sounding was fired. Taking daily scientific readings, we careered on at a good pace, finding Ed's depots spaced along our route. Scott had walked 1,800 desperate miles on foot, and died just short of his final food depot. We crossed the glorious mountain peaks on the Pacific coast and plunged down a winding glacier, descending from 8,000 ft to sea level in just 60 miles.

177

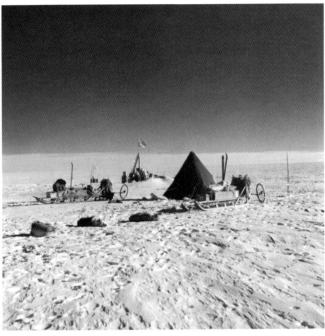
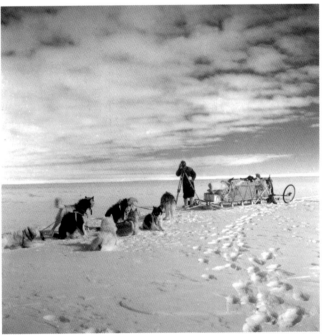
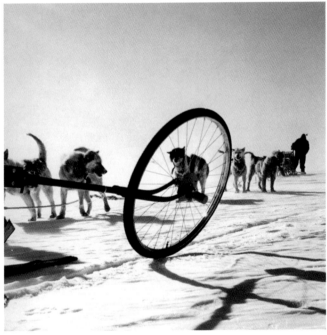

ABOVE Clockwise from top left: the New Zealand Northern Party surveyors at work between Fry and Mawson glaciers. A sledging camp on the polar plateau near Depot 700; wheels attached to the back of the sledges were for recording mileage. Bob Miller, of Ed's Southern Party, taking a noon-sight on New Year's Day 1958.

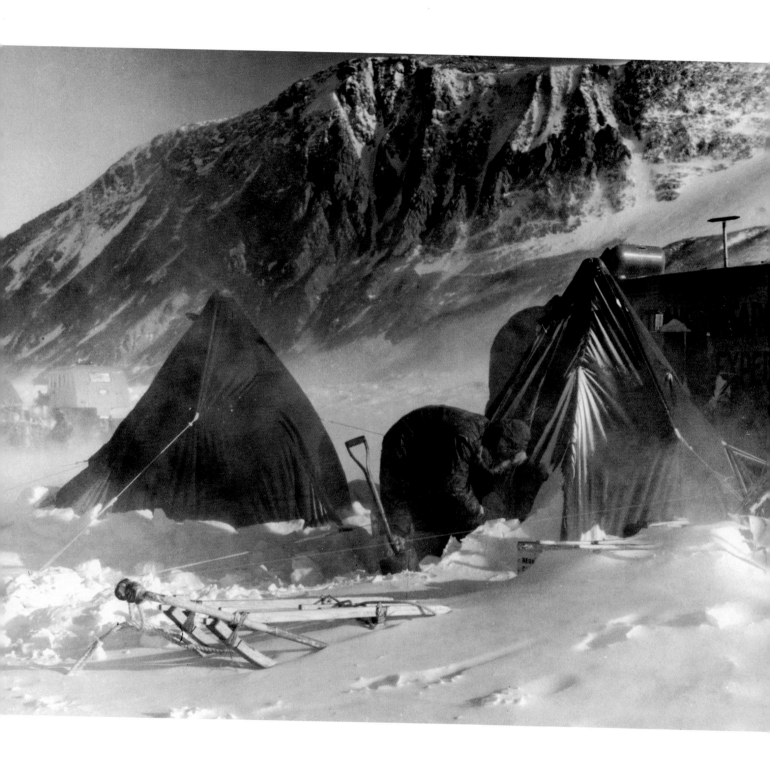

ABOVE On the Skelton Glacier in high
wind and drifting snow, with the
temperature falling below minus 40°F,
we struggled to get the tents up. All
night long the poles were bending as
the sides of the tent flapped furiously.

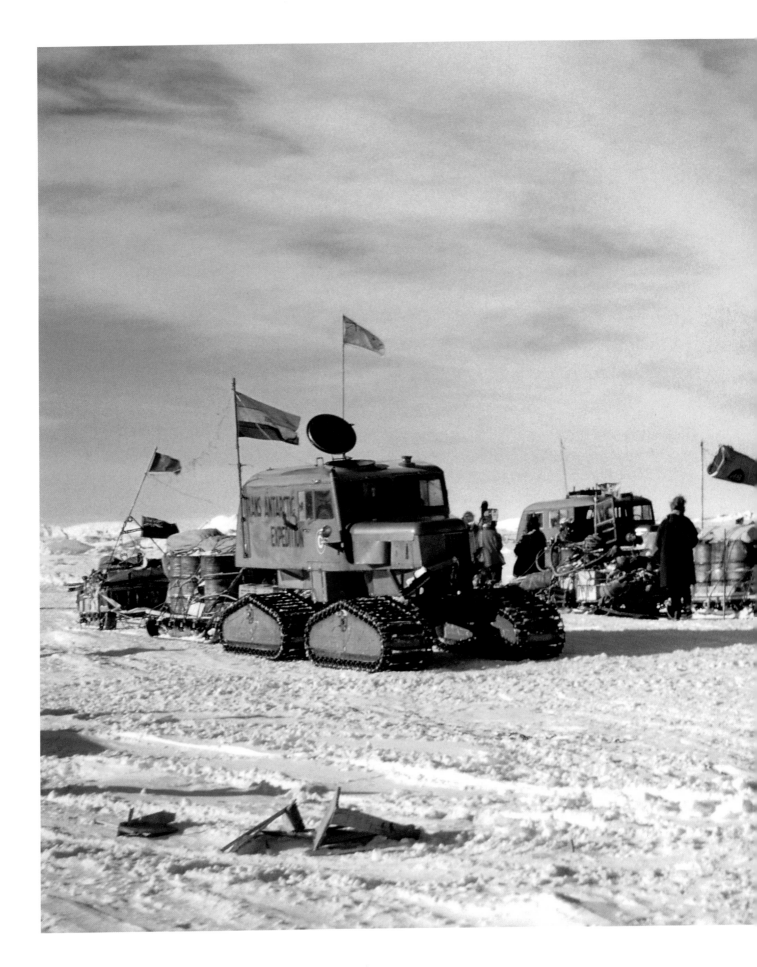

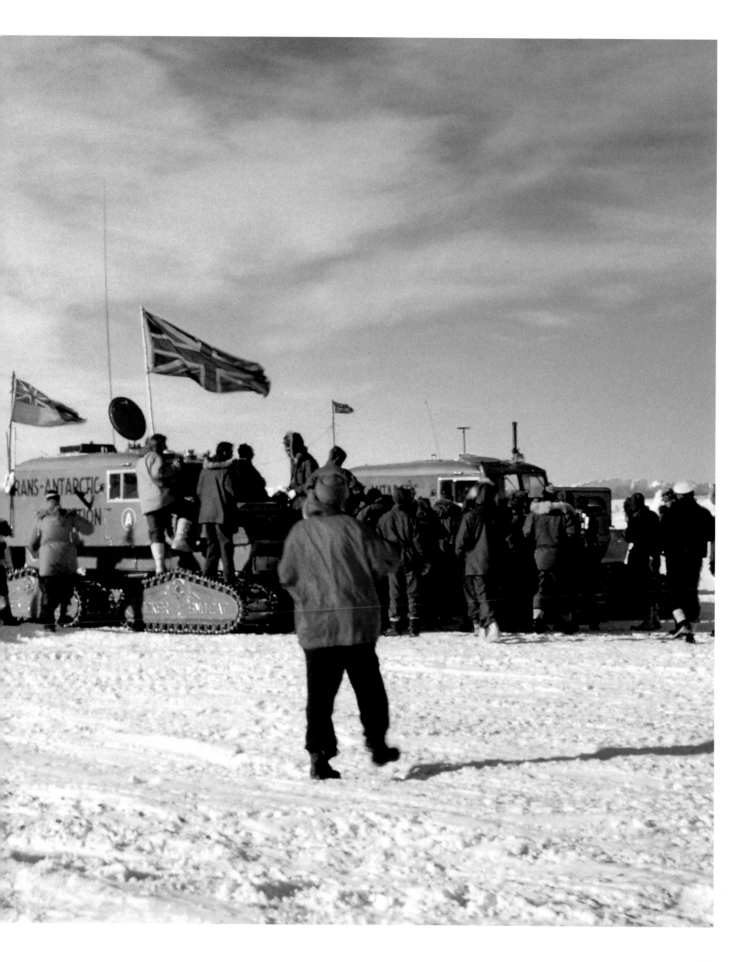

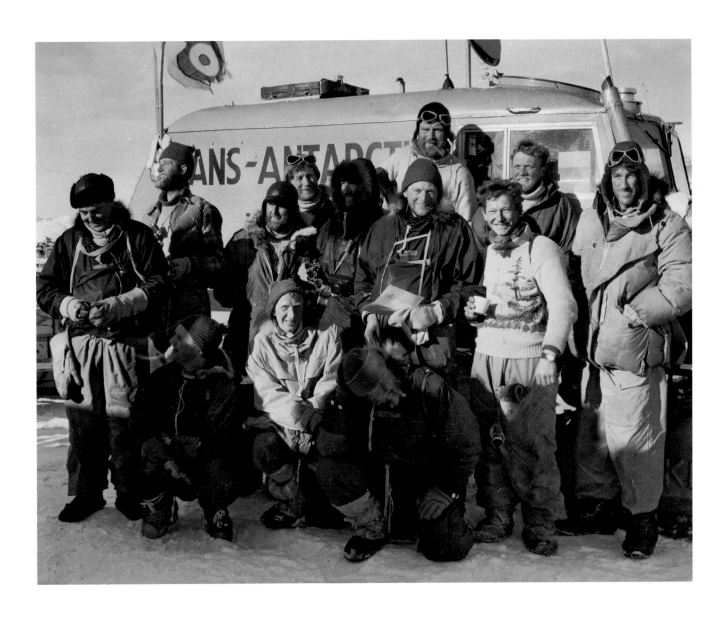

PREVIOUS On 2 March 1958 Scott Base finally came into view, Vehicles raced out across the smooth sea ice to meet us and a huge crowd gave us a noisy welcome. It was a moment of great happiness, particularly for Bunny – the realization of a dream. We were all hugely relieved, and a little surprised, to think that we had finally made it.

ABOVE Our team at Scott Base, journey's end at last. It had taken us ninety-nine days to cross and some three years of effort. Shackleton had called it 'the last great polar journey', and despite all the technological advances that had made our success possible – Sno-Cats, radio and aircraft support – it was still a formidable undertaking.

RIGHT Now it was over, Bunny went off for a bath, his first since we had left the Pole over a month before. While he was soaking in the steaming water, a message arrived from the Queen to say she'd awarded him a knighthood.

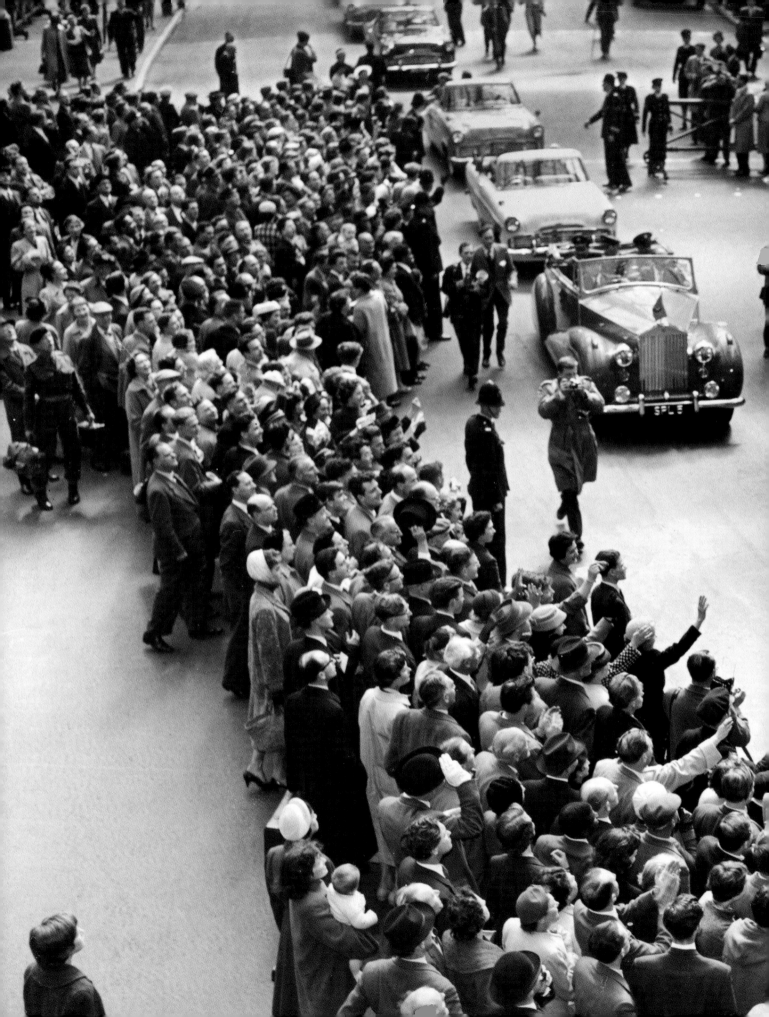

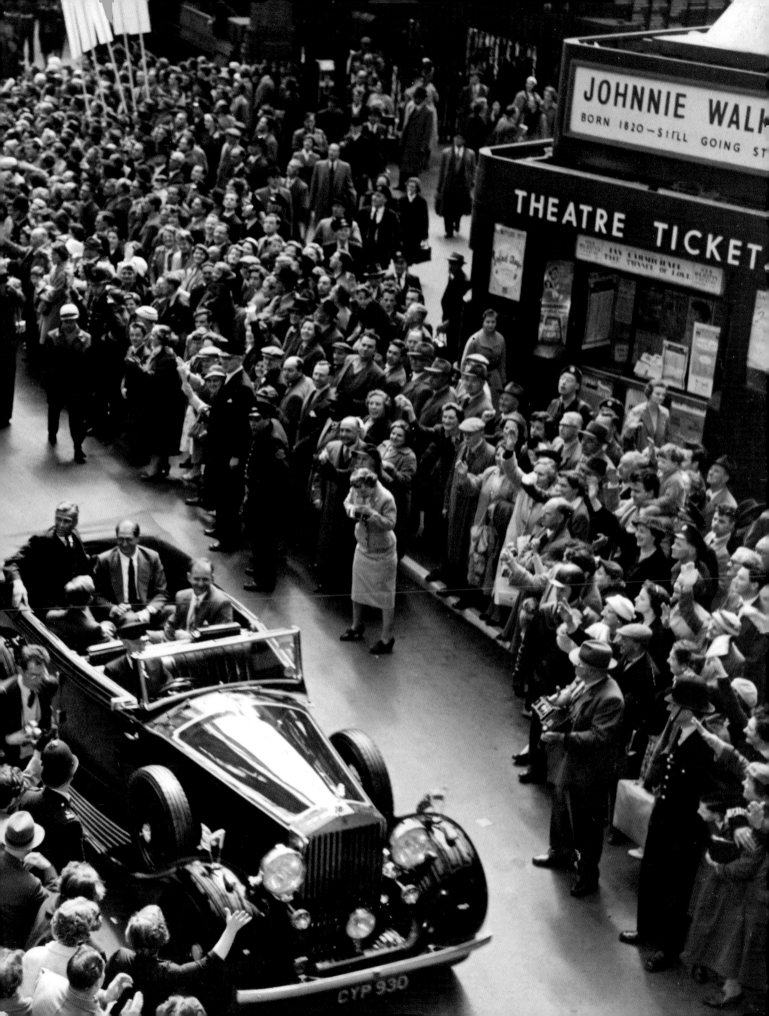

PAGES **184–187** We arrived back in England on 12 May 1958 to a tremendous welcome, perhaps even greater than the one I'd experienced after Everest. From Waterloo Station a cavalcade of open-topped cars drove us through cheering crowds. Bunny and David Stratton gave the first public lectures in London, at the RGS, and then to thousands at the Royal Festival Hall. The Queen and Duke of Edinburgh came along too. We later learnt that the Queen had named one of her racing horses Sno-Cat, though I'm not sure it enjoyed huge success on the track.

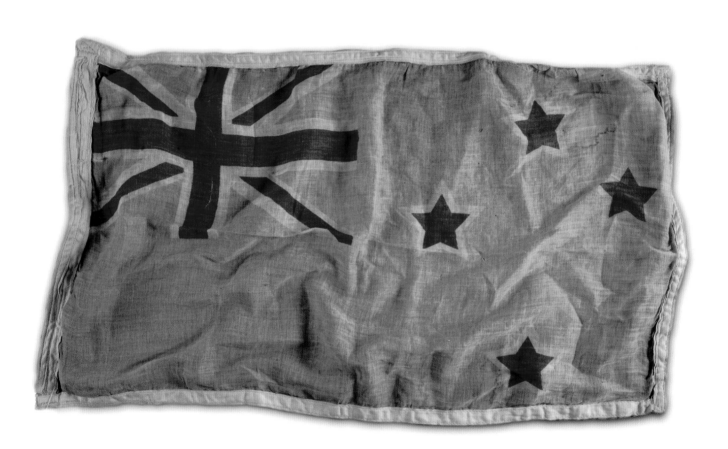

4 | REFLECTIONS

These men expanded the realms of possibility. Most of us will never climb Mount Everest, cross Antarctica, or land on the moon, but we know we can. The truth is we are all liberated by the successes of others because they show it can be done.

Peter Hillary, 2013

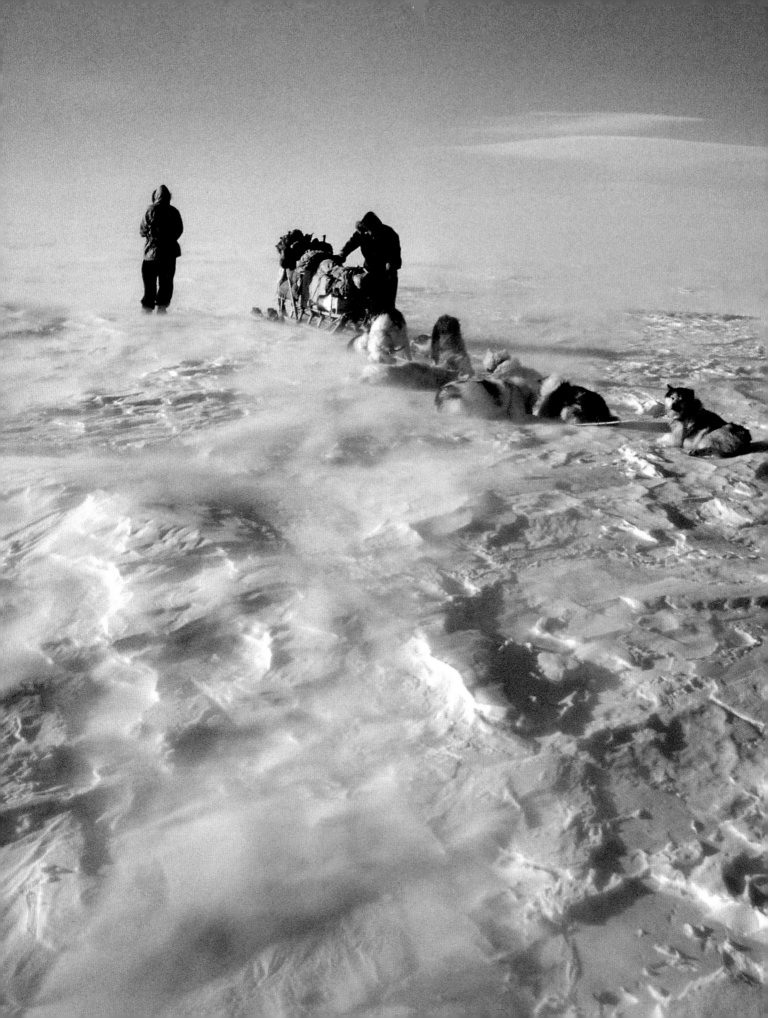

THE NOTHING IS EVERYTHING

ARVED FUCHS

Without a trace of fear, the little Adélie penguin waddles curiously along the shore towards me and stops directly at my feet. No question – he's at home here. Hope Bay on the Antarctic Peninsula is his world, I'm just a guest. He prods my boots with his beak with a look that seems to say: 'What are you doing here?'

I have heard a different question hundreds of times: 'Why do you always go back to the cold?' And every time I'm a little helpless, struggling for words. The vague answers I sometimes give – 'because it's beautiful' or 'because the landscape is fascinating' – rarely satisfy me, let alone the person asking the question. It is so hard to explain something that casts such a spell over you.

What is the appeal of a continent that is about twice the size of Australia, but covered almost completely in ice? It is a continent of superlatives, but none of its qualities are particularly inviting. The lowest temperature ever recorded on Earth, minus 89.2°C (-128.6°F) was noted here. Fierce winds of 300 km per hour (186 miles per hour) are not uncommon; and it is – unsurprisingly – the most desolate continent. It would appear that there is nothing here for man. Surrounded by the stormiest ocean in the world, the approach is also a committed adventure. Resistant, even hostile to life, surely this cannot be an attractive landscape? No one – you might think – in his or her right senses would waste even a moment's thought on spending a vacation here. And yet the number of people who come increases year by year. Are they all hopeless masochists? Looking at the Antarctic traveller, you will be amazed to find that in most cases people are acting in very carefully considered ways. Whether scientists, adventurers or tourists – they all come here because they really want to. Anyone travelling to Antarctica has to do so with deep conviction.

That said, there are also those who are flown to 89° South latitude to walk or race the remaining one degree – around 112 km (70 miles) – to the South Pole. They often then proudly proclaim that they have 'won', or even 'conquered' the Pole. These so-called Last Degree expeditions are a nightmare to me – but they have become increasingly popular. This is a South Pole for everyone, available like a desirable destination, a St Moritz or an Aspen, just a little more exclusive perhaps. And soon it will be more available still, with all-terrain cars, motorcycles even, and regular tourist flights. The true spirit of a South Pole expedition is in the *way* you get there, not just because you *can*.

When I first came to Antarctica in 1989, flying in an ancient DC-6 chartered from Chile, we landed on polished slopes of ice. As the roar of the big radial engines died and I bundled myself up in my thick jacket to step outside, it was as if I had just landed in a spacecraft on another planet. The sudden silence was overpowering and almost physically palpable. With the intensity of the piercing wind, each noise penetrated me. My eyes narrowed in vain as I tried to judge distances. My senses were overwhelmed. It was all too instant.

Over the next hundred days, together with Reinhold Messner, I walked about 2,500 km (1,550 miles), hauling a 130-kg (287-lb) sledge behind me. It was the first time the continent had been crossed on foot without dogs or machines. I suppose we had created a part of polar history, but I was following the men of the Trans-Antarctic Expedition of 1955–58, and they in turn were inspired by Ernest Shackleton's voyage, which headed south in 1914 to try a great crossing. It was Shackleton's dream – something he had imagined over seventy years before me – a goal he had not managed to achieve.

LEFT Snow blows across the ice cap near the Mawson Glacier. Captain Scott described this as 'the most desolate region on earth'. Here New Zealanders Bernie Gunn and Murray Douglas were heading north to climb Mount Gauss. This photograph is by Bernie, using a timer and with the camera fixed to his survey tripod.

PREVIOUS This little New Zealand flag flew from the engine cowl of George's Weasel *Wrack & Ruin* across Antarctica. By the end of its journey it had turned almost white, bleached by the fierce Antarctic weather.

But had he failed, though? Some people still say that Shackleton was a failure, a man who never fulfilled his life's aim, or reached the South Pole, which he'd attempted on a previous expedition in 1909. What nonsense! Shackleton is a hero for me. Life should not be measured as a performance, with success only marked by the reaching of a destination. For me, Shackleton was one of the most significant polar explorers the world has seen. To turn back just short of 160 km (100 miles) from the South Pole, though he would have been the first man to have reached that magic point, is almost unbelievable. To decide to live to fight another day is evidence of his calmness and sense of responsibility. He recognized the hopelessness of the situation and made a great decision. 'Better a live donkey than a dead lion', he wrote to his wife.

Shackleton's legendary journey in the lifeboat *James Caird* is equally admirable. After the destruction of his expedition ship, *Endurance*, he gathered his shipwrecked men on the ice. They were desperate and many blamed him for their misfortune. Scarcely anyone believed that a rescue was possible. And then Shackleton, standing in the midst of his men, *promised* them rescue. To say so was one thing, but that the men believed in him is another. He was able to put his words into action despite the truly desperate situation.

Their subsequent ordeal across the Weddell Sea, making landfall on Elephant Island, and eventually finding salvation in South Georgia, is unprecedented in polar history. I have lived this adventure myself, travelling the same route in a replica of the original boat in 2000. Having done this my admiration for Shackleton is boundless. I did it willingly and well prepared – Shackleton, however, had no choice.

When I arrived exhausted but happy at the finish of our crossing of Antarctica, everything was somehow different. It was no longer a question of whether I would come back to Antarctica, just when. I had been frozen, exhausted and hungry. I had walked my feet sore. But I had enjoyed every moment and was rewarded by the effort. It was a sensory experience too: silence and time, light and darkness, each have a different quality and intensity here. This was life as I had never lived it before.

Antarctica is a continent bursting with contradictions: in contrast to the plateau, which is harsh and empty, the coastal areas are full of variety. In the penguin colonies the animals throng in their hundreds of thousands side by side – as if this were the only place in the world. Elephant seals doze in the sunshine, fur seals defend their territory and chase anyone who ventures near. This is a serious, beautiful, challenging environment. Even when seasick, rolling south in your ship, as the first icebergs appear shimmering and drifting in the stormy sea, all is forgiven; no two icebergs are the same as they pass in an endless procession. The sounds, the smells, the building storm clouds, the hot sun, the break in the ice, a firework of colours – they are all part of the overall impression.

Nowhere else in the world have I felt so much humility before creation as here. The normal world is overtaken, eclipsed by nature in its largest form, and everything seems immediate, important and essential to life. The huge expanses of empty sea, vast ice, open sky – the great swathes of nothing – are everything to me.

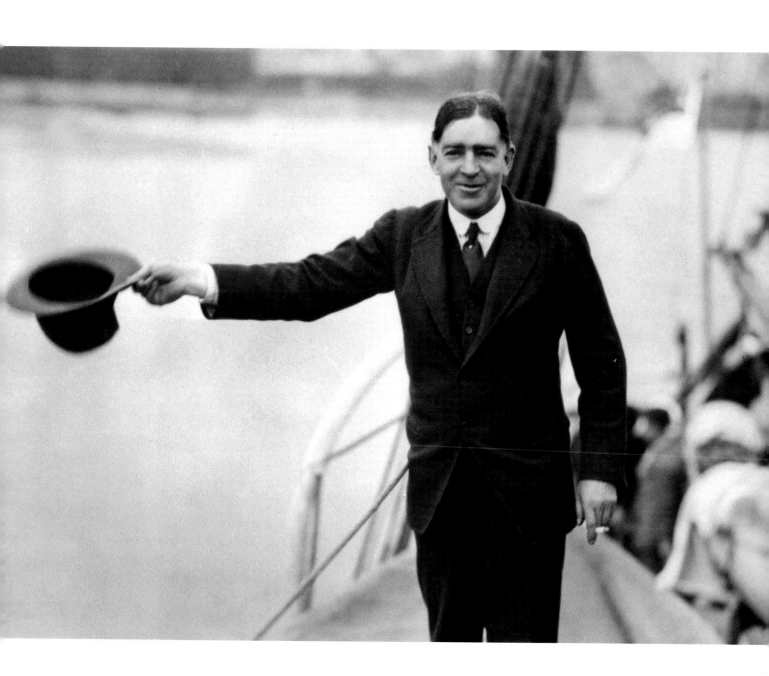

ABOVE As his ship *Quest* motored down the Thames on
17 September 1921, Shackleton waved a final farewell
to large crowds. They would never see him again. He died
of heart failure early in the morning of 5 January 1922,
anchored at Grytviken in South Georgia. His body is buried
in the small cemetery there.

ADVENTUROUS HEARTS

SIR WALLY HERBERT

It was my good fortune to go to the Antarctic for the first time in the 1950s, just before the wave of science broke. I was undeniably a romantic and the appeal of the South was for the rigours and adventure of it all, and I was not yet driven by the quest for knowledge. My companions on our surveying journeys were men in the same mould – we revelled in the blizzards and enjoyed every tough minute. In just a few years, though, man the scientist would come, bringing with him his retinue of servicemen and their thundering machinery. They preferred to spend their days in their geophysical observatories, comfortable and snug, and often had few words in common with our ideas of a continent alive with heroic ideals and explorers of old. The men we admired were no longer here.

I sailed for Antarctica on the research ship *Shackleton* on a cold and rainy day, 27 December 1955. We were following a few weeks in the wake of *Theron*, the Trans-Antarctic Expedition's advance party ship. In the Falklands I joined the old *John Biscoe* for passage to Hope Bay at the northernmost tip of the Antarctic Peninsula, which was to be my base for the next two years of dog-sledging and mapping. David Stratton and his fellow surveyor Ken Blaiklock, members of the Fuchs expedition, were both Hope Bay men. We were keen to follow in their footsteps.

To winter in the Antarctic is to climb a hill in the dark: a long, hard struggle because the mind and body are unfamiliar with the experience. At the summit – Midwinter's Day, 21 June – there is a feeling of elation, the effort of getting there is momentarily forgotten in the intoxication that accompanies the shaking of hands and slapping of backs. For some men the descent to sunrise is worse than the climb – for others the run down starts easily, a soothing rhythm, a delightfully carefree loping movement which gathers speed.

That post-midwinter rhythm awakened the minds of men who had been torpid and insensitive during the darkening period. We were racing towards spring. The survey office and the sledge workshop came alive. The smell of wood and linseed oil, rope and canvas, dogs, dope, blubber, tobacco; the clutter of brightly painted boxes, half-built sledges, filed rations bulging in polythene bags; the classical symphonies on the tape recorder, the buzz of conversation, and the chatter of the sewing machine – all built up an atmosphere of urgency, of expectation. It was a pocket of the old expedition spirit. In the forefront of our minds were the men who had wintered in Antarctica before us.

My task for the next few years was to map the plateau, coasts, mountains and glaciers from Hope Bay to Portal Point, some 26,000 sq. km (10,000 sq. miles). We actually spent the entire first year laying depots of food and fuel to support the journey we would later make – the first crossing of the Antarctic Peninsula – and we had no aircraft to help us. We were four men with two teams of dogs, and in fifty days we achieved what many had thought impossible. Yet seldom have I ever been so sharply aware of the narrow margin between safety and disaster, whether enduring blizzards confined to our small tent, or crossing precarious ridges as clouds surged over our route. Once we had started, we had no choice but to continue on.

For a month, at journey's end, we survived in a small refuge hut until the *John Biscoe* was spotted weaving her way through the ice towards us. Not long after I would be making my way home, hitchhiking alone overland through South America, but dreaming of expeditions that would, many years later, result in our first crossing of the Arctic Ocean. But here, in Antarctica in 1956, just as George Lowe and the men of the Trans-Antarctic

LEFT The aurora throbs and shimmers over the base at Shackleton. George took this photograph at 11.43 p.m. on 31 August 1957. They saw the aurora on twenty-one 'nights' that month of total winter darkness.

Expedition were beginning their great journey, it was certainly one of the happiest times of my life. We were a world of men in harmony with our environment. We saw a paradise in snow-scapes and heard music in the wind, for we were young, and on our journeys we felt with the pride of youth that we were making history.

In later years I'd come to know George Lowe and Bunny Fuchs well. In 1967 I was planning my Arctic crossing and Bunny agreed to help me. In time I was blessed with the full support of the Royal Geographical Society and the patronage of HRH The Duke of Edinburgh, and two other doyens of exploration came into the fold: Sir Raymond Priestley, who had been a geologist with Shackleton and Scott, and Rt Revd Launcelot Fleming, Bishop of Norwich, who had been the geologist on the *Penola* expedition of 1934–37 – the last expedition to venture to the Antarctic entirely under sail.

After years of roughing-it in Antarctica, I now had a sports car, a bedsit in London – the very same that had been used by Bunny Fuchs before he had sailed South – and a wealth of experienced explorers each keen to lend advice. I found it easy to admire many of these men, for their actions spoke clearly to me. I was encouraged by those who had gone before, though would need all the skill I could muster to achieve my own polar ambitions. But for all the advice on offer, my own journey had begun long before, with that first overwintering in Antarctica and our forays out across snow and ice. Far away from the grey suits and fast cars, we were young men with eager dogs and full sledges, travelling by compass, sextant and the stars – learning the art of surviving yet also having the time of our lives. My years in Antarctica were crucial to my future success; we were living our dreams almost every day, but also preparing ourselves for journeys we had yet to dare to imagine.

ABOVE Bunny responds to the toast at the Royal Automobile Club in Pall Mall on 10 November 1958, when the expedition was awarded the Diamond Jubilee Trophy. On the far left is David Pratt and next to him Lord Mountbatten.

'Your hazardous journey was an epic of initiative, courage and endurance', Mountbatten declared, adding, appropriately for the location: 'It was also an outstanding contribution in the field of automotive transport!'

SCIENCE AND GEOPOLITICS

KLAUS DODDS

The first overland crossing of the Antarctic continent was achieved on 2 March 1958. A team of men, largely from Britain and New Zealand, had at last realized the aspiration of an earlier generation of explorers, including the legendary Sir Ernest Shackleton. The rather unlikely pairing of polar scientist Sir Vivian Fuchs and the world-famous mountaineer Sir Ed Hillary managed to lead the expedition to success despite a litany of challenges, not least the task of working in such a harsh and dangerous environment.

My interest in the Commonwealth Trans-Antarctic Expedition (the Commonwealth element was later dropped in favour of the shorthand TAE) lies in the various claims made about the crossing. This privately organized expedition was, in my view, caught up in a series of distinct and even *competing* contexts – cultural-national, personal, scientific and geopolitical. To give a sense, for instance, of the cultural-national domain we might draw an easy parallel with the conquest of Everest in 1953, another great expedition that showcased the achievements of a mixed British and New Zealand team. Was the TAE, thus, another example of what had been dubbed a 'new Elizabethan age', whereby Britain and a new Commonwealth revealed a stunning capacity to overcome extraordinary odds to triumph over planet Earth? If that was the case then the widely released photographs of TAE leaders Fuchs and Hillary standing together at the South Pole seemed to embody this spirit well.

But what if the two leaders found one another's company less than appealing? If you investigate the various archival sources held in Cambridge, London, Wellington and Christchurch, a different vision emerges of the TAE – one in which Fuchs and Hillary had rather different leadership styles and expedition agendas. Having interviewed both men, I was left with the distinct impression that they respected each other, but clearly had differing memories of one another's role in the TAE. The press, no doubt, played their part in manufacturing a 'controversy'.

For Hillary, the TAE was an adventure, one in which he could take his converted Ferguson tractors to the South Pole and in so doing tear up the agreement to wait for Fuchs's Sno-Cats making their way across from the Weddell Sea. Hillary was supposed to stop at a supply depot – Depot 700 – but decided to push on to the South Pole. Fuchs, as well as his supporters, felt that Hillary had 'upstaged' him and complained privately of the New Zealander's ambition. For Fuchs, the Cambridge-educated scientist, the TAE was fundamentally a scientific expedition animated by interest in what lay beneath the polar ice sheet. He had been planning the TAE since the 1940s and now he discovered to his horror that Hillary's 'dash to the pole' was grabbing the world's headlines. Local newspapers in New Zealand even mocked what they called Fuchs's 'donnish scientific probings'.

Yet, the TAE was never just a scientific expedition, nor was it just an exploratory adventure. It was an expedition caught up in what was termed 'the Antarctic problem' – in short, who 'owned' the continent and how would future rights there be negotiated? While British polar authorities such as Brian Roberts at the University of Cambridge and Foreign Office polar advisor were not supportive of Fuchs's plan, they could see that a Commonwealth polar crossing had some geopolitical value. In the 1950s, the Antarctic continent was subject to competing territorial claims. Britain and its Commonwealth allies Australia and New Zealand were claimants, but faced counter-claimant pressure from Argentina and Chile. Worse still, from London's point of view, Cold War ally the United States and its main adversary the Soviet Union were actually in agreement on

the status of territorial claims in the Antarctic – they rejected all of them and reserved the right to press their own claims in the future on the basis of their own record of exploration, discovery and activity, including scientific investigation. So rather than being non-claimants, like for instance South Africa and Belgium, they were and remain active semi-claimants.

Fuchs pressed his case within and beyond Cambridge. Apart from the scientific agenda of the TAE, the proposed crossing would send a powerful signal to the superpowers that Britain and its allies could pull off a spectacular achievement. The planned route would ensure that the TAE party never left British-Commonwealth polar territory. And this mattered in 1957–58, in the midst of the International Geophysical Year (IGY), which placed a high premium on Antarctic-based scientific investigation. As part of their IGY plans, the United States established a South Pole research station and made it clear to the other participants, including Britain, that the US research programme would not concern itself with territorial claims. Scientific freedom was paramount and Australia had to reconcile itself to the presence of Soviet stations in Australian Antarctic Territory.

The relationship between science, nationalism and geopolitics was a potent one. Both claimant and semi-claimant could invoke science and nationalism to make a fundamentally geopolitical point about the access to and control of territory. The TAE's demonstration of British-Commonwealth mobility on the ice intersected with the rooted presence of the United States in the form of the South Pole station and its impressive logistical infrastructure.

Almost sixty years on now, the footprint of the TAE is intriguing. Scientifically, Fuchs's team contributed to greater knowledge about the thickness of the Antarctic ice sheet. In the 1950s, our understanding of the polar continent was patchy and full of speculation. The successful completion of the TAE helped bolster the UK's commitment to continue with Antarctic research – serious consideration was given to withdrawal in 1958 on budgetary grounds – and helped to generate a fresh round of public enthusiasm for polar exploits. The dashing adventure across the ice rather than the science, unsurprisingly, was what won the attention of the public. Men and machines were stretched to the proverbial limit.

Expeditions may continue, but the mutually reinforcing relationship between science and geopolitics remains paramount. Antarctica continues to be 'probed' by both scientists and politicians eager to divine the future of humankind and planet Earth.

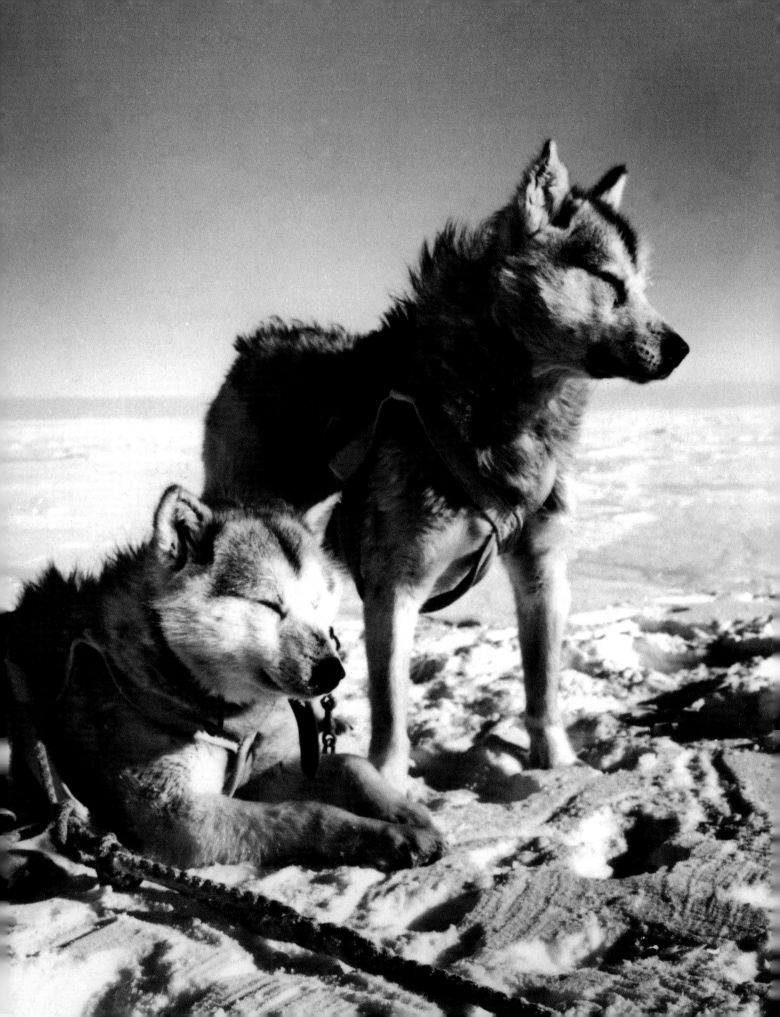

WHO DARES, WINS

GEOFF SOMERS

We all face challenges in our lives, whether we want them or not. It might be school, work, managing a family or simply managing in the family. I can't say that I was anyone special. I did not excel at anything. I was moderate in sport, shy and poor in my studies. I suppose I was very much a Mr Ordinary. As a result of being an academic disaster, continually failing my exams, I left school with neither ambition for regular work, nor much enthusiasm for a trade. I had no qualifications and few ideas, other than a faint hope of passing my life in a reasonable fashion, to get by happily, to find something that I could do. I guess that was my dream.

My real start in life came when I enrolled in a couple of four-week Outward Bound courses, one in Wales and the other in the English Lake District. Here I found my forte: the rough and tough of challenging activities, the joy of the outdoors. Within a year I started my apprenticeship as an Outward Bound instructor and went on to spend seven years in such schools around the world. Early on, one of the other instructors gave a slide presentation about his recently completed three years of working for the British Antarctic Survey. With that, I was hooked.

It would not be for another six years from that first glimpse, though, that I finally chugged my way to the Antarctic continent, with other new recruits, on board the *John Biscoe* research ship. It was September 1978. We were a motley bunch of young men – scientific researchers, essential skilled workmen and a few like me, the outdoor guides. We would be away from home, radios, letters and fresh food for nearly three years.

Life at base on the Antarctic Peninsula was all very well, but it was the environment outside that inspired me, in the winter travelling with my dog team and one companion, and during the summer using snowmobiles on scientific explorations. I

covered several thousands of miles among fjords, glaciers and virgin mountains. To be with the dogs – not pets I assure you – and an agreeable companion, all relying on each other, moving day to day, experiencing the snow and weather in all its facets from frightening storms to magnificent searing sunshine, the thrill of the first midnight sun, and JUST US – this was it! I was not in Antarctica for any altruistic reasons back then, just for my own satisfaction.

From this beginning, Antarctica would become a part of my life. In 1989 I was invited to join the International Trans-Antarctic Expedition. We were six men from six nations, six cultures, different languages and six ways of thinking. Our proposed journey was ludicrous – not bold, just ludicrous. At the time it was thought to be madness to attempt and it is still outrageous when I think about it now. Using three dog teams we would cross, over 221 days, 6,020 km (3,740 miles) by the continent's greatest axis. We would have to start in one winter and continue through the summer into the next, and I was to be the team's navigator.

Again, I could not say I joined for fame, or for personal gain, as financially it would almost ruin me. Nor was it a case of fulfilling a long-held ambition, like Shackleton or Bunny Fuchs. The idea of crossing the continent did not keep me awake at night, because I did not think it possible. It was the lure of the wilderness, the immensity of the undertaking that I considered the attraction: 'Who dares, wins'. I've always remembered those words – *Qui audet adipiscitur*, the motto of the SAS. They rang in my head. We simply had to have a go. Or perhaps, in the words of the indomitable polar traveller Norman Vaughan: 'dream big and dare to fail'. But we did not fail. Our seven-month journey was one of companionship, struggle, little conflict and total

LEFT Nanook and Erik rest on the polar plateau. Along with the other huskies they had served the TAE well and were the first dogs to the South Pole since Amundsen's team in 1911. The Americans kindly flew them back to Scott Base. Some then stayed in Antarctica working at other bases; a few even came back to England, though they were by no means pets. Bunny had one in Cambridge that would menace the local dogs at garden parties.

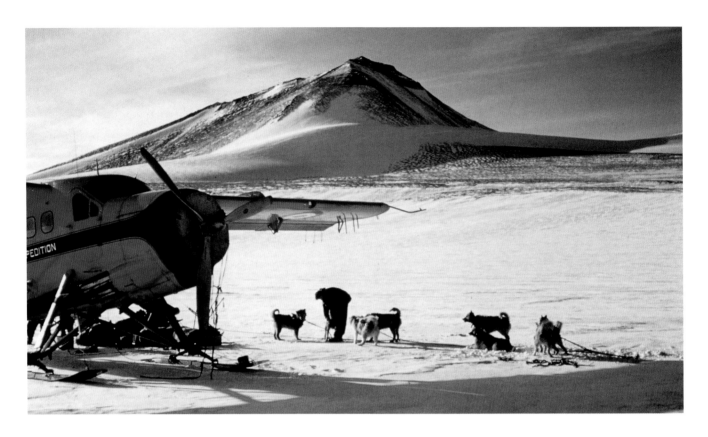

commitment. Once on the ice there was no choice but to keep going. We had a responsibility to our sponsors, but what drove us most of all were the promises made to our families and all those who had helped us. We could not give in or turn back. Though we hoped to send a message about the climate changes taking place there, it was essentially a grand sporting event, and in the end a very personal effort.

Today, having guided groups to both Poles, I can see that each participant has a personal reason for visiting this wilderness. Some go just to race and attain the Poles; others come to savour each and every day, to treasure the experience of being in the wild. By whatever method used – kite, dogs, hauling your own sledge, sitting on a machine – and whatever the distance travelled, the reason is valid in each person's own eyes. Should each of us travel the way that

Scott or Shackleton did? And where do we draw the line? For true integrity should we sail in a small vessel, overwinter, do away with radio or phone, aircraft or motor vehicles altogether?

Regardless of endeavour, the reward is that each of us will come home with stories of a wilderness beyond our expectations. It is true that the vastness and mystery of the continent shrink with increased numbers of visitors, and the fragility of the environment is further exacerbated by overuse. However, it is through tourism that the people of the world are awakened to the need for conservation of these precious areas, whether cold or hot, land or sea. This is the message that I have found after so many years spent travelling through the endless polar snows. I didn't need to cross the continent on foot to discover this for myself, but it certainly helped.

ABOVE This Otter aircraft, flown by the RAF team of John Lewis, Gordon Haslop, mechanic Peter Weston and radio operator Taffy Williams, would later fly all the way from South Ice to Scott Base, completing the first single-engined flight across Antarctica. They took exactly 11 hours to fly 2,288 km (1,422 miles) through the Pole and down the Beardmore Glacier, following the route of Captain Scott. It was a huge achievement, done without any fanfare.

ALONE ACROSS ANTARCTICA

BØRGE OUSLAND

ntarctica is endless, windy, empty and overwhelming. But most of all, it is cold. There's no denying it. Yet the extremes of nothingness here – the loneliness and mind-numbing temperatures – are precisely the things that give it all meaning to me. I find contentment in this environment that life elsewhere can't offer. You have a deeper dialogue with nature and with yourself. An expedition here is therefore not just a physical journey, but very much a state of meditation in which you reach levels inside yourself that you did not know existed. I find it hard to describe – I think that you touch some basic feelings that have dwelt deep inside every human being since the stone age, the state of being one with nature. When I return home and life becomes warm and secure again, I yearn for this land: for that feeling of being on the edge of the universe, with no one but myself to rely on.

I arrived here in 1996 having just completed the first solo and unsupported trip to the North Pole. I felt I had served my apprenticeship on the ice. It was something that I had worked towards for many years. The great journey that was left to do in Antarctica was to cross the continent solo, from ocean to ocean, and that was the goal that I looked to complete. Shackleton had always wanted to get across. I hoped that I would succeed.

The beginning of a solo trip is always the hardest part of any expedition. Of course, the distances seem greater and the task so much bigger than in the planning phase. This is voluntary suffering though: no one but yourself is urging you to go. Watching the plane disappear above my head and then taking the first few steps is an intimate and troubling moment. It's a shock to the system, but you shake yourself out of it and push forwards. You have to. Standing there on the edge of the Weddell Sea, having such a huge distance ahead to cover was almost too much

to comprehend. That's when I understood that to survive in Antarctica you have to take one day at a time.

I reached the Pole on 19 December 1996 but moved quickly on. I had dreamt about this place for so long – imagining it as it was when Amundsen and Scott arrived there in 1911/12, a place so remote, harsh, isolated and beautiful that I felt it should always remain that way. That's how I like to picture the South Pole in my head, but today it resembles a big factory for science. It appears on the horizon like a row of dark huts, or untidy piles of metal. It's a human place now, with buildings and workers, a disorientating mess. I stayed for a little over five hours, but that was almost too long. I was happy to continue on without any celebration – after all, I was only half way.

My most memorable moments on my solo crossing were leaving the intense cold of the plateau and entering the sheltered valley of silence at the top of the Axel Heiberg Glacier. Below me was the glacier itself, bathed in sun, inviting and calm. Far beyond that again I could make out a white, endless plain that stretched to the horizon – the Ross Ice Shelf – and that was the final route home. What came next was a real test of endurance. Many times I wondered if Amundsen really had faced the depth of loose snow that I had to contend with. It was almost incomprehensible to me how anyone could have climbed up here in such conditions. It was bad enough going down.

In order to keep moving at all, I soon had to revert to the counting technique. First I tried counting to a hundred before pausing, but even this proved too much. Soon I was down to fifty, leaning on my ski-sticks and gasping for breath after each pull. It was almost funny. I'd imagined the whole thing would be a piece of cake, all downhill slopes and good running, only to come up against this. It was a dreadful slog. During the whole of

that first day on the glacier I covered my shortest distance so far. I couldn't remember facing such awful conditions.

I'd get there in the end, it was just a matter of time, I consoled myself. The most important thing was not to wear myself out completely, or overstrain tendons and muscles that had already taken a pounding. After twelve gruelling hours, I finally got off the glacier. I was so exhausted by the time I pitched camp that I had problems keeping my balance. But, my heavens, how wonderful it was. My respect for Amundsen increased enormously. I'd regarded his journey as a dawdle more or less, but I take my hat

off to him for being the first man up this glacier. And those poor dogs. What slopes! I'm glad it wasn't me that had to climb them.

I reached Scott Base on Ross Island on 17 January 1997. Quite by chance, I arrived in time for the celebration of the base's fortieth anniversary. Sir Ed Hillary was there and I talked about the great journey I had just been through. Ed joked that it would have been easier using a tractor, as he had done in 1957. We were then able to fly back to the South Pole together a few days later. It took just two and a half hours to fly the same distance it had taken me more than a month to walk.

ABOVE A stunning icescape photographed by Sebastian Copeland near Port Lockroy on the Antarctic Peninsula. The British established a base here in 1944. Bunny Fuchs became overall Field Commander in 1947 and it was on the Antarctic Peninsula, in environments like this, that he would hone his skills as a surveyor and polar traveller.

Before leaving Antarctica, I spent some time wandering around McMurdo Station at the tip of Ross Island. I visited Cape Evans and Captain Scott's old hut and paid my respects to those who had come before me. History felt very close. On Scott's bunk lay some of his clothes, a balaclava and a pair of gloves and boots. He never returned to this hut. His frozen body is still locked somewhere in the ice, buried under years of drifting snows.

On Observation Hill is a cross raised by the men of the *Terra Nova,* a memorial for Scott and his party who died in 1912 on their journey back from the Pole. On it are words from Alfred, Lord Tennyson's poem 'Ulysses': 'To strive, to seek, to find, and not to yield.' The words were chosen by Apsley Cherry-Garrard, who had accompanied Scott to the top of the Beardmore Glacier and was one of the last to see the men alive. For me the line is a poem in itself. They sailed here in wooden ships and for years were cut off from the outside world; and the men who also overwintered here in the 1950s followed in their footsteps. Many other expeditions have come here in the years since, but these men seem to me to be the true heroes of Antarctica. Their struggles and their courage continue to inspire me.

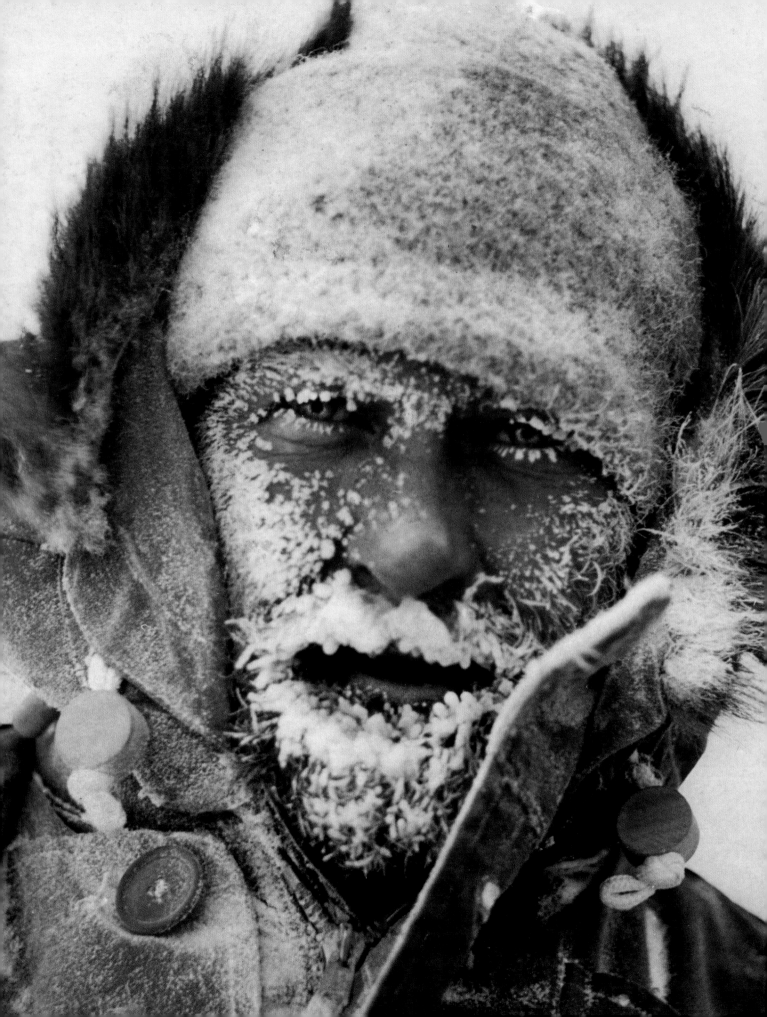

THE BEST IN OURSELVES

FELICITY ASTON

'Any fool can be cold.' This was the first piece of wisdom I was taught when I arrived in Antarctica as a twenty-three year old meteorologist fresh out of university. I was to spend two consecutive winters working for the British Antarctic Survey at Rothera Research Station. As the youngest of an overwintering team of twenty there was a lot to learn. The first lesson was that there was nothing brave or heroic about suffering stoically in the cold: the skill was in keeping yourself warm.

I learnt quickly about the cold. You had to. I became familiar with the dry touch of subzero air, discovering that it is the wind rather than the temperature itself that is the true enemy, and I came to recognize the subtle shift between numb fingers and dangerously numb fingers. I learnt about people too. I saw how characters behaved when they felt vulnerable and noticed changes in the dynamics of our group. I didn't realize it at the time, but it was an experience that was to stand me in good stead when it came to creating and leading my own expedition teams years later.

Reading accounts of the Trans-Antarctic Expedition, and the first ascent of Everest a few years earlier, what strikes me is how much of the writing focuses not on the environment or the challenges faced but on the camaraderie of the experience. Again and again recollections return to the relationships forged and it is clear that for many the loyalty and friendship gained count as an achievement equal to, or perhaps even greater than, the goal itself.

I can understand why. Expeditions allow people to get to know each other very well, very quickly. When cold, tired, hungry and far from home there can be no pretence for long – there is nowhere to hide and all bluff is stripped away. You cannot help but reveal your true character, in all its raw imperfections. When those around us see us at our most exposed and yet offer not only acceptance but also respect and support, something solidifies in our soul. We call it camaraderie and it can be a powerful experience, shaping who we are and inspiring us to be the best possible versions of ourselves.

Travelling in Antarctica on repeated expeditions with different teams taught me the value of camaraderie, but I don't think it was until I had travelled alone in that vast wilderness that I appreciated its true importance. Skiing solo across the continent in 2012 was, for me, an act of homage as much as it was a challenging adventure. It appeared to be a way of showing gratitude and paying respect to a continent that has given me so much. I was drawn to the completeness of moving across a landmass from one coast to the other and felt that by seeing an entire cross-section of this most majestic of places I might come to understand it better.

I had expected travelling alone to be an intimate experience: just me and Antarctica for two peaceful, solitary months. But in fact the shock of loneliness turned out to be a distraction I couldn't get over. I found that the lack of a team didn't just increase the isolation of the experience or the weight of my sledge – it changed me as a person. It affected the decisions I made and the way I made them. From the moment the plane left me on the Ross Ice Shelf I was far more emotionally indulgent than on any other expedition. If I felt upset I cried, if I was annoyed with myself I shouted at the sun. I allowed my inner emotions to be released because there was no one to witness my outbursts. The alone-ness altered my response to the environment around me too. By the time I reached the South Pole, the half-way point of my journey, I saw Antarctica as something like a cruel temptress, luring generation after generation to give so much of themselves to reach the point of 90° South at its heart.

LEFT Pilot John Lewis returns covered in ice and snow after digging out the Otter for a rescue flight to locate Gordon Haslop and Allan Rogers, 23 September 1957. The two men had left a few days earlier in the Auster, but in bad weather and with just one hour of fuel left they had been forced down on to the ice. The main task that bitter night was to de-ice the wings and fuselage so that the Otter would be able to take off the following morning.

Antarctica is certainly addictive, and life after the ice can be difficult. Polar travellers often lose their way once home, feeling that they can never regain that sense of purpose and fulfilment that accompanied their time in Antarctica. What I admire most about George Lowe is that he achieved so much on Everest and in Antarctica, but then didn't lose his way. His companions too: most had happy and rewarding lives of purpose away from the mountains and polar plateaus. Their memories of these epic expeditions enriched rather than haunted the life that came after. For George, it seems that Antarctica was a cherished embellishment on a life already generously endowed with adventure, happiness and achievement in both education – his first love – and his tireless charitable work with Ed Hillary in the Himalaya.

Each of us has to find our own answers. I left the South Pole with a certainty that although Antarctica is a treasured experience, and a privileged one, for me the answer did not lie at the end of the world. It is the emptiness of Antarctica, I think, that allows us to see clearly what has been present the whole time. So is this why we go? To gain insight and understanding? I don't think so – this is just a realization that comes after.

Every polar explorer heading South gets asked, 'Why?' It's a maddening question for those for whom the answer is so self-evident that it is beyond explanation – and yet it is important to try to answer. It strikes me that the motivation that prompts the question is a little of the same motivation that drives us to Poles and mountains and wild places: the basic instinct of curiosity. We are driven by curiosity to know what is out there, to know what the landscape will look and feel like, to know how we as individuals will respond to the challenges we will encounter. When I read of others achieving extraordinary things I am always absorbed by trying to imagine what it would be like to stand in their shoes.

How would it feel to have experienced those moments? Would I be capable of doing the same or would I have found myself lacking? Do I possess the same strength of mind and spirit?

As I read the stories of George Lowe and his companions forging a path across the southern continent on the back of bone-rattling vehicles and tractors, I try to imagine their reality during that expedition. I guess I have an advantage over most in conjuring up what it must have felt like: the relentless cold of the plateau with its endless ability to wreak havoc unexpectedly; the brutal monotony of a landscape which is unchanging in all but the most subtle of ways; the constant and energy-sapping vigilance needed against disaster; the crushing weight of knowing the distance yet to cover. Antarctica is an exhausting place.

Undoubtedly the members of the Trans-Antarctic Expedition must have fought through many tough and miserable days and yet I envy them. I covet the adventure and the camaraderie they shared, but above all, strange as it may sound, what I envy them most are those instances of greatest hardship: days when food, any trace of personal comfort and even rapidly freezing fingers are long forgotten in the greater need to get the job done; moments when the abyss of failure feels very near. I envy them the gruelling stretches because these often become the most precious memories of an expedition. It is precisely at the very worst of times that we find the best in ourselves and in those around us. It is then that we feel most strongly the glow of everything that is magnificent about the human spirit.

I appreciate their struggles because I'm willing to bet that for George Lowe and his comrades the memories of those tough times were the ones they held closest and dearest till the end of their days. Remember – any fool can be cold; the skill is in finding a way to keep warm.

A RISK WORTH TAKING

EIRIK SØNNELAND

I had barely taken a single step and there were still 3,800 km (2,360 miles) to go. The sledge behind me was almost impossible to move. Our companions during that first overwintering at the Norwegian research base 'Troll' – doctor Gunnar Børre Thoresen and our technician Frode Nedrebø – had just given us a hug and wished us a safe journey. I looked over at my best friend and fellow expeditioner, Rolf Bae, and, seeing the frustration in his eyes, realized he couldn't really move his sledge either. We both started laughing; it wasn't a heroic start. Humour had been important to us in all the four years we had thought about this moment, planned and prepared, and it would prove a vital mental tool to bring us through the challenges of our unsupported Trans-Antarctic ski expedition. It ignited something extra within our minds and, step by exhausting step, we slowly moved forwards.

We only travelled for about four hours that first day, at the end of October 2000, before we stopped and put up our tent. We ate freeze-dried food with thick olive oil, which made Rolf puke. He assured me this was normal. Our bodies would soon adapt to the large amount of high-energy oil we'd need. I was worried for him. Seriously, this was just day one of our ski trip. We'd calculated that we could do this crossing of Antarctica in around ninety days. Yet this first day ended like every day on our journey, with two friends talking about absolutely everything in this life, only stopping when our bodies turned off and went to sleep. We had cut our large Antarctic map into many smaller pieces. Every time we walked through one piece of the map we felt successful and transferred it from one bag to another. It was a strong symbol of progress for us.

Personally, I have never understood why people who have made journeys towards the South Pole describe the landscape as monotonous. We felt we were going up and down large waves, and walking through labyrinths of crevasses; the ice dazzled us with its variety of colours. For years we had read about the pioneers in Antarctica. This had given us time to think and dream about how it would feel to get frostbite on our faces; how we would go to the toilet in a storm. We had planned the work and now we worked our plan. What we couldn't prepare for was what most people might say is a cliché: the tantalizing journey in our minds. We endlessly thought about girls, taco dinners with families, perhaps having a beer with friends. Rolf spent whole days imagining cutting the lawn back at his parents' house.

Going on a ski trip in Antarctica must be the closest one can get to space travel on Earth. It is cold and lifeless in every direction, with only the tent and your clothes as thin shells between you and eternity. The one thing you know to do is to repeat your movements over and over, one ski in front of the other, one pole in front of the other. You are balanced between things that strengthen or weaken you. But you have to stay focused. If you sprain an ankle crossing Antarctica, the Red Cross does not come to the rescue. The ice may eat you alive.

Approaching the South Pole is a time I will never forget. I felt we were looking for a needle in a haystack, because a base in Antarctica is tiny. The first sign of being on the right track was the exhaust smoke from an LC-130 in the distance, taking off from the runway. We were three days away at that point. Then we started to see small buildings on the horizon. As we got closer, a guy from Switzerland was out taking photos and stopped and simply stared at us. We continued along the 'roads' to the station, slightly bothered by the traffic lights to get across the runway. I remember looking at the buildings and thinking how ugly it all was.

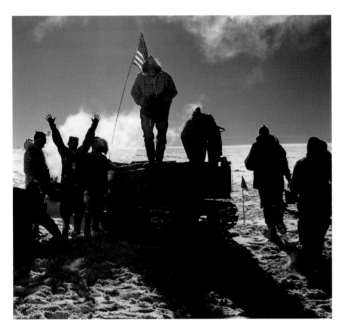

Near the South Pole itself about twenty or thirty people were walking with us, asking all kinds of questions, many I don't remember. I was in some kind of happy trance. One girl, from the gift shop I believe, asked me why my sledge was still so full when we arrived. I answered, 'because we are going to McMurdo'. Some guy behind me said, 'Crazy Norwegians!' A few people applauded as we closed in on the Pole.

Our route down the Axel Heiberg Glacier took us to the Ross Ice Shelf, which meant better temperatures and kinder snow conditions. We finally reached McMurdo after 105 days. I remember the last day, the two of us sitting together on my sledge. Although we knew we had made it we couldn't talk. I was expecting a reaction like crossing the finishing line first in the Olympics, but there was nothing, only emptiness. It was as if we had both awoken from a wonderful dream. We hugged each other without laughs or smiles, both seemingly needing comfort. Our adventure was over.

We had crossed the Antarctic continent on skis from Queen Maud Land, via the South Pole, to McMurdo. At that time it was a world record in unsupported skiing. I know very well what inspired us – it was certainly not about breaking records. We took those first steps because of our love for the wilderness and from our respect for the people like Amundsen, Shackleton and Fuchs who had gone on epic polar journeys before us. We were young men, twenty-five years old, and what these pioneers had achieved encouraged us to try to turn our own ambitions into action.

Today I eat tacos with my family, I drink beer with my friends and I cut the grass outside my house. I have become a middle-aged businessman. My friend Rolf died in 2008 while climbing K2, still following his dreams and doing what he loved. I miss him hugely. Yet not doing what you love is equally risky, I now realize. I have just had a serious accident: I fell down the stairs, fracturing my skull. I don't remember anything, but the doctors say I had passed out because of a lack of sleep and too much work. They told me I was lucky. I know I have to move forwards again in a new way. Antarctica should have taught me that.

ABOVE On 20 January 1958 the Trans-Antarctic Expedition reached the South Pole at last. They were met by American scientists and a crowd of journalists who had been flown in to report their success – it really was a global news story. Ed Hillary's tractor team had also reached the Pole on 4 January: welcomed into the warmth and safety of the American base, they were rewarded with beer and an evening in the small cinema watching a cowboy Western.

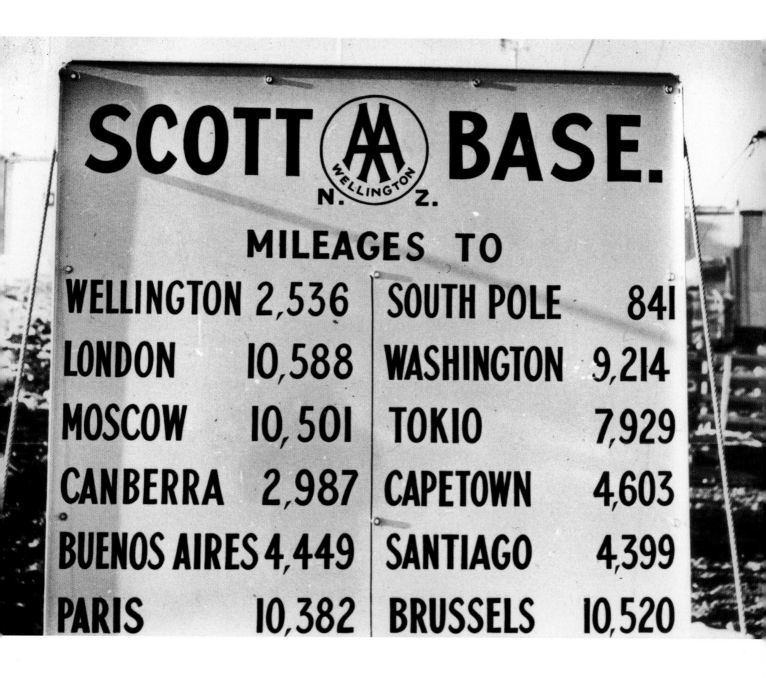

SCOTT 🅐🅐 BASE.
WELLINGTON N. Z.

MILEAGES TO

WELLINGTON	2,536	SOUTH POLE	841
LONDON	10,588	WASHINGTON	9,214
MOSCOW	10,501	TOKIO	7,929
CANBERRA	2,987	CAPETOWN	4,603
BUENOS AIRES	4,449	SANTIAGO	4,399
PARIS	10,382	BRUSSELS	10,520

ABOVE After the press controversy had settled down, Hillary's contribution to the Antarctic expedition was clear. His New Zealand party had built the well-equipped Scott Base, initiated a programme of scientific research and explored and surveyed thousands of square miles of virgin territory. But what was most important to him was that he'd shown that with resourcefulness and determination it was possible to get even a farm tractor to the South Pole.

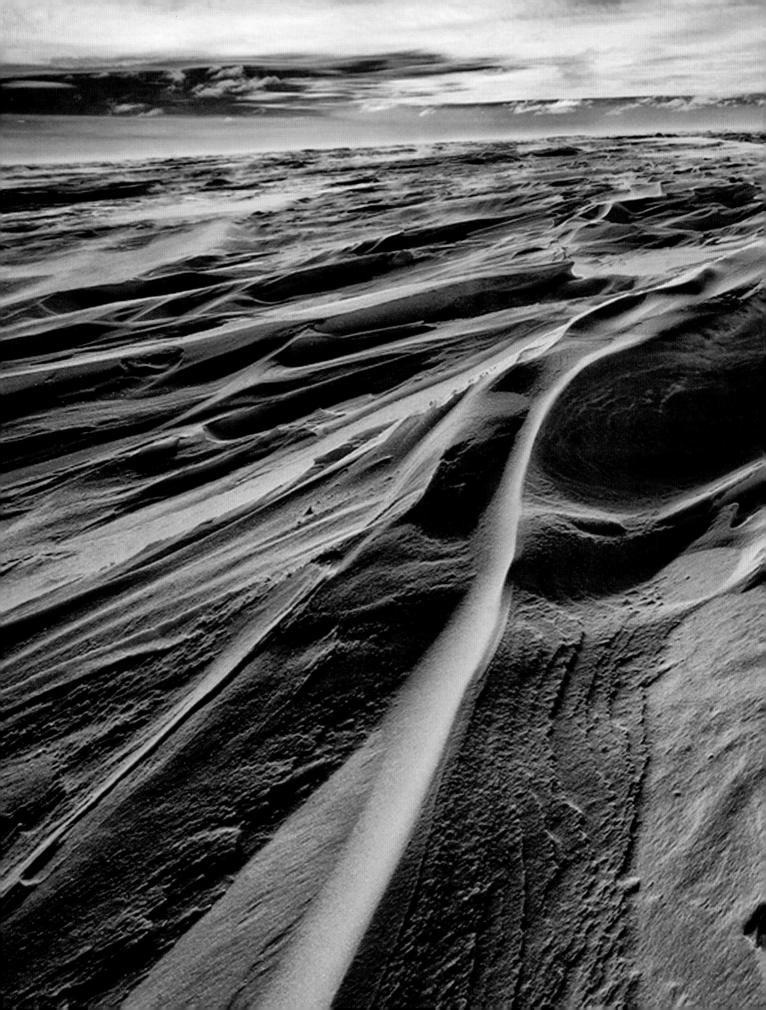

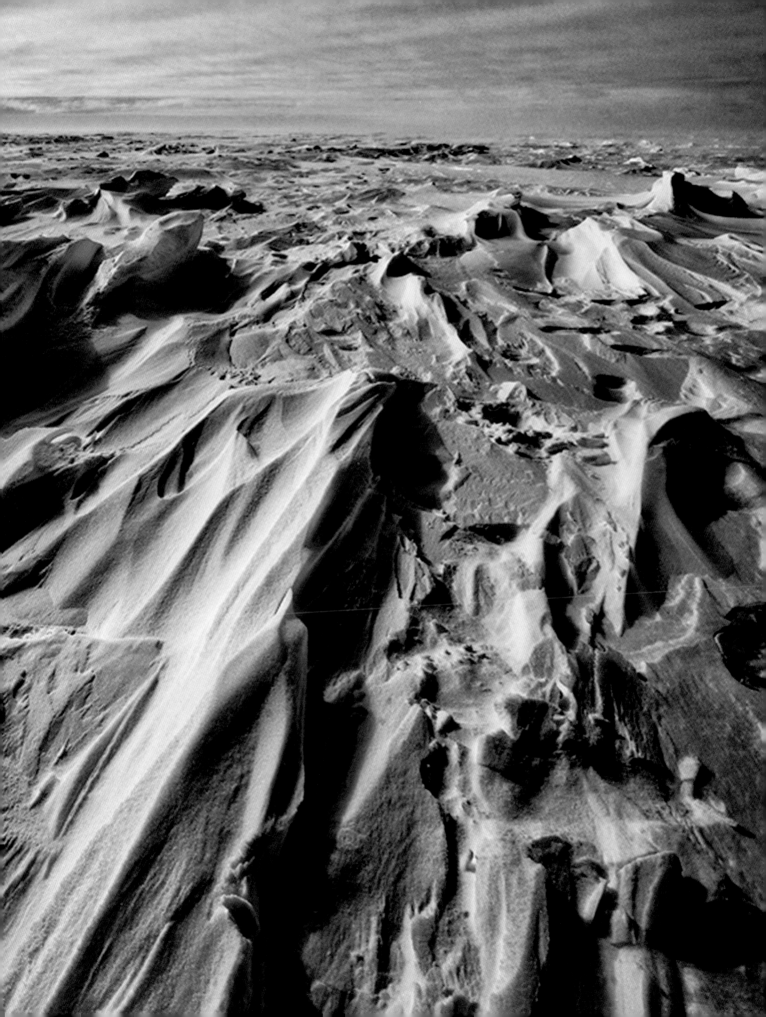

AN INFINITE EXPANSE

SEBASTIAN COPELAND

A desert is the landscape of the imaginary and the sacred. It is where you go to have conversations with God. And like most deserts, Antarctica challenges the mind to fill the proverbial void. But Antarctica plays on its own terms. It is the largest, coldest, highest and driest desert on Earth. Few places evoke awe and quiet respect like Antarctica does. It is very much part of our planet, but up on the plateau you could easily be on another. There are no food sources, and no life. No contrails overhead; no smells; no significant features; and no sounds except those of the wind on the ice. And when the white clouds overspread the terrain and the winds shut off entirely, there simply is nothing but a frigid void. No detail on the ground; no horizon to separate dimensions; and a silence that will pierce your eardrums, while booming your heartbeat. It feels like being lost on a giant blank canvas.

In 1911 Amundsen etched his name in history for being the first to reach the South Pole, and Scott soon followed him. Before them both, Shackleton had gained the furthest latitude south and later also tried to cross the continent, but lost his ship and didn't even reach the coast. Since then, countless explorers have been drawn to this land of contradictions to make their mark and all have experienced to varying degrees the very same feeling that overwhelmed these polar heroes when they first set foot on its ice sheet: no other place makes you feel smaller and more alone than Antarctica.

On my third trip there, in 2011, I chose to attempt, together with Eric McNair-Landry, the first east to west transcontinental crossing from coast to coast via two of its poles – the Geographical Pole and the Pole of Inaccessibility, the point inland most distant from the ocean. I had already walked 700 km (435 miles) on the Arctic Ocean to reach the North Pole, and in Greenland I travelled 2,335 km (1,450 miles), a crossing from south to north, which had felt like a good warm-up trip. But nothing quite prepares you for Antarctica. Stepping out of the plane on the east coast in late spring, the cold dry air hits you in the face like a fist of needles.

Whatever bravado you may have immediately vaporizes. An expedition always looks easier in the planning stages. But with over 4,000 km (2,500 miles) of journeying ahead, it is impossible not to feel vulnerable. The first few days are the toughest. Starting from sea level and moving up a glacier with 180 kg (400 lb) in tow is like pulling a car uphill. Doubt, anger and fear gnaw at your thoughts, but no one is to blame but yourself. And while there is some nobility, I guess, in pushing the limits of human potential, you are not curing cancer. In the age of Google maps and satellite technology, setting foot where no one has before doesn't capture the imagination as it once did. But the effort, for the most part, remains the same. The chain of events that got you there is either too complex or too simple – I haven't decided which – to explain easily. But once you're on the ice, the reasons are almost irrelevant. By then, you have no choice but to keep going and pray that you will get through to the other side.

As you gain elevation, the temperatures drop to a mean average of minus 35°C (-31°F), which, not counting wind chill, will remain the norm for much of the trip. While ascending the glacier and crossing the crevasse fields, the vertical mountain peaks that pierce through the ice make for a dramatic and spectacular backdrop. But it won't last. Those peaks are gasping for air: they are fighting a losing battle with the mammoth ice sheet that soon buries them.

And then come the winds. The wind in Antarctica defines the landscape and shapes the ice into mangled battlefields. The

PREVIOUS Antarctica's polar plateau photographed by Sebastian Copeland in 2011. Sastrugi are beautiful wind-eroded ice ridges; they can seriously impede travel and buckle sledge runners, as was very much the case in 1958. As Sebastian says: 'How can something so painful on the joints be so easy on the eye?'

size of Antarctic sastrugi – sculpted by the ferocious katabatic winds – makes travelling across Greenland seem like child's play. The sastrugi more than anything else humbled me. If winds can sculpt rock-hard ice, one particle at a time, into formations sometimes 2 m (6½ ft) high, imagine what they could do to us.

But the sastrugi also inspired me. I thought of photographers such as Herbert Ponting and Frank Hurley, who brought back visual testimonials of this mysterious land, and it felt like a moral obligation to try to continue this tradition. Their images shaped my youth to follow in their footsteps, like an invitation to escape. George Lowe earnt his place among these giants too. High on the desolate plateau, the sastrugi take on patterns aligned with the dominant winds. The sun's low angle coupled with a stripped-down colour spectrum creates monochromatic displays of light and shadow. These shapes cannot be found anywhere else on the globe and to witness them requires a commitment to survive, and to thrive, in this lifeless, frozen world. When you are feeling coldest, no doubt, the best images appear before your camera. But that is why you came. You reach for your camera and hope that you'll capture something of the beauty you see around you.

Two days after Christmas 2011, and fifty-three days into the trip, an unmistakable shape appeared on the horizon. A major objective of our expedition was to reach the Pole of Inaccessibility, and sticking out of the ice was what remains of the Russian station that has slowly been buried since it was abandoned in 1958. At the onset of the Cold War, the Russians wanted a claim to Antarctica that rivalled the US-managed South Pole station. And in 1957, they set off for the most remote and difficult point to reach: the Pole of Inaccessibility. They left two men to overwinter there, with barely enough resources to survive. The experiment proved mostly pointless. The station was abandoned the following year, but not before the rescued men placed a bust of Lenin atop its chimney, facing Moscow. The bust remains in exile to this day, like a forlorn Napoleon on St Helena. My partner Eric and I were only the fourth party to reach there since 1958, and the first to do so without assistance or motorized transportation.

It took us eighty-two days to complete our crossing via the South Pole and reach the west coast, at the edge of the Weddell Sea. I had set off wanting to carve my name here, but I returned forever transformed by this land. Antarctica is a country of deep impressions. Sparse. Profound. And pure. To the casual observer, the ice may look monotonous, a repetitive blanket of white that stretches agonizingly in all directions. In reality, this icescape reveals itself in its multitude of subtle details, constantly changing with the light and the dynamics of the day. I can honestly say that over the course of three months, I do not recall seeing the same vista twice.

The serene feeling of being immersed in this magnificent frozen world, staring for hours at an infinite horizon, leads naturally to contemplation. Enduring questions echo in the chambers of the mind: 'Who am I? Why am I here?' For one thing, you learn to do very well with very little. I'm eternally impressed by the resilience of Man, heading out into such a difficult place, yet surviving with little more than determination and the sum of nylon fabric, with a few poles and some line to hold it down. You get to rediscover yourself and come face to face with your limitations. But mostly, the ice is there to remind us that we are just one of millions of different species inhabiting this Earth, and down there it's pretty clear that we are no more special than that.

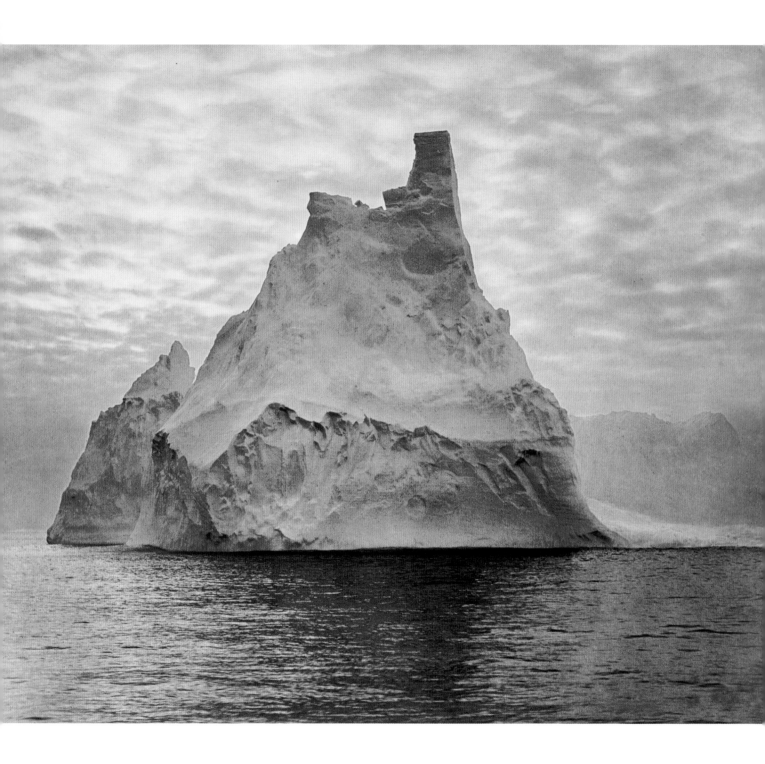

THE HEART OF ANTARCTICA

JON BOWERMASTER

I like being places where you are forced to listen to your own heartbeat, commanded by nature to pay attention to the in and out of each and every breath. Antarctica is definitely one of those places.

It was so windy last night that I thought at one point my tent was going to explode. Literally. Thanks to a trio of pinholes along one seam, the sides of the thin nylon membrane were being sucked in by the strong gusts, and then exploded outwards, making a cracking sound, like a firework going off. This went on for several hours. With morning, the winds dropped. By noon, they were back, gusting katabatics whipping snow across the ground at chest level. As I trudged across the crusty snow, the wind whistling inside my fur-lined hood was the sound of freedom … and frostbite.

My friend Steve Pinfield and I spent the afternoon kick stepping up an ice- and snow-packed bowl to the peak of the tallest of the Patriot Hills. Looking towards Mount Vinson, Antarctica's highest peak, we could see a jagged line of granite, separated by fields of ice and snow, sastrugi and crevasses. With our axes dug in for stability we continued up the knife-edge of the rocky ridge to the snowy summit. Thankfully the wind had turned constant, not gusty. Big gusts would have easily picked us off and dumped us over the edge. Everywhere we looked the wilderness was vast, unending. It is remarkably humbling to stand so far beyond civilization, so far beyond help.

My first experience of Antarctica was also my first assignment for *National Geographic*, documenting the 1989–90 International Trans-Antarctic Expedition. Led by American Will Steger and Frenchman Jean-Louis Etienne, and including Geoff Somers, a six-man team, each representing a different country, traversed the continent along the longest route possible. It will stand as the longest ever crossing of the continent by dog sledge, since the following year dogs were banned from Antarctica.

After this, Antarctica got into my blood. I have now enjoyed many adventures here, from kayaking the length of its Peninsula to ascending its highest peaks. The second time I arrived at the South Pole was by Twin Otter, accompanying a small group of high-paying tourists. It was thrilling to set foot at the bottom of the Earth, but disheartening too, since my companions never fully realized exactly how remote, and lucky, they were. A couple of them treated it like it was just another day, checking 'South Pole' off some imaginary list. For me, taking a long walk straight out from the dome until it faded from sight was one of the most thrilling afternoons of my life. My one disappointment at the South Pole station was interacting with several of the summer-season crew who admitted they barely poked their heads outside the dome.

In the early 21st century tourism has replaced whaling as Antarctica's boom industry. Demand has rocketed at the same time that big boat operators have figured out the best routes, landings and anchorages. More than thirty cruise ships, ranging from the 3,700-capacity *Golden Princess* to the around 100 of *Endeavour*, make back-to-back visits each season, turning the port of Ushuaia in Argentina into a buzzing Antarctic gateway. Yet as far back as 1938, Australian explorer Douglas Mawson, who accomplished many firsts here, would ponder how the continent would evolve: 'from an economic aspect, the frozen South may not attract immediate attention. But who can say what a train of enterprise the future may bring?' Natural resources may prove to be the economic lure that whaling and sealing were two centuries ago. But today it is other impacts of man affecting even this unpopulated continent that are most worrying.

LEFT Photographer Frank Hurley had his first taste of ice voyaging south with Douglas Mawson in 1911. The following year, he captured this beautiful iceberg lit up by the midnight sun in a glass plate lantern slide, now silvered with time. He wrote: 'No grander sight have I ever witnessed among the wonders of Antarctica. We threaded a way down lanes of vivid blue with shimmering walls of mammoth bergs rising like castles of jade on either side.'

The Antarctic affects all our lives, but through forces so deep and elemental that we're not even aware of them. If in the final equation the surface of the Earth is a single, complex system, then Antarctica is its heart, the slowly beating pump that drives the whole world. Each austral winter, a vast halo of sea ice forms around the continent, and each spring trillions of tons of fresh water are released into the ocean as it thaws. This is the planet's great annual climate cycle, the thermodynamic engine that drives the circulation of ocean currents, redistributing the sun's heat, regulating climate, forcing the upwelling of deep ocean nutrients, setting the tempo of the planet's weather.

Yet global change is most clearly seen here. The consequences of ozone depletion and global warming are strongest in polar regions, where they are reinforced by atmospheric and meteorological conditions. Because Antarctica is essentially uninhabited and without industry, there is virtually no local pollution: any ecological and climate disturbances on the continent are certainly caused by global forces. Global warming models from the early 1970s predicted that climatic effects of human greenhouse gas emissions would be felt first and most strongly at the Poles. More than two decades ago scientists prophesied that one of the first signs of human-caused climate change would be the collapse of the Antarctic Peninsula's ice sheets. This is exactly what is happening today.

In March 2002 scientists watched the 500-billion-ton Larsen-B Ice Shelf shatter into thousands of tiny icebergs before their eyes. In 2008 a huge section broke off the Wilkins Ice Shelf. Two of the ten shelves along the Antarctic Peninsula have vanished completely within the past thirty years. Another five have lost between 60 and 92 per cent of their original extent. What is happening so dramatically, so quickly to those shelves suggests it's possible that the rest of the Peninsula's ice may deteriorate soon. And fast. Today, when you find yourself in the heart of Antarctica it remains unique: the most remote, the most forbidding and the most awe-inspiring place on Earth. Yet somehow, Antarctica seems at the same time fragile, in need of our protection.

I worry that parts of Antarctica run the risk of becoming 'Everest-ized', available to anyone with a week's holiday and the cash to pay for it. In 2012 a team made the first double-crossing of the continent, by jet-fuelled 6x4 Toyota trucks. Which takes some of the romance out of the adventure, doesn't it, especially when it claimed to be trying to draw attention to environmental concerns while, no doubt, leaving traces all along their route of our fossil fuel dependence. The reality is that such adventures can't be stopped, nor should they be. I do have real concerns for the Peninsula, though, when the day comes – not if, but when – that the first tourist ship goes down and there's a sizeable oil spill or loss of life. As a species mankind has a tendency only to respond when truly in trouble.

But you cannot go to Antarctica and not return something of an evangelist or ambassador for protecting the place. You cannot Zodiac through one of its iceberg alleys without coming away feeling it's the most stunning place on the planet. You cannot stand in the midst of a penguin rookery, or watch 10,000 of the little fellows file away over the hill in single file, without smiling, despite the one-of-a-kind stench that will linger in your nostrils for weeks afterwards. You cannot watch a great glacier crack and roar and fall into the sea without feeling somehow reverential. You will return home a changed person. Even the most cynical of tourists, those simply out to check the place off some kind of list, cannot help but be moved by Antarctica.

RIGHT A huge east–west chasm in the Filchner Ice Shelf was the first major obstacle encountered by the Fuchs expedition after they set out on the crossing: this photograph shows about 25 km (15½ miles) of it, with the left wall probably at least 30 m (100 ft) high. It marks a kind of fracture point.

WINTER COMES

KEN BLAIKLOCK

On 7 February 1956 we stood at the ice edge and watched as our ship disappeared from sight. We were the eight men of the advance party, left to build a base, move 300 tons of stores and then lay some depots to ease the passage of the Trans-Antarctic Expedition crossing team who would return the following year. At twenty-eight, I was the leader of this hardy group. We survived the fierce Antarctic winter, living by day in a Sno-Cat packing case and sleeping in tents at night, all the while trying to build a hut for our friends. But that day, as the ship *Theron* chugged away north through the floes in the Weddell Sea, we turned and climbed the hill to the crate that was to be our home. We cooked up our first meal on the Primus stove – bacon, tomatoes and cocoa – and crawled into our sleeping bags for our first night alone on the ice.

I've seen it written that our tough overwintering was a precarious ordeal similar to that of Captain Scott's marooned Northern Party, or Shackleton's Ross Sea group in 1915. May was our coldest month, in constant darkness, with a minimum temperature of minus 55°C (-67°F), and those winds we did record often exceeded 70 knots. The loss of much of our stores, carried out to sea in a storm, certainly didn't help and at times we did have doubts about what we were doing. Yet to my mind it wasn't so bad – often those who write about conditions being terrible really don't understand what it is like to winter down here. It is a hard, bleak existence, that's for sure, but not impossible. Our kit was good, we had plenty of food and our tents withstood the blizzards that buried everything in sight. It was the fourth winter I had spent in Antarctica and though it was certainly the hardest, I knew we'd be all right. Scott's men didn't have the same luxury of knowing that help would eventually come.

I first met Bunny Fuchs in 1948 when he was the field commander of the FIDS bases, and leader at Stonington Island in Antarctica, where I was one of the two surveyors. In 1955 I was in charge of a summer team aboard the ship *Norsel* and went south to set up two more bases on remote islands. I heard about Bunny's plans and immediately asked to be considered. At the time most reactions to his proposals for a crossing had been negative: too risky, too costly, too difficult. Opposition to the idea was strong even within the Scott Polar Research Institute and the Royal Geographical Society, though both soon joined in as the tide of public opinion turned in our favour. Most of us with Antarctic experience believed that it could be done and we didn't think twice when applying.

I suppose in a way the TAE proved to be the last of its kind. More and more, Antarctic expeditions would rely on larger bases, or smaller teams on the ground: moving quickly by aircraft or ski-doo vehicle, or even reverting to man-hauling. The science of expeditions is still unjustly judged second to the newsworthy adventure and suffering for its own sake. The competent explorers don't always get attention; it's the ones who make mistakes that seem to capture the headlines. In this way, the public's memory of the TAE has almost totally faded over the years, although for those of us who were on the expedition it was a time that we'd never forget.

During the expedition I had the chance to drive a dog-sledge team to the South Pole, the first to do so since Amundsen's party had raced there in 1911, and we often travelled ahead of the main crossing party to reconnoitre the route ahead. For long stretches of the journey we had the polar plateau to ourselves, though before long the rumbling cavalcade of orange Sno-Cats would once again catch up with us.

LEFT On 21 January 1959 the Americans visited the deserted hut at Shackleton; their Navy photographer took this shot of the workshop garage. Inside the hut they found everything as Bunny's team had left it. Books were still on the shelves and piles of unopened cornflakes' packets filled the kitchen stores. The hut is now probably entombed within a giant iceberg.

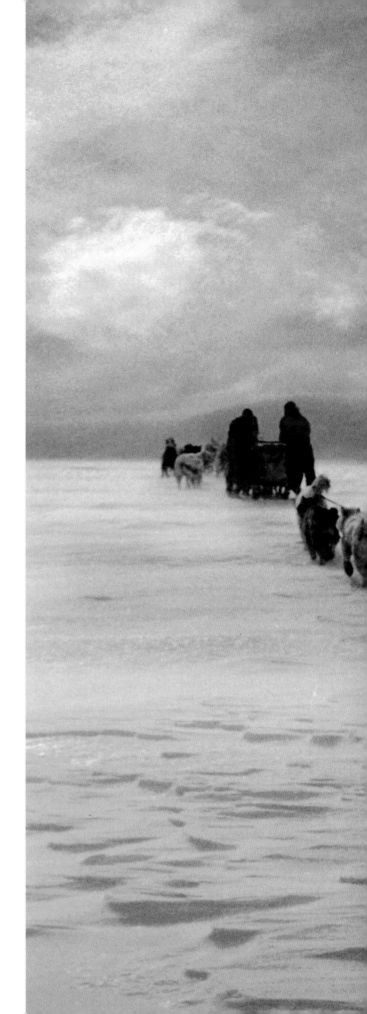

After TAE I spent another two years in Antarctica at a Belgian base, which was in a way a much more enjoyable time, most of it surveying and sledging in the Sør Rondane Mountains, free of large machines and petrol fumes, with just the sound of my dogs and the wind whipping across the ice. Back at base the food was pretty good too, with an almost endless supply of red wine, from what I can remember.

When I look back, over sixty years since I first went to Antarctica, I feel nothing but happiness for my time there. I am lucky to have had such a wonderful experience with solid companions; and feel more lucky still, despite a few close calls, to have returned home safely each time. I was awarded the Polar Medal, and its white ribbon is decorated with three Antarctic bars for my efforts on different expeditions. Although this means so much to me, when I am gone it is just metal and silk in a small box. I suppose our memories don't add up to much for those who have no taste for our tale, but I do hope that the story of the TAE will continue to be remembered.

Antarctica has little room for warm nostalgia; her deep winters will long outlive us all. We left the base hut at Shackleton on 24 November 1957, when Fuchs and the members of our crossing team at last set out on the long drive southwards. The hut was finally abandoned on 2 December, when the four RAF men flew the Otter aircraft all the way to McMurdo Sound. This hut that had taken us so long and so much effort to build, which had been our refuge and our home, was with little fanfare or farewell surrendered to the snows. For many years afterwards it was boarded-up and empty, until a major calving of the Filchner Ice Shelf in 1986 cast it off into the Weddell Sea, leaving no trace that we'd ever been there. That is a fitting end, I have to agree.

RIGHT The first sledge dogs came to Antarctica with the Heroic Age expeditions, and they were crucial in helping Amundsen reach the South Pole in 1911. In time, dogs were replaced by machines. The 1991 Protocol on Environmental Protection to the Antarctic Treaty banned all introduced species, except humans, from being taken into the Antarctic. It was with much sadness that in 1994 the last remaining huskies left the continent.

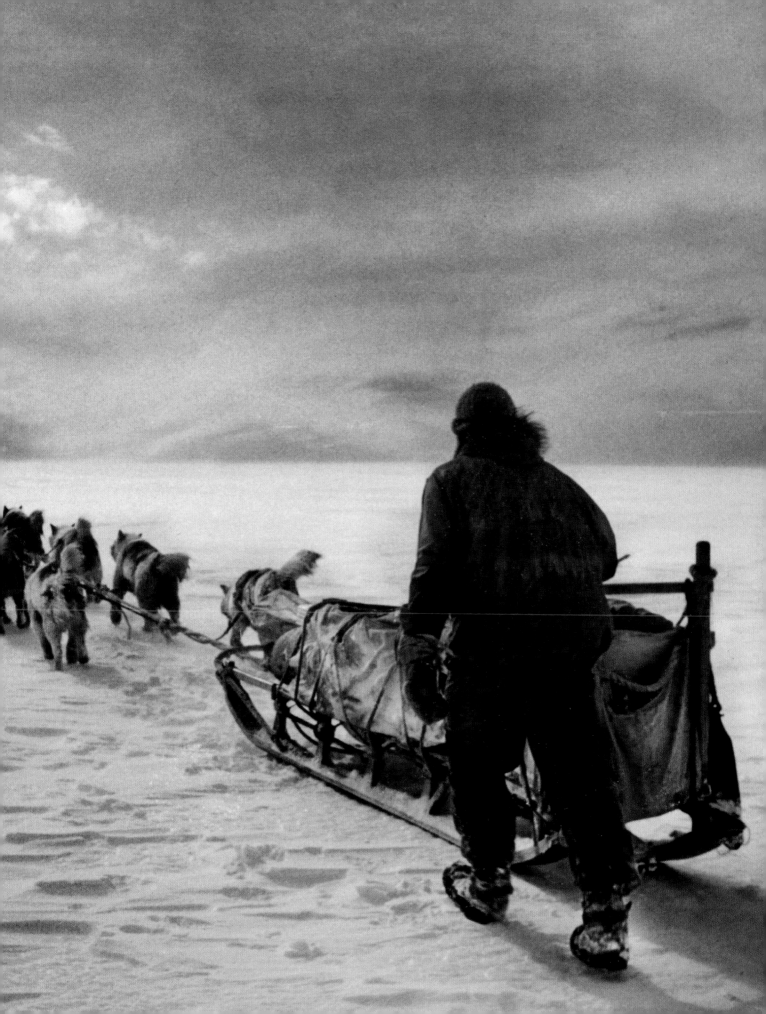

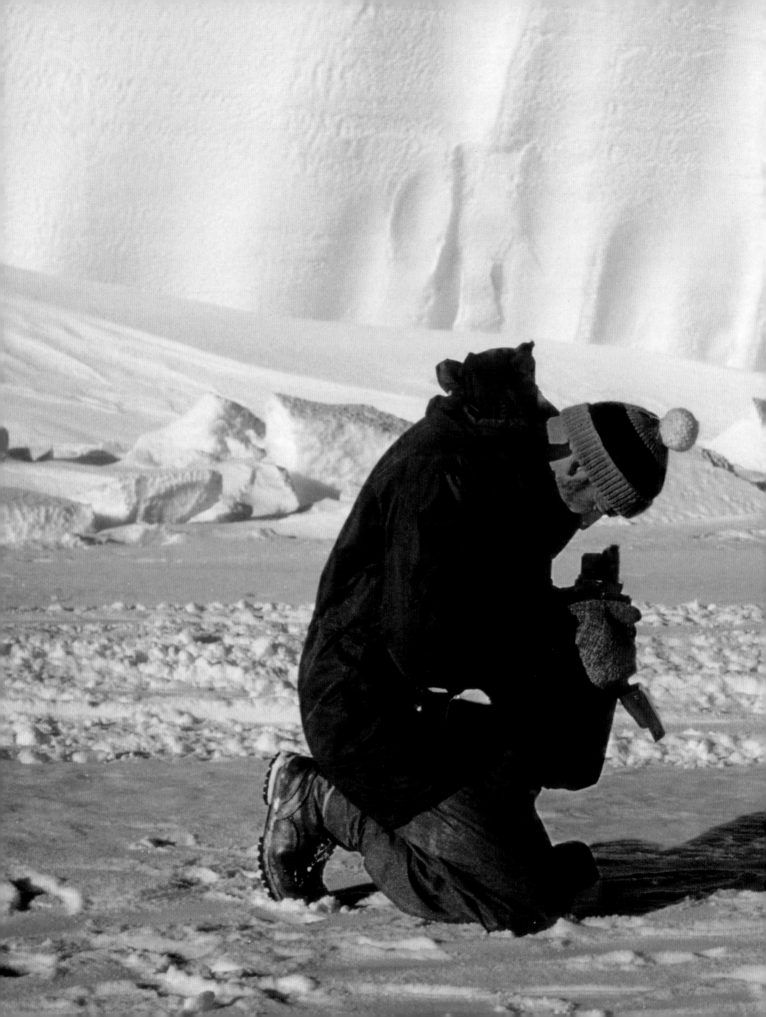

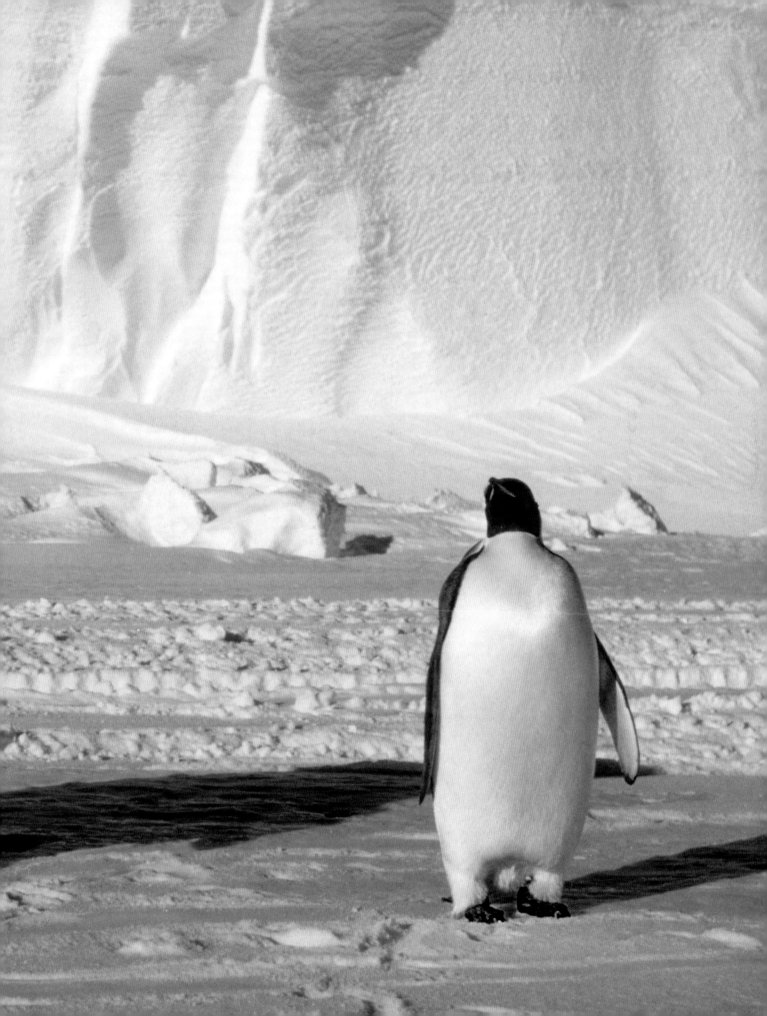

FOOTSTEPS IN THE SNOW

PAUL DALRYMPLE

The only real hardship in going to Antarctica is being separated from home and family. For me this was compounded by leaving a twenty-month-old daughter asleep in her crib. But if you have the proper attitude and have prepared well, the rest is simply the beginning of a glorious experience. Forget the temperatures you will encounter, the fierce winds that blow – they are all minor issues that can become routine. You stand on the brink of the greatest moments of your life. Antarctica beckons and as you take your first steps there it is impossible not to smile.

My thirst for knowledge in my discipline at the time, micrometeorology, was what enabled me to go there, but I was first inspired by reading about the explorers of the past. And in those days I was lucky enough to meet many of them. In the office where I worked in America I was separated by a sheet of glass from the first man to fly in Antarctica and to go below the ice in a submarine, Sir Hubert Wilkins. There too was Paul Siple, an enthusiastic member of the Antarctic expeditions led by Richard Byrd in the 1930s, and the man who would later become the inaugural scientific leader at the South Pole station. Was it any wonder that I wanted to follow in their footsteps?

I had the good fortune of going to Antarctica on the last American ship to take an expedition there, leaving from San Diego on the USS *Curtiss* in late December 1956. Having made our way first to McMurdo, we proceeded on to Kainan Bay where Little America V base camp had been established. Here we were on one of Antarctica's largest floating ice shelves, the Ross Ice Shelf, where Amundsen had established the base from which he raced to the Pole back in 1911. Though their footsteps had long since been covered by the drifting snows, we felt history all around us.

During the winter a call came through from Paul Siple at the South Pole station saying that there would be room the next year for micrometeorology there if I should like to go. At that time in Antarctica every person's dream was to work at the South Pole and it had come my way through luck and making sure to answer the phone! I said yes without hesitation. A little later, Sir Hubert Wilkins came down to the ice, his very last trip to Antarctica, and helped me dig out my scientific equipment for shipment to the Pole. He was sixty-nine years old at the time, yet could still shovel snow much better than me.

I arrived at the South Pole on 5 December 1957, in the middle of a hugely busy austral summer for this remote outpost. Scientists were being flown in for the first stages of the International Geophysical Year, and the press were also gathering so that they could record the arrival of the Trans-Antarctic Expedition teams. The daily positions of the Fuchs and Hillary parties were almost constant subjects of conversation and conjecture. No one expected that Hillary would be

LEFT An Adélie penguin and man-hauled sledges leave their different and distinctive tracks in the snow, photographed by Herbert Ponting, 8 December 1911.

PREVIOUS When George's film was shown in cinemas every penguin shot had been deleted. As the prime object was to depict the crossing of Antarctica, the backroom powers had argued: '*Every* Antarctic picture is full of penguins – this one will do without them.' George felt this was a pity, as he wrote in his journal: 'Sleek and fat in their black, white and gold, in the sunshine their feathers sparkle like sequin suits on television cabaret stars.'

coming all the way to the Pole. Then on 27 December Armed Forces Radio reported that Sir Ed was 'Hell bent for the South Pole', and 'God willing will arrive'. I'll never forget those words. It was the first time we learnt that God too was on the polar plateau.

Needless to say, 4 January was a very big day at the Pole as Sir Ed Hillary arrived at 2 p.m., with three Ferguson farm tractors hauling their two sleds, one with fuel, one with tents. Travelling with Hillary – who instantly became plain Ed as soon as he dismounted from his tractor – were his close climbing friends, Peter Mulgrew, his radio operator, and Murray Ellis, one of his mechanics. Also with the party were another mechanic, Jim Bates, and their photographer Derek Wright. Their last 200 miles had been through extremely deep soft snow and travelling was difficult. They had to dump a ton and a half of supplies to get to the Pole, averaging only two and a half miles per hour. They arrived with just 30 gallons of petrol left, good for only about 10 miles of travel. Hillary, Ellis, Wright and Bates left the Pole the next day, taking with them the corps of correspondents so they could spread their news across the world. Peter Mulgrew stayed on for a cup of coffee, in fact many cups of coffee. He remained at the Pole for three full weeks, and he was a sheer delight to have in camp. After Ed Hillary got back to Scott Base he sent us a bottle of Kiwi grog, which endeared him forever with our personnel too.

Excitement reigned supreme for the next two weeks as more reporters converged to await the arrival of Fuchs and the main Trans-Antarctic party. Ed Hillary had flown back in to meet them. At 8 a.m. on the morning of 20 January, Ed and I climbed the ladder to the aurora dome to look out over the landscape to see if they were in sight. We soon spotted them, though barely dots on the horizon. Weasels went out from the station, but they were still a considerable distance away.

When the crossing party finally arrived it was chaos. Everyone wanted to get pictures of Hillary and Fuchs, and our admiral, George Dufek, did his best to get into all the scenes. Coming into the staging area about a mile from camp, driving his own Weasel, *Wrack & Ruin*, was a face in the open window that I immediately recognized as that of the famous Everest photographer George Lowe, wearing a broad-brimmed Panama hat. He wore a big smile, too, and was warmly greeted by Ed Hillary, his mountain-climbing buddy. The crossing party then arrived in their Sno-Cats and with two dog teams. The celebrations continued in our small galley kitchen – it did not matter that our Navy cook had misspelled the word Trans-Antarctic on the welcoming cake!

Fuchs's party was with us for four days. I took the opportunity to tape as many of the team as possible in the form of 'letters' to my wife Gina, a fellow British subject. I was particularly

interested in my scientific counterpart, Hal Lister. He was very easy to get to know, intelligent and affable, a delight to be with. Ken Blaiklock quickly became a favourite among us, reminiscing about his dogs. It was said that he held the record for driving dog teams, over 8,000 km (some 5,000 miles) in Antarctica. I also had a tremendous thirst to talk to George Lowe about Everest and we spoke for some time about photography. What a treat to sit down and chat with such a bunch of men, all explorers fresh from the very first crossing from the Weddell Sea side of the continent. It was history in the making.

Then they were off again. The saddest thing I saw was Ken going down the lines of dogs, patting each one, stroking their ears in thanks and saying goodbye before he left to continue the crossing without them. We wondered as they all pulled out if we would ever see any of these men again. I have been lucky to know several of them as friends. Some of the nicest few hours I ever had were when George Lowe, *en route* to Nova Scotia, dropped in to stay at my home in coastal Maine. We laughed and talked long into the night.

Just after my own departure from the ice after two years, we were all saddened by the death of Sir Hubert Wilkins, the day I arrived back in New Zealand. I was returning with his Arctic fur parka made by an Eskimo friend, which he had given me to wear while I was at the South Pole. I am happy to say that it now resides in the museum in Christchurch. There is one final memory from my first trip to Antarctica, one last footstep in the snow left by an old explorer. As I made my way home I met Sir Raymond Priestley, a scientist who had been south with Shackleton, Mawson and Scott, in Wellington in December 1958. I shook his hand and remember thinking he was ancient, but as I write this I'm eighteen years older than he was at the time! I'm almost ninety now but I remember my time at the South Pole as if it were yesterday. There have been many new generations of scientists in Antarctica since and ever more footsteps are made as the years pass.

I also came home with a real treasure, a first edition of a book, *Scott's Last Expedition*, which I bought at an auction in New Zealand. It wasn't so much the book that was important as the signature inside it: 'Kathleen Scott, 1913'. Unlike her husband, Captain Scott, I was able to return from my time at the South Pole to see my family again. I had modern aircraft to thank for my safe homecoming; yet, as important as technology was the knowledge that it was *possible* to survive there. Scott and his men, pushing back the boundaries of what was possible, had hauled their way across the ice, off the edges of the map of the known world. They were the true explorers. We were the lucky ones.

FOLLOWING A scientist trudges back to base at the South Pole in October 1957 during the International Geophysical Year. Humans have been present at the bottom of the world continuously ever since. Over a hundred winters have now passed since the first men stepped foot here in 1911, and it remains a harsh, yet beguiling, landscape.

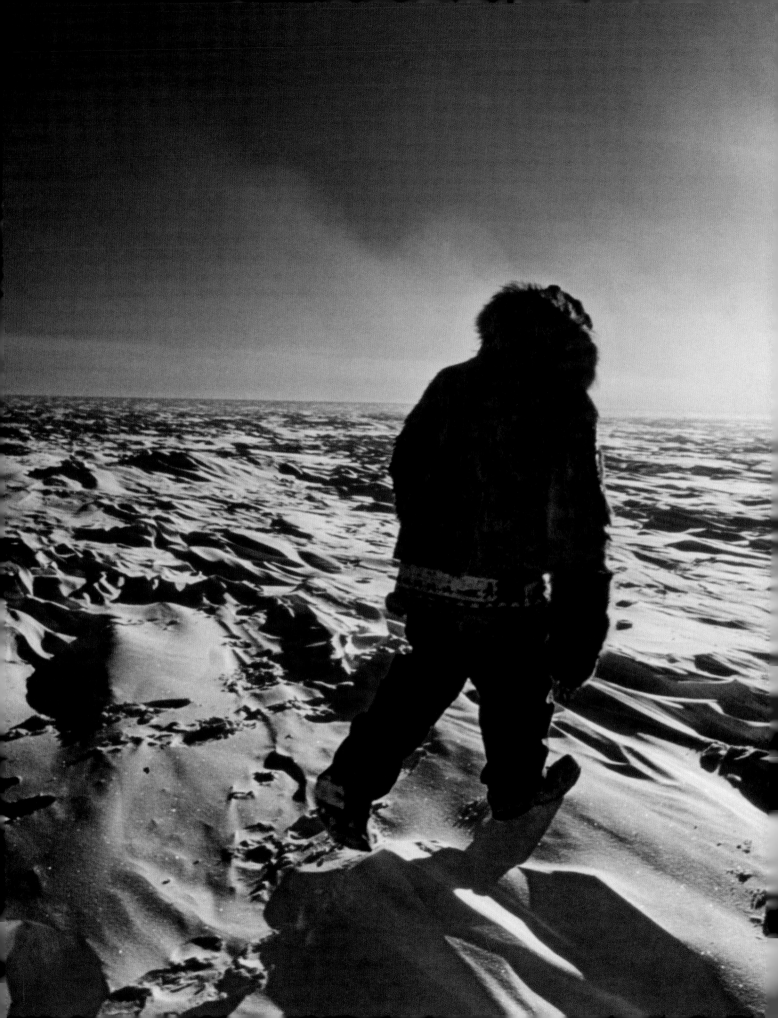

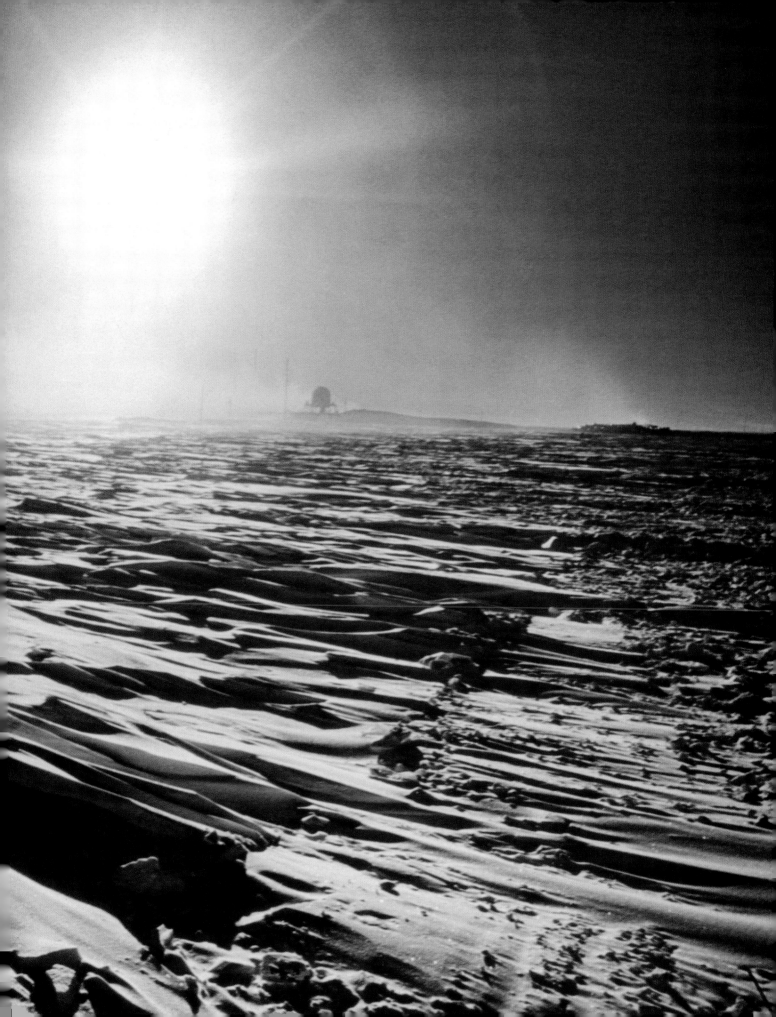

BIOGRAPHIES

AUTHORS

GEORGE LOWE was a New Zealand-born explorer, mountaineer, photographer and filmmaker. He was a leading high-altitude climber on the 1953 British Everest Expedition, during which his best friend, Edmund Hillary, and Sherpa Tenzing Norgay became the first men to summit the world's highest peak. As well as taking photographs throughout this journey, Lowe directed the Oscar-nominated documentary *The Conquest of Everest*, and the following year again joined Hillary to climb in the Himalaya. He was official photographer on the Commonwealth Trans-Antarctic Expedition, which, between 1955 and 1958, not only traversed Antarctica but also became the first to reach the South Pole overland since Captain Scott in 1912. His film of the expedition, *Antarctic Crossing*, was an international success. In later years a teacher, Lowe was the founder and first Chairman of the Himalayan Trust. He died on 20 March 2013.

DR HUW LEWIS-JONES is a historian of exploration with a PhD from the University of Cambridge. He travels in the Arctic and Antarctic each year working as a historian and polar guide. Huw was Curator at the Scott Polar Research Institute, Cambridge and the National Maritime Museum, London, and he is now an award-winning author, who writes and lectures widely about adventure and the visual arts. His books include *Arctic*, *Ocean Portraits*, *In Search of the South Pole*, *The Lifeboat*, *Mountain Heroes*, which won Adventure Book of the Year at the World ITB Awards in Germany, and *The Conquest of Everest*, also co-written with George Lowe, which won the History Award at the 2013 Banff Mountain Festival. He lives in Cornwall.

છ૭

OUR CONTRIBUTORS

SIR RANULPH FIENNES is described as 'the world's greatest living explorer' by the *Guinness Book of Records*, and his achievements prove this is no exaggeration. He was the first person to reach both Poles by surface travel and to cross the Antarctic continent unsupported. He is the only person yet to have been awarded two clasps to the Polar Medal for both the Antarctic and the Arctic regions. Fiennes has led over thirty expeditions, including the first polar circumnavigation of the Earth, and in May 2009 he successfully reached the summit of Mount Everest. His ongoing dream is to make the first crossing of Antarctica in winter, the so-called 'coldest journey'.

FELICITY ASTON is the first and only woman to have skied alone across Antarctica. She completed the 1,744-km (1,084-mile) traverse in 59 days in 2012. The journey was the culmination of more than a decade of travel in Antarctica, during which time she spent three years consecutively living and working on a British Antarctic Survey research station, drove more than 6,000 km (3,728 miles) across east Antarctica on a return journey to the South Pole, and led the largest and most international team of women – from countries including Jamaica, Brunei and India – on a ski expedition to the South Pole. Felicity is an ambassador for the British Antarctic Monument Trust, which is raising awareness of the science being undertaken in Antarctica by men and women from the UK and collecting funds for a monument to honour those who did not return.

KEN BLAIKLOCK has overwintered eight times in Antarctica and has been involved in activities on the continent for over six decades. He has travelled many thousands of miles by

various forms of transport: dog sledge, vehicles such as ski-doos and Sno-Cats, aircraft and man-hauling. He was leader of the advance party of the Trans-Antarctic Expedition, and surveyor and dog-driver on the crossing party. He later joined the Expedition Antarctique Belge, and with Tony Van Autenboer carried out a full triangulation, geological and gravity survey of the Sør Rondane mountain range in Queen Maud Land. His last visits to Antarctica were with Bernard Stonehouse on the Project Antarctic Conservation, assessing the effects of increasing polar tourism on the continental environment. He is holder of the Polar Medal, with three bars for his Antarctic achievements.

JON BOWERMASTER is a six-time grantee of the National Geographic Expeditions Council and an award-winning writer and filmmaker. His adventures and reporting have taken him around the world several times, including more than twenty visits to Antarctica. He co-authored *Crossing Antarctica* with polar explorer Will Steger in 1990, and in 2009 produced *Terra Antarctica*, a documentary film about the Antarctic Peninsula, which his team travelled by sailboat, small plane, sea kayak and on foot. For the past decade his focus has been on the health of the world's oceans and man's relationship with them. His most recent film, *SoLa: Louisiana Water Stories* was completed just as the BP oil well began gushing; his most recent book is the companion to the Jacques Perrin/DisneyNature film *Oceans*.

SEBASTIAN COPELAND is an award-winning photographer, adventurer, filmmaker and environmental activist. He has earned multiple polar records for his various crossings on skis and using kites. An international speaker on climate crisis, Copeland has addressed audiences at the United Nations, the World Affairs Council, as well as museums, universities and Fortune 500 companies around the globe. With over 8,000 km (4,970 miles) under his skis, Sebastian has reached both the North and South Pole on foot, crossed the Greenland ice sheet from south to north, and completed the first east to west transcontinental crossing of Antarctica via two of its poles. He was 'Professional Photographer of the Year' at the International Photography Awards in 2007, for his first book *Antarctica: The Global Warning*. His film, *Into The Cold: A Journey of the Soul*, chronicling his North Pole mission has won international acclaim. Sebastian sits on the Board of Directors of Mikhail Gorbachev's environmental organization Global Green USA.

DR PAUL DALRYMPLE is an American physical geographer who first went to Antarctica in 1956. He was the micrometeorologist during the International Geophysical Year – overwintering at Little America V in 1957 and then at the South Pole station in 1958 – and was at the South Pole when the Trans-Antarctic Expedition team arrived during their history-making first crossing of the continent. For the past thirty-five years he has been very active in the American Antarctican Society, writing all their Newsletters while serving as its president, editor and now as its treasurer. The 3,600-m (11,811-ft) Mount Dalrymple in the Sentinel Range was named in his honour.

PROFESSOR KLAUS DODDS holds the Chair of Geopolitics at Royal Holloway, University of London, and is a Visiting Fellow at St Cross, University of Oxford. He is an Academician of the Academy of Social Sciences. He has travelled to the Antarctic on four separate occasions and is author of a number of books, including *Pink Ice: Britain and the South Atlantic Empire* and

The Antarctic: A Very Short Introduction. His latest publications include a co-edited collection, *Knowledges, Resources and Legal Regimes: The New Geopolitics of the Polar Regions*, and a co-authored book called *Scramble for the Poles: The Contemporary Geopolitics of the Arctic and Antarctic*.

ARVED FUCHS is a renowned adventurer, filmmaker, author and explorer who became the first German to reach the North Pole on foot in 1989. Most famously, with mountaineering legend Reinhold Messner, he was the first to reach the South Pole without animal or motorized help, later that year. Though he shares the same surname he is not related to Sir Vivian Fuchs, but he has certainly been inspired by his example. Over the last twenty years he has made countless voyages in the polar regions on foot and by boat, following the routes of many historic expeditions and repeating Shackleton's voyage of survival across the Southern Ocean.

PETER FUCHS is the son of Sir Vivian Fuchs, leader of the Commonwealth Trans-Antarctic Expedition 1955–58. He graduated from Cambridge with an MA in Natural Sciences, and after a spell in Alaska and two years in Nigeria prospecting for diamonds, he spent thirty-five years in the minerals and mining industries in the UK. On his retirement he served as a board member for a Primary Care Trust and was a councillor in local government. In 2005, after taking a postgraduate diploma in Antarctic Studies at Canterbury University, New Zealand, and camping on Antarctica's Ross Ice Shelf, he became Chairman of Trustees of the Fuchs Foundation, an educational charity developing leadership skills in science and geography teaching.

SIR WALLY HERBERT was a pioneering explorer and an award-winning writer and artist. During the course of his polar career, Sir Wally travelled with dog teams and in open boats well over 40,000 km (25,000 miles) – more than half of that distance through previously unexplored areas. During his five years in the Antarctic he mapped on foot some 116,500 sq. km (45,000 sq. miles) of new country, and is most famously remembered as the leader of the first expedition to cross the Arctic Ocean from Alaska to Spitsbergen via the North Pole. He wrote the reflection included here, and his memoirs, *The Polar World*, shortly before his death in 2007.

BØRGE OUSLAND is a renowned Norwegian explorer, writer and filmmaker, arguably the world's leading polar traveller. He is widely admired not only for his exploration achievements but also for the core values he promotes: humility, meticulous planning, self-reliance and a sincere appreciation of the natural world. He made the first unsupported trek to the North Pole in 1990, doing it again solo and unsupported in 1994 in just 52 days. In 1997 he completed the first unsupported solo crossing of Antarctica, an epic journey of 2,845 km (1,768 miles) in 64 days, experiencing temperatures as low as minus 56°C (-69°F). In 2001 Ousland made the first solo crossing of the Arctic Ocean from Siberia to Canada via the North Pole, and in 2006 he reached the North Pole again, with fellow epic adventurer Mike Horn, this time becoming the first to trek solely in the 24-hour darkness and intense cold of the polar night.

JONATHAN SHACKLETON is the cousin of renowned explorer Sir Ernest Shackleton. Following research in Arctic Alaska while at Ohio State University, he has travelled widely

as a lecturer and guide, including more than thirty trips to Antarctica, most recently with Captain Scott's grandson Falcon. He has been beset in ships in both the Weddell and Ross seas. Author of *Shackleton: An Irishman in Antarctica*, Jonathan is a member of the BAS Club and the James Caird Society, and contributes to the annual Ernest Shackleton Autumn School in Athy, County Kildare, Ireland.

GEOFF SOMERS is a formidable polar traveller. Having spent three years working as a field guide in Antarctica, he went on to undertake various polar journeys including the first traverse, some 2,250 km (1,400 miles) unsupported, south to north, of the Greenland Ice Cap, and then the first and only crossing of the entire Antarctic Continent from near the tip of the Peninsula via the South Pole to the furthest part of the coast at Mirnyy. The six-man, six-nation expedition, using three teams of husky dogs to haul the sleds, took 220 days to complete the journey. Additionally Geoff has completed another five journeys to the South Pole and six to the North, plus numerous other polar undertakings.

EIRIK SØNNELAND was the leader at the Norwegian research station in Queen Maud Land, 1999–2001, the first Norwegian wintering in Antarctica in forty years. He was just twenty-four years old. Sønneland and his three team mates prepared the station for the next year's research expedition, installing water treatment systems and communications, as well as contributing to psychology research. At the end of October 2000, Rolf Bae and Sønneland then skied unsupported from Queen Maud Land via the South Pole to McMurdo, some 3,800 km (2,360 miles) over 105 days, the longest unsupported ski trek in history.

RIGHT Digging Sno-Cats from crevasses was hot work in blazing sunshine. On paper, three summers and two winters on the southern continent might seem a long time to accomplish a crossing journey that lasted just three months, but complex logistics were required to make the whole undertaking feasible. Even now, such a journey is fraught with difficulty.

Why? On account of the great geographical discoveries, the important scientific results? Oh no; that will come later, for the few specialists. This is something all can understand. A victory of human mind and human strength ... a deed that lifts us above the grey monotony of daily life; a view over shining plains, with lofty mountains against the cold blue sky, and lands covered by ice-sheets of inconceivable extent; a vision of long vanished glacial times.

Fridtjof Nansen, 1912

And I tell you, if you have the desire for knowledge and the power to give it physical expression, go out and explore. If you are a brave man you will do nothing: if you are fearful you may do much, for none but cowards have need to prove their bravery. Some will tell you that you are mad, and nearly all will say, 'What is the use?' For we are a nation of shopkeepers, and no shopkeeper will look at research which does not promise him a financial return within a year. And so you will sledge nearly alone, but those with whom you sledge will not be shopkeepers: that is worth a good deal. If you march your Winter Journeys you will have your reward, so long as all you want is a penguin's egg.

Apsley Cherry-Garrard, 1922

RIGHT George Lowe stands on the polar plateau in February 1958, still some 1,125 km (700 miles) from the end of his journey, but the worst has been overcome. The expedition had just heard on the radio that a case of champagne and a large tin of caviar would be flown in from London's Savoy Hotel, but they never appeared. 'I do remember having a huge slice of cake and a tankard of beer', George recalled: 'That was more than enough for me.'

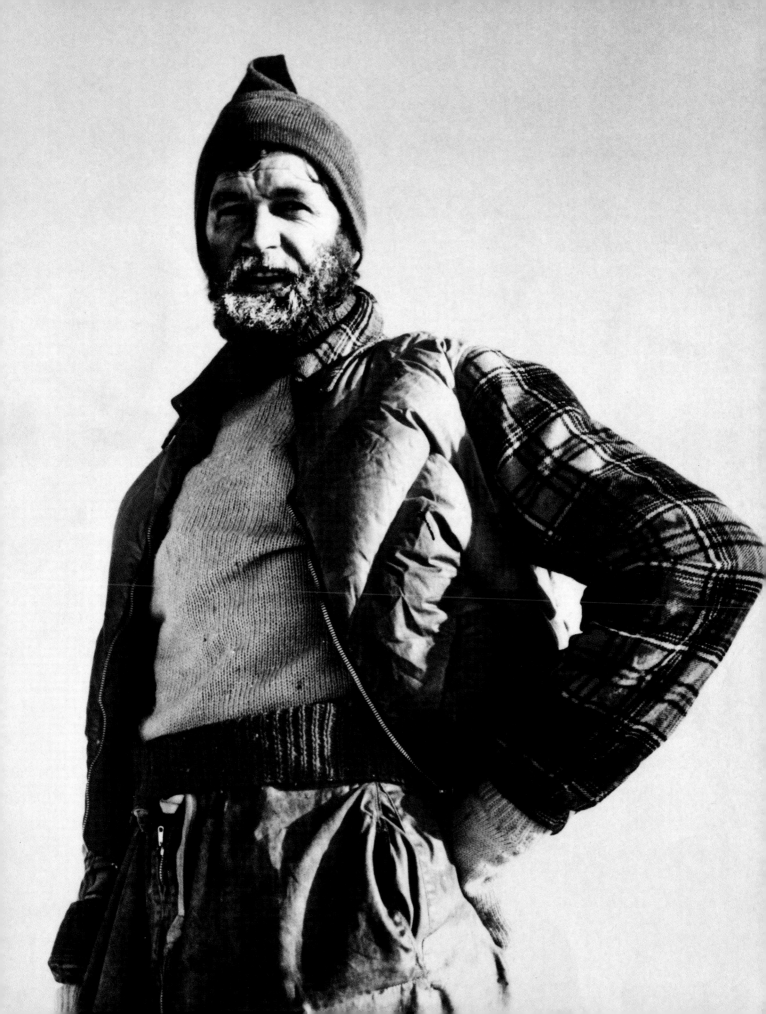

FURTHER READING

Amundsen, Roald, *The South Pole* (London: John Murray, 1912)

Arnold, Anthea, *Eight Men in a Crate* (Norwich: The Erskine Press, 2007)

Aston, Felicity, *Alone in Antarctica* (Chichester: Summersdale, 2013)

Barber, Noel, *The White Desert: His Personal Story of the Trans-Antarctic Expedition* (London: Hodder & Stoughton, 1958)

Brandt, Anthony, *The South Pole: A Historical Reader* (Washington: National Geographic Adventure Classics, 2004)

Byrd, Richard, *Little America: Aerial Exploration in the Antarctic* (New York: Putnams, 1930)

Cherry-Garrard, Apsley, *The Worst Journey in the World* (London: Constable, 1922)

Copeland, Sebastian, *Antarctica: A Call to Action* (San Rafael: Earth Aware, 2008)

— *Antarctica: The Global Warning* (San Rafael: Earth Aware, 2007)

Crane, David, *Scott of the Antarctic* (London: Harper Collins, 2005; New York: Alfred A. Knopf, 2006)

Day, David, *Antarctica: A Biography* (Oxford & New York: Oxford University Press, 2012)

Dodds, Klaus, *Pink Ice: Britain and the South Atlantic Empire* (London & New York: I. B. Tauris, 2002)

— *Geopolitics in Antarctica: Views from the Southern Oceanic Rim* (Chichester & New York: Wiley, 1997)

Dufek, George, *Operation Deepfreeze* (New York: Harcourt, 1957)

Fiennes, Ranulph, *Cold: Extreme Adventures at the Lowest Temperatures on Earth* (London: Simon & Schuster, 2013)

— 'Introduction' in Herbert, Kari and Lewis-Jones, Huw, *In Search of the South Pole* (London: Conway, 2011)

— *Mad, Bad and Dangerous to Know* (London: Hodder & Stoughton, 2007)

— *Captain Scott* (London: Hodder & Stoughton, 2003)

— *Mind over Matter: The Epic Crossing of the Antarctic Continent* (London: Sinclair-Stevenson, 1993)

Filchner, Wilhelm, *To the Sixth Continent* (Banham: The Erskine Press, 1994)

Fisher, Margery and James, *Shackleton* (London: Barrie Books, 1957)

Fuchs, Arved, *In Shackleton's Wake* (London: A & C Black; Dobbs Ferry, NY: Sheridan House, 2001)

Fuchs, Vivian, *A Time to Speak* (Oswestry: Anthony Nelson, 1990)

— *Of Ice and Men: The Story of the British Antarctic Survey, 1943-73* (Oswestry: Anthony Nelson, 1982)

Fuchs, Vivian and Hillary, Edmund, *The Crossing of Antarctica: The Commonwealth Trans-Antarctic Expedition, 1955–58* (London: Cassell, 1958)

Giaever, John, *The White Desert* (London: Chatto & Windus; New York: Dutton, 1954)

Haddelsey, Stephen, *Shackleton's Dream: Fuchs, Hillary and the Crossing of Antarctica* (Stroud: The History Press, 2012)

Helm, Arthur Stanley and Miller, John Holmes, *Antarctica: The Story of the New Zealand Party of the Trans-Antarctic Expedition* (Wellington: Owen, 1964)

Herbert, Wally, *The Polar World* (London: Polarworld, 2007)

— *A World of Men: Exploration in Antarctica* (London: Eyre and Spottiswoode, 1968)

Hillary, Edmund, *View from the Summit* (London: Doubleday, 1999)

— *Nothing Venture, Nothing Win* (London: Hodder & Stoughton, 1975)

— *No Latitude for Error* (London: Hodder & Stoughton; New York: Dutton, 1961)

Huntford, Roland, *Shackleton* (London: Hodder & Stoughton; New York: Atheneum 1985)

Hurley, Frank, *Argonauts of the South* (New York: Putnams, 1925)

Johnson, Nicholas, *Big Dead Place: Inside the Strange and Menacing World of Antarctica* (Los Angeles: Feral House, 2005)

Jones, Max, *The Last Great Quest: Captain Scott's Antarctic Sacrifice* (Oxford & New York: Oxford University Press, 2003)

Kagge, Erling, *Philosophy for Polar Explorers* (London: Pushkin, 2005)

— *Alene til Sydpolen* (Oslo: Cappelen, 1993)

Lewis-Jones, Huw, *In Search of the South Pole* (London: Conway, 2011)

— *Face to Face: Polar Portraits* (London: Conway and Polarworld, 2009)

Lowe, George, *Letters from Everest* (London: Silverbear, 2013)

— *Because It Is There* (London: Cassell, 1969)

— and Lewis-Jones, Huw, *The Conquest of Everest: Original Photographs from the Legendary First Ascent* (London & New York: Thames & Hudson, 2013)

McGregor, Alasdair, *Frank Hurley: A Photographer's Life* (London: Penguin; Camberwell, Vic., 2004)

McKenzie, Douglas, *Opposite Poles* (London: Hale, 1963)

Martin, Geoffrey Lee, *Hellbent for the Pole* (New South Wales: Allen & Unwin, 2007)

Mickleburgh, Edwin, *Beyond the Frozen Sea: Visions of Antarctica* (London: Bodley Head; New York: St Martin's Press, 1987)

Nansen, Fridtjof, 'Introduction' in Amundsen, Roald, *The South Pole* (London: John Murray, 1912)

Ousland, Børge, *Alone Across Antarctica* (Oslo: Boksenteret, 1997)

Ponting, Herbert, *The Great White South* (London: Duckworth, 1921)

Pyne, Stephen, *The Ice: A Journey to Antarctica* (Washington: University of Washington Press, 1998)

Ronne, Finn, *Antarctic Command* (Indianapolis: Bobbs-Merrill, 1961)

Scott, Robert Falcon, *Scott's Last Expedition* (London: Smith, Elder, 1913)

— *The Voyage of the Discovery* (London: Smith, Elder, 1905)

Shackleton, Ernest, *South: The Story of Shackleton's 1914–1917 Expedition* (London: Heinemann, 1919; New York: Macmillan, 1920)

— *The Heart of the Antarctic* (London: W. Heinemann; Philadelphia: J. P. Lippincott Co., 1909)

Siple, Paul, *90° South: The Story of American South Pole Conquest* (New York: Putnams, 1959)

Spufford, Francis, *I May Be Some Time* (London: Faber and Faber, 1996; New York: St. Martin's Press, 1997)

Steger, Will and Bowermaster, Jon, *Crossing Antarctica* (New York: Knopf; London: Bantam Press, 1992)

Stephenson, Jon, *Crevasse Roulette: The First Trans-Antarctic Crossing, 1957–58* (New South Wales: Rosenberg, 2009)

Sullivan, Walter, *Assault on the Unknown: The International Geophysical Year* (New York: McGraw Hill, 1961; London: Hodder & Stoughton, 1962)

Thomson, John, *Climbing the Pole: Edmund Hillary and the Trans-Antarctic Expedition, 1955–58* (Norwich: The Erskine Press, 2010)

Walton, Kevin, *Of Dogs and Men: Fifty Years in the Antarctic* (Malvern Wells: Images, 1996)

Worsley, Frank, *Endurance: An Epic of Adventure* (London: P. Allan & Co, 1931)

INDEX

ILLUSTRATION CREDITS

The George Lowe Collection: endpapers, 2–3, 4, 7, 8–9, 12, 14, 28, 38, 47, 49, 51, 53, 56, 58, 60, 61 (all), 62–63, 64, 65, 66–67, 68, 72–73, 74, 75, 78–79, 80, 81, 82, 83, 86–87, 88a, b, 89, 92, 97, 99, 100, 106, 110, 111, 112–13, 114 (all), 115, 116–17, 118, 119, 120–21, 122a, b, 123a, 124–25, 126, 127, 128–29, 138–39, 140, 141, 142a, b, 142–43, 144–45, 150, 152, 157, 163, 166, 167, 168, 169, 172–73, 174–75, 176, 177, 179, 180–81, 200, 202, 206, 210, 219, 226, 235.

The Sir Vivian Fuchs Collection: 69, 70–71, 84–85, 109, 132, 146, 147, 148, 149, 178 (all), 183, 184–85, 186, 187, 194, 196, 211, 220, 222–23.

Object Photography by Martin Hartley: 1, 17, 18, 20–21, 90, 188.

© **Antarctica New Zealand Pictorial Collection:** TAE 1957, John Claydon: 130; TAE 56/57: 131; TAE 1958: 182.

Sebastian Copeland: 204–05, 212–13.

Corbis: © Morton Beebe: 170–71; © Thomas Abercrombie/National Geographic Society: 230–31.

Getty Images: Time & Life Pictures: 59; George W. Hales/Fox Photos: 165; Central Press/Hulton Archive: 237.

The Bernie Gunn Collection: 37, 133, 134–35, 136–37, 190.

Mitchell Library, State Library of New South Wales, Sydney: Frank Hurley, British Imperial Trans-Antarctic Expedition, 1914–1917 (ON 26, Album ID 823227): 40, 44 (all); Frank Hurley, Australasian Antarctic Expedition (1911–14) (PXD 158, a1985007): 216.

The Polarworld Collection: 193, 199.

© **Press Association Images:** 76–77; © **AP:** 160.

© **Punch Ltd:** 198.

Royal Collection Trust/Her Majesty Queen Elizabeth II 2013: 10.

Royal Geographical Society (with IBG): 22, 27, 32–33a.

Photo Jon Stephenson: 224–25.

ACKNOWLEDGMENTS

This book was always thought of as a companion to *The Conquest of Everest*, which we finished shortly before George Lowe passed away. With the kind and heart-warming support of many people we have managed to complete *The Crossing of Antarctica* in honour of this truly remarkable man.

I should like to acknowledge the efforts of our team: Kari Herbert at Polarworld; photographer Martin Hartley; our glorious designer Liz House; Pauline Hubner; Charlie Hey and Craig Farley at the Photography Centre at the University College Falmouth; and our polar contributors whose talents and

insights have added greatly to this project. Both Mary Lowe and Peter Fuchs have been immensely generous and supportive throughout. And once more all the team at Thames & Hudson in London helped us to make this book a reality.

I should like to remember again the tremendous George Lowe. Teacher, explorer, photographer, humanitarian; he was an inspirational man with a wonderful story to share. And lastly my grandfather, Commander Keith Dedman, who also voyaged to Antarctica in the 1950s. He opened my eyes to the polar world and I'm forever grateful for his example in life. Like George, he was a true gentleman.

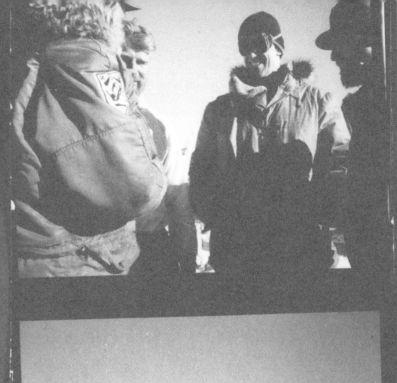
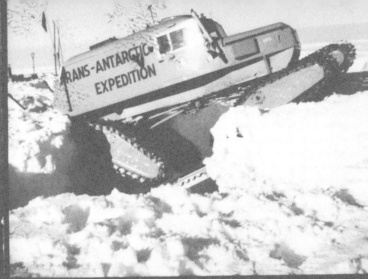
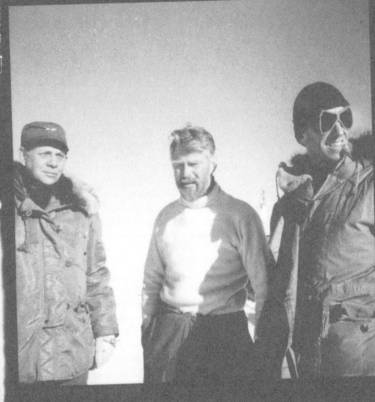
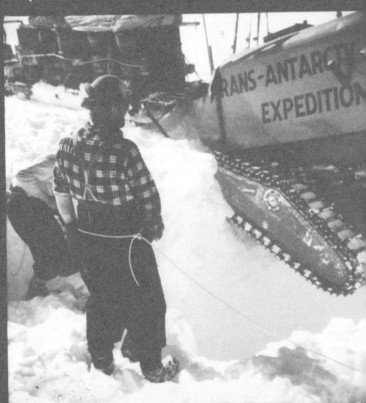